European Art of the
Sixteenth Century

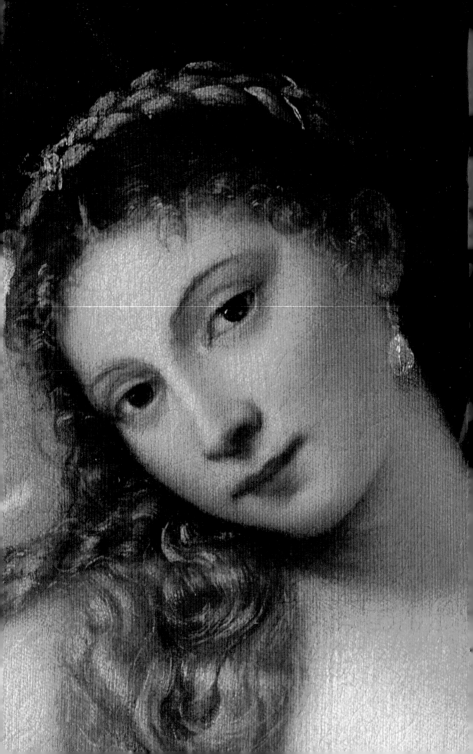

Stefano Zuffi

European Art of the Sixteenth Century

Translated by Antony Shugaar

The J. Paul Getty Museum
Los Angeles

Art through the Centuries

Italian edition © 2005 Mondadori Electa S.p.A., Milan
All rights reserved. www.electaweb.it

Series Editor: Stefano Zuffi
Original Design Coordinator: Dario Tagliabue
Original Graphic Design: Anna Piccarreta
Original Layout: Sara de Michele
Original Editorial Coordinator: Caterina Giavotto
Original Editing: Barbara Travaglini
Original Photo Research: Valentina Minucciani
Original Technical Coordinator: Andrea Panozzo
Original Quality Control: Giancarlo Berti

English translation © 2006 J. Paul Getty Trust

First published in the United States of America in 2006 by
Getty Publications
1200 Getty Center Drive, Suite 500
Los Angeles, California 90049-1682
www.getty.edu

Mark Greenberg, *Editor in Chief*

Ann Lucke, *Managing Editor*
Mollie Holtman, *Editor*
Robin H. Ray, *Copy Editor*
Pamela Heath, *Production Coordinator*
Hespenheide Design, *Designer and Typesetter*

Printed in Hong Kong

Library of Congress Cataloging-in-Publication Data

Zuffi, Stefano, 1961–
 [Cinquecento. English]
 European art of the sixteenth century / Stefano Zuffi ; translated by
 Antony Shugaar.
 p. cm. — (Art through the centuries)
 Includes index.
 ISBN-13: 978-0-89236-846-4
 ISBN-10: 0-89236-846-2
 1. Art, European— 16th century. 2. Art, Renaissance. I. Title:
European art of the 16th century. II. Title: European art of the XVIth
century. III. Title. IV. Series.
 N6374.Z8413 2006
 709'.031—dc22
 2006000532

Page 2:
Titian, *Venus of Urbino* (detail), 1538.
Florence, Uffizi.

Contents

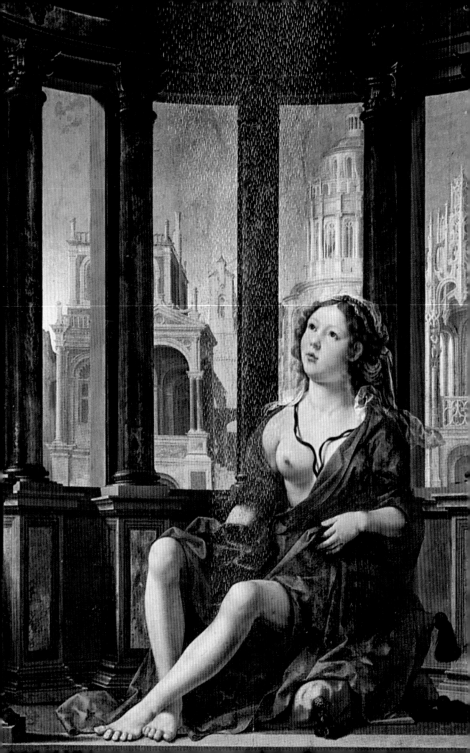

KEY WORDS

◀ Mabuse (Jan Gossaert), *Danaë*
(detail), 1527. Munich, Alte Pinakothek.

Until the beginning of the 16th century, many nations were still immersed in a Gothic universe. Ornamental creativity and technical virtuosity prevailed over classical symmetry and regularity.

Flamboyant Gothic

▼ Interior of Granada Cathedral (begun in 1523).

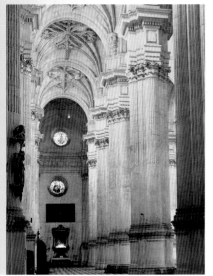

Between the first encounter with America (1492) and the beginning of the Protestant Reformation (1517), the Old World lived through a phase of redefinition, not just political and economic but cultural as well. It was during these years that the ideas of Italian humanism began to spread, being assimilated into and modified from nation to nation. Moreover, the style of the latest Gothic, whimsical in shape, material, and form of expression, produced spectacular results throughout Europe. Buildings and their decorative programs show a basic similarity, ranging from the Spanish Mudéjar style (Seville cathedral) and the "Manueline" style of Portugal (Belém monastery in Lisbon) all the way up to the church of Brou, just outside of Bourg-en-Bresse, which served as the mausoleum of Philibert of Savoy and Margaret of Austria, a masterpiece and the epitome of Flamboyant Gothic. Particularly daring are the creations of such sculptors and architects as Anton Pilgram and Benedikt Ried in central Europe, in places such as Brno, Vienna, Prague, and Budapest. The remarkable fan vaults built by John Wastell and William Vertue are extreme expressions of the Perpendicular Gothic style in Tudor England. In Antwerp and Brabant, just before the advent of the Italian-influenced school of painting, complicated, intricately carved wooden altars were being produced. The great masters of German sculpture in the early 16th century, beginning with Tilman Riemenschneider, grappled with virtuoso pediments, pinnacles, spires, and fretwork. But the Gothic tradition in the courts of Europe soon collapsed amid a yearning for the new, a need to explore new "boundaries," in human as well as geographic terms.

The railing features highly expressive busts of the four Doctors of the Church, with dramatically exaggerated features.

The shaft and the support arches are a spectacular assembly of Gothic decorative elements, clearly at the very extreme of this expressive and ornamental style.

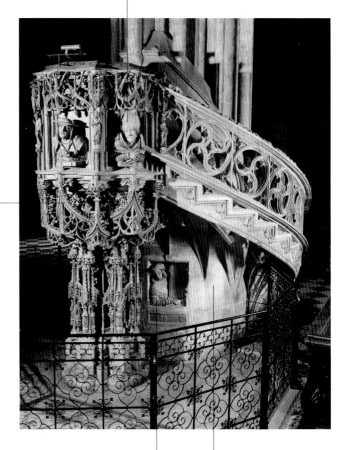

At the base of the monument, Pilgram inserted a vivid self-portrait. It looks as if the sculptor were leaning out of a small window to see whether his creation was a success.

▲ Anton Pilgram, Pulpit, 1511–15. Vienna, Stephanskirche.

The weight of the pulpit is held up by one of the pillars of the Viennese cathedral. Access is provided by a spiral staircase, with a handsome fretwork balustrade.

Flamboyant Gothic

The geometric pattern of the lines is clearly taken from nature, as if imitating the intertwined branches of a bower. It bears absolutely no relationship to the external structure of the church's roof, which has the unusual shape of a steeply pitched pavilion with three steeples.

The ribs in the reticulated vaults spring directly from the clustered piers, without capitals, according to a system that was very popular in late-Gothic architecture in central and eastern Europe.

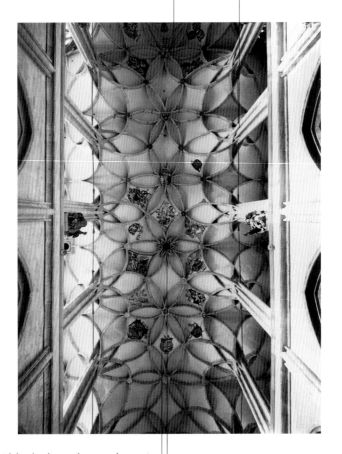

Brightly colored coats of arms stand out against the white plaster, set in the bays with curving borders that are defined by the arching vaults. This church in what was once a major Bohemian city, the site of the royal mint, is dedicated to Saint Barbara, the patron saint of miners.

The entire system of fanciful vaults connects to a central element shaped like a star, or perhaps a flower.

▲ Benedikt Ried, Vaulting of the church of Saint Barbara, ca. 1506. Kutná Hora (Czech Republic).

The abbey church of Brou, perhaps the most complete example of Flamboyant Gothic in existence, was built beginning in 1505 at the behest of Margaret of Austria, who had been widowed the year before. She intended it to symbolize the "temple of love and faithfulness."

The exotic headdress gives this figure an unusual, slightly Eastern appearance. A recurring feature of late-Gothic art is the use of unusual clothing and elaborate hairstyles.

The statuette features the distinctive trait of balancing on one hip, typical of the mature Gothic style at the French court.

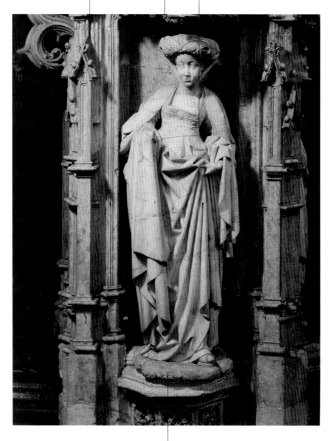

The tombs of Margaret of Austria and Philibert of Savoy are the focal point of the church's very elaborate decoration.

▲ Statuette of a sibyl, from the monument to Philibert of Savoy, ca. 1514. Abbey church of Brou, near Bourg-en-Bresse (France).

The buoyant figure of Christ is almost hindered by his mantle, which appears to be entangling the arm with which he is holding up the crown of the Virgin Mary.

In the left panel stand the deacon saints Lawrence and Stephen (to whom the cathedral of Breisach is dedicated), clad in ample robes with virtuoso pleating and folding.

▲ Master H.L., *Altar of the Coronation of the Virgin*, 1523–26. Breisach (Germany), cathedral.

Looking out of the predella are four very lively portraits of the evangelists.

The altarpiece is dedicated to the Coronation of the Virgin. This theme was considered heretical by Protestants, but it had many precedents, including one painted by Hans Baldung Grien just a few miles away in the main altar of Freiburg Cathedral. Enveloped in undulating drapery held up by angels, the Virgin almost seems to disappear amid the fanciful decoration.

The most impressive figure is perhaps that of God the Father. The overwhelming expressive imagination of the artist has pushed an extreme Gothic style to the verge of Baroque whimsy.

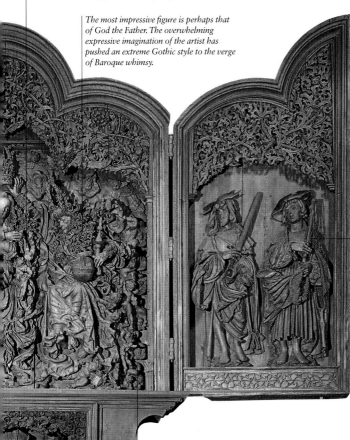

In the right panel we see the 2nd-century Milanese martyrs Gervasius and Protasius, a few of whose relics were preserved in the church. Despite their antiquity, here they look quite "contemporary," like two wealthy, bellicose young aristocrats from the early 16th century.

The artist who carved this altar remains unnamed. We know only his initials, H.L., which appear in a small plaque held by an angel.

The term "Renaissance" is inadequate to define the passions and masterpieces of such geniuses as Leonardo, Raphael, Michelangelo, and Titian, interacting in an intense artistic debate.

The High Renaissance

Related entries
Rome, Florence, Siena, Venice

Andrea del Sarto, Giorgione, Michelangelo, Raphael, Sebastiano del Piombo, Titian

▼ Leonardo da Vinci, *The Mona Lisa (La Gioconda),* 1503–13. Paris, Louvre.

The first two decades of the 16th century were one of the most fertile periods in art history in terms of new ideas and experimentation. The achievements of humanism in the fields of geometry, perspective, composition, and light were by now common property in the world of art, even outside of Italy. Expressions, gestures, color, and a canon of ideal beauty were now closely studied, in a full awareness of the Renaissance's coming of age. The traditional style of several masters who enjoyed long careers (Botticelli, Perugino) entered into crisis. The first decade of the 16th century witnessed a flourishing of human passions in the paintings of Leonardo, the enchantment of Raphael's supreme equilibrium, the confident and magnificent power of Michelangelo, and

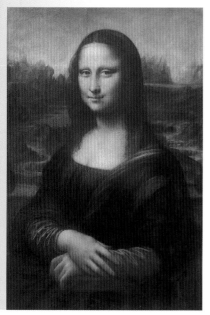

Giorgione's tender sensitivity to nature. A push also began to overcome the geometric strictures of humanism, with its mathematical rules of symmetry and perspective. The most important laboratory for the production of new ideas and concepts was Rome, both because of the ongoing archaeological discoveries and because of the monuments being commissioned by Pope Julius II. Beginning in 1508, scaffolding was erected for the frescoes done by Raphael in the Vatican Stanze and for the ceiling of the Sistine Chapel, Michelangelo's grueling but magnificent masterpiece. Leonardo returned to Milan in 1506; there he imposed his style on the local school. In Venice, which Dürer repeatedly visited, the analytical and narrative tradition of Carpaccio and Gentile Bellini was fading from the scene, to be replaced by Giorgione's uneasy gentleness and Titian's first explosions of color.

The powerfully modeled head is slightly out of proportion. Michelangelo made it larger because he took into account the sheer size of the colossal sculpture, the spectator's point of view from below, and especially his desire to communicate, even from a distance, an expression of physical energy, albeit contained and mastered by reason.

The enlarged volume of the torso is a finely calibrated compromise between authentic anatomical observation and the heroism of classical sculpture.

For his David, Michelangelo was obliged to use a block of marble that had previously been roughed out by Agostino di Duccio. The equilibrium of this figure derives from a pose that is slightly in contrapposto, in keeping with the classical canons, with a center of gravity corresponding to the navel.

The arms and hands, muscular and vibrant, yet at rest, underscore once again the sculpture's symbolic meaning, so typical of the culture of the Florentine Renaissance. It conveys the idea that brute force must never be expressed in a rough, disorderly fashion, but is truly efficacious only when controlled and directed by the superior qualities of will and intelligence.

▶ Michelangelo, *David*, 1501–4. Florence, Galleria dell'Accademia.

The vast, serene arches of the Temple of Wisdom are a specific tribute to the start of construction on Saint Peter's Basilica under the supervision of Bramante, who, like Raphael, came from Urbino.

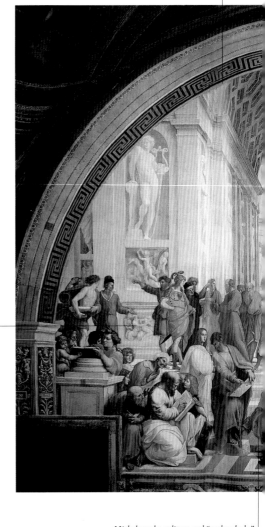

The clear, diffuse light, the elegant composition of the groups of figures as if posed on a stage, the learned, civilized presence of classical statues and bas-reliefs: every element of this fresco helps to evoke an atmosphere of nobility and tranquility, illuminated by faith in reason.

▲ Raphael, *The School of Athens*, 1509–10. Vatican City, Vatican Palace, Stanza della Segnatura.

Michelangelo, solitary and "melancholy," personifies Heraclitus. Raphael identified the artists of the High Renaissance with classical philosophers, thus emphasizing their intellectual role.

In the center, we see the two greatest philosophers of antiquity, fully rediscovered during humanism: Aristotle and Plato. Plato, with one finger pointing upward toward the heavens, resembles Leonardo da Vinci.

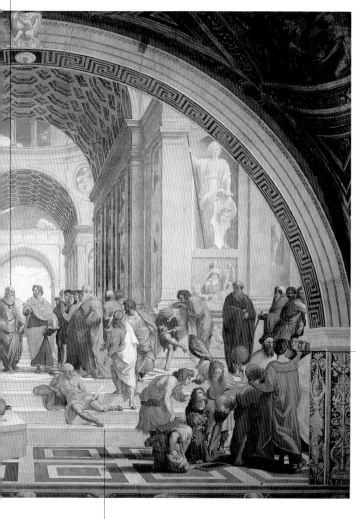

In the group of philosophers on the far right is a self-portrait of Raphael. Just as with Dante in Limbo, the artist-intellectual here chose to identify himself as a member of the "bella scuola" of the ancient thinkers.

The composition of the scene follows the rules of central linear perspective. The Stanza della Segnatura was originally built to house the library of Pope Julius II; The School of Athens was painted on the wall that was meant to hold books of philosophy.

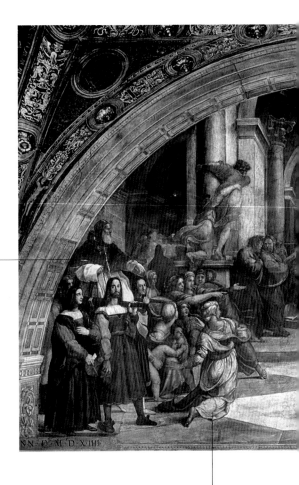

Pope Julius II himself watches the scene, which alludes to the military reverses that the pontiff had recently suffered. His presence imbues the tableau with a note of explicit currency.

▲ Raphael, *The Expulsion of Heliodorus*, 1511–12. Vatican City, Vatican Palace, Stanza di Eliodoro.

While the figures in The School of Athens *are portrayed in relaxed, natural poses, in the next Stanza, Raphael begins to introduce rotated poses and dramatic gestures that herald the advent of Mannerism.*

The architectural composition here is similar to that in The School of Athens, *but the discrete shafts of oblique light produce an entirely new and highly dramatic effect.*

A comparison of the two frescoes, so close in space and time, reveals how fleeting and splendid the ideas of "High Renaissance" really were.

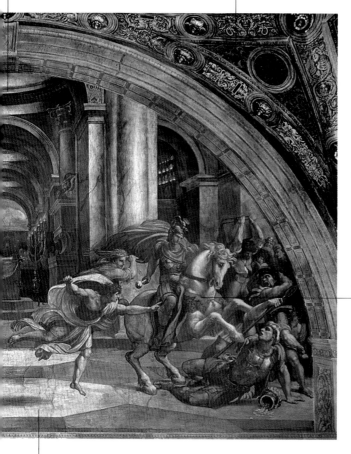

The room, which was originally intended as the private papal-audience chamber, took its name from this fresco. It depicts an episode from the Bible: Heliodorus, attempting to profane the temple, is expelled and beaten by avenging celestial forces, summoned by the praying priest.

The scene presents a vivid contrast with the serene and harmonious arrangement of the figures in The School of Athens, *painted only a couple of years earlier. Here Raphael paints empty and divided spaces in which figures cluster together, thus accentuating the emotional tension of the scene.*

Contacts with Italian humanism were undercut by the appeal of a more intense, direct form of religion; the trend was toward ancient Rome, away from the Rome of popes and indulgences.

Northern Humanism

▶ Jan van Scorel, *Portrait of a Twelve-Year-Old Schoolboy* (detail), 1531. Rotterdam, Museum Boijmans van Beuningen.

Erasmus of Rotterdam, the greatest humanist north of the Alps, provided in his *Adages* (1508) a lively blend of folk wisdom, classical quotations, and common sense. In his next work, *Praise of Folly* (*Encomium Moriae*, 1509), Erasmus called for a complete rethinking of history, morality, and religion, while questioning the very roots of his own humanism. In north-central Europe, cultural eclecticism and the growing influence of skepticism were key factors. In 1501, Emperor Maximilian I founded the University of Vienna, appointing the poet Conradus Celtis as its head. At the same time, in Germany, cultural patronage involved, variously, prince electors (such as that of Saxony, patron of Cranach), dukes (such as William IV of Bavaria, one of Altdorfer's patrons), cardinals (such as the archbishop of Mainz, Albert of Brandenburg, who invited Dürer's and Grünewald to his city), financiers (such as the Fugger dynasty in Augsburg), or such intellectuals as Willibald Pirkheimer, a friend of Dürer's. At the same time, the cities of the Hanseatic League, along the shores of the Baltic, began to decline. The thriving mercantile cities of Bavaria, such as Nuremberg (Dürer), Regensburg (Altdorfer), Augsburg (Burgkmair, the Holbeins), specialized in the manufacture of jewelry, precision instruments, weapons, clocks, and mechanical automata. Printing presses also made them centers for the diffusion of culture. The cultural polycentrism was particularly rich along the Rhine in the Alsatian cities, where there was a solid tradition of painting from Schongauer to Grünewald and Baldung Grien, and in the cultivated city of Basel, where the Holbein dynasty worked.

Several portraits of Erasmus of Rotterdam survive, not only this one by Metsys, but others by Dürer and Holbein the Younger. The number of portraits indicates the debt of gratitude felt by the leading artist-intellectuals toward the greatest humanist of north-central Europe. All of these artists, however, were forced to admit that Erasmus's face, to their surprise, was substantially lacking in charisma and expression.

The books stacked on the shelves and the various writing implements are a frequent presence in the history of Renaissance art, indispensable props in portraits of intellectuals.

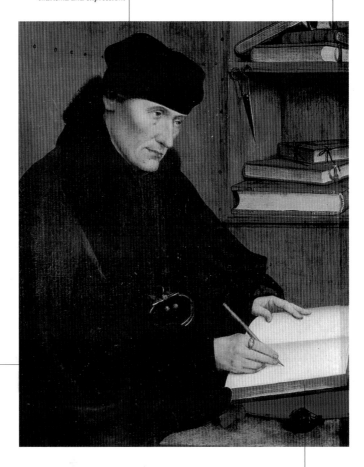

The sobriety of his dress is in keeping with the general style of men's clothing in the 16th century, but it is accentuated here to emphasize the depth and nobility of his personality, indifferent to outward appearances.

▲ Quinten Metsys, *Portrait of Erasmus of Rotterdam*, 1517. Rome, Palazzo Barberini, Galleria Nazionale d'Arte Antica.

In order to make up for the lack of any distinctive facial features, Metsys and other portraitists focused on Erasmus's intellectual work, depicting him either studying or writing.

Northern Humanism

The broad plumed hat and the seductive gaze give Cranach's Venus the look of a courtesan. The painting, in fact, contains numerous symbols that evoke the physical and moral perils of love.

The enchanting landscape, with crags rearing up over streams and thick woods, is reminiscent of the settings favored by the painters of the Danube school.

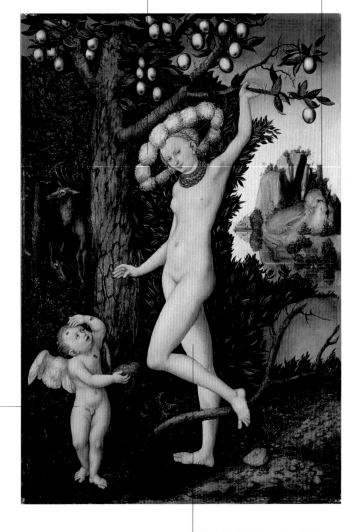

Cupid has stolen a honeycomb, and now he is crying over the painful beestings. Cranach depicts here, to the letter, the text of one of Theocritus's idylls, but he adds a bitterly up-to-date theme. In the first decades of the 16th century, syphilis and other venereal diseases were sweeping through Europe, carried by the numerous armies waging war across the continent.

▲ Lucas Cranach the Elder, *Cupid Complaining to Venus*, ca. 1529. London, National Gallery.

The goddess's slender, nude body is shown in a pose that emphasizes its sleek, well-turned silhouette.

Ironically depicted with a funnel on his head, a quack surgeon extracts from the cranium of the unfortunate patient the stone that, according to folk beliefs, caused his madness.

Written in elaborate Gothic script, the legend is an invocation of the patient, asking that the stone be extracted, and stating that he is called "Lubbert das" (foolish man).

The woman with a book on her head and the priest with a beer tankard add to the satirical nature of the scene.

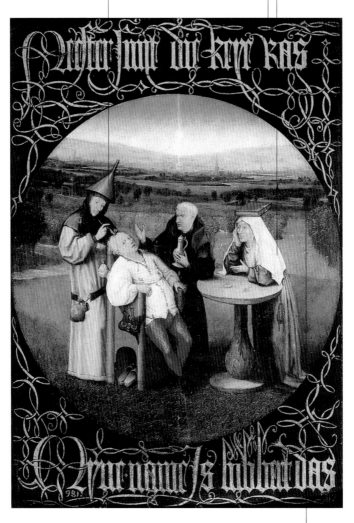

▲ Hieronymus Bosch, *The Extraction of the Stone of Folly*, ca. 1490. Madrid, Prado.

The broad, still rural landscape stretches out in the distance, underscoring the distinctly northern theme of nature's majestic indifference to the frantic pursuits of man.

A devil blows in the ear of the sleeping scholar. This same theme appears later in Goya's renowned print El sueno de la razon produce monstruos (The Sleep of Reason Produces Monsters).

A lovely nude woman inspires lascivious dreams.

Lulled by the warmth of a large stove, his head resting on a pillow, the "doctor" has drifted off to sleep. The figure's massive proportions are reminiscent of Willibald Pirkheimer, one of the most learned humanists of Nuremberg, and a close friend of Dürer's.

The precarious balance of the little Cupid, trying to climb onto a pair of stilts, and the nearby sphere, symbol of Fortune, both hint that it is best not to waste time or miss opportunities.

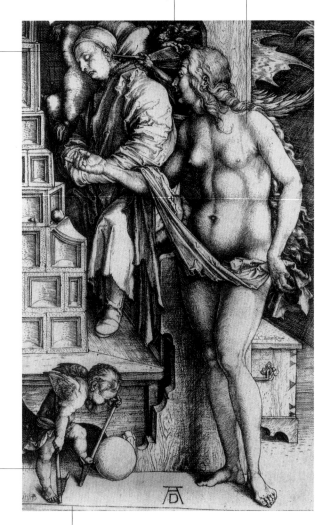

▲ Albrecht Dürer, *The Doctor's Dream*, Burin engraving, 1497–98.

If we compare this print with the one that follows, we can see the stylistic difference between Dürer's engravings and his woodcuts; there is also a distinct difference between a scene in which the allusive elements are set in everyday reality and one that is explicitly symbolic and intellectual.

This image is poised at a fascinating midpoint between a dawning northern European humanism and a symbolic heritage that is still distinctly Gothic. Note the magical reiteration of the number four: the points of the compass, the winds, the ages of the soul, the seasons, the elements, and the humors that flow in the human body.

The winds that blow in the corners of the page determine the weather in the various seasons.

Four medallions commemorate different types of intellectuals in the history of civilization: Chaldean and Egyptian "priests," Greek "philosophers," Latin "poets and rhetoricians," and German "scholars," represented by Albertus Magnus.

▲ Albrecht Dürer, *Allegory of Philosophy*, woodcut, frontispiece of the works of Conradus Celtis, 1502.

Enthroned like a queen, Philosophy is depicted as governing and directing everything on earth, in the sky, and on the seas.

The mathematician's intent, disinterested expression would become, in time, a stereotype for the scientist, detached from the world.

Holbein reveals a special interest in scientific and precision instruments, symbols of an era that was attempting to support the realms of philosophical speculation and the senses with objectively obtained, verifiable data.

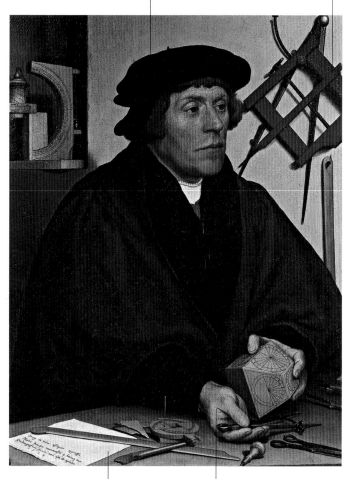

The inclusion of a letter with heading and date is a fairly common technique used by artists to insert unobtrusively the name of the subject and the year of the painting.

The compass and the polyhedron marked with the celestial spheres were used to carry out complex astronomical observations. Astronomy was developing as an experimental science, increasingly separate from the divinatory practice of astrology.

▲ Hans Holbein the Younger, *Portrait of the Astronomer and Mathematician Nikolaus Kratzer*, 1528. Paris, Louvre.

Sobriety of dress and a calm gaze were to become, over the course of the 16th century, distinguishing features of the social category of intellectuals and scientists, especially in contrast with the bold cockiness of gentlemen and soldiers.

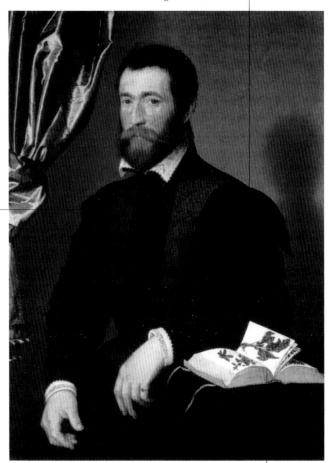

Clouet confers an official flavor on his portrait through a few distinctive techniques: the use of a satin curtain, the subject's erect posture, and the gaze turned directly toward the viewer.

The herbal represents a midpoint in the progression from the handbooks and prescription books of the late Middle Ages to the collections of natural and exotic "wonders" that appear at the dawn of the Baroque era. It was during the second half of the 16th century that the arts of the apothecary and the herbalist became independent disciplines in the universities.

▲ François Clouet, *Portrait of the Apothecary Pierre Quthe*, 1562. Paris, Louvre.

Art and architecture often turned to the classical world, not only to capture its essence, but also in a quest to understand the complex relationships among art, history, and nature.

The Relationship with Antiquity

Beginning with the controversial papacy of Alexander VI (Rodrigo Borgia) in the last decade of the 15th century and continuing at a quickening pace under his successors, Julius II and Leo X, systematic campaigns of excavation and exploration were undertaken in Rome among the ruins of the ancient palaces of the Roman emperors. These archaeological digs, often directly supervised by major artists and architects, produced new and more complete material for the study of classical architecture (particularly influential was the discovery of the Hellenistic sculptural group *Laocoön*, in 1506). They also resulted in the discovery of ornamental frescoes and stuccoes, which were used as models in the decoration of aristocratic villas and *palazzi*. In 1514, in a letter written jointly with Baldassare Castiglione and addressed to the pope, Raphael insisted on the importance of preserving classical ruins and statues and studying the "model of antiquity." From this point on, and for the three centuries that followed, it became almost obligatory for European artists to travel to Rome to study "antiquity" and its Renaissance interpretations. The travels of artists and intellectuals encouraged the spread of Italian humanist culture to foreign capitals. The controversial relationships between classical rules and nature, the lessons of antiquity and the vitality of present reality, and the duality of science and faith, were interpreted, freely and intensely, by the leading European artists and intellectuals of the time.

▶ Antico (Pier Jacopo Alari Bonacolsi), *The Belvedere Apollo*, 1498. Venice, Galleria Franchetti at the Ca' d'Oro.

The scene progresses in quite an unusual ascending rhythm. In a reversal of the customary direction, we follow Aeneas's journey from the bottom of the painting to the top.

The meeting of Aeneas and Queen Dido adheres to the elegant style of Flemish miniatures in the 15th and 16th centuries, with stately gestures, landscapes abounding in details, and figures that stand out against verdant backgrounds.

Troy, in flames, is to all appearances a Gothic city of north-central Europe.

The artist who painted these miniatures of scenes from Virgil remains unnamed. It is known that he was active in Bruges around the end of the 15th and the beginning of the 16th centuries.

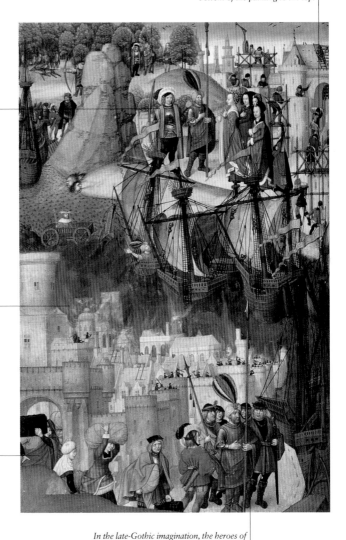

In the late-Gothic imagination, the heroes of the classical age are transformed into exotic characters from contemporary literature. Aeneas is wearing an extravagant and unmistakable hat, with a towering multicolored plume.

▲ Master of the Prayerbooks of ca. 1500, *Scenes from the Aeneid*, ca. 1495. Holkham Hall, Collection of the Earls of Leicester.

The picturesque creepers covering the Roman ruins are an effective indication of the state of semirural decay into which much of the Eternal City had fallen by the 16th century.

In a fanciful antiquarian style, the Dutch artist mingles real details with imaginary sculptures and fragments of architecture, creating a pastiche that is particularly unusual given the period of the painting.

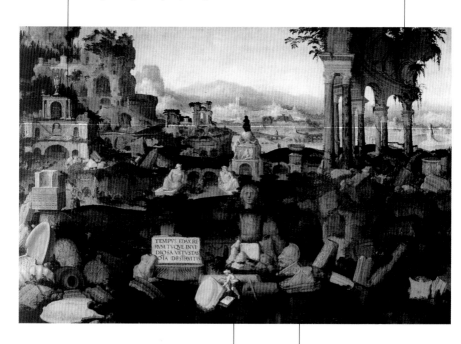

At the base of the colossal foot, it is just possible to make out the signature and date of the work. Posthumus, about whom little is known, belonged to the growing number of "Romanists," painters who converged on the city from every corner of Europe, residing there for periods of study of varying duration.

In the middle of the scene, an artist is using a compass to measure the immense base of a column. The tiny human figure seems to be swallowed up amid the grandeur of the ancient ruins.

▲ Herman Posthumus, *Fantastic Landscape with Roman Ruins*, 1535. Vienna, Collection of the Princes of Liechtenstein.

This bloody historical episode offered the artist an opportunity to illustrate the main buildings of ancient Rome. We can see, in a curious clustered montage, the Colosseum, the Pantheon, the three-story portico of the Septizonium (later destroyed), and an obelisk.

This style of composition, based on groups of small figures, is typical of the work of this French painter, a member of the school of Fontainebleau.

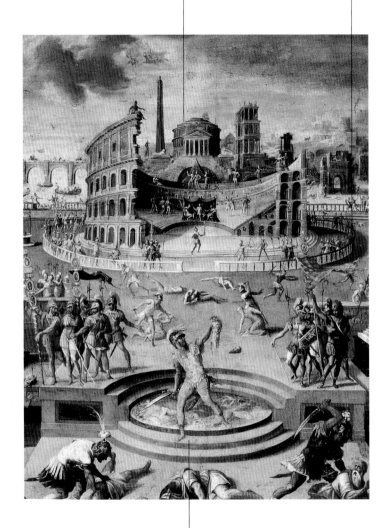

▲ Antoine Caron, *The Massacres of the Triumvirate* (detail), 1566. Paris, Louvre.

This unusual scene is based on the period of turmoil in the 1st century B.C., but it would not be difficult to read into it a brutal image of life during the Wars of Religion in the second half of the 16th century.

The muscular writhing of the three characters was carefully studied during the Mannerist period. The proliferation of copies on various scales and the transposition of the sculpture from marble to bronze encouraged the work's diffusion throughout Europe.

The lacunae in the classical original, such as Laocoön's missing right arm, left Renaissance artists in great doubt, uncertain whether they should reproduce the damaged group or undertake reconstructions based on guesswork.

The Trojan priest, along with his two sons, is being devoured by serpents for having attempted to unmask the trick of the wooden horse left as a gift by the Greeks. His agonized expression decisively pointed the way toward a new understanding of painful expressionism in ancient paradigms, which began to displace the serene composure modeled after the work of Praxiteles or Lysippus.

▲ Francesco Primaticcio and assistants, copy in bronze of *The Laocoön*, 1550. Fontainebleau, château.

The 1506 discovery of the Hellenistic marble group, found in Rome, is a crucial date in the study and revival of classical art during the course of the 16th century.

Near the center of the composition, it is possible to see the horse, set, however, not outside an imaginary Troy, but at the gates of a phosphorescent, magical Toledo.

On the right of the painting, incongruous and charming, there appear two evanescent, elongated young figures, sometimes interpreted as the god Apollo and the goddess Venus.

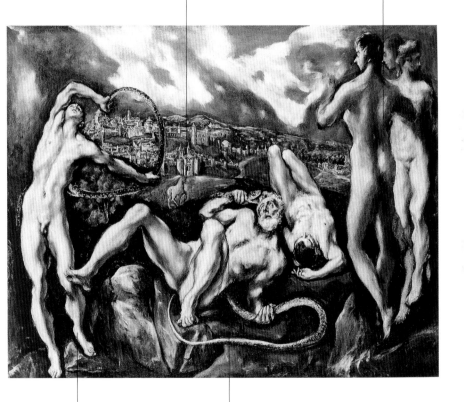

The lithe young limbs of Laocoön's sons become an excuse for a gymnastic display.

With the liberty of a genius nearing the end of his career, El Greco breaks free of the Hellenistic model and completely reinvents the scene.

▲ El Greco, *Laocoön and His Sons*, 1607. Washington, D.C., National Gallery of Art.

This engraving by the Dutch artist Goltzius not only documents a renowned ancient statue but also interprets the "meaning" of classicism. The clouds scudding by in the sky, the figure's substantial solitude, its distance from the earthly world—all engender a sense of admiration but also of melancholy, as if we were looking at a survivor, the last of a race of heroes that is entirely lost save for isolated fragments of memory.

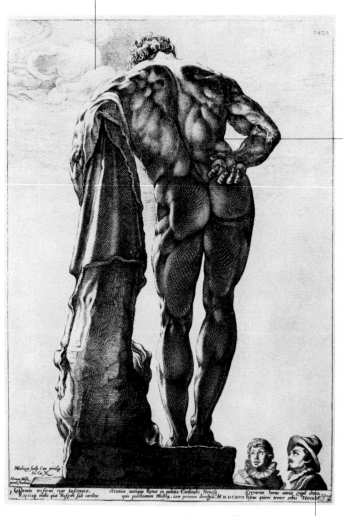

The view from the back, used in nearly all the depictions of the Farnese Hercules in the 16th century, emphasizes its massive muscles, as if it were an anatomical manual for artists.

▲ Hendrick Goltzius, *The Farnese Hercules*, engraving from the series The Ancient Statues of Rome, 1590–91.

The position of the two viewers serves the practical purpose of offering a sense of the statue's colossal size but also hints at the sense of astonishment and "wonder," already almost Baroque, prompted by the colossus.

▶ Sebastiano del Piombo, *Saint Louis of Toulouse*, 1510. Venice, Galleria dell'Accademia.

*In the works of Leonardo and the Venetian masters, outlines are
no longer sharply defined with a clear graphic sign but instead
appear slightly blurred, with gradations of light and color.*

Leonardesque Sfumato
and Tonalism

While 15th-century painting tended toward sharp lines, precise
shadows, and enameled colors, at the turn of the 16th century the
opposite trend began to manifest itself in northern Italy. The col-
ors shifted toward muted tones, and a natural atmosphere circu-
lated freely throughout the canvas. Paradoxically this affirmation
of the distinctive values of painting and color was first begun by
Leonardo, one of the greatest draftsmen of all time. He introduced
the concept of sfumato ("shading"), beginning with his landscape
backgrounds, where mist, clouds, and humidity blurred outlines.
Leonardo's ideas were taken up by the group of Lombard artists
known as "Leonardesques," as well as other artists, such as

Correggio and, especially, the Venetians. In fact, the later
works of Giovanni Bellini and those of Giorgione blazed
the way for "tonalism," a technique of applying layers
of glazing in order to bring out an image through a grad-
ual progression of muted tones of light and color. This
technique tends to emphasize the effect of chromatic
impasto, relegating draftsmanship to a secondary role.
Venetian painting—like Leonardo's before it—opted for
a different approach, both practical and aesthetic, from
the Florentine school, which had traditionally focused on
careful draftsmanship. The presence of Albrecht Dürer in
Venice (1505–6) provided an occasion for a timely inter-
national consideration of Venetian tonalism. Writing to
his friend Willibald Pirkheimer, Dürer spoke with plea-
sure of the attention that the aging Bellini had accorded
him, and he observed that Bellini was in his opinion still
the finest painter working in Venice.

This painting underwent a lengthy process of execution, and Leonardo finished it in France. Nonetheless, the natural background and the atmosphere refer to the Lombard landscape, with rivers and mountains fading into the light-blue haze of humidity.

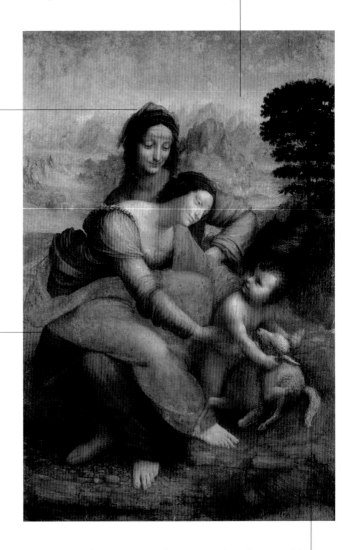

Saint Anne's smiling face is a distinctive example of Leonardo's treatment of women's faces. It is perhaps paradoxical that an artist who insisted (both in writing and in drawing) on offering variety in features and expressions should have established a facial model that was so relentlessly imitated by his followers.

The Virgin Mary is seated on the knees of her mother, Saint Anne, in keeping with the iconographic motif of generational succession. Also linked to this theme is the clear facial resemblance of the two women. Still, Leonardo breaks with tradition by infusing the work with a dynamic sense of action.

▲ Leonardo da Vinci, *The Virgin and Child with Saint Anne and a Lamb*, 1510–13. Paris, Louvre.

Mimicking Mary's gesture, the Christ child takes the symbolic lamb into his arms. The presence of the animal, certainly justified by the subject matter but absent in Leonardo's early versions of this painting, adds a further element to the touching description of the natural world in which the characters are immersed.

According to Vasari, Giorgione attentively studied Leonardo's drawings. While this may be true, his work also fits into the larger development of Venetian painting in a direction that evoked natural atmospheres by building up layers of light tones and color.

An unusual protagonist of this painting is the lightning bolt that pierces the clouds, casting a sudden glow over the landscape.

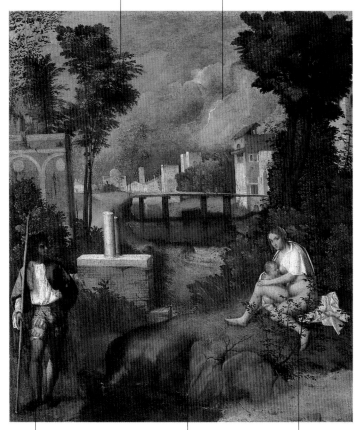

The narrative subject of the painting has never been established to general satisfaction. Even the earliest critics considered it a "landscape."

In the center foreground, a stream carves a bed, narrow but deep, separating the man from the woman.

The key figure of the composition is the partially nude woman nursing an infant near a bush; some critics have identified her as Eve, expelled from Paradise and obliged to provide for her children.

▲ Giorgione, *The Tempest*, ca. 1505.
Venice, Galleria dell'Accademia.

Leonardesque Sfumato and Tonalism

As in Giorgione's Tempest, *the women are partially nude and the young men are elegantly clothed. The two paintings seem to belong to the same figurative culture, though this canvas is attributed, not to Giorgione, but to Titian.*

The way that the light on the tree leaves is rendered almost suggests that this canvas was painted outdoors, which would have been completely out of keeping with the methods of the early 16th century. Yet it was these very atmospheric qualities that led Manet to use this work as an example in the earliest years of the Impressionist movement.

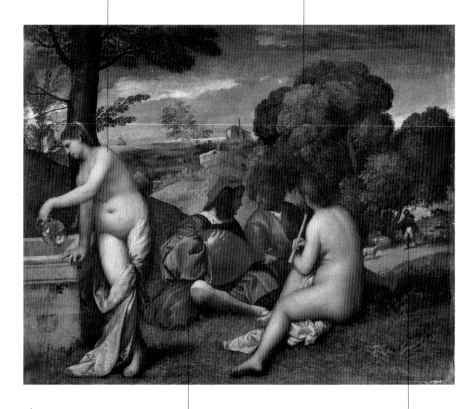

The musical subject alludes to a natural harmony that binds the characters together, enhanced by the vivid evocation of atmosphere and countryside.

▲ Titian (also attributed to Giorgione), *Concert champêtre (The Pastoral Concert)*, ca. 1510. Paris, Louvre.

The shepherd with his flock in the background marks the distance between a rustic, agrarian setting and the group of main characters, young aristocrats who have "chosen" the countryside as a place for intellectual amusement and contemplation, not as an obligatory and often harsh workplace.

The landscape, with its light-blue hues and blurry outlines, is closely reminiscent of Leonardo's style.

The Virgin Mary and the Christ child have distinctively Leonardesque features, but Correggio has interpreted them with a further note of affectionate tenderness.

The tall and powerful figure of Saint Jerome closes off the scene at the left. The saint's head is placed at the summit of the visual diagonal that runs through all the characters in the painting, binding them together in a composition that appears spontaneous but is in fact the product of painstaking effort.

▲ Correggio, *The Virgin of Saint Jerome*, 1523. Parma, Galleria Nazionale.

The magnificent figure of Saint Mary Magdalen, in a pose that, though quite complex, has been resolved in a wonderfully natural manner, brilliantly completes the group. This treatment would be imitated by painters throughout the 17th century, from the Carracci family on.

Leonardesque Sfumato and Tonalism

The clothing reflects Italian fashions of the time. Holbein's contemporaries clearly saw in this painting an allusion to the wife of a nobleman from Basel, whose loose morals were the subject of much gossip.

In Holbein's first decade of work, before he moved to England, Italian motifs were especially evident. Venus's features correspond perfectly to Leonardo's "type," as does the soft, hazy treatment of the shadows, probable evidence that the German painter had traveled to Lombardy.

The long arrow alludes thematically to the dangers and suffering caused by love; this moral motif is common in northern humanism.

▲ Hans Holbein the Younger, *Venus and Cupid*, ca. 1525. Basel, Kunstmuseum.

The portrait's dark, neutral background is a Leonardesque feature, incorporated and developed in a symbolic portrait of considerable power.

As the inscription at the bottom of the painting confirms, John the Baptist has the unmistakable features of Francis I, king of France, patron of Leonardo da Vinci.

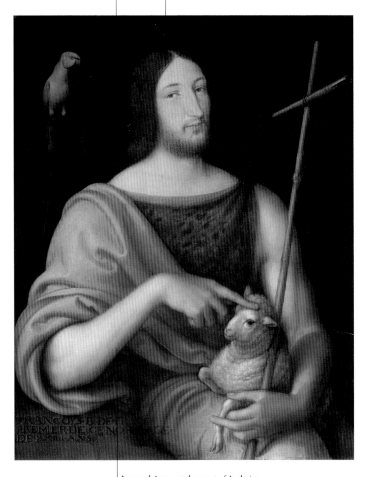

▲ Jean Clouet, *Portrait of Francis I Dressed as Saint John the Baptist*, 1518. New York, private collection.

Leonardo's stay at the court of Amboise marked a turning point in French artistic culture. The court painter, Clouet, adopted the style of the Italian master, right down to the eloquence of the gestures, though his treatment was perhaps slightly overemphatic, given the disproportionate size of the hands.

The exodus of artists following the Sack of Rome in 1527 hastened the encounter between European art and the Italian stylistic developments, especially those of Tuscany and Rome.

Italianism

Leonardo, Raphael, and Michelangelo: three fundamental points of reference, to whom many international schools of art turned for inspiration and guidance. The diffusion of Italian figurative models into other nations was encouraged by a two-way traffic in art and artists. On the one hand, such European masters as Dürer, Bosch, Mabuse, Holbein, Metsys, and various Spaniards traveled to Italy to study. On the other hand, the increasingly precarious economic and political conditions in Italy resulted in a steady outflow of both artists and artworks. When Leonardo moved to France (1517), it marked the beginning of close relations between Italian painters and the great monarchs of Europe. In some cases, indeed, these rulers became the artists' principal patrons—for instance, Charles V for Titian—replacing the old family dynasties of the small courts of Italy, by now irreversibly in decline. There were two chief centers for the diffusion of Italian paradigms throughout Europe. At Fontainebleau, numerous Italian masters of two successive generations worked on the construction of the palace. In Antwerp, by contrast, there were no Italian artists but the local school (thriving in the context of the engraving and printing industries) adopted the styles of the Renaissance and, later, of Mannerism.

▶ Albrecht Dürer, *Young Woman in a Venetian Costume*, 1505. Vienna, Kunsthistorisches Museum.

The numerous characters depicted here are members of a confraternity of German merchants in Venice, which commissioned the work. The altarpiece originally adorned the chapel of German merchants in the church of San Bartolomeo in Rialto. Dürer painted it during his second and last stay in Venice.

Standing off to the side, but clearly recognizable, Dürer portrays himself holding a scroll that bears his signature and the date.

For the landscape, Dürer chose to remain faithful to a painstaking, graphic execution, rather than availing himself of the technique of tonalism, adopted in the same years by Giorgione.

The angel playing music at the foot of the throne is an explicit, direct homage to Venetian tradition, and specifically to Giovanni Bellini.

Emperor Maximilian I, kneeling at the Virgin's feet, is being crowned with a garland of roses, as if in a divine investiture. Just two years after this altarpiece was painted, Maximilian organized a military alliance against Venice.

▲ Albrecht Dürer, *Virgin of the Rose Garlands*, 1506. Prague, Narodny Gallery.

Van Scorel was active in Rome during the brief papacy of his compatriot Adrian VI, the only Dutch pope and former tutor to Charles V. This connection helped the painter to attain very important commissions in the Vatican.

The magnificent Renaissance architecture of the temple, with barrel vaulting, ornamental bas-reliefs, fluted pilasters, coffered ceilings, and domes, was clearly inspired by the buildings of Bramante and Raphael in Rome.

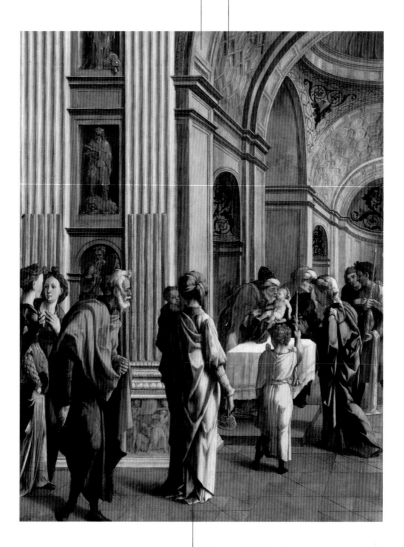

▲ Jan van Scorel, *The Presentation of Christ in the Temple*, ca. 1524. Vienna, Kunsthistorisches Museum.

The figures, tall and slender, are elegantly scaled within the perspectival treatment of space.

The expression and the features of the Virgin are reminiscent of prototypes by Raphael.

The sfumato landscape features architectural and archaeological elements, in a clear reference to the countryside around Rome.

The slightly contrived, ostentatious pose of the Christ child is reminiscent of the styles of classicism and early Mannerism.

The monumental quality of the figures, presented in an extreme foreground, is a distinctive borrowing from Italian painting.

▲ Maerten van Heemskerck,
The Rest on the Flight into Egypt,
ca. 1532. Washington, D.C., National
Gallery of Art.

Italianism

The motif of the kiss between the Christ child and the young Saint John the Baptist is one of the most common "Italian" themes in 16th-century European painting. The appearance and hairstyles of the two infants also faithfully echo Leonardesque models.

The influence of Leonardo is unmistakable in the Virgin's face.

The painstaking rendering of the lighting effects on the landscape is also taken from Italian painting of the early 16th century.

▲ Luis de Morales, *The Virgin and Child with Young Saint John*, ca 1550. Madrid, Prado.

The Virgin's position, shifted notably into the foreground, is emphasized by the drapery that closes off the landscape behind her.

Originating in Florence as a style of "rebellion," Mannerism had become by about 1540 an "establishment" style, expressing the fixed, invulnerable imagery of absolute power.

Mannerism in the Courts of Europe

Strengthened by its references to Raphael and Michelangelo, by artists' travels, and by the circulation of models expedited by the growing availability of printed materials, the stylistic phenomenon of Mannerism spread internationally, ultimately becoming the lingua franca of court art in the late Renaissance. In more than one country, in fact, there was a direct transition from late-Gothic art to Mannerism. In a political landscape characterized by the rise of the large nation-state, which absorbed small local powers, art tended toward a Europe-wide "globalization," taking standardized forms. One crucial factor was the Sack of Rome (1527): Raphael's collaborators, who continued to form a tight-knit school even after the master's death, abandoned Rome and scattered to a variety of European courts, both large and small. The aristocratic ideal and the firm stability of power were expressed through a three-dimensional, almost crystallized form. The explicit or tacit references to classical formal models, whether ancient statues or engravings taken from works by Raphael, could be appreciated only by individuals with a refined, current understanding of art; it thus became a sort of coded language, accessible only to an elite. In France, the taste for the "Modern Manner" (often called, simply, "Renaissance") was especially evident in the artworks commissioned by the court. In the second half of the 16th century, this learned, exquisite style spread across the continent, prompted by the French example.

Related entries
Scandinavia, Prague, Augsburg, El Escorial, Antwerp, Brussels, United Provinces, Paris, Fontainebleau, London, Milan, Mantua, Ferrara, and Urbino, Genoa

Arcimboldi, Berruguete, Bronzino, Caron, Cellini, Clouet, de Vries, Floris, Giambologna, Giulio Romano, Heintz, Hilliard, Mor, Parmigianino, Pilon, Pontormo, Primaticcio, Rosso Fiorentino, Spranger, Van Heemskerck

◄ Hendrick Goltzius, *Phaeton*, engraving from The Titans series, 1588.

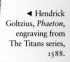

One of the two putti who accompany the sibyl has turned toward his companion, presenting the so-called profil perdu *(lost profile)* that became a recurrent theme in international Mannerism.

There was intense interest in Michelangelo and Raphael as model artists. For example, authors of 17th-century treatises debated at length over a subject that might seem of only secondary interest to us: whether the sibyl's gesture should be interpreted as laying down or picking up the huge book.

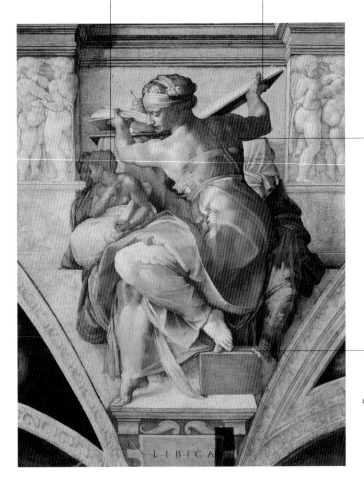

Her spine twists in a serpentine motion that extends the length of the figure, from head to foot. This was eventually to become a favorite pose in Mannerism.

The big toe, pressed down hard on a squared-off pedestal, is the fulcrum from which the entire vigorous figure begins its rotation.

▲ Michelangelo, *The Libyan Sibyl*, 1508–12. Vatican City, ceiling of the Sistine Chapel.

Here, in contrast with the two Stanzas painted in preceding years, Raphael is not seeking to attain a spatial and narrative whole through the use of noble and coordinated architectural structures. The fragile backdrops open out to give emphasis to individual figures, each of which constitutes an autonomous dramatic "unit."

The miraculous intervention by Pope Leo IV extinguishes the raging flames that had broken out in the Borgo quarter, directly in front of the Vatican basilica. He is shown giving his benediction in the background, far away from the large figures in the foreground.

A number of gestures, like that of the young athlete who is lowering himself from the wall, are clearly pretexts for displays of physique.

The "quotation" of Aeneas as he flees Troy in flames, carrying his paralytic father on his back and with his young son at this side, elevates the intellectual level of the composition.

▲ Raphael, *The Fire in the Borgo*, 1514. Vatican City, Vatican Palace, Stanza dell'Incendio di Borgo.

A small, isolated cloud is the only element in the painting that provides a clue to its setting. Because of the disposition of the various figures, we may imagine a sloping surface, but Pontormo painstakingly refrains from inserting any natural or atmospheric features.

The figures in the upper section of the painting bend their backs or necks in order to conform to the shape of the panel, which must fit into the lunette curve of the top edge.

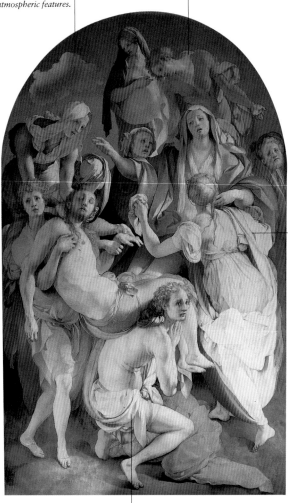

The violent light that beats on the figures kindles unnatural, metallic shades of color.

Each pose is carefully programmed to impart a sense of instability and discomfort, with clashing, unharmonious movements that reveal the artist's great skill at rendering bodies and articulated limbs.

▲ Jacopo Pontormo, *The Lamentation*, 1526–28. Florence, Santa Felicita, Capponi Chapel.

One distinctive feature of Mannerism is its impatience
with the traditional humanistic rules of symmetry and
eurhythmy. Here, the figures of the angels cluster to
one side of the painting, creating a dramatic sense of
precarious imbalance, accentuated by the reclining
pose of the Christ child, sleeping deeply.

The neck, hands, and
feet of the Virgin
Mary are unnaturally
elongated, in order
to accentuate the
expressive effects.
Her face, on the
other hand, harks
back to Leonardo's
example, filtered in
Parmesan painting
through the work of
Correggio.

The painting, which
went through a long
and difficult process
of execution, was left
unfinished. A number
of aspects appear
incongruous and
unsettling, such as the
immense column that
supports nothing.

As in the figures of
Michelangelo, the
complicated torsion
of the body begins
with the foot, which is
given prominence in
order to illustrate the
difficulty of the pose.

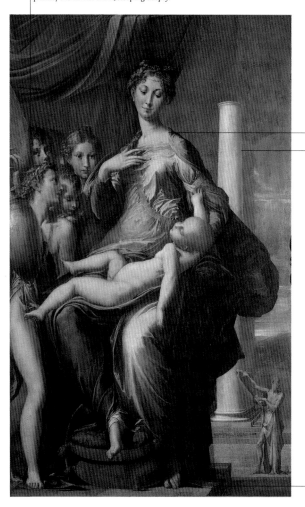

▲ Parmigianino, *The Madonna of the
Long Neck*, 1535-40. Florence, Uffizi.

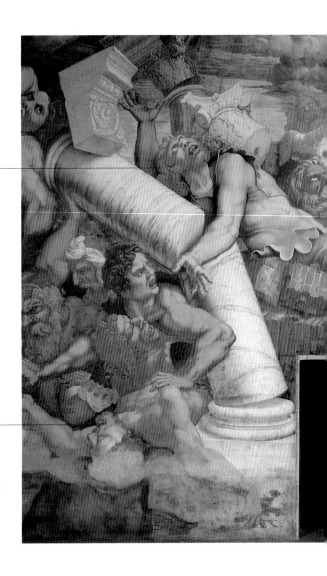

The giants look upward, toward the ceiling of the room, where Jupiter, set within a dizzying perspectival illusion, hurls thunderbolts from above.

Throughout the decoration of the Palazzo Te, Giulio Romano used teams of workers, a mode of operation that he had learned in his youth when he collaborated with Raphael. The master was responsible for the core task of "invention," while the various aspects of execution were delegated to assistants and collaborators.

▲ Giulio Romano and assistants, *Sala dei Giganti* (detail), 1532–35. Mantua, Palazzo Te.

The colossal, muscular bodies of the giants, thunderstruck and crushed, may be viewed as a profane, irreverent parody of Michelangelo's creations.

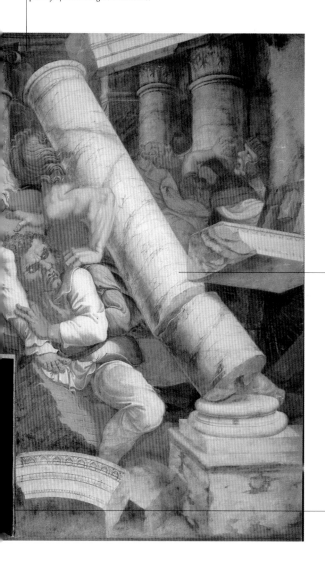

Shattered columns, tumbling walls, collapsing segments of brickwork—the disintegration of architectural elements provides a glaring contradiction to the actual building's unmistakable solidity. The outside of the palazzo is clad in stout ashlars.

The entrance to this hall, certainly one of the most renowned and astonishing rooms in the Palazzo Te, has virtually no molding so that the visitor should perceive no break between the actual space and the painted architecture, between reality and illusion.

The light-blue shade is typical of Niccolò dell'Abate, and it would later be adopted by the masters of Fontainebleau.

The long, slender figures assume a variety of elaborate poses, a genuine Mannerist repertory.

The background is an homage to the "Gothic" architecture found north of the Alps.

▲ Niccolò dell'Abate, *Pharaoh's Daughter Finding the Infant Moses*, 1550. Paris, Louvre.

The painting shows the infant Moses three times: beneath the bridge, being set adrift on the Nile in his floating basket; in the right middle ground, being found by the maid of Pharaoh's daughter; and in the foreground, being presented to her.

The entire composition gives the impression of a refined tableau vivant, a gallant and placid performance in which each actor plays a part.

The hunter Actaeon, in the background, serves as an idealized portrait of Henry II, king of France. It was quite common during the 16th century to identify real people with mythological figures.

Diana, at center, is obviously a mythical transposition of the king's mistress, Diane de Poitiers.

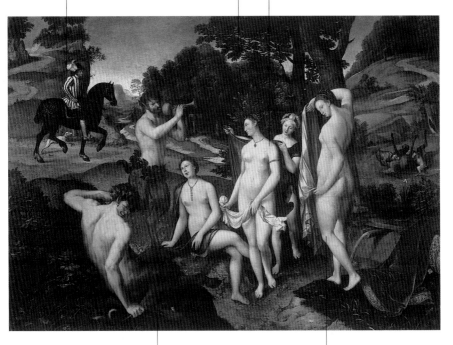

Typical of the expressive interplay of counterpoint, a fundamental part of Mannerism, is the contrast between the half-animal woodland satyrs and the luminous bodies of Diana and her companions, stripped for bathing.

The fluid, uninhibited poses of the bodies adhere to the Italian-influenced formal code that was so solidly established at Fontainebleau.

▲ François Clouet, *The Bath of Diana,* ca. 1555. Rouen, Musée des Beaux-Arts.

Among the painters of Venice, Tintoretto was the one most attracted by the experimentalism of Mannerism. The architectural perspective here is slipping, no longer linear and central but veering off diagonally toward the vanishing point, creating a powerful dramatic effect.

This subject is rare and especially complex. A band of Venetians has traveled to Egypt and by night enters a church in Alexandria in order to spirit away the remains of Saint Mark. Their quest is interrupted by an apparition of the saint himself.

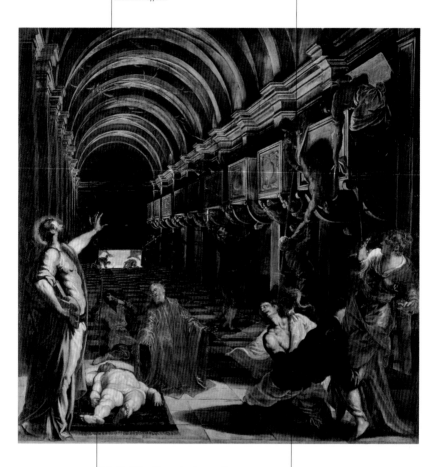

Like his fellow Mannerists in central Italy, Tintoretto shows off with unusual and especially challenging poses, such as the foreshortened corpse at the feet of the monumental figure of Saint Mark.

The group on the right consists of characters in contorted virtuoso poses. It revolves around the central figure of a possessed man, from whose mouth a plume of smoke emanates. It was believed that the contortions of the possessed aid in finding the relics of saints.

▲ Jacopo Tintoretto, *Finding of the Body of Saint Mark*, 1562–66. Milan, Pinacoteca di Brera.

This scene forms part of a dense and elegant decorative ensemble, inspired by the archaeological finds of early-16th-century Rome (especially Nero's Domus Aurea) and the ornamental creations of Raphael and his school.

As if it were the conclusion of a film sequence, we see in the upper room the scene of David and Bathsheba embracing. Sixteenth-century clients for nonreligious paintings increasingly requested and admired scenes of love.

The cantilevered staircase winds around the side of the tower, in a pattern that makes little or no architectural sense but is wonderfully effective in dramatic terms.

During the central period of Mannerism, elongated, serpentine poses became practically obligatory and even came to influence the structure of architecture.

▲ Francesco Salviati, *Bathsheba Goes to King David*, 1553–55. Rome, Palazzo Sacchetti.

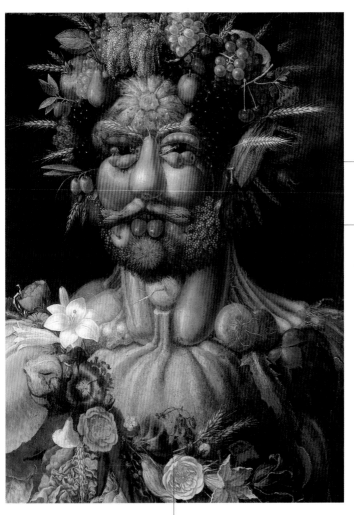

Rudolf II is depicted here as the pagan god Vertumnus, symbol of the inexhaustible transformations of nature, made possible by agriculture.

This allegorical portrait of Rudolf II was originally set at the center of a series of canvases that included images of the Seasons and the Elements, making it the culminating point of the allegories that Arcimboldi created for the Holy Roman Emperor.

▲ Giuseppe Arcimboldi, *Portrait of Rudolf II as Vertumnus*, 1591. Stockholm, Skoklosters Slott.

This prodigious metaphor of man and vegetable is accentuated by the simultaneous appearance of flowers and fruits representing different seasons.

The iridescent reflections shimmering across the lining of the cape are reminiscent of the lights and colors of Venetian painting, providing a reference to the painter's international figurative culture.

The faces of the two lovers draw together in a kiss, and Adonis's expression reveals a certain component of lust. Among all the royal patrons of the arts at century's end, Rudolf II was especially interested in erotic themes.

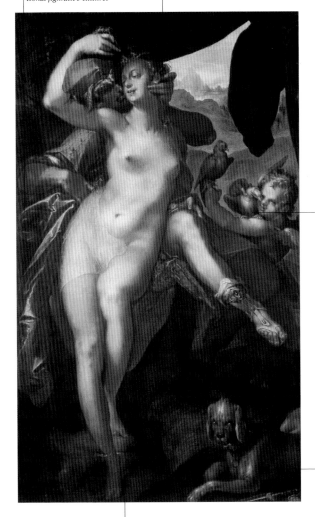

The dove pushing its beak into Cupid's face is a parody of two lovers kissing.

The dog and weapons are references to Adonis's love of hunting. The painting is a renowned example of the style of the Prague court at the end of the 16th century, where Spranger was an important figure.

Venus and her lover assume one of the contrived, serpentine poses so dear to the international tastes of the late 16th century. The figure of the goddess, in particular, is closely reminiscent of late-Mannerist sculpture.

▲ Bartholomaeus Spranger, *Venus and Adonis*, 1597. Vienna, Kunsthistorisches Museum.

The troubled relationship between the religion of the Reformation and the use of images slowed the development of German art and triggered iconoclasm in northern Europe.

The Reformation and Iconoclasm

▼ Lucas Cranach the Elder,
Portrait of Martin Luther, ca.
1530. Milan, Poldi-Pezzoli
Museum.

In the early years of the 16th century, north-central Europeans became increasingly dissatisfied with traditional forms of worship, which seemed to be imposed from far away by a papal Curia greedy for money and privilege. While Dürer pursued the illusory goal of codifying the beauty and infinite variety of nature, the sublime cloudburst of Matthias Grünewald's altarpiece, now in Colmar (pages 310–11), constitutes a visual emblem for the era. In this volatile situation, the Reformation was unleashed, sparked by Martin Luther nailing his Ninety-five Theses to the church door in Wittenberg. In July 1520, Pope Leo X issued *Exsurge Domini*, a bull reprimanding Luther—which the latter publicly burned—followed in January by a bull of excommunication. Violent rebellions sprang up all over, among them the bloody Peasants' War. Artists who had betrayed sympathy for the mutinous peasants faced grim consequences: Grünewald was dismissed by the archbishop of Mainz, and Tilman Riemenschneider was tortured and thrown into prison. Luther rejected the cult of the Virgin Mary and the saints and prohibited devotional images. He should not, however, be considered responsible for the campaigns of iconoclasm over the following decades; he did no more than urge the faithful to "remove the icons from their hearts, not from their altars." But in fact this suggestion brought the development of German art to an abrupt halt, especially after the deaths of Dürer and Grünewald, and Holbein the Younger's permanent move to England in 1532. All the same, Cranach continued to work, leaving a visual portrayal of the protagonists and the concepts of the Reformation.

The words issuing from the mouths of
Christ and the centurion are (astonishingly)
in German, and not in the more standard
Latin. The translation of the Holy Scriptures
and the use of local languages were among
the remarkable cultural contributions that
Luther urged upon the Reformation.

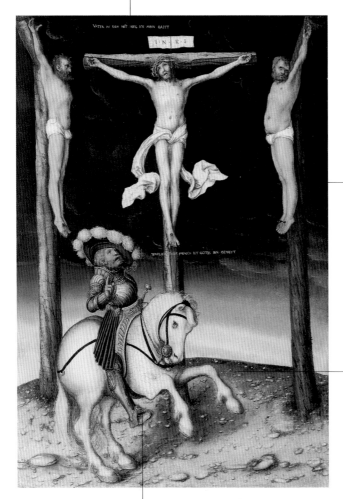

As Cranach's
intense artistic career
demonstrates, in its
first few decades the
Reformation was any-
thing but hostile to
images and indeed made
extensive use of them to
convey its ideas.

The setting of the
Crucifixion appears
bare and empty, devoid
of the numerous figures
(the Virgin Mary, the
Holy Women, Saint
John the Baptist, etc.)
traditionally present in
the Catholic icono-
graphic treatment.

▲ Lucas Cranach the Elder, *The
Crucifixion with the Converted
Centurion*, 1536. Washington,
D.C., National Gallery of Art.

The Roman centurion, wearing an
obviously contemporary suit of armor
and looking very like a German
nobleman, recognizes the "true" God.

With muscular determination, the four evangelists throw the pope to the ground and punish him. In this violent image, painted in the earliest years of the Anglican breach with Rome, the pain of the schism—which would lead to the suppression of all the monasteries in England—is clearly expressed.

Among the evangelists, Mark seems to be less ferocious than the other three. This may be a political observation: Saint Mark is the patron saint and practically the symbol of Venice, and this painter, born within the Venetian realm, knew quite well that the Serene Republic had to take great care not to make enemies on the international diplomatic scene. Thus, Venice would always work as a moderate mediator, especially as the development of maritime trade brought it into increasingly regular and close contact with England.

The painting was done by the Italian artist Girolamo da Treviso, who moved to England.

The elderly pope with a flowing beard resembles the Farnese pope, Paul III.

▲ Girolamo da Treviso the Younger, *A Protestant Allegory (The Pope Being Stoned by the Four Evangelists)*, ca. 1536. Windsor Castle, The Royal Collection.

The pontiff falls facedown onto a heap of jewels, ecclesiastical stipends, and indulgences. Beneath him lie the lifeless bodies of the allegorical figures Avarice and Hypocrisy.

In the foreground, the prince-elector of Saxony presents himself as a devoted follower and protector of the Reformation.

At the time the painting was executed, Luther had already been dead for several years.

The column standing directly behind the figure of Christ is meant to indicate that Jesus is the sole, powerful support of the faithful.

Melanchthon, too, died before this canvas was painted. The tableau thus has commemorative value, depicting Christ in the presence of the modern apostles of the Protestant faith.

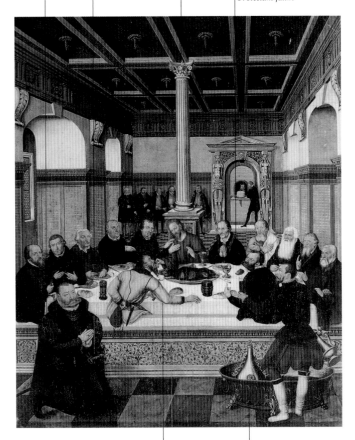

Cranach the Younger, a faithful adherent to his father's style, in part made use of traditional iconographic models. Thus, there are twelve men dining with Christ, and among them is the traitor, Judas.

The scene is set in a Renaissance hall, which possesses a certain sumptuous magnificence. The furnishings, the clothing, and the objects convey a sense of wealth. All the same, there is a clear sense of concern about the internal divisions among the reformed churches and the new initiatives of the Catholic Counter-Reformation.

▲ Lucas Cranach the Younger, *Symbolic Last Supper*, 1565. Dessau-Mildensee, Schlosskirche (castle church).

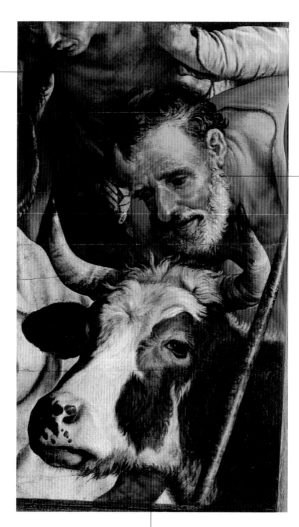

This painting is all that survives of an altarpiece depicting the Adoration of the Shepherds, done for Amsterdam's Nieuwe Kerk and almost completely destroyed in the Calvinist Iconoclastic Fury of 1566. Despite Luther's initial warnings, over the course of the 16th century the Reformation resulted in the devastating destruction of artworks depicting the Virgin Mary and various saints in many parts of Europe (especially Switzerland, Germany, Holland, and Antwerp).

The realism of the Antwerp-born artist Aertsen was one of the chief components in the founding and early development of the Dutch school.

The cow is virtually a symbol of Holland's agricultural wealth and is sometimes considered an expression of national virtues; it is significant that this particular detail of the larger painting should have escaped destruction.

▲ Pieter Aertsen, Surviving fragment of *The Adoration of the Shepherds*, ca. 1560. Amsterdam, Historisch Museum.

The Council of Trent was convened by Pope Paul III in 1545, as a response to the calls for reform. It launched the Counter-Reformation, in part through the use of art and architecture.

The Counter-Reformation and New Sacred Art

The council, which lasted until 1563, was originally slated for Bologna, but it was moved to Trent in order to attract prelates from the German-speaking regions. In addition to introducing important changes in liturgy and the organization of religious orders, the final documents of the council contained crucial "instructions" for the renewal of sacred art. Rejecting the elitist intellectualism of Mannerism, the cardinals of the council (among them, Saint Charles Borromeo) encouraged a new form of art capable of "speaking" to one and all and restoring a clear religious identity to the region. In opposition to one major aspect of Lutheranism—rejection of the cult of the Virgin Mary and the saints—the council advocated the reintroduction of devotion to especially popular figures, whose lives and martyrdom would be illustrated in a spectacular manner in statues, paintings, and frescoes. All along the borderlands between regions that had gone over to the Reformation and those that were still predominantly Roman Catholic, grand churches and sanctuaries were built, outsized for the small towns in which they stood, but eloquent visual reminders of the Catholic presence. In the field of painting, in particular, the new rules of the Counter-Reformation governing sacred art were crucial to the transition from the Renaissance to the Baroque. According to Gabriele Cardinal Paleotti, sacred art should "enlighten the intellect, encourage devotion, and prick the heart," through its order, clarity, simplicity, mastery of form, and rejection of Mannerist whims. He recommended the inclusion of characters and details taken from everyday life.

Related entries
Augsburg, Bavaria, Innsbruck, Castile, El Escorial, Andalusia, Antwerp, Milan, Rome

Barocci, Bassano, Correggio, Ferrari, Tintoretto, Titian, Veronese

▼ Michelangelo, Dome of Saint Peter's Basilica, Vatican City, begun in 1546.

The quality of austere, intense realism is characteristic of 16th-century Lombard painting and constitutes a key precedent for Caravaggio's style.

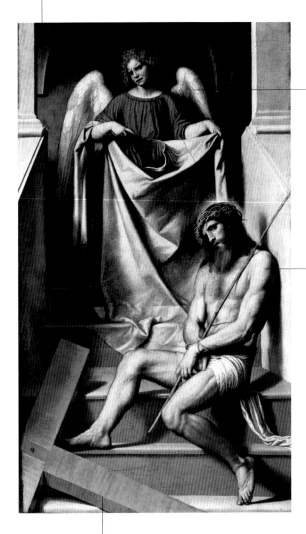

The weeping angel expresses the grief of the heavens, but also mankind's tragic abandonment of Christ. One of the chief themes of the Counter-Reformation is the "solitude" in which Christ was left.

In this extremely rare iconographic motif, Christ has just been subjected to the Mocking and the crown of thorns (probably understood as a symbol of the "suffering" caused in Christendom by the schism), and he turns directly to the faithful with a gaze filled with pathos.

With a noteworthy piece of perspectival artifice, the cross looms from the stair-case in the foreground, reiterating the importance of the personal engagement of the faithful.

▲ Moretto da Brescia (Alessandro Bonvicino), *Christ with an Angel*, ca. 1550. Brescia, Pinacoteca Tosio-Martinengo.

The painting depicts the moment during the climb to Calvary in which Christ is stripped of his clothing. This is an unusual theme, and El Greco has interpreted it in a daring and innovative composition, in which the vertical and horizontal compression of the figures takes on a violent, suffocating, antinaturalistic quality.

The quest for expressivity combines with exquisite formal devices, worthy of the Venetian tradition that the artist knew so well, such as the reflection of the red garment in the armor of the officer on the left.

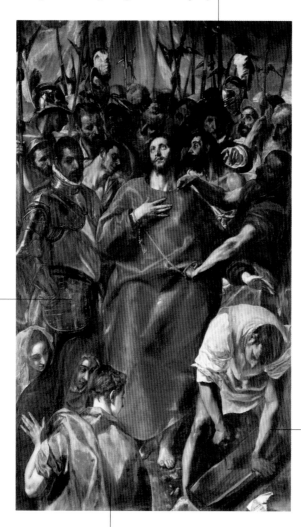

The carpenter who is readying the cross brings a note of vital realism to the scene.

▲ El Greco, *Disrobing of Christ*, 1577–79. Toledo, sacristy, cathedral.

The group of the Holy Women, in the foreground, stirs the empathy of the faithful with intensely human figures and feelings, well suited to popular devotion and ritual.

A parallel process in northern Italy and Flanders led to an artistic style that focused on the "natural," on simple and honest daily life, as opposed to the aristocratic style of Mannerism.

Realism and Naturalism

After 1520, while admiration for Raphael and Michelangelo was spreading and, due to the availability of classical models, the formulation and diffusion of Mannerism were under way, a reaction began to take shape against the increasingly elitist and intellectual nature of "official" art. We can detect in the most common portraits and sacred themes a desire for increasing realism, especially in northern Italy in the former duchy of Milan and in the westernmost provinces of the Venetian Republic, Bergamo and Brescia. The characters and settings are no longer idealized but, rather, are depicted in a straightforward, realistic manner. Such fidelity, found in the works of Gaudenzio Ferrari, Lorenzo Lotto, Moretto da Brescia, Savoldo, Romanino, and even Correggio in Parma, does not rise to the level of a full-fledged movement. Instead, it heralds an expressive approach that would develop further in the latter half of the 16th century, in part due to the recommendations of the Counter-Reformation, giving rise to the art of Annibale Carracci and Caravaggio. At the same time, in Antwerp, the prevailing fashion for the Italian style was powerfully challenged by the work of Pieter Bruegel the Elder. The realism of Antwerp lies at the root of Flemish and Dutch genre painting of the 17th century: neither caricatural nor ethnographic like the heavy-handed, vulgar realism of past artworks, its approach was instead intensely participatory.

▼ Pieter Bruegel the Elder,
Land of Cockaigne.
Munich, Alte Pinakothek.

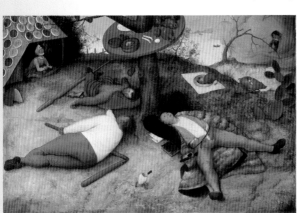

Details of the setting add notes of everyday realism.

It is possible that this painting was more than a simple "genre scene"— that is, a depiction of an everyday scene—and that it contains symbolic meanings. All the same, Lucas van Leyden's expressive power consists precisely in his ability to identify with the social and narrative context of the scenes he painted.

The man on the right is aware that he has a winning card, and he is raising the stakes.

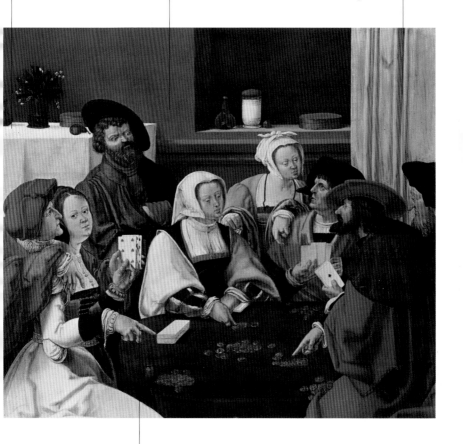

▲ Lucas van Leyden, *Card Players*, 1508–10. Washington, D.C., National Gallery of Art.

Among the many possible symbolic meanings, alongside the fairly common one of the "ill-matched couple" and the obvious condemnation of greed, Lucas van Leyden is probably also referring to the Dutch proverb according to which true love has only one card it can play, the card of faithfulness.

The engaging cheerfulness of the two children is an amiable antidote to the stereotypical expressions that so often seem to plague children in painting, as well as a clear sign of a quest for an open and sincere realism.

Heemskerck is, nevertheless, an artist of his time, and he cannot refrain from offering a reference to a classic contrapposto in the pose of the youngest (nude!) child.

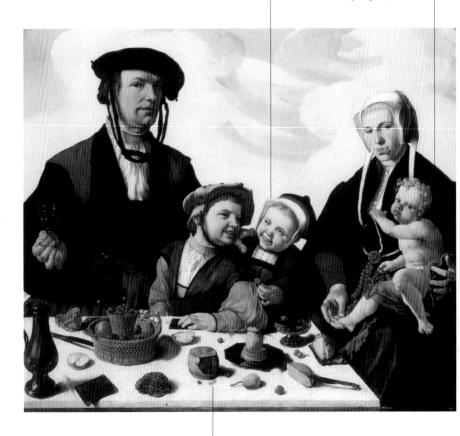

▲ Maerten van Heemskerck, *Family Portrait*, ca. 1530. Kassel, Staatliche Kunstsammlungen, Gemäldegalerie.

The food on the table, carefully and individually identified with sharp, precise shadows, constitutes one of the most explicit precedents for the "banketjestukken," the feasting tables so common in 17th-century Dutch and Flemish painting.

The everyday, modest atmosphere of this painting is enhanced by Christ's casual pose, with a large cloth napkin tucked into his lap.

The astonished boy is a major precedent for Caravaggio.

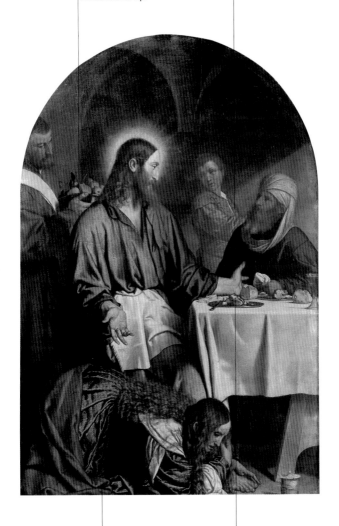

▲ Moretto da Brescia (Alessandro Bonvicino), *Supper in the House of Simon Pharisee*, ca. 1550. Brescia, Santa Maria Calchera.

Mary Magdalen, in tears, is anointing Christ's feet with a precious perfume.

The details of the food and the silverware on the table are surprisingly realistic, as is the fruit bowl carried by the waiter on the left.

Realism and Naturalism

Up to the end of the century, human figures offered the narrative "justification" of the subject. It was only later that the "still life" would establish itself as an independent form, free of the presence of men or women.

Even though some precedents can be identified in paintings with sacred subjects (such as the episode of Christ driving the money changers from the temple), market scenes were a substantially new development in painting.

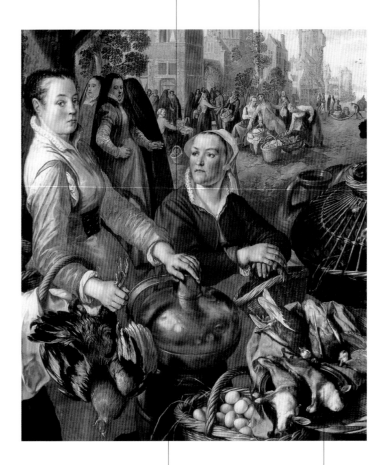

In the paintings of the incipient genre of the still life, it was imperative that the artist include a variety of materials and surfaces, with effects bordering on optical illusion.

The opulence of the market stalls reflected the prosperity of the wealthy trading regions of the Netherlands.

▲ Joachim Beuckelaer, *The Poultry Market* (detail), 1570. Ghent, Museum voor Schone Kunsten.

Fishwives belonged to a social station quite different from that of the clients who commissioned this painting, which helps to explain why their depiction borders on caricature.

The painting is part of a series of four canvases (which the Cremona-born artist Vincenzo Campi repainted many times) and it is quite typical of the late 16th-century Lombard style.

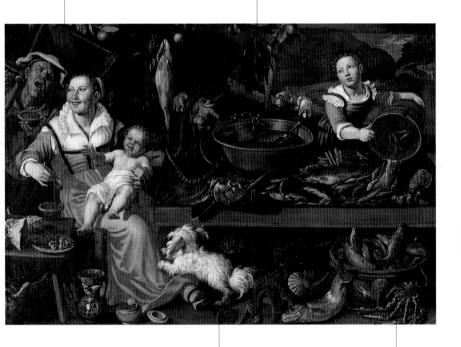

This canvas is an expression of the same figurative culture that engendered Giuseppe Arcimboldi's "compound heads."

In keeping with the taste for the Wunderkammer and scientific collecting, the depiction of the various types of fish, crustaceans, mollusks, and sea creatures strives simultaneously for virtuosity of execution, expressive variety, and an almost scientific catalogue of species of fish.

▲ Vincenzo Campi, *The Fishwife*, ca. 1585. Milan, Pinacoteca di Brera.

Realism and Naturalism

Bassano was born and lived in the provinces, and he took his inspiration from the Venetian countryside; this work was clearly an alternative to the magniloquent "official" art being done by the masters then active in Venice.

The episode from the Gospels, though fully articulated, is pushed off to one side and into the background, thus offering an excuse for a realistic scene with an exquisitely everyday flavor.

Intended for private collectors, Jacopo Bassano's canvases abound with realistic details and animals. Aspects of nature and objects are reproduced with special attention to the surfaces, reflections, and texture of their materials.

▲ Jacopo Bassano, *Christ in the Tavern at Emmaus*, 1576–77. Private collection.

After moving to Rome, Annibale Carracci became a pioneer of academicism. Nevertheless, his education and his early work constitute a powerful expression of northern Italian naturalism at the end of the 16th century.

Compared to Flemish or Lombard market scenes, in which the prevailing impression is of variety and abundance, Carracci's butcher shop is a clean, somber place, with the cuts of meat distributed in an orderly and regular manner.

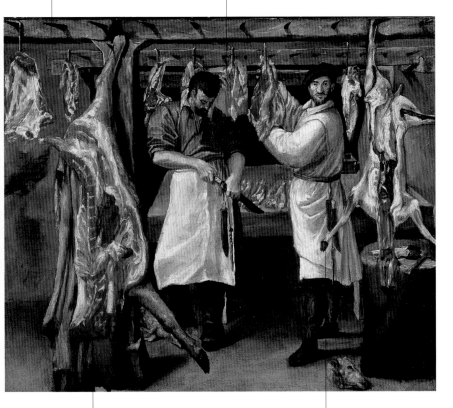

Carracci's uncles were butchers. The subject, which this Bolognese painter treated more than once, was not therefore alien to his personal experience.

▲ Annibale Carracci, *The Butcher's Shop*, 1583. Fort Worth, Kimbell Art Museum.

Because of the painter's direct personal involvement, the butchers are not shown here in a spirit of burlesque or caricature, but with the serious dignity of tradesmen.

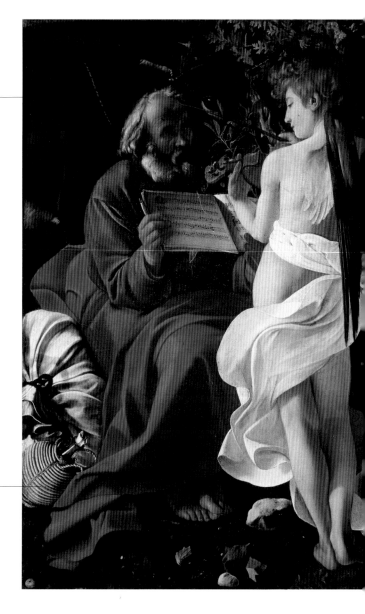

Caravaggio, still in the earliest phase of his career in Rome, placed all the traditional figures in this painting, including Saint Joseph, the angel, and the ass, half-hidden in the leaves. All the same, none of the characters shown is a stale recycling of existing models. The inspiration here is based on the immediacy of reality.

The painstaking rendition of details shows the young Caravaggio's focus on every aspect of vision and his indifference to the alleged "nobility" of the subject.

▲ Caravaggio, *The Rest on the Flight into Egypt*, 1595–96. Rome, Galleria Doria Pamphilj.

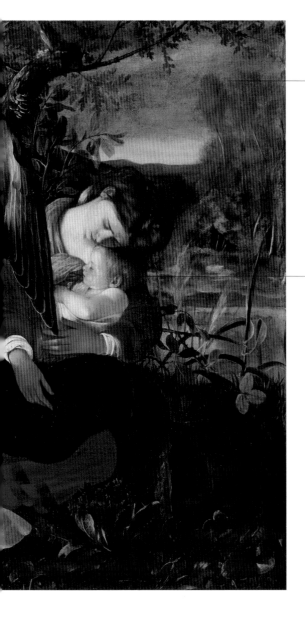

This is one of Caravaggio's few paint-
ings set in a natural landscape. The
Lombard painter usually preferred
neutral backgrounds, at first light in
color and then, after 1600, generally
dark. The atmospheric light and the
wonderful references to the country-
side emphasize the scene's sense of
modest, poetic realism.

With a courageous choice of
iconography, Caravaggio
portrayed the exhausted
Virgin Mary as having nod-
ded off to sleep, though she
is still holding the Christ
child in a movingly tender
and protective embrace.

The liberation of 16th-century science from the Aristotelian tradition offered a new, more direct relationship with nature. One emblematic example, closely tied to art, was the study of anatomy.

Anatomy

Leonardo da Vinci was the first artist to plan an illustrated treatise on anatomy. For this project he did a series of remarkable drawings, in a clear polemic against the traditional "ideal" canons. Direct observation, made possible by dissection, showed that one could not constrain the "accidents" of biology within a schematic relationship of predefined proportions. An alternative to the *auctoritas* of classical authors thus appeared. Dürer offers the most obvious case of an artist-cum-intellectual torn between the two tendencies. He studied not only "virile," athletic male nudes—the standard "type" from Greek art forward—but also the bodies of women and children, and body types ranging from obese to emaciated. The result was a treatise on the proportions of the human body, published just after the artist's death (1528). The study of human anatomy, following the pioneering treatise by Jacopo Berengario da Carpi (1521), finally found a solid basis in the scientific book by Andreas Vesalius titled *De humani corporis fabrica*, published in 1543 and illustrated with magnificent engravings by the German artist Jan Steven van Calcar, probably in collaboration with Titian. During the same period, Michelangelo completed his *Last Judgment* in the Sistine Chapel, presenting in the astounding crowd of nude bodies an image of an "interior" anatomy, tragically complementary to that of Vesalius. The strong, confident man of the early Renaissance, exalted by Michelangelo himself, had finally collapsed.

▼ Albrecht Dürer, *Artist Sketching a Nude Woman*, illustration for an unrealized treatise on painting, ca. 1520.

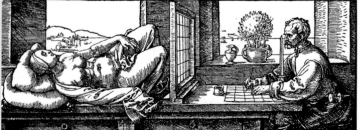

The left shoulder is rotating in the opposite direction from the neck, creating an effect of dramatic dynamism. The entire figure expresses the "serpentine motion" that Vasari would hold up as the supreme model of energy and elegance in the art of the "Modern Manner."

The back, at once muscular and dynamic, emphasizes the athletic nature of the pairs of "ignudi" (nudes) that Michelangelo placed on either side of the biblical scenes on the ceiling of the Sistine Chapel. These figures were immediately acclaimed as a full-fledged "academy" for the study of the male nude.

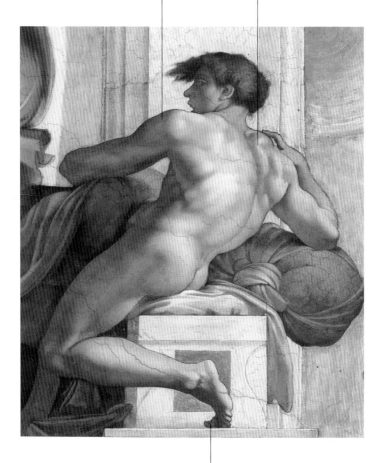

▲ Michelangelo, *Ignudo*, 1508–12.
Vatican City, ceiling of the Sistine Chapel.

Once again, the starting point for the elaborate pose is the foot's solid purchase on the ground, clearly depicted.

Anatomy

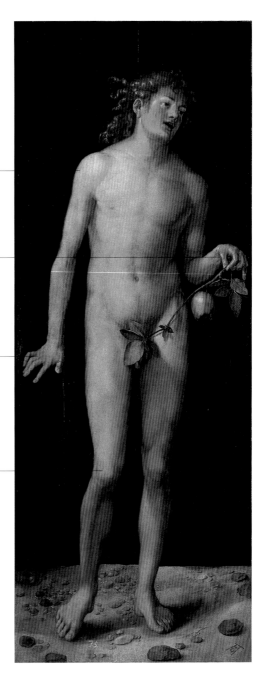

Painted shortly after his return to Nuremberg from his second stay in Italy, the two nudes are clearly demonstrative and theoretical in nature.

The left hand is holding the branch with the apple, in order show how muscles swell when they exert a degree of effort.

The pose is designed to give relevance to every anatomical detail, including the joints of the fingers, always calculated according to a system of proportions.

The man's skin has a darker hue than the woman's. The figure hints at the classical contrapposto pose.

▶ Albrecht Dürer, *Adam and Eve*, 1507. Madrid, Prado.

A partial concession to German tradition can be seen in the woman's rounded face and her long blond hair.

Her shoulders counterbalance the action of moving forward. Her left shoulder is higher than her right one, and the entire figure is elegantly bent in compliance with the classical contrapposto scheme.

The woman's crossed legs show a greater degree of dynamism than we see in the man, whose pose is more static.

The face, with its penetrating gaze, turns toward us, with an opposing ("serpentine") motion to the left leg.

The boy's smooth, luminous back is shown without the excessive muscularity of Michelangelo's figures.

The two children at the bottom, mythological personifications of the caprices of Love (in the person of Cupid), effectively illustrate the expanding array of expressions and "impulses of the soul" described by 16th-century painting.

Here, too, the foot visibly exerts force upon the book that supports it.

▶ Parmigianino, *Cupid Cutting His Bow*, 1533–34. Vienna, Kunsthistorisches Museum.

The silhouettes of
the curly-headed
angels clearly reflect
a classical model.

Christ's head, raised in an unnatural
manner and turning to his right, com-
pletes the complicated motion of the
limbs with a final twist. Each of the
body's many joints seems be posed so
as to contradict its adjoining parts.

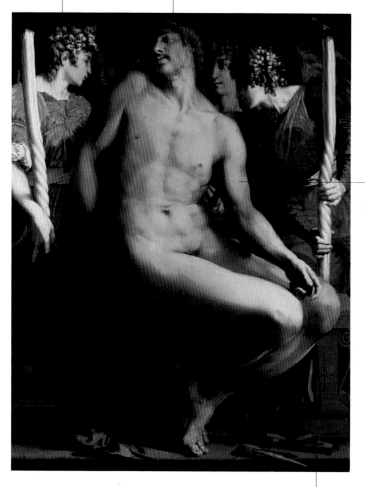

Another classical
quotation is the
lifeless, lolling arm.

▲ Rosso Fiorentino, *The Dead Christ
with Angels*, ca. 1525. Boston, Museum
of Fine Arts.

The crossed legs, extending toward the
foreground, hark back to examples by
Michelangelo and convey a sense of a
powerful physique.

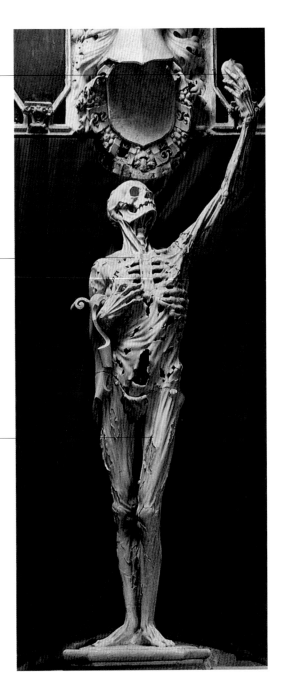

This skeleton contemplating its own heart, which it has ripped from its chest, is a dramatic invention with an almost Baroque flavor.

The remaining tendons wrapped around the throat appear to be tensing with effort, and if we look carefully, we can see that they obey the dictates of Michelangelo's exaggeration of the possible poses.

Macabre, or even disgusting, effects aside, the sculptural virtuosity of this Lorraine-born master offers an eloquent demonstration of the diffusion of richly illustrated treatises on anatomy, beginning in the 1540s.

▶ Ligier Richier, *Skeleton Holding Its Own Heart*, from the tomb of René de Chalon, ca. 1550. Bar-le-Duc (France), Saint-Étienne.

A sculptor is finishing a colossal allegorical composition.

A painter executes a vast canvas on a military theme, with armed men on horseback.

The bespectacled artist, apparently the owner of the workshop, is measuring the proper proportions of the forearm on what appears to be either a cadaver or a very elaborate dummy.

A suspended skeleton is being studied by a few very young apprentices.

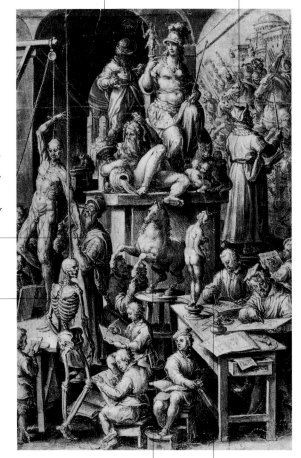

A goldsmith is carefully completing the final polishing of an equine statue, executed in an especially difficult position— rearing up on both hind legs.

An engraver and a miniaturist, expert collaborators within the workshop, labor at a bench. On its cluttered surface stands a delightful statue of Venus, posing in the unmistakable contrapposto so dear to the Mannerists.

▲ Stradanus (Giovanni Stradano),
The School of Design, 1573. London,
British Museum.

A distinction began to be drawn between the "arts of design" (painting, sculpture, and architecture) and all the other techniques, ranging from goldsmithing and cabinetmaking to ceramics and textiles.

Fine Arts and Applied Arts

Related entries
Nuremberg, Rome,
Florence, Venice

Andrea del Sarto,
Bronzino, Cellini,
Giorgione, Michelangelo,
Raphael, Titian

The debate over the hierarchy of the arts, a distinctive feature of 16th-century treatises, is summarized and concluded by Vasari, beginning with the very title of his *Lives*. Painters, sculptors, and architects were elevated to a higher social and intellectual status because of the importance of "ideas" in their work, expressed through design. Ceramists, cabinetmakers, goldsmiths, tapestry weavers, and even engravers, by contrast, were relegated to the level of specialized technicians, because the work they did demanded, first of all, a mastery of the materials, instruments, equipment, and practices of the workshop. There were further distinctions among the various materials and subjects within the larger heading of the "fine arts." According to Michelangelo, fresco painters were held in higher esteem and considered more "virile" than those who merely painted panels and canvases; "true" sculpture was that which was executed "through the process of removal," by painstakingly chipping away at marble. Materials that could be worked more easily, such as wood or terracotta, were considered less noble from then on. Michelangelo thought an artist should pursue the most elevated subject: the human body or, even better, male nudes, either in isolation or within the context of a narrative episode of great exemplary worth. Religious scenes and austere literary and mythological subjects were considered "elevated," as were celebratory portraits of illustrious personages. Less elevated, but progressively more popular with collectors, were episodes from everyday life, landscapes, and still lifes.

▶ Nuremberg goldsmith, working to a design by Albrecht Dürer, *Apple-Shaped Goblet*, gilded silver, 1510–15. Nuremberg, Germanisches Nationalmuseum.

The subtle elegance of his clothing is, in itself, testimony to the tailor's prowess.

The alert, focused gaze underscores the tailor's self-awareness, even at a time when history and culture were trending toward a sharper separation between the "intellectual" skills of painters, sculptors, and architects and the more "technical" skills of other artisans.

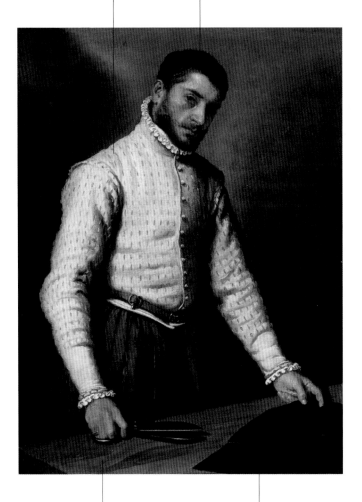

▲ Giovanni Battista Moroni, *The Tailor*, 1565–68. London, National Gallery.

The Bergamo-born Moroni is one of the most interesting portraitists of the mid-16th century. In this masterpiece, he brings a member of the "middle class" into the artistic spotlight.

The dark cloth that the tailor is preparing to cut is typical of the increasingly solemn fashion of the mid-16th century.

In this youthful portrait, Moroni's friend, a sculptor, is depicted in a direct, straightforward manner, his hair slightly unkempt, wearing a work smock.

Even the damaged statue seems to hint at "work in progress," as if the sculptor (a leading figure in Venetian art during the second half of the 16th century) had been briefly interrupted by the painter during his workday.

The rolled-up sleeve underscores the informal approach, which does not seek to conceal the manual and physical aspect of the sculptor's work.

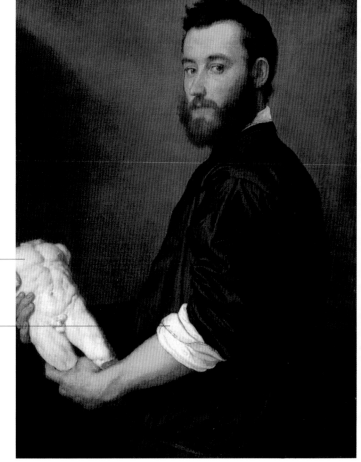

▲ Giovanni Battista Moroni, *Portrait of the Sculptor Alessandro Vittoria*, 1560–65. Vienna, Kunsthistorisches Museum.

Paolo Veronese, like Moroni, was a friend of Alessandro Vittoria's. All the same, in this portrait, he seems to be emphasizing the social standing that artists in general, and this one in particular, had attained.

The sculptor, who by this time had reached the height of his career, has a much more studied and "official" appearance than in the earlier painting. He is not wearing a sculptor's smock but is soberly dressed in an impeccable dark suit.

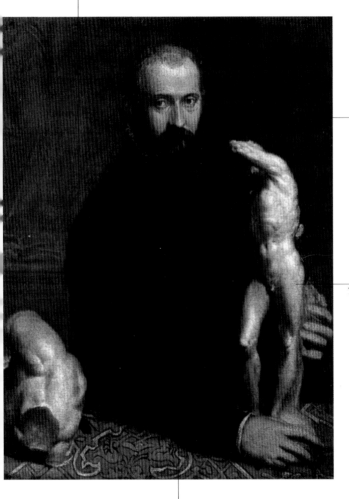

The sculptor is displaying an exceedingly elegant, well-finished statuette as evidence of his skill.

The oriental carpet adds to the atmosphere of refined prosperity in the setting. This might be a portrait of an antiquarian, showing artworks to his clients, rather than a sculptor.

▲ Paolo Veronese, *Portrait of the Sculptor Alessandro Vittoria*, ca. 1570. New York, Metropolitan Museum.

There was lively debate over art and architecture, with authoritative contributions by and harsh polemics between intellectuals and artists, whose role in society was changing.

Treatises and Writings on Art

▼ Jean Cousin the Younger,
frontispiece of the *Livre de
perspective*, 1560.

The audience for art was expanding, and critical debate was stirred by writings and treatises. The century dawned with the debate between Leonardo and Michelangelo over which was superior, painting or sculpture. Though in sharp disagreement, the two masters did agree that the criterion to be used was not manual creation but the "idea" underlying the artist's work. Titian, encouraged by the writings of Pietro Aretino and Ludovico Dolce, set the relationship between artist and client in a new sphere of reciprocity. The "supremacy of design," typical of Florentine and Roman milieus, contrasted with the rich, textured approach to color of the Venetians. In the print shops of Nuremberg, Dürer produced three treatises that he illustrated with engravings of great didactic clarity: the first was on geometry (1525), the second on fortifications (1527); the third and last volume, published posthumously in Latin and German (1532), treated the symmetry and proportions of the human body. France under Francis I also saw a flurry of treatises, chiefly having to do with perspective (Serlio, the French edition of Vitruvius in 1547, and Cousin). Other important works on architecture would be published by Palladio and Vignola. Giorgio Vasari sought to define the summit of the three arts "of design" (painting, sculpture, and architecture); he also explored the reciprocity between the imitation of nature and the application of rules.

The treatise on the symmetry of the human body was published posthumously, shortly after Dürer's death, under the supervision of his widow, Agnes.

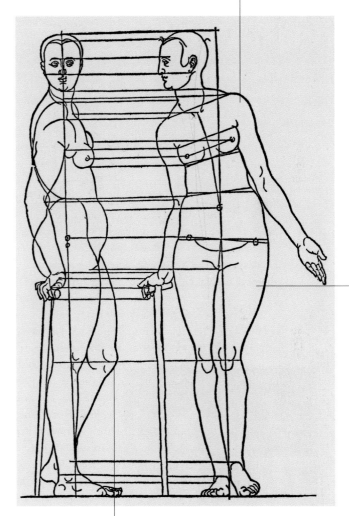

The female figure, in a pose reminiscent of the Eve painted by Dürer in 1507 (page 81), is shown in profile and facing forward through a system of projection lines.

▲ Albrecht Dürer, *The Proportions of a Female Body in Motion*, illustration for the treatise *De symmetria partium*, 1532.

Despite the artist's best efforts and the painstaking series of engravings that illustrate the treatise, the theoretical relationships resulted in nothing more than cold, mechanical images.

Giorgio Vasari's Lives of the Artists, *published in a first edition in 1550 and in a second in 1568, featured biographies of painters, sculptors, and architects, from Cimabue to Michelangelo.*

Vasari's Lives

Giorgio Vasari
Arezzo 1511–Florence 1574

School
Florentine

Principal place of residence
Florence

Travels
Stays in Rome (1531–38; 1542–46 and later); periods in Venice (1541; 1566)

Principal works
As an architect, the Palazzo degli Uffizi in Florence (1560) and the Studiolo of Francesco I in the Palazzo Vecchio (1572); as a painter, he did the frescoes in the Palazzo della Cancelleria in Rome (ca. 1545) and in the Palazzo Vecchio in Florence (1563)

Links with other artists
Writing the *Lives* put him into direct contact with the Italian artists of the mid-16th century

Despite his respectable career as a painter and architect, Giorgio Vasari's fame is based primarily on his *Lives*, which is considered, perhaps wrongly, the first book of art history. Vasari describes an evolutionary process: after reaching its lowest point in the Middle Ages, art gradually rose again, in stages marked by the progressive conquests of the depiction of nature, perspective, and the human body. A first "age" was inaugurated by Cimabue, with Giotto as its central figure; a second age, in the 15th century, ran from Masaccio to Botticelli and Perugino. Progress continued in the "third age," the period of Leonardo and Raphael, and the zenith was finally attained with Michelangelo, after whom nothing but decline could ensue. In the second edition, written after Michelangelo's death, Vasari made it clear that no one could ever outshine the master, especially his perfect depiction of the most elevated subject of all, the male nude. As for techniques, open preference was given to marble sculpture and fresco painting, neither of which allows rethinking or correction. Vasari's personal

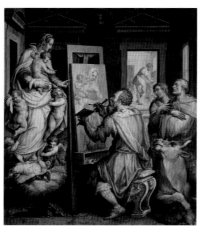

▶ Giorgio Vasari, *Saint Luke Painting the Virgin Mary,* 1564–73. Florence, Church of Santissima Annunziata, Cappella di San Luca (seat of the painters' confraternity in Florence).

vision of the history of art, his preference for Tuscan masters, his hyperbole, and several anecdotes and details that were proven inaccurate —none of these factors outweigh the fundamental importance of the *Lives*, an invaluable source of information as well as a significant expression of the taste and culture of the Tuscan Renaissance.

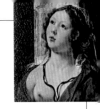

Drawing underwent a remarkable phase of development not only as a process preparatory to painting but also as an intense art in its own right.

The Supremacy of Drawing

To Leonardo, drawing was a way of understanding the world, of exploring the wonders of nature, penetrating the mysteries of life, designing machinery of all sorts, studying physiognomies and anatomical details, and envisioning apocalyptic deluges and devastations. With a combination of drawing and literary or scientific reflection, Leonardo assembled thousands of pages of notes, an immense patrimony of thought and art, which never attained finished form. Raphael's drawings reveal the painter's method of work, through increasingly refined "variations on a theme" or else by sketching his apprentices, who were drawn "from life" in the poses of saints for altarpieces. Dürer debuted in art as a draftsman: we know of works that he did at age fourteen. The German master glorified the graphic arts, and in addition to hundreds of engravings, he executed magnificent watercolors of nature with landscapes, animals, and plants. He used drawing to try to establish the canons of an "ideal" beauty.

Drawing was considered one of the noblest aspects of artistic endeavor in the 16th century, of which Holbein's draftsmanship in England and Clouet's *crayons* at the French court are eloquent demonstrations. With the significant exception of the Venetians, European artists found drawing to be the purest expression of the "idea," the most elevated form of mental conception. Vasari's founding of the Academy of Design in 1561, with strict admission and testing standards, underscores the exclusive and intellectual nature of draftsmanship.

Related entries
Nuremberg, Antwerp,
Paris, London, Florence

Baldung Grien, Clouet,
Dürer, Giulio Romano,
Hilliard, Holbein,
Michelangelo,
Parmigianino,
Primaticcio,
Raphael

▼ "No Day without a Line,"
from the collection of
emblems engraved by Crispijn
de Passe and published by
Gabriel Rollenhagen in
Utrecht, 1613.

The back muscles are described in an exemplary fashion with the usual tools of drawing: shadows and highlights.

The *profil perdu (lost profile)* would become a character-istic pose in Mannerism.

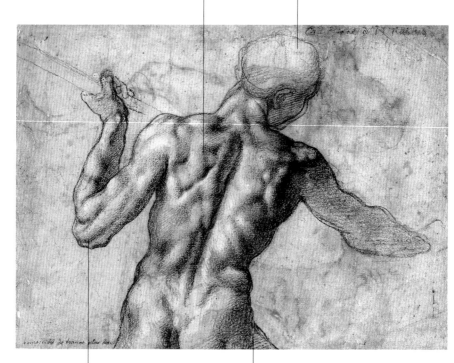

Sketching athletic male nudes would become, from Michelangelo on, the most classic academic exercise.

Among the absolute masterpieces of Michelangelo's work as a draftsman were the preparatory drawings and the cartoon for the large fresco The Battle of Cascina, which would decorate the Salone dei Cinquecento in the Palazzo Vecchio, in Florence, in competition with Leonardo's Battle of Anghiari.

▲ Michelangelo, *Male Nude Depicted from Behind*, 1507. Vienna, Graphische Sammlung Albertina.

This is a preparatory drawing for the fresco The Battle of Ostia *in the third Vatican Stanza. The main character, the so-called field marshal, appears fully and heavily clothed in the fresco, but Raphael posed the model nude to study the pose and gesture.*

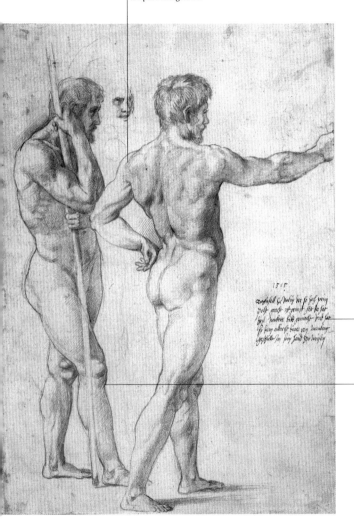

The date and the writing are by Albrecht Dürer, to whom Raphael had sent the sketch, documenting an exchange of courtesies between two of the greatest draftsmen of all time. From Nuremberg, Dürer sent Raphael a watercolor.

As is characteristic of his style, Raphael sketched out the anatomy with simplicity and confidence, and never overemphasized gestures or muscular mass.

▲ Raphael, *Study of Male Nudes,* 1515.
Vienna, Graphische Sammlung Albertina.

"Painting on a wall is the most masterful and beautiful, because it means doing in a single day what in other methods can be extensively retouched over the initial work." — Vasari

Fresco

The early 16th century in Italy saw a relentless production of frescoes. Pinturicchio frescoed the Baglioni Chapel in Spello and the Piccolomini Library in the Siena cathedral. Perugino decorated the Collegio del Cambio in Perugia. Luca Signorelli, after painting *The Legend of Saint Benedict* at Monte Oliveto Maggiore, decorated the San Brizio Chapel in the Orvieto cathedral. In Florence, in the church of Santa Maria Novella, Ghirlandaio frescoed the Tornabuoni Chapel while Filippino Lippi worked on the adjoining Strozzi Chapel. Only in Venice, the dampness of the city discouraged the use of fresco, as evidenced by the decay of the paintings by Giorgione and Titian at the Fondaco dei Tedeschi (1508). The triumph of the fresco was further solidified by the simultaneous presence in the Vatican of Raphael and Michelangelo (1508–12). At the same time, Titian was frescoing the Scuola del Santo in Padua. The 1510s–20s witnessed the work of the first Mannerists in Florence, the debut of Gaudenzio Ferrari in Valsesia, the "provincial" series by Romanino and Pordenone, the work of Sodoma and Beccafumi in Siena, the sacred scenes by Lorenzo Lotto in the Bergamo area, and the work by Correggio in his hometown of Parma. In the 1540s, with the work of Giulio Romano in Mantua and Rosso Fiorentino in Fontainebleau, the fresco became a part of interior decoration, along with stuccoes, figures in relief, and boiseries (carved wood panels).

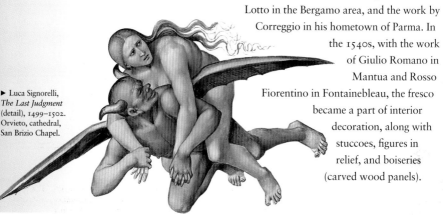

▶ Luca Signorelli, *The Last Judgment* (detail), 1499–1502. Orvieto, cathedral, San Brizio Chapel.

The ornamental facings were a new feature linked to archaeological finds in Rome.

The scenes simulate broad arches opening along the walls of the rectangular hall.

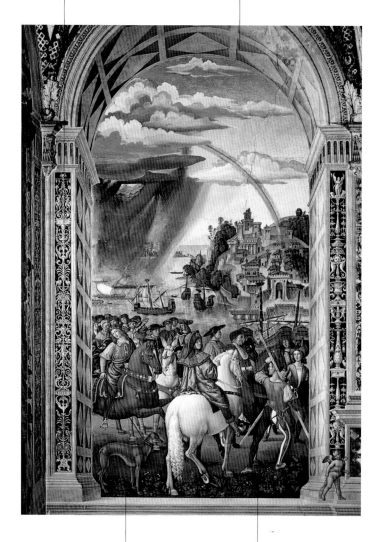

▲ Bernardino Pinturicchio, *Aeneas Silvius Piccolomini Travels to the Council of Basel*, 1502–7. Siena, Cathedral, Piccolomini Library.

Pinturicchio made use of drawings by the very young but already famous Raphael.

The narrative sense is very successful, with an insistent pace, sustained by the clear light and the lively colors.

In the first half of the ceiling the protagonist is God the Father, portrayed hard at work in the process of creation; in the second half, man takes center stage.

At either side of the five minor scenes, Michelangelo painted exemplary pairs of young male nudes.

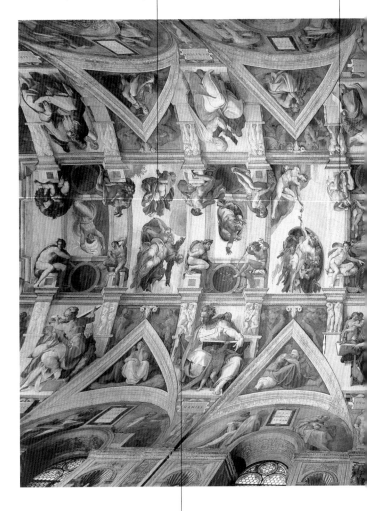

Despite the apparent freedom of composition, the ceiling is organized by a vigorous painted architecture.

Colossal figures alternating with sibyls and prophets take the place of the twelve apostles, called for in the first plan that Pope Julius II submitted to Michelangelo.

▲ Michelangelo, Ceiling of the Sistine Chapel, 1508–12. Vatican City.

Nine narrative scenes, small and large in alternation, are developed in the central part of the ceiling, depicting episodes from Gen.

In the spandrels and lunettes, the lengthy series of Christ's ancestors are depicted.

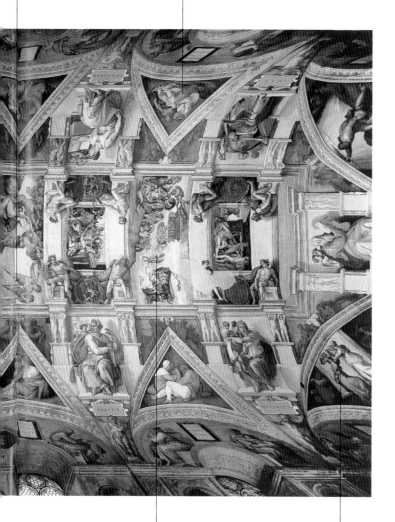

The Flood, partly ruined by leaking water, is the only episode in which we can detect the hand of two collaborators, Francesco Granacci and Giuliano Bugiardini, whom Michelangelo hired on probation and soon fired.

In the four large corner spandrels are depicted episodes from the Old Testament.

The descriptions of nature and atmosphere, clearly derived from the tonalism of Venetian easel painting of the same period, are a radical innovation in the technical field of the fresco.

Titian introduced very light shades, arrayed in a checkerboard pattern, that are outside the customary range of hues found in frescoes.

The jealous husband stands ready to kill his innocent wife. The pose of the stabbed woman is exceptionally complex, but it powerfully expresses the tragic immediacy of the event.

This fresco belongs to a series of scenes illustrating the miracles of Saint Anthony. Titian, nonetheless, places the actual miracle—the husband begging forgiveness—in the background, laying full emphasis on the bloody scene of murder in the foreground.

▲ Titian, *Miracle of the Jealous Husband*, 1511. Scuola del Santo, Padua.

In a spectacular invention, Raphael simulated the heavy grate of a prison, clamped between the dark, massive walls in the foreground.

In the scene, Saint Peter appears old and weary. It is very likely an allusion to the death of Pope Julius II, interpreted as a "liberation from the earthly prison" of the controversial pontiff.

In a very unusual treatment for a fresco, the scene is set at night, with enchanting reflections of light on the armor of the soldiers standing guard.

The light emanating from the angel fills the space behind the grate, creating a sense of depth.

▲ Raphael, *The Deliverance of Saint Peter from Prison*, 1511–13. Vatican City, Vatican Palace, Stanza di Eliodoro.

The very long pike that extends diagonally upward links the crowded lower section of the fresco with the less populated upper portion.

The demon seizing the impenitent thief inserts an infernal note among the angels weeping in the sky.

One touch of realism is provided by the armor, depicted in relief. This scene is the most important in a series of panels depicting episodes from the life of Christ, frescoed by Gaudenzio on the partition wall of the small monastic church.

▲ Gaudenzio Ferrari, *The Crucifixion*, central panel of the partition wall with scenes from the life of Christ, 1513. Varallo Sesia (Vercelli), Santa Maria delle Grazie.

The scene of the Virgin Mary fainting at the foot of the cross constitutes a group unto itself, as it would be, just a few years later, in the statues that Gaudenzio would create for the Sacro Monte (literally, Sacred Mountain) of Varallo.

The presence of women, children, pilgrims, and common folk confers upon the scene a strong sense of the populace. We should keep in mind that it was painted at the same time as Raphael's frescoes in the Stanza di Eliodoro.

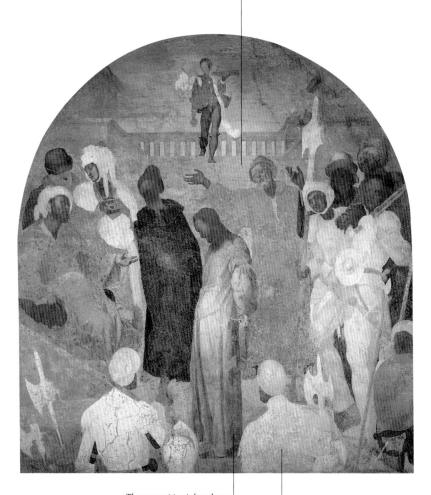

The staircase in the background increases the sense of depth in the scene.

The composition is based on a print by Dürer. For Italian painting, and especially for Florentine painting, the use of a northern model was a major new development, indicating that the figurative culture was opening up to new ideas.

Pontormo's frescoes in the Certosa del Galluzzo (a large monastic building on the outskirts of Florence) are in a very precarious state of preservation. The lunettes, in fact, are located beneath the arches of the large cloister, which is to say, practically outdoors.

▲ Jacopo Pontormo, *Christ before Pilate*, 1521. Florence, Certosa del Galluzzo.

The composition is quite complex, abounding in unexpected foreshortenings. Notice how the groups of clouds and figures followed an ascending spiraling motion, in a clear foreshadowing of the "glories" of Baroque domes.

The swirl of legs and arms makes it very difficult to pick out the figure of the Virgin Mary, who is being carried into the heavens by a group of angels. Only after gazing carefully and at length is it possible to identify her clearly, at the bottom center of the photograph.

The focal point of the entire composition is the intensely luminous heavenly paradise, toward which all of the figures seem to be rising, as if sucked upward in a vortex.

▲ Correggio, *The Assumption of the Virgin*, 1526–28. Parma, cathedral.

The Gospel parable of the wise and foolish virgins (Matt. 25) offers an excuse for a sophisticated procession of models in the "Modern Manner." Here we see three of the wise virgins, carrying their lamps and the oil to light them.

Astonishingly realistic details emerge from the background, including vases, crabs, birds, seashells, and the magnificent vegetal architectural decorations.

The sharp, bright colors are a direct, polemic response to Correggio (facing page).

The series of frescoes in the choir of the church of the Steccata is the final, controversial monumental work of Parmigianino, who had openly clashed with the clients.

▲ Parmigianino, *The Wise and Foolish Virgins* (detail), 1534. Parma, Madonna della Steccata.

Fresco

The classical gods of Olympus are identified here with the astrological symbols of the Zodiac. Painted in a villa that sits at the center of an immense farming estate, they allude to the influence of heavenly bodies upon the progression of seasons and crops.

The figures of the gods are accompanied by distinctly recognizable attributes: Diana, the goddess of hunting, is affectionately nuzzling a greyhound.

The physical beauty of Veronese's characters is enhanced by the generous proportions of the nudes.

▲ Paolo Veronese, Ceiling of the Sala di Olimpo, ca. 1560. Maser (Treviso), Villa Barbaro.

The decoration of Villa Barbaro has an essentially profane and mythological tone, but because one of the two brothers who commissioned the work was a high prelate, Veronese took care to insert effective though improbable references to Christianity. Thus, Divine Providence is surrounded by a circle of pagan deities.

Because of its versatility, technical innovations, and the work of great masters, engraving rose to prominence in the creation and marketplace of art.

Engraving

Over the course of the 16th century, engraving spread rapidly, establishing itself as the quickest, most effective medium for the communication of visual ideas. Before this period, engravings had been done by painters or goldsmiths. The 16th century saw the emergence of a new type of artist, the professional engraver, who expressed himself solely through prints. Through Dürer's work especially, engraving became a fully autonomous discipline, attaining a high degree of expressivity. The adoption of copperplate engraving techniques opened up new expressive horizons, and the new ideas spread rapidly across Europe, given the unlimited capabilities of reproduction and the ease with which cheap copies could be distributed. Engraving was used to illustrate books (which led to the decline and virtual extinction of the illuminated manuscript), for original creations, either on individual sheets or in thematic series, and for the reproduction of renowned ancient and modern works, which were thus made available to far-flung artists and amateurs. As early as 1520, beginning in the circle of Raphael, a distinction came to be made between two different kinds of engraving. There was engraving for "invention," in which new images were created and tested, and there was engraving for "reproduction," which provided an accurate graphic depiction of ancient and modern statues and paintings. Last of all, we should mention the engravings taken from drawings by great masters, prepared specifically to be made into prints. Such specialists as Marco Dente of Ravenna and Marcantonio Raimondi were frequently employed at the graphic rendering of Raphael's "ideas."

Related entries
Augsburg, Nuremberg, Rhine Basin, Antwerp, Brussels, United Provinces, Rome, Florence, Venice

Baldung Grien, Cranach, Dürer, Giulio Romano, Lucas van Leyden, Parmigianino, Raphael

▼ Albrecht Dürer, *The Monstrous Sow of Landser*, 1498. Burin engraving.

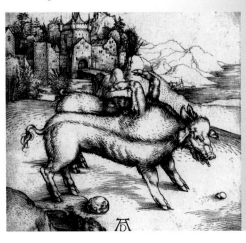

Engraving

The title is borne on the wings of a bat. The Roman numeral I refers to the first stage of the alchemical process.

All of the instruments and objects shown in this engraving are linked to the practice of alchemy.

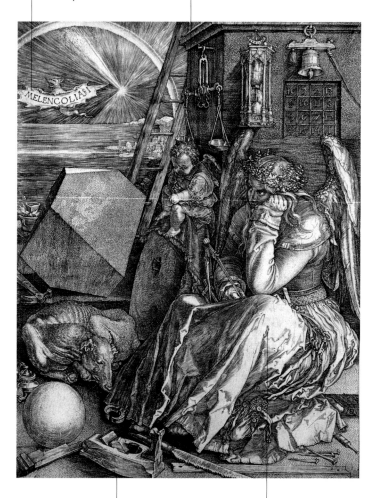

▲ Albrecht Dürer, *Melencolia I*, 1514. Burin engraving.

Geometric solids, thoughtful figures, tools abandoned on the ground: this renowned engraving alludes to the phase of waiting and thinking that precedes the initiation of both alchemical and artistic creation.

The monumental and captivating pose of the allegorical figure is especially distinctive: the face propped up on the hand is the classic symbol of the brooding, melancholy humor.

The reflection of the bull's-eye window-panes on the wall is a touch of absolute virtuosity in the rendering of light.

The wooden ceiling beams follow the perspective lines toward the vanishing point, perfectly controlled and consistent in every detail of the picture.

The slate with the unmistakable AD monogram is the artist's signature.

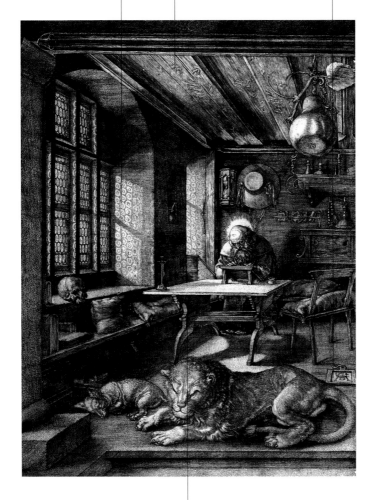

▲ Albrecht Dürer, *Saint Jerome in His Study*, 1514. Burin engraving.

The Saint Jerome *forms part of the triptych of the "master engravings," completely independent yet linked thematically, that Dürer executed in 1513 and 1514.* Saint Jerome *represents intellectual thought, while* Melencolia I *alludes to alchemy, and* Knight, Death, and the Devil *symbolizes the active life.*

Although he was still quite young when he made this work, Lucas van Leyden shows a complete and autonomous mastery of the technique of engraving, comparable only to Dürer's.

The cows, oddly enough, are the true subjects of this engraving. They dominate both the vertical and the horizontal axes.

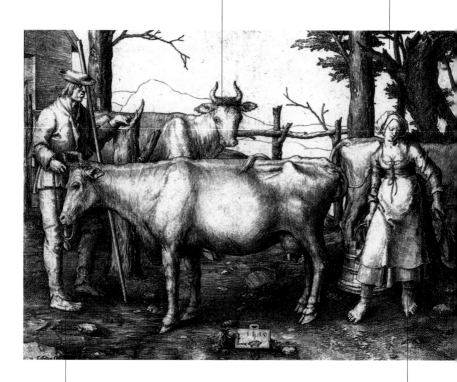

More than that of any other nation, Dutch art readily turns to "genre" scenes inspired by everyday life.

The poses of the milkmaid and the cowhand have led some to suggest a sexual reference, but the tone of the scene remains straightforward and realistic.

▲ Lucas van Leyden, *The Milkmaid*,
1510. Drypoint engraving.

The naturalistic details of the landscape and the interplay of the chiaroscuro are especially effective.

The complexity of the composition clearly shows that Marcantonio Raimondi borrowed not from a single painting but from an array of drawings and projects, assembling them into a single montage.

This engraving takes details from Raphael for the renowned mythological scene in which Paris must choose which of three goddesses—Juno, Minerva, or Venus— is the most beautiful.

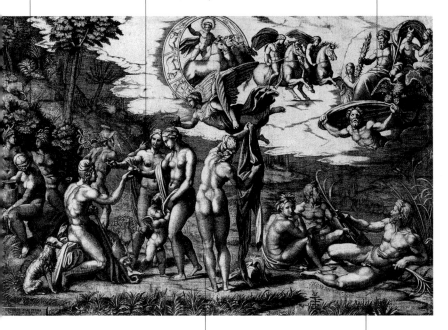

In a few particularly successful figures, we can see how the soft modeling of Raphael's drawings was transferred to the engraving plate.

Manet used the entire group on the bottom right as a model for the poses of the figures in his famous painting Déjeuner sur l'herbe.

▲ Marcantonio Raimondi (from Raphael), *The Judgment of Paris*, 1513–14. Drypoint engraving.

In the work of painters, in the tastes of collectors, and in the consciousness of treatise writers, the still life emerged toward the end of the Renaissance as an autonomous genre.

Still Life

▼ Jacopo de' Barbari, *Still Life*, 1504. Munich, Alte Pinakothek.

While the rarified style of Mannerism was developing throughout Europe, in Flanders and northern Italy, painters and clients were increasingly drawn to the "natural." Two great schools—in intense, reciprocal contact—share credit for the development of the still life. In Antwerp, Aertsen and Beuckelaer were at work; beginning in the middle of the 16th century, they relegated the narrative pretexts to the background and gave pride of place to kitchen and market scenes. In Bologna, through the efforts of the scientist and collector Ulisse Aldrovandi, the naturalistic image—as close to reality as possible—was being perfected for purposes of classification and study; it rapidly extended to art created for collectors, especially thanks to the work of Bartolomeo Passerotti. In Lombardy, a number of Leonardesque themes were revived and adapted to the new style: flowers, fruit, and inanimate objects were interpreted with intense dignity, as a test of the artist's skill at counterfeiting nature, but also and primarily as bearers of dense allegorical, symbolic, and moral meanings. This new direction progressed, in both content and form, with the Lombard artists linked to the court of Rudolf II (Arcimboldi, Figino) in the first decades of the 17th century, spurred on by aristocratic collectors. Only much later did critics define this genre of art. Because of this delay, we see a divide between the terms and meanings used in Mediterranean and Catholic Europe, where the phrase used was "dead nature" (*natura morta* in Italian and Spanish, *nature morte* in French, etc.), and that used in the northern, Protestant area, which used linguistic variants on "still life."

Giovanni da Udine worked closely with Raphael in the execution of the Vatican Loggias. This watercolor was part of the formal development process for that magnificent decorative complex.

The incorporation of unusual pieces of fruit, such as chestnuts still in their husks, is an indication of the great decorative liberty and the creative flair lavished by Raphael's workshop on the Vatican Loggias, unquestionably one of the most advanced art projects of the early 16th century.

The festoons of flowers and fruit, possibly derived from ancient decorations, progressively came to acquire a figurative autonomy that was entirely innovative. The shadows emphasize their expressive energy.

▲ Giovanni da Udine, Sketches for festoons of flowers and fruit, 1520. Vienna, Graphische Sammlung Albertina.

With an extreme Mannerist use of fantasy, Arcimboldi created his "composite heads" for the court of Rudolf II, unusual portraits formed of objects and animals belonging to the same class or environment.

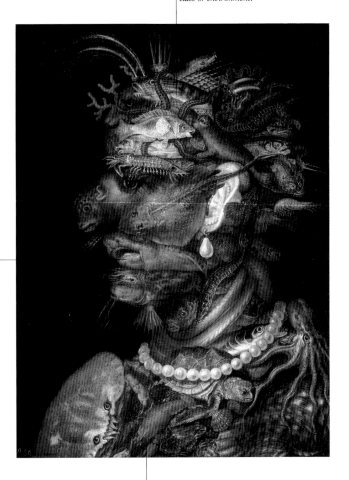

In some cases, Arcimboldi matched the natural characteristics of the elements that made up the portrait with the corresponding anatomical zone. Thus, the shark's powerful jaws make a persuasive mouth.

▲ Giuseppe Arcimboldi, *Water*, from the series The Four Elements, 1566. Vienna, Kunsthistorisches Museum.

The effectiveness of Arcimboldi's heads (as opposed to the often unsuccessful results obtained by imitators) is a result of the great formal quality and structural solidity, the product of a painstaking and loving observation of nature, which was seen as a new subject for art.

The Gospel story of Christ's visit to the house of Martha and Mary is in the background, relegated to a distant and marginal role compared with the spectacular presentation of the objects in the foreground.

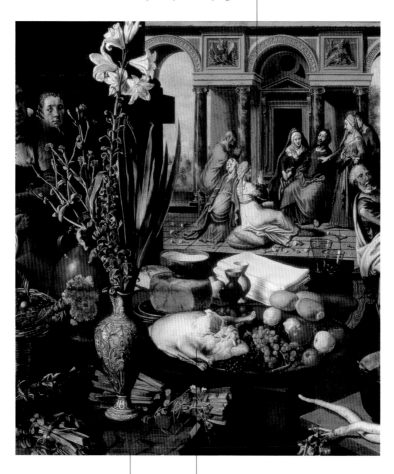

Note the refined execution of the vase of flowers, another subject that within a few years would be able to stand alone.

The large platter of banquet food has, in all likelihood, a symbolic meaning, but it easily seizes center stage.

▲ Pieter Aertsen, *Kitchen Scene with Christ in the House of Martha and Mary*, 1553. Rotterdam, Museum Boijmans van Beuningen.

Because of a laudatory sonnet, we can date this little Lombard painting to the beginning of the 1590s, making it definitively one of the earliest autonomous "still lifes" in the history of art, a couple of years before Caravaggio's.

The dark, neutral background heralds a style that would become common in the 17th century.

The pale reflection of the fruit on the pewter dish is, in all likelihood, homage to the "still life" painted by Leonardo a century earlier, on the table of The Last Supper, *where the food is reflected on the surfaces of the serving dishes.*

The light and shadows are studied with great care.

▲ Giovanni Ambrogio Figino,
Still-Life with Peaches, 1591–94.
Private collection.

The apple in the middle features a glaring wormhole. This defect, along with the detail of the withered leaves on the right, introduces the moral theme of the fragility of beauty and of ripe maturity, ephemeral qualities that soon vanish.

The background, light hued and neutral, focuses the viewer's attention on the basket of fruit.

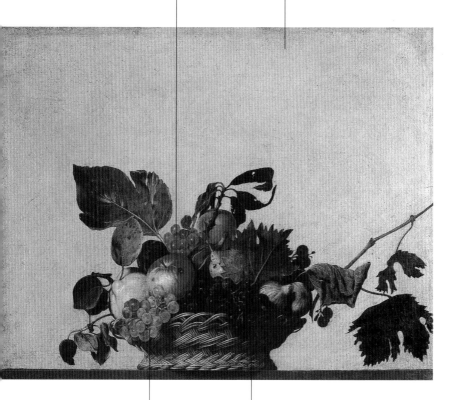

The painting was done in Rome, for Cardinal Del Monte, who presented it as a gift to Federico Borromeo. It has remained ever since in that collection, which Borromeo opened to the public as the Pinacoteca Ambrosiana.

The reproduction of the woven wicker is astonishingly realistic. With an almost trompe-l'oeil effect, Caravaggio seems to bring the basket beyond the edge of the painting itself.

▲ Caravaggio, *Basket of Fruit*, 1596. Milan, Pinacoteca Ambrosiana.

Bronze gained new status as a prized material for sculpture, whether in the form of a small tabletop statue or a colossal equestrian monument, a decorative object or a fountain statue.

Bronze Sculpture

▼ Peter Vischer the Elder, *Kneeling Man with a Branch*, ca. 1490. Munich, Bayerisches Nationalmuseum.

While marble sculpture demands a broad, solid base with a very robust support, bronze allows sculpture to be lighter and thus permits daringly balanced virtuoso solutions, applicable to objects of all sizes. Moreover, in the Renaissance, the symbolism ascribed to materials tended to emphasize the commemorative worth of bronze for statues of monarchs and illustrious men in public spaces (such as the equestrian monument, from the mid-15th century on), or else for the "civic" value of fountains and other urban furnishings. One of the most evident results of the recovery and study of classical models is the development of the bronze statuette as a refined genre. Meant for a scholarly, discerning type of collector, the bronze statuette became a distinct area of pursuit, always balancing classical precedents with Mannerist style. Moreover, the bronze statuette came to rival monumental bronze statues in creativity and technical excellence. The very fact that the audience was a small circle of intellectual connoisseurs encouraged artists to explore exquisite new iconographic, technical, and formal realms, making the bronze statuette a driving force in the production of new ideas and concepts in High and late-Renaissance sculpture. Bronze became a focus for forms of execution, areas of technical expertise, and expressive capacities that derived equally from goldsmithing and monumental sculpture. Beginning in the middle of the 16th century, bronze was also the preferred material for major public works, partly because of its ability to withstand the elements. Throughout Europe, there was a proliferation of bronze commemorative statues, ornamental complexes, and fountains with numerous figures.

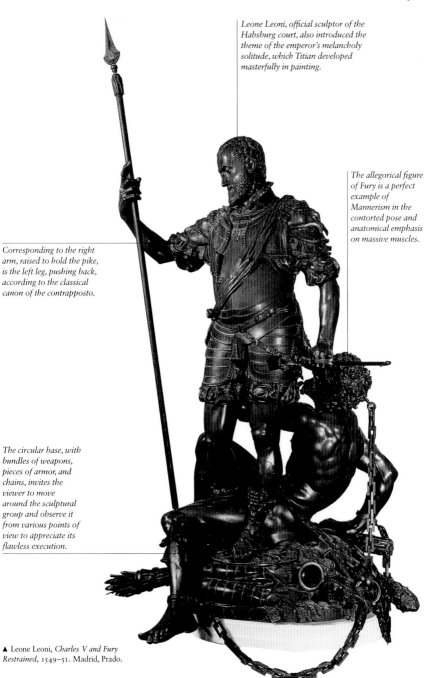

Leone Leoni, official sculptor of the Habsburg court, also introduced the theme of the emperor's melancholy solitude, which Titian developed masterfully in painting.

The allegorical figure of Fury is a perfect example of Mannerism in the contorted pose and anatomical emphasis on massive muscles.

Corresponding to the right arm, raised to hold the pike, is the left leg, pushing back, according to the classical canon of the contrapposto.

The circular base, with bundles of weapons, pieces of armor, and chains, invites the viewer to move around the sculptural group and observe it from various points of view to appreciate its flawless execution.

▲ Leone Leoni, *Charles V and Fury Restrained*, 1549–51. Madrid, Prado.

The head turned to one side is a concession to the Mannerist preference for rotating bodies.

The ample form of this nude is a proverbial physical attribute of the goddess.

The peacock is a symbolic animal that accompanies Juno, linked to the mythological episode of the killing of Argo, the hundred-eyed guard. Juno commemorated his loyalty by symbolically "spangling" the peacock's tail with his eyes.

This exceedingly elegant sculpture stood in the private study of the grand duke Francesco I de' Medici, in the Palazzo Vecchio, an authentic jewel box of late-16th-century Florentine decoration.

▶ Giovanni Bandini, *Juno*, ca. 1570. Florence, Palazzo Vecchio, Studiolo of Francesco I.

The influence of Michelangelo can be seen in the Herculean power of the arms and the muscles of the torso.

The gesture is an elegant and, at the same time, energetic instance of contrapposto.

In compliance with the finest Mannerist tradition, Giambologna places in prominent view the solid purchase of the foot, the launch point of the figure's motion and the point of equilibrium of its pose.

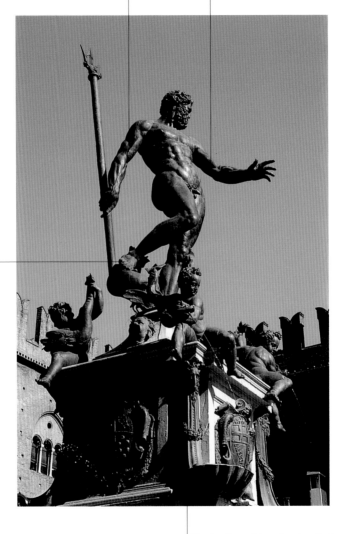

▲ Giambologna, *The Fountain of Neptune*, 1563–67. Bologna, Piazza del Nettuno.

The giant figure of the god tends to dominate the viewer's attention, but the smaller bronzes that decorate the pedestal are truly delightful, with little sprites, mermaids, fish, and maritime motifs.

This group is dominated physically and spiritually by Charles V, the great emperor who had died some years before but whose image continued to appear to his son, Philip II.

Isabella of Portugal, Charles's young wife, died early; her presence endows this somewhat spectral group with a note of diaphanous, melancholy beauty.

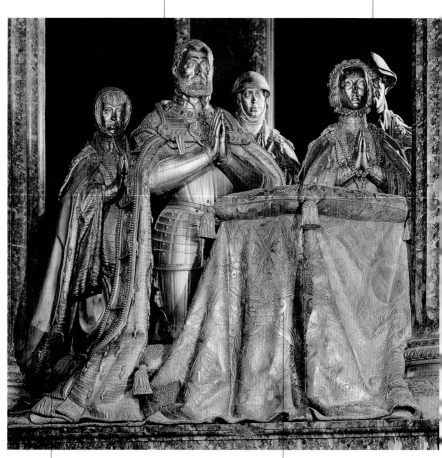

Pompeo Leoni, son and heir to Leone Leoni, and—like his father—an artist with a controversial, turbulent life, moved to Spain in 1556.

The members of the royal family are depicted kneeling before an altar, also made of gilt bronze. Facing them, Pompeo Leoni sculpted a similar group, with Philip II, his three wives, and his son.

▲ Leone and Pompeo Leoni, Group in gilt bronze with the family of Charles V, completed in 1593. El Escorial, basilica.

The noble, tranquil figure of the risen Christ conforms to classical models.

The little angels have positions and functions very like those of the little marine sprites found on pagan fountains, confirming the substantial interchangeability of the models.

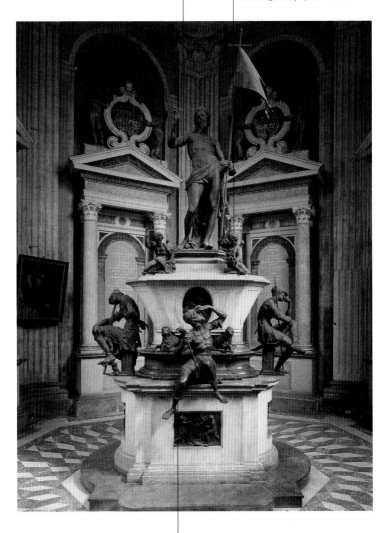

▲ Adriaen de Vries, *The Resurrection of Christ*, completed in 1620. Stadthagen (Germany), St. Martini-Kirche, Schaumburger Chapel.

The soldiers at the base of the tomb exemplify several interpretations of the canonical Mannerist theme of "serpentine motion," the spiraling movement made possible by the flexibility of bronze.

In the latter half of the 16th century, a new artistic genre rapidly gained popularity: the "intellectual" garden, incorporating pavilions, sculptures, fountains, surprises, and artificial grottoes.

Gardens, Grottoes, and Fountains

Related entries
Scandinavia, Bavaria, Fontainebleau, Châteaux of the Loire, Rome, Florence

De Vries, Giambologna

▼ *Monstrous Portal*, in the "sacred grove" of the Villa Orsini, ca. 1560. Bomarzo, province of Viterbo (Italy).

The architectural gardens of the declining years of the Renaissance are enchanted, secret places, set on a theoretical continuum between nature and art, full of literary allusions and technical innovations, magnificent sculpture and esoteric labyrinths. Because these man-made creations are so difficult to preserve—plants decay, tastes vary, and properties change hands—the number of aristocratic gardens has declined drastically. Those that survive continue to exert fascination. First was the Palazzo Te of Mantua, where Giulio Romano created for Federico Gonzaga a "secret" garden, separate from the rest of the building and its surrounding green areas, with pebble mosaics, an artificial grotto, and frescoes inspired by the *Metamorphoses*. That style then spread throughout Europe: the fabulous ceramic creations by Bernard Palissy for the "grottoes" of the Jardin des Tuileries in Paris; the Grottenhof in the Bavarian princes' residence, in Munich; the nymphaeum of Pirro Visconti at his villa in Lainate, near Milan; and, later, the grottoes of the Villa Borromeo on the Isola Bella, in Lake Maggiore. But the most significant creations were in central Italy, beginning with Florence's Boboli Gardens designed by Tribolo with the help of Bartolomeo Ammanati, Bernardo Buontalenti, and Giambologna.

Fashioned with simulated rocks, seashells, and other materials, figures of shepherds and flocks emerge from the walls, in an ambiguous blending of nature and artifice.

In a gradual transition, the pronounced relief of the lower sections merges into the ceiling, frescoed with the same pastoral motifs.

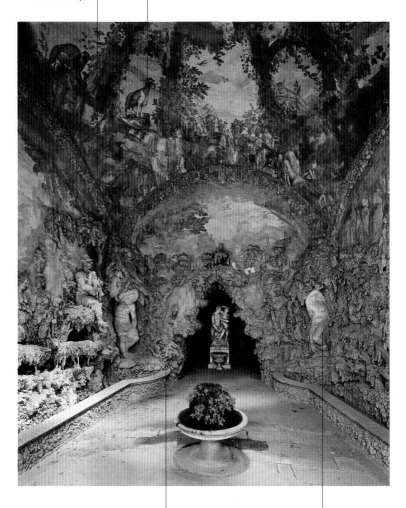

▲ Bernardo Buontalenti, *The Grotto,* 1588. Florence, Boboli Gardens.

The grotto consists of a series of rooms, each decorated with groups of mythological sculptures and charming surprises.

In the first room, which serves as a vestibule, the walls drip with artificial rocky encrustations. In each of the four corners, Buontalenti placed one of Michelangelo's four unfinished Prisoners (copies now replace the originals), as if they were struggling to escape from the living rock.

With the decline of optimistic humanism, the "ideal city" became a conscious, and occasionally heretical, utopia. At the same time, the love of nature and country life was rediscovered.

Villas and Country Residences

Andrea Palladio
Andrea di Pietro della Gondola; Padua 1508–Vicenza 1580

School
Venetian

Principal place of residence
Vicenza

Travels
Frequent trips in his youth to study archaeology in Rome, Naples, and Dalmatia; in mid-career, aside from the many trips he took to the Veneto, he worked as a consultant in Bologna and Turin; in 1570 he moved to Venice

Principal villas
Villa Godi Valmarana (1542, Lonedo di Lugo Vicentino); Villa Capra, "La Rotonda" (ca. 1555, Vicenza); Villa Pisani, "La Malcontenta" (1555–60, Mira); Villa Barbaro (ca. 1560, Maser)

Poets and writers singing the praises of rural life blazed a path for a distinctive moment in cultural history. In the Austro-German region, the poetry of Conradus Celtis was the literary counterpart of the paintings of the Danube school, celebrating the magic of forest and river; while in the Veneto in the early 16th century, the theme of the country idyll was developed, evoking a loving, musical harmony that encompassed landscape and figures. The great rulers of the 16th century built country residences (Henry VIII at Hampton Court, Francis I at Fontainebleau), and they were emulated by ambitious local dynasties like the Gonzagas, who commissioned the exemplary Palazzo Te just outside Mantua. The most visible and substantial show of architectural experimentation in country homes, however, was found in the Veneto. Facing a commercial crisis in the Mediterranean, many Venetian patricians opted to buy farms in the hinterland of the republic. The buildings erected there served the dual purpose of offering a pleasant home for the landowner and providing a functional economic center for the agricultural estate. The villas that Palladio designed were models of clarity, classical elegance, and equilibrium between the "useful" and the "comfortable," as Palladio put it in his treatise *I Quattro Libri dell'Architettura* (1570), and they would be imitated for centuries to come.

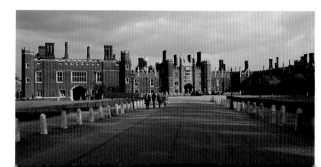

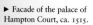 ▶ Facade of the palace of Hampton Court, ca. 1515.

The villa is actually not "rotonda" (round), despite its name. If anything, it is cubic, but the cylindrical central hall, covered by a dome that is slightly lower than the original design called for, may justify the nickname.

The four facades of the villa are identical, but each of them looks out onto a different landscape, offering an unexpected variety of views.

Each facade has a bright six-columned Ionic pronaos rising symmetrically above a tall staircase.

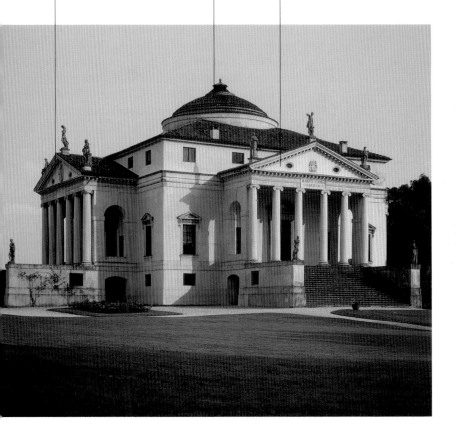

▲ Andrea Palladio, Villa Almerico Capra, "La Rotonda," ca. 1555. Near Vicenza (Italy).

Writers, painters, and architects took a new interest in the performing arts, resulting in new perspectival views, monumental backdrops, symbolic references, and comparisons with classical theater.

Theater

Related entries
Villas and Country
Residences

Paris, London, Florence,
Venice

Tintoretto

▼ Sebastiano Serlio,
Perspective, ca. 1515. Ferrara,
Pinacoteca Nazionale.

Beginning around 1500 documents attest to the construction by painters of backdrops, stage sets, and temporary installations to provide venues for theatrical productions. The architect Baldassarre Peruzzi, perhaps as early as the second decade of the century, introduced theater perspectives. Painters increasingly dealt with the hypothetical point of view of the spectator, and indeed certain artists, like Tintoretto, built themselves little model theaters and sets, in part to study lighting effects. Theaters, however, continued to be temporary spaces, with movable, provisional equipment. In the *Secondo libro di prospettiva* (1545), Sebastiano Serlio codified three fundamental types of stage sets—tragic, comic, and rustic—while the engravings that illustrated the treatise became a key resource for set designers and painters. The culmination of 16th-century research into the relationship between architecture and theater is found in Palladio's last work, a brick-and-mortar theater built in Vicenza for the Accademia Olimpica. Carved out of a restricted urban space alongside the city walls, the Teatro Olimpico marked the return in European architecture of theaters with permanent stages, something that had vanished with the fall of the Roman Empire. Palladio died on August 19, 1580, after construction had begun. The theater would be inaugurated five years later, after Vincenzo Scamozzi completed it; soon thereafter, Scamozzi built a similar structure in Sabbioneta, not far from Mantua, for the Gonzaga court (1588).

The diagonal perspective accentuates the impression of a backdrop, in keeping with the classical model of the "tragic scene."

The architectural backdrop is taken directly from the treatises on set design by Sebastiano Serlio, widely read in Europe beginning in 1540.

The figures "performing" the Bible story in the foreground assume somewhat forced poses, as if to underscore the eminently theatrical quality of the image.

▲ Paris Bordone, *Bathsheba Bathing*, 1545. Cologne, Wallraf-Richartz Museum.

The theater was built on steeply sloping ground, against the city walls. The seating area is semicircular, with a frescoed ceiling emulating a cloudy sky, while above the stage there is a ceiling with carved coffers.

The backdrop is illusionistic, with exaggerated perspective. The theater, completed after Palladio's death by Vincenzo Scamozzi, was inaugurated in 1585 with a performance of Sophocles' Oedipus Rex.

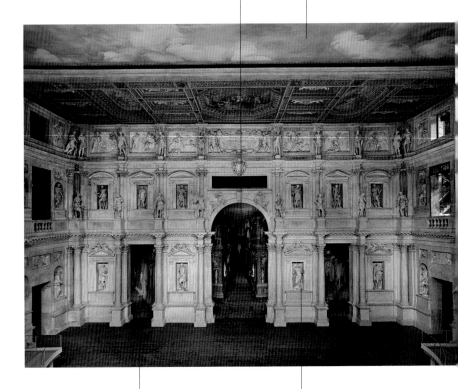

Stage-perspective views branch off from three large archways. They allude to the seven roads of the Greek city of Thebes, the setting of several classical tragedies.

The permanent scaenae frons *(stage building) features an elegant three-level facade. The Teatro Olimpico, whose name recalls the Accademia Olimpica, which commissioned the structure, was the first building of its kind since classical times.*

▲ Andrea Palladio (completed after his death by Vincenzo Scamozzi), The Stage of the Teatro Olimpico, 1580–85. Vicenza (Italy).

The "cabinet of wonders" offered an astonishing combination of nature and art, confounding the trend toward a more methodical classification of scientific knowledge.

Wunderkammer

Beginning in the second half of the 16th century, surprising and eclectic collections were formed in various cities of Europe, in which man-made creations (*artificialia*) were juxtaposed with scientific specimens (*naturalia*). The entire collection, usually displayed in specially designed rooms, with furniture fitted with drawers, shelves, and containers of various sorts, strove to astonish and impress visitors, with the collection as a whole and with the individual wonders (*mirabilia*), whether natural or artistic. The first impetus toward eclectic collecting came with the discovery of the Americas, which brought to the Old World astounding new animals, plants, minerals, and artifacts and stimulated an almost obsessive interest in objects from the "Indies." No distinctions were made between artworks (such as ceremonial garb made of feathers), everyday instruments, and natural specimens, ranging from seashells to crocodile teeth. The seaports of London and Amsterdam and their merchants offered the richest samplings of exotica, sought after by collectors from across the continent. The concept of "artificial nature," so dear to international Mannerism, created a link between the quest for strange, rare, monstrous, and allusive natural objects and the creation of art and goldwork that simulated them. The Mannerist style became a visual expression of the melancholies and manias of the great collectors of the end of the century, such as Emperor Rudolf II of Habsburg, Archduke Ferdinand II of Tirol, the Bavarian princes William V and Maximilian I, and Francesco de' Medici, the grand duke of Tuscany.

Related entries
Prague, Bavaria, Innsbruck, Brussels, Milan, Florence

Arcimboldi, Cellini, de Vries, Heintz, Spranger

▼ Wenzel Jamnitzer, *Ornamental Ewer Made of a Trochus Shell*, ca. 1570. Munich, Treasury of the Residenz.

131

Wunderkammer

The broad barrel-vault ceiling is derived from classical architecture. Friedrich Sustris, the Bavarian court painter, supervised the overall architectural, decorative, and exhibition components.

The decoration is in keeping with the fashion for grotesques, ornamental elements discovered in archaeological digs in the early 16th century in Rome.

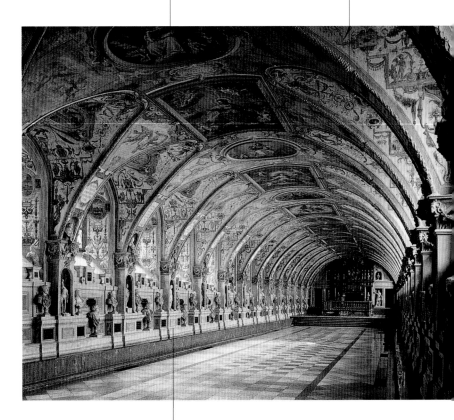

Along the lower section of the walls are lines of niches and bases to hold classical busts and statues, with a special taste for sculpture in mixed or colored marble.

▲ Friedrich Sustris (with the advice of Jacopo Strada), Hall of the Antiquarium in the Munich Residenz, built beginning in 1576.

The refined statuette shown in the foreground appears in other paintings by Lotto.

The development of aristocratic art collecting begins with the figure of the "antiquarian," a sophisticated art merchant in contact with international buyers. Alongside the traditional cities (Venice and Rome), new cities joined the field, such as Antwerp and London, where it was possible to find interesting natural and anthropological specimens from transoceanic explorations.

Among the objects shown by this antiquarian-collector are coins and fragments of both ancient and "modern" sculpture. Odoni was a wealthy Venetian merchant who amassed a varied and famous collection of antiquities, natural objects, and contemporary art.

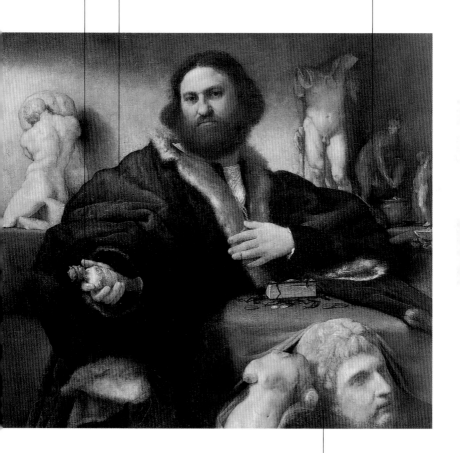

Classical statues and fragments are scattered everywhere.

▲ Lorenzo Lotto, *Portrait of Andrea Odoni*, 1527. Hampton Court, Royal Collection.

PLACES

◄ Hans Holbein the Younger, *The Ambassadors*, details of scientific and geographic instruments, 1533. London, National Gallery.

Northern and Central Europe and the Austrian Branch of the Holy Roman Empire

Over the course of the 16th century, northern and central Europe formed the heart of the Reformation. The historic and cultural geography of that region was dealt a series of tremendous shocks, whose impact would continue to reverberate into the following century. Austria, meanwhile, was at the center of the most significant phenomena affecting the development of art, serving as the capital of the Holy Roman Empire for two periods of time. The first period was under Maximilian of Habsburg, in a transitional phase between the late Gothic and humanism. The second period came after the middle of the 16th century and the separation of the Spanish and Austrian crowns dictated by Charles V. This took place in the stylistic context of international Mannerism, in which Prague—elevated to the rank of capital by Rudolf II—played a dominant role. In Germany's traditional polycentric structure, the economic and cultural axis shifted. The Baltic towns of the Hanseatic League and the river ports along the Rhine declined in importance, while the southern cities of Nuremberg, Augsburg, and Munich gained stature and influence. We may add Krakow, the thriving capital of Poland, to that latter list, considering its intense economic and artistic links with Germany. The aggressive expansionism of the Turks stalled the promising development of the Danube region. No less important, especially for the long term, was what was happening beyond the horizon. To the north, Scandinavia experienced a period of dynamic change, especially in the contentious relationship between Denmark and the ambitious kingdom of Sweden. To the east, the figure of Tsar Ivan the Terrible—controversial but hard to ignore—drew wary attention to the new power of Russia and Muscovy.

Scandinavian nations began to emerge as subjects in European history and art: the "prince of Denmark" that Shakespeare described late in the century began to seem less distant and exotic.

Scandinavia

A profound political development marked the early 16th century: the dissolution in 1523 of the Kalmar Union, a pact between Denmark, Sweden, and Norway that had held since 1397. An indirect cause of the rupture was the progressive weakening of the Hanseatic League, allowing new constellations of commercial and political power to develop in the Baltic region. The episode that triggered it, however, was the attempt by King Christian II of Denmark to establish Danish rule over Stockholm; among his tactics was to slaughter more than eighty Swedish noblemen (1520). The Swedish reaction, in which conversion to Lutheranism played a unifying role, brought Gustav I Vasa to the throne of Sweden (1523). A rapid expansion ensued, and indeed Sweden entered the 17th century as a new northern European Protestant power. Denmark reacted to Swedish independence by tightening its ties to Norway, where the Danish kings owned vast hunting preserves and built great homes. Scandinavian architecture long remained bound up with late-Gothic models and traditional local materials. One important development occurred in Denmark with the advent of Dutch models of construction, in which buildings featured brick alternating with stone and distinctive stepped gables.

1520: Gustav I Vasa leads the Swedish revolt against King Christian II of Denmark.
1523: Gustav is crowned king of Sweden. In Denmark, Christian II is overthrown.
1536: Christian III of Denmark declares Norway a Danish vassal; Norwegian resistance is quelled through the introduction of the Reformation and the expulsion of Archbishop Olaf Engelbrektsson.
1560: Death of Gustav I Vasa.
1561: Erik XIV, son of Gustav, forestalls the conquest of Tallinn by Ivan the Terrible, tsar of Russia.
1587–1607: Under King Sigismund (the grandson of Gustav I Vasa, who converted to Catholicism), an attempt is made to merge the crowns of Poland and Sweden.

◄ The Swedish royal castle of Gripsholm, built by Gustav I Vasa in 1537 on the shores of Lake Mälar (Sweden).

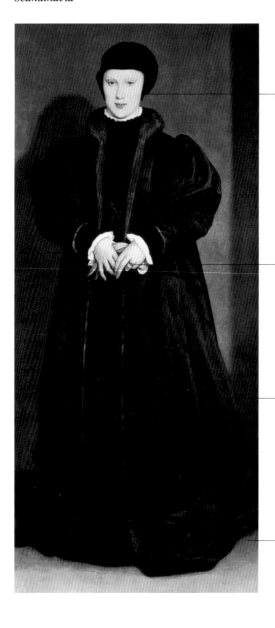

Following the death of his third wife, Jane Seymour (October 1537), Henry VIII considered marrying Christina of Denmark. For that reason, in March of 1538, he sent Holbein to Brussels, accompanied by a diplomat, to do a full-length portrait of his potential bride. She was sixteen years old at the time and still dressed in mourning.

The younger daughter of King Christian III of Denmark, she was just thirteen when she was widowed by the death of Francesco II Sforza, the duke of Milan. Christina was a princess renowned throughout Europe for her gentle temperament and her lovely hands; she was dubbed the "Splendor of Flanders."

She posed for just three hours. This very brief session was, however, long enough for Holbein to capture the girl's features, which he later transferred to a final, "most perfect" portrait of penetrating simplicity and power.

A marriage between the English king and the Danish princess could have brought about a new political landscape in northern Europe, but it was not to be: in 1540, Henry VIII married Anne of Cleves instead.

▲ Hans Holbein the Younger, *Christina of Denmark, Duchess of Milan*, 1538. London, National Gallery.

The minute and descriptive style of the painting, the work of a local master called Urban, still fits into the late-Gothic tradition.

In the subarctic night, the positions of the stars described mysterious circles. Celestial events of this sort were observed with morbid attention in the early 16th century, in a quest for arcane signs hinting at coming "revolutions" (to paraphrase the title of Copernicus's treatise).

▲ Urban the Painter (Urban Malår), *Astral Phenomena in the Sky over Stockholm*, 1537. Stockholm, cathedral.

This "bird's-eye" view depicts late-medieval Stockholm, clustered on its archipelago between Lake Mälar and the fjord to the sea, with some precision.

The princes of Muscovy united "All the Russias," a move that justified the title of "tsar" (Caesar) adopted in 1480 by Ivan III, whose wife was the niece of the last Byzantine emperor.

Moscow

In the reign of Vasily III, in the early 16th century, Moscow was dubbed the "third Rome," successor to Rome itself and to Byzantium; the title of tsar was consecrated by the Orthodox patriarch. Vasily's successor, Ivan IV, known as Ivan the Terrible, fashioned Russia into a new, aggressive power, whose influence on European politics was viewed with increasing concern by nations from Scandinavia to the Balkans. Ivan IV increased and consolidated the tsar's power with the bloody domination of ancient city-states (Kazan in 1552, Astrakhan in 1556, Novgorod in 1570) and the conquest of the entire Volga basin. His war against the Tatars, a historic thorn in Russia's side, was commemorated with the construction of the fanciful cathedral of Saint Basil. A symbol of Moscow but also of a Russian "national" style, the cathedral eschewed the Western style that had marked the 15th-century buildings of the Kremlin, some designed by Bolognese architect Aristotele Fioravanti. Icon painting continued with no major changes from medieval models. Ivan IV settled internal political issues in the country with brutal attacks on the major landowners, known as boyars. Expansion toward the Baltic Sea and Livonia, which was controlled by the Teutonic Order, was less successful. Ivan the Terrible tried repeatedly to win a Baltic port, but he was thwarted by the superior navies of Sweden, Poland, and Denmark, and the Hanseatic League.

► Icon with a portrait of Ivan the Terrible, ca. 1560. Copenhagen, Statens Museum for Kunst.

The central, tallest belfry features the distinctive decoration with tapered, stacked arcades that is so typical of Russian church architecture.

The differing heights of the domes over the chapels arranged around a central space created an effect of great variety, and yet the building's plan is fairly simple. It commemorates the military victories of Ivan the Terrible.

The gleaming polychrome decoration, which became a distinctive feature of Saint Basil's cathedral, is not original; it was added in the 17th century.

▲ Barma and Yakovlev Postnik, Saint Basil's cathedral, 1555–60. Moscow.

The covered staircases, with pavilions and arcades, enhance the overall spectacular appearance.

The Krakow of the Jagiellon kingdom was one of the most ambitious and magnificent courts in Europe, employing Italian sculptors, Flemish weavers, and German painters.

Krakow

The Jagiellon dynasty ruled the kingdom of Poland for nearly two centuries, from 1385 to 1572, establishing a de facto hereditary succession, despite the fact that the crown of Poland and Lithuania was nominally elective. During the 16th century, Poland's territory expanded to include eastern Prussia and parts of Lithuania, Byelorussia, and the Ukraine. Thus, a multilingual, multireligious Poland extended from the Baltic to the Dniester River. With the death of Sigismund II Augustus (1572), the Jagiellons died out but, after the brief reign of Henry of Anjou (later Henry III of France), King Stephen Báthory, prince of Transylvania, beat back Russian expansionism with a series of brilliant military campaigns. In Krakow, the prestigious university attracted intellectuals and witnessed the rise of Copernicus. The halls of the royal palace were decorated with a magnificent Flemish tapestries. The cathedral was enriched with chapels, sculptures, reliquaries, paintings, and bronze plaques. Hermann Vischer, the most skillful of Peter Vischer's sons, and Hans Dürer, brother of the great Albrecht, both

came to this city. Nevertheless, most noteworthy was the monumental sculpture. After Veit Stoss went back to Nuremberg, the Tuscan sculptors Francesco Fiorentino and Bartolomeo Berrecci were summoned to Krakow. They embellished the cathedral with some of the most magnificent examples of Renaissance sculpture outside of Italy.

In 1574, the sarcophagus was moved and retouched by another Italian sculptor, Santi Gucci, so that the tomb of King Sigismund II Augustus could also be placed in the chapel.

The Sigismund Chapel in the Krakow cathedral is considered one of the absolute masterpieces of the Italian-influenced Renaissance north of the Alps.

The statue, carved in red marble, depicts the king asleep, in a pose that suggests he is about to awaken and rise up.

Although the figure is dressed in a complete suit of heavy armor, in keeping with the Gothic tradition, the sculpture presents the stylistic features of the Italian Renaissance. In all likelihood, it was done by Bartolomeo Berrecci, perhaps with the assistance of Giovanni Maria Padovano, both of whom had moved permanently to Krakow.

◄ Original binding of Copernicus's treatise *De revolutionibus orbium coelestium*, edition published in Krakow in 1551. Krakow, Czartoryski Library.

▲ Bartolomeo Berrecci, *Reclining Statue of King Sigismund I Jagiellon*, 1529–31. Krakow, cathedral, Sigismund Chapel.

The naturalistic details of the smaller tapestries offer an extraordinary botanical and zoological repertory.

Note the magnificent panels with landscapes and animals, woven around 1560 in the Brussels workshops of Nikolaus Leyniers and Jan van Tiegen, to cartoons executed in Antwerp by masters from the workshop of Pieter van Aelst.

▲ Hall of the Senators, or Throne Room, Royal Palace, Wawel, Krakow.

The main scenes, some eight meters across, are absolute masterpieces from the looms of Brussels, and especially from the workshop of the Kempener family. The large Bible stories—here we see the animals boarding the Ark (left) and the Flood (right)—are based on drawings by Michiel Coxie.

The Royal Palace, built on the Wawel hill near the Krakow cathedral, was given a Renaissance appearance at the behest of King Sigismund I Jagiellon, first through the work done by Francesco Fiorentino (1506), later by Benedikt of Sandomierz, and finally by Bartolomeo Berrecci (1533).

The sequence of the eight large tapestries with Bible stories on the walls of the Hall of the Senators follows a description dating from 1533. The tapestries were woven specially for this castle, and their size is scaled to the walls they adorn. The colorful coffered ceilings add to the intense beauty of the hall.

The appearance of this hall and the others in the palace is defined by the remarkable collection of Brussels tapestries commissioned by Sigismund I.

*With Emperor Rudolf II, Prague became at the end of the century
the most brilliant center in north-central Europe for the creation
of images in the international Mannerist style.*

Prague

The century began in the tradition of the boldest Flamboyant
Gothic, with the rebuilding of Prague Castle by architect Benedikt
Ried. In other parts of the kingdom (such as Kutná Hora and
Brno), the early 16th century saw the final, fanciful blooming of the
Gothic. From 1516, the kingdom of Bohemia entered into the politi-
cal orbit of the Habsburgs, but Prague always remained secondary
to Vienna. Italian Renaissance models gradually replaced the
Gothic style. Then, in 1583, Emperor Rudolf II of Habsburg made
the surprising decision to move the capital of the Holy Roman
Empire from Vienna to Prague. In a rich cultural milieu that
included the cabalist Rabbi Löw ben Bezulel and the Golem,
Rudolf acquired fabulous treasures, bizarre objects, exquisite art-
works, rare natural specimens, masterpieces of goldwork, lathe-
work, and intaglio, stupefying and exotic creations. A cohesive
school sprang up around Rudolf's court, including masters from
various lands, such as Joseph Heintz from Basel, the German Hans
von Aachen, the Italian Giuseppe Arcimboldi, the Dutch de Vries,
and Spranger from Antwerp. All had Italian experience, and their
work was marked by openly erotic subjects and a fascinating, sen-
sual style. The school carried on even after the death of the emperor
and was not interrupted
until 1618, when the
start of the Thirty Years'
War was marked by the
Defenestration of
Prague. The war brought
about the Swedish sack
of the city and its disper-
sion of the collections.

▶ View of the Vladislav
Hall in Prague Castle, with
ceiling vaults designed by
Benedikt Ried, in a 1607
painting now in the Prague
Museum of Decorative Arts.

The determined gaze, seeking out a
high, distant horizon, accentuates the
impression of energy and power,
enhanced by the slight rotated pose
of the bust.

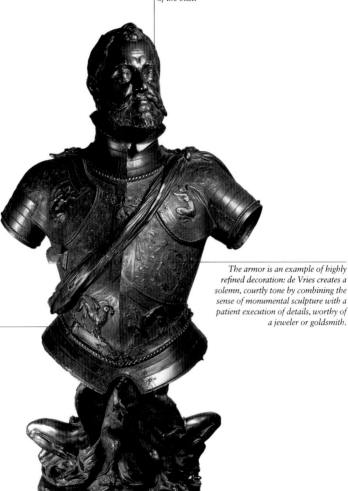

The diffusion of
portrait-busts is a
distinct characteristic
of the Habsburg
Empire, in part as a
way of multiplying
the "presence" of the
emperor in various
territories.

The armor is an example of highly
refined decoration: de Vries creates a
solemn, courtly tone by combining the
sense of monumental sculpture with a
patient execution of details, worthy of
a jeweler or goldsmith.

The base of the statue, with the
unusual support of nude figures,
harks back to an analogous device
utilized by Leone Leoni for a bust of
Charles V. Rudolf II purchased this
bust in 1600 and certainly offered it
to de Vries as a model.

▲ Adriaen de Vries, *Bust of Rudolf II*,
1603. Vienna, Kunsthistorisches
Museum.

Athena's coy gaze and her
unusual pose can be explained
by the sensual tastes evident in
Rudolf II's commissions.

Spranger, who came to Prague
after doing important work in
Italy, was one of the chief
Mannerist figures in Bohemia.

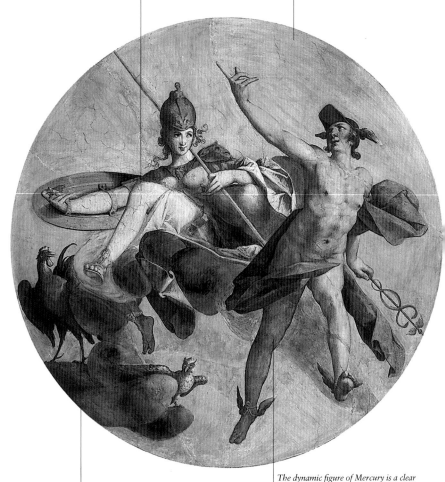

The rooster and the owl, animals
that symbolized the two gods, add
an enjoyable note of naturalism.

The dynamic figure of Mercury is a clear
reference to Giambologna's celebrated
bronze (page 298), known widely from
numerous copies and on its way to
becoming a sort of canonic point of
reference in late Mannerism.

▲ Bartholomaeus Spranger, *Athena
and Mercury*, ca. 1585. Prague
Castle, White Tower.

▶ Albrecht Dürer, *Portrait
of Jakob Fugger, the "Rich,"*
1518–20 Augsburg, Staatsgalerie.

Augsburg entered onto the political and artistic scene with the discovery of silver deposits, the commercial banking dynasty of the Fuggers, and a number of innovative civic initiatives.

Augsburg

Ruled politically by the dukes of the Wittelsbach dynasty, Augsburg was one of the most dynamic cities of 16th-century Europe. Crucial to its prosperity was the Fugger banking family. Jakob Fugger, "the Rich," was responsible for the construction, beginning in 1514, of the Fuggerei, a residential quarter meant to house the poor, while the family chapel, in the church of Saint Anne, marked the introduction into Germany of classical and Italian-style architectural and artistic elements (1509–12), along with the paintings of Hans Holbein the Elder and Hans Burgkmair. In 1518, one year after the posting of the Ninety-five Theses, Jakob Fugger encouraged the opening in Augsburg of a Diet of Conciliation between Luther, Emperor Maximilian, and the Dominican friar Tetzel. Dürer also attended these historic sessions and made portraits of several of the participants. The diet was a failure in religious terms, but from that point forward Augsburg became the site of high-level political meetings. In 1530, Melanchthon presented the theological statement known as the Augsburg Confession. It was there that the 1555 peace was signed between Catholics and Protestants. Among the city's artistic products were outstanding, precision-made objects, jewelry and goldwork, and small altars made of ebony and silver. The century ended in the Mannerist style, with bronze fountains by Adriaen de Vries and buildings by Elias Holl and Joseph Heintz.

1515: The Fuggers are authorized to sell indulgences.
1518: Diet of Augsburg, organized by Jakob Fugger in an attempt to reconcile Luther and the church hierarchy. Maximilian I and Albrecht Dürer also attend.
1519: Two great banking families, the Fuggers and the Welsers, finance the election of Charles V as emperor.
1530: Melanchthon publishes the Augsburg Confession.
1540: Stock exchange established in Augsburg.
1548: Augsburg Interim, with a number of concessions by Charles V to the Protestant princes.
1551: Charles V returns to Augsburg, this time with artist-ambassador Titian.
1555: Declaration of the Peace of Augsburg and the end of the Wars of Religion in Germany.
1558: Philippine Welser marries Count Ferdinand II of the Tirol.
1560: Death of Anton Fugger and ensuing decline of the dynasty.

Painted just after Titian's arrival in Augsburg, this painting commemorates Charles V's victory at Mühlberg, a decisive battle in the war against the German princes who had formed the Protestant Schmalkaldic League.

Encased in his glowing armor, Charles V is indifferent as the restless horse tosses its head, shaking the reddish saddlecloth. He appears as a solitary hero, at the threshold of a landscape that extends out into the distant horizon.

Charles V had summoned Titian to be near him during the decisive days of the peace negotiations. He had provided the painter with an apartment adjoining his own, with direct access.

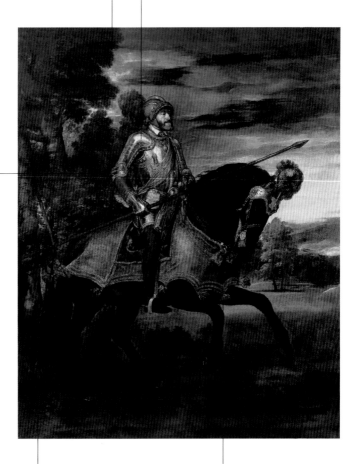

Titian set this portrait at nightfall. Charles V's physical frailty is redeemed by his absolute determination of will. Similarly, the passing hours of the dying day are transformed into the promise of immortality in the pages of history.

The painting suffered damage during a fire that destroyed the Madrid Alcazar in 1734, but the glory of the victorious condottiere—the illustrious and unrivaled prototype of numerous equestrian portraits, from Rubens, Van Dyck, and Rembrandt to Velázquez, David, and Manet—is undimmed.

▲ Titian, *Equestrian Portrait of Charles V at the Battle of Mühlberg*, 1548. Madrid, Prado.

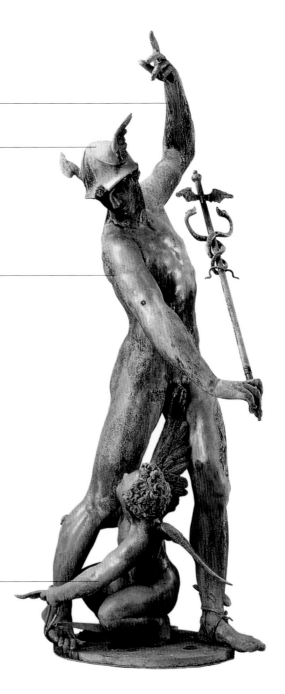

The raised arm reveals de Vries's attention to the canonical model of Mercury by his master, Giambologna (page 298).

Mercury is the patron deity of commerce. In a bourgeois, mercantile city like the wealthy Augsburg in the 16th century, the symbolic meaning of a tribute to the god would have been evident.

Intended for one of the city's fountains, the statue is an exceedingly elegant example of late-Renaissance art. The casting, based on a model by de Vries, was done by Wolfgang Neidhart.

The little Cupid lacing the god's winged sandals is turning his body in one direction while the main figure turns in the other, thus conveying the impression of circular motion in the entire group.

▶ Adriaen de Vries, *Mercury and Cupid*, formerly a sculptural group in the fountain of Moritzplatz in Augsburg, 1596–99. Augsburg, Städtische Kunstsammlungen.

In Dürer's time, Nuremberg was the leading city for German art; its active printing industry complemented a brilliant school of sculpture, goldwork, painting, and engraving.

Nuremberg

Albrecht Dürer was emblematic of the artistic culture of Nuremberg in the early 16th century, the epitome of the refined cultural and publishing milieu of one of the most intellectually advanced cities in Europe. Nuremberg had a flourishing international merchant class, eager to appreciate the new ideas of humanism. The city's artistic heritage was rapidly enriched, thanks to the work of the sculptural workshops of Veit Stoss and Peter Vischer; the former specialized in fine carving in wood, the latter in casting monumental bronze. With the coming of the Reformation, the German Renaissance took a detour, only to resume a few decades later in a new form: elaborate, exquisite, aristocratic, and at the service of the capricious princely collectors of the late 16th century. In the 1500s, Nuremberg was an advanced center for the production of goldwork. Exported throughout Europe, its products were prized, both for their high artistic quality and for their technical mastery. Particularly sought after were clocks, mechanical automata, musical instruments, and precision equipment for navigation and astronomy. Over the course of the century, this leadership shifted to Augsburg, which would become the capital of silverwork between the 16th and 17th centuries. Even so, Nuremberg could still rely, even during Mannerism, on its reputation in the field of goldwork, thanks especially to Wenzel Jamnitzer.

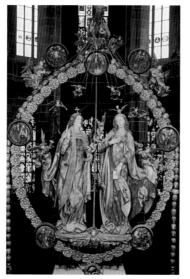

▶ Veit Stoss, *Angelic Salutation,* 1517–19. Nuremberg, Lorenzkirche.

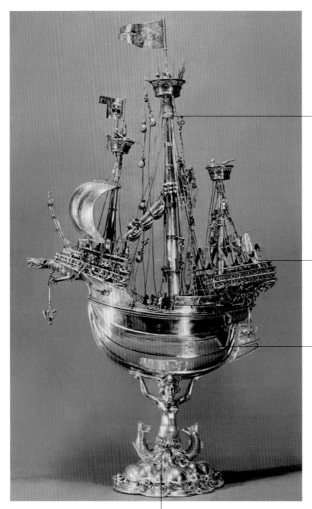

Fashioned in solid silver, standing nearly eighty centimeters tall, this ship weighs approximately six kilograms.

Aboard the ship is a crew of no fewer than seventy-four tiny sailors, proof of the virtuosity of Nuremberg's gold- and silversmiths.

Following a custom established in the 14th century, these objects were used at table as sumptuous centerpieces.

▲ Goldsmith of Nuremberg, *The Schlüsselfelder Ship*, 1503. Nuremberg, Germanisches Nationalmuseum.

A mermaid emerging from the waves serves as a base for the ship.

Wolgemut, one of the finest painters in late-15th-century Nuremberg, was Dürer's teacher from 1483 to 1486.

The first part of the German inscription reads: "Albrecht Dürer portrayed from life his master Michael Wolgemut in the year 1516." Without a break, Dürer resumed three years later: "and he was 82 years old, and he lived until the year 1519, when he died on Saint Andrew's Day, before sunset."

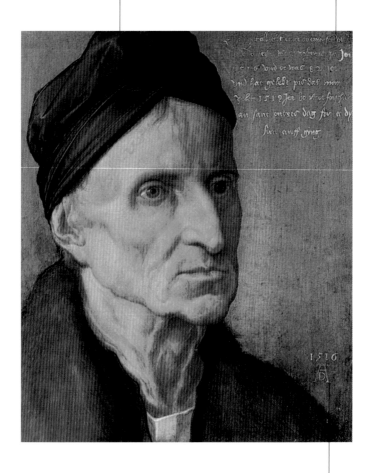

▲ Albrecht Dürer, *Portrait of the Painter Michael Wolgemut*, 1516. Nuremberg, Germanisches Nationalmuseum.

The inscription that Dürer placed on the portrait confirms the devotion of the pupil—by this point a renowned figure on the international artistic stage—to his elderly teacher. More than thirty years after his apprenticeship had ended, Dürer still referred to Wolgemut as "Lermeister" (master, teacher).

This painting forms a pair with a similar portrait of Hieronymus Holzschuher, a senior member of the Nuremberg town council; the other portrait has the same distinctive light-blue background.

Dürer explores the subject's features and soul with exacting penetration, producing with vivid immediacy the thoughtful intelligence and lonely decision making of a politician.

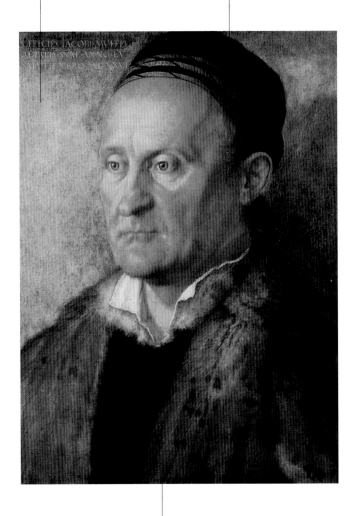

Muffel held the office of burgomaster of Nuremberg during the difficult times of the town's transition to Lutheranism. Dürer admired his qualities of caution and moderation.

▲ Albrecht Dürer, *Portrait of Jakob Muffel, Burgomaster of Nuremberg,* 1526. Berlin, Gemäldegalerie.

The 16th century saw the rise and consolidation of a new capital, Munich, home to the Wittelsbachs and one of the first cities in Europe to accept the sophisticated forms of Mannerism.

Bavaria

A Catholic stronghold in Germany, Bavaria carved out a space for itself in the political and cultural geography of 16th-century Europe. In the early decades, however, the capital city, Munich, was certainly not the most active Bavarian center. Nuremberg and Augsburg, as well as the small fortified towns of Nördlingen and Rothenburg (where the great sculptor Riemenschneider worked) or Regensburg and Passau on the Danube, were much more dynamic artistic centers. After 1550, the Munich court entered a particularly active period. The power behind the most important artistic initiatives was Duke Albert V, a great collector of paintings, antiquities, goldwork, and exotic curios; he ultimately assembled a renowned *Wunderkammer*. In 1569, work began on the Antiquarium in the Munich Residenz, a magnificent hall of Italian Mannerist inspiration, created under the supervision of the Dutch designer Friedrich Sustris. A short while later, the bizarre grotto courtyard was built, in accordance with the latest ideas on the relationship between art and nature, while a bronze statue of the Virgin Mary, the patron saint of Bavaria, was installed on the facade of the palace. The construction of the monumental Michaelskirche, with the adjoining oratory of a Marian congregation, further underscored the loyalty of the city—and the region—to Catholicism, as well as confirming its fealty to late Renaissance architectural and decorative styles.

► Workshop of a Bavarian goldsmith, reliquary statuette of Saint George, in gold, with enamels, rubies, emeralds, agate, and chalcedony, 1586–97. Munich, Treasury of the Residenz.

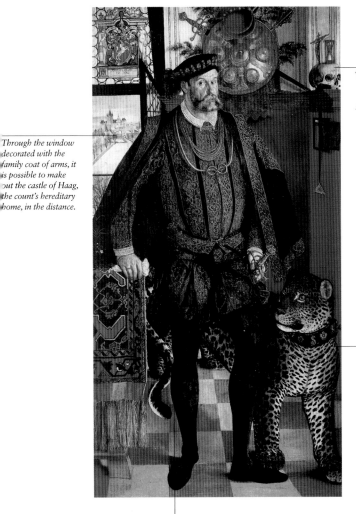

The crucifix, the hour-glass, and the skull with an admonitory inscription all point to the ephemeral nature of earthly glory.

Through the window decorated with the family coat of arms, it is possible to make out the castle of Haag, the count's hereditary home, in the distance.

The exotic leopard is not a symbolic addition, but an authentic detail. Count Ladislaus was given the animal in Ferrara in 1556, as a wedding gift in honor of his marriage to Emilia Roverella, a relative of the ducal house of Este.

The elegant, imposing, and, at the same time, apprehensive figure of the count is a metaphor for the crisis of the small local seigniories. It was in that same year, 1557, that the earldom of Haag was incorporated into the duchy of Bavaria, and Ladislaus, after having been placed under arrest by Duke Albert V, regained his freedom, but at the cost of a sizable ransom.

▲ Hans Müelich, *Portrait of Ladislaus von Frauenberg, Count of Haag*, 1557. Vienna, Collection of the Princes of Liechtenstein.

The overall design is the work of Friedrich Sustris, court architect to the dukes of Bavaria, also active in the "antique-style" redecoration of the Residenz.

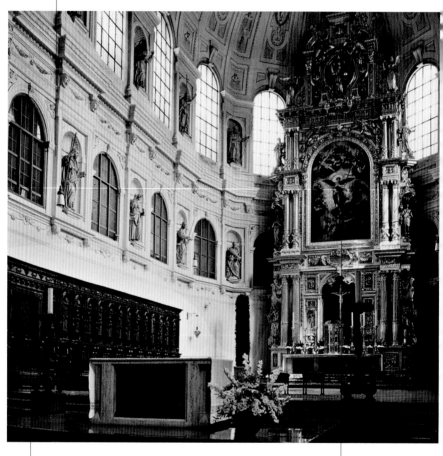

The choir of the Michaelskirche is the earliest piece of sacred architecture in the northern Mannerist style, featuring the use of stuccoes as well.

The main altar marks the definitive transition from the traditional paneled structure to that of a monumental carved "machine," verging on the Baroque. The altarpiece, with the archangel Michael defeating the devil, is by Christoph Schwarz.

▲ Friedrich Sustris, Interior of the Michaelskirche, consecrated in 1597. Munich.

▶ Urs Graf, *Battle Scene*, 1521. Basel, Kunstmuseum, drawings collection.

In the Rhineland of the 16th century we find a complex, multifaceted administrative and artistic setting that produced both remarkable masterpieces and powerful religious tensions.

Rhine Basin

Between 1510 and 1520, southern German art blossomed, especially in the regions of Franconia, the Rhineland (including Alsace), and the Black Forest, in an area extending from Cologne to Basel. At work were such masters as Dürer, Altdorfer, Baldung Grien, Grünewald, and Holbein the Younger. Clients and the public at large now favored polyptychs that were entirely painted over the more traditional carved wooden altars. A notable example is the enormous complex painted by Matthias Grünewald for the monastery of Isenheim in Alsace, which the painter infused with his tumultuous, dramatic expressivity, nearly causing the visitor to overlook the shrine carved by Nikolaus Hagenauer. On the other hand, commercial traffic on the great river dropped off dramatically, edged out by the burgeoning maritime mercantile powers, which led to the decline of cities like Cologne. The Rhineland was riven by the Reformation: the powerful archbishop of Mainz, Albert Cardinal of Brandenburg, was turning his interests and commissions elsewhere, forcing many artists to seek new lines of work. In the mid-16th century, the cities along the middle course of the Rhine began to fade, and the fragmented German political system would clash with the superior might of the great nation-states.

1507: A council assembled at Saint-Dié, in Alsace, decides to name the New World "America," in honor of Vespucci.
1512: Work begins on both Grünewald's polyptych for Isenheim and Baldung Grien's for Freiburg.
1519: Zwingli begins preaching in Switzerland.
1521: Diet of Worms: Luther is outlawed and takes refuge in Saxony.
1527: The University of Marburg is founded. Two years later, Lutheran and Swiss reformers meet there.
1528: The Reformation spreads to Basel and Strasbourg.
1529: The princes meeting in the Diet of Speyer take the name of "Protestants."
1531: Zwingli dies in the Battle of Kappel.
1535: The attempt of the Anabaptists to form a commune in Münster is crushed.
1541: The Diet of Regensburg, an attempt at religious and political compromise, fails.

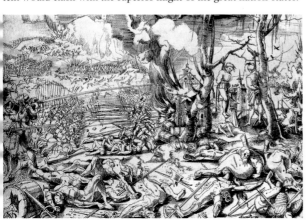

A marvelous halo of light radiates from the transfigured and luminous face of Christ. This panel formed part of the pictorial complex executed by Grünewald for the shrine that Nikolaus Hagenauer carved for the Antonite monastery of Isenheim.

The wings were opened or closed according to the religious calendar and the cycles of the liturgical year.

Christ's white shroud is magically transformed into a colored vortex, which seems to absorb the rainbow of the new covenant created between God and men by the resurrection of Christ.

The soldiers standing guard around the tomb seem to tumble to the ground, overwhelmed by the blinding light.

▲ Matthias Grünewald, *The Resurrection of Christ*, panel from the Isenheim polyptych, 1516. Colmar (France), Musée d'Unterlinden.

Over time, the altar's superstructure and many of the minor figures carved by Hagenauer have been lost or dispersed, but the main shrine sculptures and Grünewald's paintings are intact (see pages 310–11).

The monumental female nude fit stylistically between the Italian style of the early 16th century and the debut of the school of Fontainebleau, at the very beginning of international Mannerism.

Bartholomaeus (or Bartel, for short) Bruyn was the leading figure of the Cologne school in the mid-16th century. The fortunes of the great city on the Rhine had fallen from the previous century, and the art community there suffered as well.

The landscape in the background shows the influence of Leonardo da Vinci, perhaps via the mediation of Joos van Cleve, with whom Bruyn was in contact.

Despite the idealized pose, this is certainly a portrait of a real person, although the woman has not yet been identified.

▲ Bartholomaeus Bruyn the Elder, *Bust of a Young Woman*, ca. 1535. Nuremberg, Germanisches Nationalmuseum.

One sign of torture, the crown of thorns, is still attached to Christ's head.

The prominent coat of arms is a reference to Albert Cardinal of Brandenburg, one of the most important figures in German cultural, religious, and political life during the Reformation. He was a client of Grünewald's both in the Rhineland and in the eastern fief of Halle.

The half-open mouth, the eyes rolling up out of sight, the slack jaw: the face of Christ is the terrifying and all-too-human image of a corpse in which the process of decomposition is already beginning to show its effects.

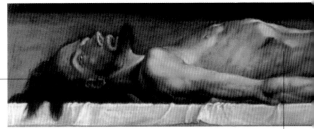

▲ Top: Matthias Grünewald, *Dead Christ*, 1523–25. Aschaffenburg, collegiate church.

▲ Bottom: Hans Holbein the Younger, *Dead Christ*, 1521. Basel, Kunstmuseum.

The chest and the belly, emaciated and apparently emptied out, with the mottled skin stretched over the bones, add a further element of anguish to the image, in which it is possible to sense the growing religious tension that was shaking central Europe.

Many small wounds—on the shoulders, chest, and legs—can be seen on Christ's body, just taken down from the cross.

The deep wounds in the feet are characteristic of Grünewald's heartbreaking interpretation of Christ's torture and execution.

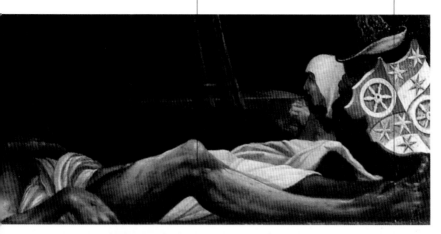

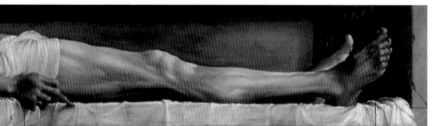

The bluish bruising around the wounds is a macabre detail, a piece of merciless realism. We do not know for whom the painting was originally done; it is a masterpiece from Holbein's time in Basel.

The niche in which Christ has been laid is without question a burial vault.

Turkish conquests in the Balkans made the Danube into a symbolic river dividing East and West. Along its banks, a distinctive artistic culture developed, full of allure and passion.

Danube Region

In 1501 Maximilian of Habsburg founded the University of Vienna and invited Italian intellectuals and humanists to come teach there. We find an interesting similarity between the painting and the poetry of the period, both taking inspiration from nature. The court poet, Conradus Celtis, rector of the university, wrote about the countryside with expressions that seem like descriptions of paintings by the masters of the Danube school. This style of painting, found in Passau, Regensburg, and Vienna, celebrated the enchanting magic of the wooded landscape. Architecture and sculpture remained tied to Gothic models, as demonstrated by Anton Pilgram's pulpit in the Vienna cathedral (1510) and the plentiful spread of hall churches, with reticulated ceilings. The Danube school painters (Albrecht Altdorfer, Wolf Huber, and Lucas Cranach the Elder) evoke a strange, suggestive natural atmosphere, with characters in odd clothing, miniaturistic details, light brushwork, and highly original and occasionally humorous compositions. In some instances, nature itself, depicted in its harshest, most savage aspects, becomes the protagonist of the paintings. Over the course of the 16th century, the Danube region

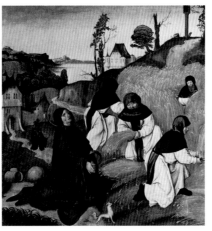

became a borderland between Western Christendom and the aggressive Ottoman Empire. After the mid-century, with the division of the Habsburg Empire, the classical models of the Italian Renaissance were widely diffused. An excellent example is the loggiaed municipal buildings in Graz (Austria).

The painting is not a depiction of a real landscape painted from life, but seems to be an amalgamation of various details studied from life and later reworked in the studio.

The density of the foliage is obtained through repeated layering of color. Altdorfer is perhaps the first artist to develop the landscape as an autonomous subject, not only in drawings or watercolors (as Leonardo and Dürer had done), but in painting as well.

The palpable presence of nature, the combination of rocks, towering trees, and water, evoke the Danube between Regensburg, Passau, and Vienna, the area where the Danube school of painting had taken root.

This is one of the first examples of an independent landscape, no longer "justified" through the inclusion of events or figures.

◀ Jörg Breu, *Saint Bernard at the Corn Harvest*, 1500. Zwettl (Austria), Cistercian Abbey, picture gallery.

▲ Albrecht Altdorfer, *Landscape with a Footbridge*, 1518–20. London, National Gallery.

Innsbruck was the capital of the small but ambitious court of Maximilian I of Habsburg, where the chivalrous Gothic age continued to reverberate in concert with the many new humanist ideas.

Innsbruck

Maximilian I was learned, elegant, steeped in humanism, bound to Italy by ties of marriage (his second wife was Bianca Maria Sforza, niece of Ludovico il Moro), and in no way intimidated by the growth of other European powers. He sought to give a fresh face to his new Alpine empire, to which he annexed Gorizia and Trieste. In his court at Innsbruck, he undertook innovative artistic projects, ranging from series of commemorative engravings to colossal bronze statues meant to adorn his tomb. He hired the greatest German artists of his time: Dürer, Altdorfer, Cranach, Burgkmair, and the sculptor Peter Vischer. Among the other cultural figures, we should mention poet Conradus Celtis, geographer Konrad Peutinger, astronomer Erhard Etzlaub, and humanist Willibald Pirkheimer, a close friend of Dürer's. The death of the emperor in 1519 and Charles V's shift in the orientation of the empire led to a sharp decline in the Tirol's fortunes, even though work on Maximilian's cenotaph continued for decades. The Tirol enjoyed a revival toward the end of the century. In 1564, Archduke Ferdinand II of Habsburg inherited the title of Count of Tirol and moved to Innsbruck. At the old castle of Ambras, he constructed

buildings to house his collections, including, among other things, 34,700 kilograms of armor, family portraits, and especially the artistic and natural curiosities of his *Wunderkammer*, one of the richest of its kind in Europe.

▶ Jorg Kolderer, *The Inner Courtyard of the Arsenal at Innsbruck*, ca. 1507. Vienna, Österreichische Bibliothek.

The symbolic monument to the court of Maximilian of Habsburg is a covered loggia, late Gothic in structure, which overlooks the main square of Innsbruck.

The name "Golden Roof" comes from the gilded copper roof tiles, which number more than two thousand.

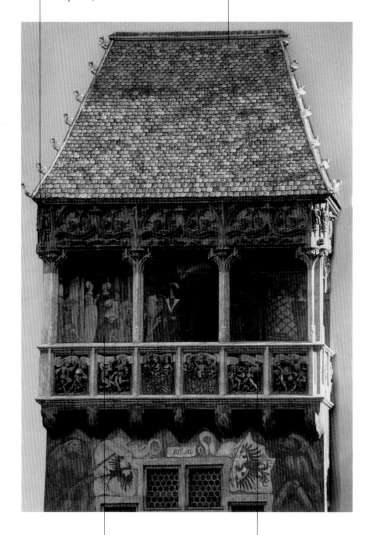

▲ Nicolas Türing, *Golden Roof* ("Goldenes Dachl"), 1507. Innsbruck.

The interior frescoes depict court ladies and dignitaries. Below, knights in armor wave two eagle standards: black for the empire and red for the province of Tirol.

The carved balustrade features dynamic and fanciful figures of dancers.

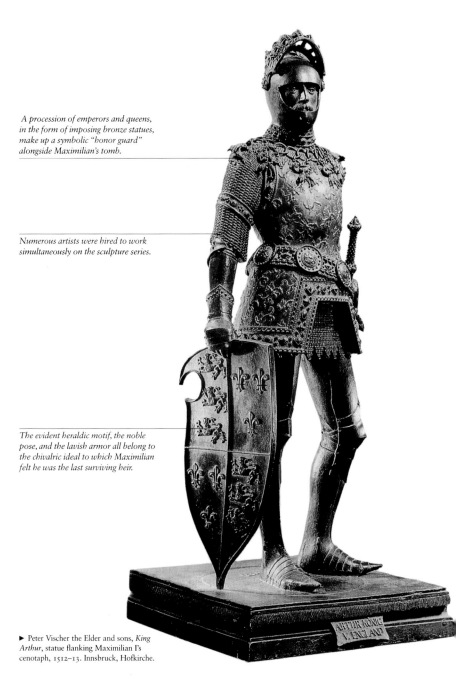

A procession of emperors and queens, in the form of imposing bronze statues, make up a symbolic "honor guard" alongside Maximilian's tomb.

Numerous artists were hired to work simultaneously on the sculpture series.

The evident heraldic motif, the noble pose, and the lavish armor all belong to the chivalric ideal to which Maximilian felt he was the last surviving heir.

▶ Peter Vischer the Elder and sons, *King Arthur*, statue flanking Maximilian I's cenotaph, 1512–13. Innsbruck, Hofkirche.

The sober and refined wooden ceiling was executed by the court cabinetmaker, Conrad Gottlieb (1571).

The pairs of stag horns, set high on the walls, remind us that we are in a country castle, surrounded by forests, and not in a city residence.

Along the walls are the portraits of twenty-seven counts, dukes, and princes of the Tirol, done by the Italian Giovanni Battista Fontana.

With this large hall, the old castle took on the character of a late-Renaissance princely residence. It was also endowed with a magnificent Wunderkammer.

We do not know why this hall—now used for exhibitions and concerts—was dubbed "Spanish." Actually, the style is rather Italian, or at any rate in line with international Mannerism.

▲ The "Spanish Hall" in the castle of Ambras, near Innsbruck.

The Habsburg
Empire–Spanish Branch

The year 1492 was decisive in Spanish history, not only because Christopher Columbus first set foot in the New World, much of which would soon become an Iberian colony, but also because the nation was united under the "Catholic Kings" following the defeat of the Moorish kingdom of Granada. The dynastic succession of the Habsburgs brought Charles V to the Spanish throne, and before long onto the imperial throne as well. Charles was a central figure for the first half of the 16th century. Spain, engaged in the conquest of the Americas and the restoration of its national unity, was at the periphery of Charles's interests, and the country continued on its path in the stylistic transition from late Gothic to High Renaissance. In the second half of the century, during the reign of Philip II, strict Counter-Reformation motifs began to creep in, along with El Greco's final blaze of glory. The situation in other western and Mediterranean areas of the empire was quite different. In Flanders, the era of mercantile cities (Ghent, Bruges) was ending, while the most vital period was just beginning for Antwerp, destined to become the Holy Roman Empire's most important Atlantic port and the site of a magnificent school of art. Religious controversies and rebellions in favor of independence divided the Netherlands until the end of the 16th century. Spanish repression was successful in Flanders, but not in the United Provinces to the north. Led by William of Orange, the young Dutch nation stepped onto the stage of history as a new, unforeseen power. In the southern quadrant, the former duchy of Milan was unquestionably one of the important venues for the international artistic and religious debate.

In order to underscore the size of his empire, Charles V chose the Pillars of Hercules as his symbol, along with the motto "Plus ultra": Spain became the hub of an intercontinental territory.

Castile

For centuries the monarchs of Europe had dreamed of leading a "renaissance," or rebirth, of the Roman Empire, though with expansion limited to Europe and the Mediterranean. Charles V of Habsburg (to the Spaniards, "Carlos Primero"), taking the place of his uncle Maximilian I in 1519, ruled over an empire "upon which the sun never set," starting with a major section of Europe (the crowns of Aragon, Castile, Austria, and Burgundy) and extending to encompass the new American colonies. Born in Ghent and profoundly middle European, Charles V never established a permanent residence in Spain. The lack of continuity in the royal commissions helps to explain why an independent Spanish school of art failed to develop. After lingering lovingly over the lengthy decline of the late-Gothic style during the Renaissance, Spanish art remained in thrall to foreign, primarily Italian, influences, and Charles V chose Titian as his personal painter. Castile was still the center of royal power, however: Valladolid was its capital, and the heir to the throne, Philip II, was born there. Toledo was the chief city and the emperor's favorite residence. Segovia built the last Gothic cathedral, while Salamanca nurtured a world-class university. In 1561, Madrid became the new capital. After the division of the empire ordered by Charles V in 1556, Spain remained a great colonial power, but one that Philip II—who, unlike his father, was deeply Spanish—barely managed to run and organize. The disastrous folly of pitting the giant galleons of the Spanish Armada against the speedy English ships (1588) symbolized a lumbering state apparatus, incapable of keeping up with the dynamics of the new era.

1512: Navarre is joined to the Spanish crown.
1516: Charles of Habsburg, the future emperor Charles V, becomes king of Spain with the name Charles I.
1519: Hernán Cortés begins the conquest of Mexico.
1520–21: Revolt of the Castilian cities.
1527: The future Philip II is born in Valladolid.
1533: Pizarro murders Atahuallpa, king of the Incas, and consolidates his conquest of Peru.
1556: Charles V abdicates, leaving the kingdom of Spain to his son Philip II.
1559: Peace between Spain and France with the treaty of Cateau-Cambrésis.
1561: Philip II establishes the capital at Madrid.
1571: Battle of Lepanto.
1588: The English fleet defeats the Spanish Armada.
1598: Philip II dies.
1600: Philip III moves the capital to Valladolid.

◀ Pompeo Leoni, *Portrait of Philip II* (head), painted silver, ca. 1556; Balthasar Ferdinand Moll (bust), polychrome terracotta, 1753. Vienna, Kunsthistorisches Museum.

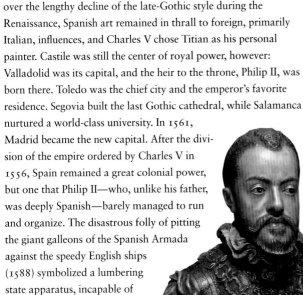

The large frescoes with scenes of the
Passion of the Christ, clearly of
Italian inspiration, are the work of
Juan de Borgoña.

The carved ceiling is a magnificent
piece of Mudéjar art, influenced by
Moorish style.

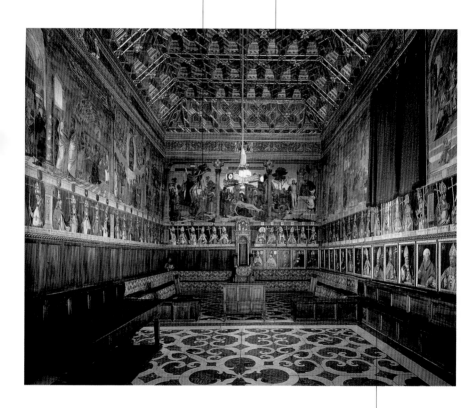

Above the benches is a series of portraits
of the archbishops of Toledo.

▲ Sacristy of the Toledo cathedral, with
frescoes by Juan de Borgoña, 1514.

The saint's intense, pathetic expression is achieved in part through the insertion of glass eyes. The unshaven whiskers are a detail of strong, convincing realism.

The Christ child assumes the classical contrapposto pose: an exquisitely up-to-date stylistic detail, and yet in this work, completely grounded in the Renaissance, we can detect reminders of late-Gothic sculpture.

Saint Anthony's powerful hand emerges from the drapery of his habit and holds a book, upon which the Christ child stands.

Juan de Juni, the greatest Spanish sculptor of the mid-16th century, was a connoisseur of the combination of various arts. Thus, this splendid carving is covered with a rich polychrome and gilding.

The point of support and equilibrium for the entire group is the tree stump upon which Saint Anthony rests his knee.

▲ Juan de Juni, *Saint Anthony with the Christ Child*, ca. 1555. Valladolid, Museo Nacional de Escultura.

The stormy sky, crackling with electricity, lowering clouds, and startling flashes of light, gives this canvas an unforgettable expressive quality: a real landscape becomes mysteriously evocative.

The ring of walls (the famous cigaralles) separates Toledo from a savage landscape.

The historic city, which houses many of the Spanish kingdom's most venerable memories, seems to be crouching on the hilltop: the large buildings, such as the cathedral and the castle, appear as phosphorescent silhouettes.

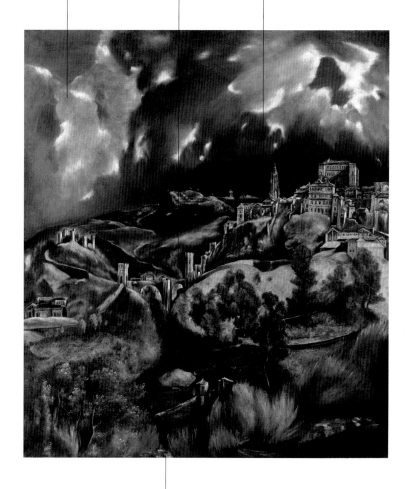

Clearly recognizable is the deep valley of the Tagus River, spanned by the Alcántara Bridge, which creates a sort of natural moat around the city.

▲ El Greco, *View of Toledo*, ca. 1597. New York, Metropolitan Museum.

*ts austere masses of granite and slate, tall, smooth walls perfo-
rated by 2,600 windows, corner towers, and grid plan express the
desire of its founder, Philip II, for greater security.*

El Escorial

Philip II mirrored himself in El Escorial, the monastery he built
between 1563 and 1584, though the work of decorating it contin-
ued for many decades, with a major cohort of Italian artists. The
monument commemorated a victory against the French, the Battle
of San Quintín, on August 10, 1557, Saint Lawrence's Day. In
honor of the saint, El Escorial was built on a plan that imitated the
grill upon which he was tortured: the 16 courtyards were arranged
in a checkerboard pattern, and the entire complex develops around
them. The rich collections of art and the frescoes by Pellegrino
Tibaldi and the Genoese painter Luca Cambiaso cannot lift the
monotony that pervades the building. The cloisters, hallways,
chapter halls, reception areas, and meeting rooms all add up to an
obsessive exercise in geometry involving 1,200 doors and 86 stair-
cases. The heart and center of the system is the basilica, a scale
model of Saint Peter's in Rome. In its vast space are some 50 altars,
and it is closed off at the end by the immense retable of the Capilla
Mayor. Among the statues are an exquisite marble crucifix by
Benvenuto Cellini and a double group in gilt bronze, depicting,
respectively, Charles V and Philip II with their families, by Leone
and Pompeo Leoni (page 122). El Escorial represents the end of an
era, the Renaissance, but not yet the beginning of the Baroque,
which in Spain would be remembered—with a mixture of pride
and nostalgic melancholy—as the Siglo de Oro, or Golden Century.

1557: Battle of San Quintín.
Philip II defeats the French
and vows to dedicate to
Saint Lawrence the largest
church in Spain.
1558: Death of Charles V.
Among his last wishes is a
fitting tomb.
1561: Philip II establishes
the capital at Madrid and
searches for a good
location in the Sierra de
Guadarrama for the
construction of the votive
and sepulchral monastery.
1563: The cornerstone is
laid for the monastery of
El Escorial. The architect is
Juan Bautista de Toledo.
1567: Upon the death of his
predecessor, Juan de
Herrera becomes the
architect of the complex.
1584: Construction is sub-
stantially finished.
Decoration continues.
1598: Philip II dies in his
apartment at El Escorial.

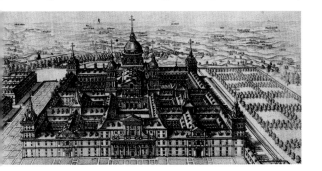

◀ Engraving with an aerial
view of El Escorial at the
end of the 16th century.

El Escorial

The heart and center of the abbey is the church, a typical piece of Counter-Reformation sacred architecture with broad vaults over pillars and a large dome, modeled on Saint Peter's in Rome, even though that church was still under construction at the time.

The interior of the church is an enormous, and yet strangely inert, space; in it, some 50 altars are arranged, crowned at the end by the impressive retable of the Capilla Mayor, or main altar, created by Italian masters.

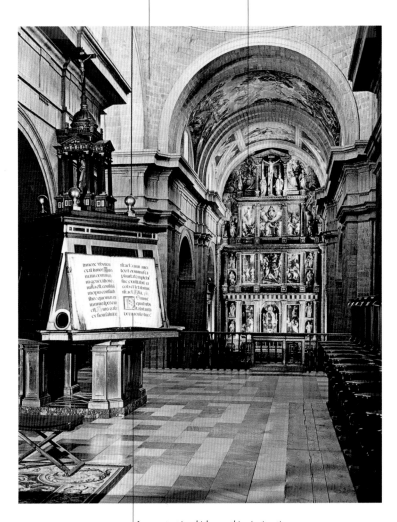

▲ Church of El Escorial: Interior with the choir and the retable of the main altar.

In a context in which everything is gigantic, particularly impressive is the lectern at the center of the austere choir; made of walnut, it is sufficiently heavy, solid, and tall to support the largest illuminated antiphonaries produced at the end of the Renaissance.

After the fall of the Muslim realm of Granada, in 1492, Andalusia was marked by an intense process of Christianization, including in art.

Andalusia

During Charles V's stays in Spain, which were never lengthy, his favorite residence was the Alcázar in Toledo. Yet many of the most important pieces of 16th century architecture are found in Andalusia, which was undergoing intense Christianization and architectural renovation. A style developed that was known as plateresque (*plateresco*), with decorations based on silverwork. Inside the most prestigious Moorish monuments, marvelous symbols of the Muslim realm of Granada, buildings were erected in late-Gothic or classical Renaissance styles. In Granada, the former Moorish capital, alongside the royal chapel of the "Catholic Kings" Ferdinand and Isabella, an imposing cathedral was built, while adjoining the Alhambra a large residential palace was constructed for Charles V, its circular plaza surrounded by loggias. In Seville, lavish furnishings completed the great cathedral in which Charles V married Isabel of Portugal (1526); a minaret was used as a bell tower, while amid the tangled streets of the Arabic and Jewish city, elegant palaces were built. In the Alcázar an apartment with a private chapel was built for Charles V. In Cordoba, the ancient mosque, one of the wonders of Muslim sacred architecture, was "profaned" with the insertion of a mediocre Christian church in the heart of the dense web of aisles.

1504: Death of Isabella of Castile; royal power nominally passes to her daughter, Joan the Mad, but the regency remains with Ferdinand of Aragon ("the Catholic").
1506: Construction begins on the Capilla Real of Granada; it will be finished in 1521.
1523: Construction begins on a Christian church inside the great mosque of Cordoba.
1526: Charles V is married to Isabel of Portugal in Seville.
1528: Diego de Siloé begins construction of the Malaga cathedral.
1568: "La Giralda" is completed, a minaret transformed into a bell tower for the cathedral of Seville.
1580: Seville is the largest and most populous city in Spain.

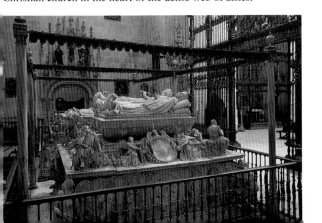

◀ Tomb of the "Catholic Kings" in the Capilla Real, adjoining Granada cathedral.

177

The city of Antwerp was the richest port in Europe, and the wharves along the Schelde offered a spectacle of incessant activity, to which the prestige of a flourishing artistic school only added.

Antwerp

Antwerp was the clearinghouse and marketplace for incoming colonial merchandise. The city became the art capital of Flanders, and it developed a style that borrowed from Italian models. Bosch, Metsys, Mabuse, and Van Scorel traveled to Venice and Rome, acquiring the monumental sense of Italian perspective, but also meeting other artists and participating in the birth of the "Modern Manner." A learned, international city, open-minded and tolerant, with a prestigious multilingual publishing industry, Antwerp remained Catholic, and it saw itself as an outpost of the Counter-Reformation in the face of the northern, Calvinist United Provinces. All the same, there were violent eruptions of Protestant iconoclasm, especially in 1579–80, which destroyed many artworks, particularly in the cathedral; they were eventually replaced with Rubens's large altarpieces. Later, around the massive late-Gothic cathedral, topped by the capricious tower of Rombout Keldermans, there sprang up large monastic complexes of various religious orders, including the powerful Jesuits.

▶ Pieter Bruegel the Elder, *Two Monkeys against the Background of the Estuary of the Schelde at Antwerp*, 1562. Berlin, Gemäldegalerie.

The objects in the background form a "still life"; in the course of a few decades, the still life would become an independent subject for artists, liberated from the need for a narrative pretext.

The woman is leafing through an illuminated book of hours. It is a sacred text, a book of prayers to the Virgin Mary, and the wife's religious devotion serves as a counterpoint to the husband's totally profane, mercantile absorption.

The number of coins from different mints and the elegance of the objects in the shop of the money changer are specific indicators of the growing wealth of Antwerp as a cultural, commercial, and financial center.

The man holds with professional care the scale with which he is checking the weight of the coins. One of the most significant economic phenomena of the 16th century would be the "price revolution," in part due to the influx of precious metals from South America. One of its results would be the first, limited circulation of paper money.

A convex mirror reflects the interior of the room. This was a common artifice in Flemish painting of the 15th century, and Metsys uses it to demonstrate this heritage consciously and explicitly.

▲ Quinten Metsys, *The Money Changer and His Wife*, 1514. Paris, Louvre.

The gifts of the Magi, as well as their crowns and scepters, are sumptuous models of late-Gothic goldwork.

The compositional structure and the impressively evoked architectural setting are linked to the monumentality of Italian painting.

The proliferation of details, the taste for luxurious clothing, and the painstaking execution of the tiniest particulars all belong to the Flemish tradition.

The face of the Virgin shows the painter's familiarity with Leonardo's models.

The dog on the right is an explicit homage to Dürer's engravings: the entire painting, to the eyes of an expert observer, reveals Mabuse's cultural eclecticism and, secondarily, the series of international contacts established by Antwerp's school of art.

▲ Mabuse (Jan Gossaert), *The Adoration of the Magi*, ca. 1515. London, National Gallery.

In the first half of the 16th century, Brussels was once again an elegant commercial and artistic city; then the failed struggle for independence bloodied and impoverished the whole of Flanders.

Brussels and Flanders

At the beginning of the 16th century, Brussels yielded to Mechelen (Malines) its status as capital of the former duchy of Burgundy, at the behest of the regent, Margaret of Austria. It regained its rank in 1519, thanks to Charles V, the emperor who had been born in Ghent in 1500 and who remained fond of his homeland. Brussels experienced an efflorescence, symbolized by the construction of the residence of the Spanish kings on the Grand Place (1536) and by its hegemony in the manufacture of tapestries. The University of Louvain grew in importance. Following Antwerp's lead, a school of painting developed in Brussels and Flanders that imitated the new ideas from Italy. Flanders also offered many indigenous alternatives: the traditional love of realistic descriptive details, a prerequisite for the development of the genre painting; a folk culture that mingled common sense and the irrational; a significant devotional component, for instance, in the paintings of Adrien Ysenbrandt and Lancelot Blondeel and the sculpture of Du Broeucq. The yearning for national independence, following the abdication of Charles V, led to a bloody uprising. Its repression, carried out by the duke of Alba, culminated with the beheading of the counts of Egmont and Hornes, the leaders of the Flemish rebellion, on the Grand Place in Brussels. The failure of the drive for independence was made official by the Protestant surrender to Philip II in 1585.

1500: The future emperor Charles V is born at Ghent.
1507: Margaret of Austria is appointed regent of the Netherlands.
1519: Brussels once again becomes the capital.
1556: The population of Brussels passes 100,000.
1568: Execution of the counts of Egmont and Hornes on the Grand Place of Brussels, by order of the duke of Alba.
1576: Don Juan of Austria is named governor, and the following year he begins a new campaign of repression against the independence fighters.
1578: Death of Don Juan of Austria; the new governor is the duke of Parma, Alessandro Farnese.
1579: The Netherlands splits into two unions: to the north, the Union of Utrecht, to the south, the Union of Arras.

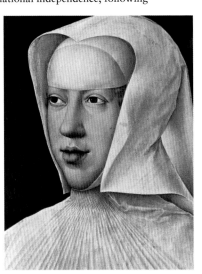

◀ Bernard van Orley, *Portrait of the Regent Margaret of Austria*, ca. 1530. Brussels, Musées Royaux des Beaux-Arts.

Charles V's unmistakable, half-open mouth is an inherited Habsburg feature, recurring through the generations: an unfortunate prognathism of the lower jaw.

On the chest of the young emperor gleams a chain with the Order of the Golden Fleece, the highest honor to which the European aristocracy might aspire.

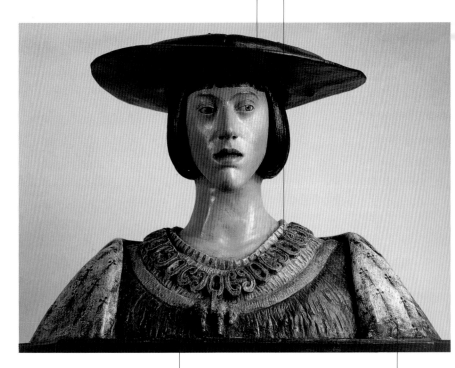

Charles V, who appears to be an adolescent in this portrayal, knew very well that he did not have an attractive appearance. All the same, he sponsored the proliferation of realistic portrayals of every sort (sculptures, paintings, engravings, etc.), believing that, once they saw him in person, his subjects might think that he was not as ugly as they had expected.

The execution of portrait busts, already frequent in 15th-century Tuscany, was encouraged greatly by the Habsburgs.

▲ Conrat Meit (attributed), *Bust of the Young Charles V*, ca. 1518. Bruges, Gruuthuse Museum.

The sword raised high in a sign of victory refers to the war between Charles V and the king of France, Francis I, which culminated in the Battle of Pavia.

At the summit of a complicated heraldic hierarchy we note the imperial coat of arms of the Habsburgs, with the two-headed eagle and, surrounding it, the collar with the Order of the Golden Fleece.

As is typical of the work of Lancelot Blondeel, each individual element of the decoration belongs to a Renaissance repertory, but the overall effect of accumulation and the abhorrence of empty space are reminiscent of the late-Gothic style.

This sumptuous piece of carving was a tribute from the city of Bruges to the emperor.

▲ To a design by Lancelot Blondeel, *Wood Carving in Honor of Charles V,* 1528. Bruges, Stedelijke Musea.

The globe, an imperial symbol by definition, further linked Charles V to the traditional image of Charlemagne, the founder of the Holy Roman Empire.

The series is composed of seven large scenes. For many years the tapestries adorned the imperial palace in Brussels.

The victorious condottiere at Pavia was Don Fernando d'Avalos, marquess of Pescara, one of the earliest strategic thinkers to grasp the importance of individual firearms (arquebuses and culverins), capable of piercing the armor of the French cavalry.

▲ Tapestry weavers of Brussels to cartoons by Bernaert van Orley, *Francis I, King of France, Taken Prisoner in the Battle of Pavia*, ca. 1530. Naples, Museo di Capodimonte.

The king of France is obliged to dismount. On this occasion, he pronounced the famous phrase, "All is lost but honor." He would be held prisoner in the fortress of Pizzighettone.

Aside from their documentary value, the tapestries of the Battle of Pavia mark a major step forward in the history of weaving, with the novel introduction of perspective in the backgrounds and a narrative sense that extends in three-dimensional depth.

Thanks to careful handling and proper conservation, the tapestries have largely preserved their original colors. We are thus able to appreciate the fine gradations of color, especially in the landscapes.

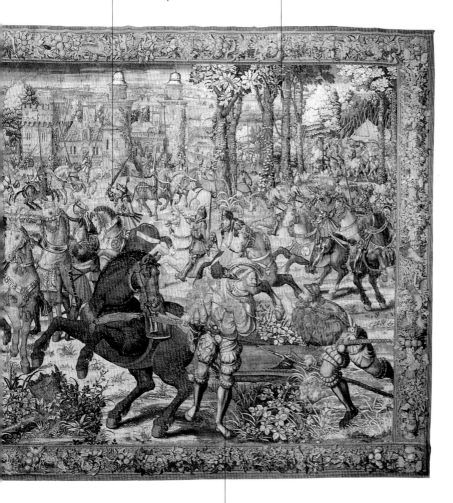

Throughout the series of tapestries we see the garish costumes of the mercenaries, the formidable soldiery consisting largely of Swiss mercenaries.

With the drive for independence guided by the house of Orange, the northern Netherlands began the economic and cultural evolution that was destined to culminate in Holland's golden age.

United Provinces

1535: Anabaptist rebellion in Amsterdam.
1543: The duchy of Gelderlands is joined to the Netherlands, which now has a population of 3 million.
1555: Work begins on the stained-glass windows of the Grote Kerk, or Saint John's Church, in Gouda.
1566: Iconoclastic campaign by the Calvinists.
1571: Calvinists expel the Catholics from Amsterdam.
1572: The Sea Beggars conquer Holland and Zeeland: the anti-Spanish revolt begins.
1578: With the Union of Utrecht, Amsterdam is proclaimed capital of the Republic of Holland.
1584: Assassination of William the Silent at Delft.
1586: The republican government is established at The Hague.
1593: The botanist Carolus Clusius introduces tulip bulbs in Leyden.
1597: The explorer Willem Barents finds an Arctic passage.

The territory of what is now the Netherlands experienced a lively cultural expansion throughout the 16th century, growing in tandem with its prosperous commerce. Erasmus of Rotterdam led a humanist movement that involved such painters as Lucas van Leyden and Bosch, who came from the Brabantine city of 's Hertogenbosch. Later, the schools of Utrecht and Haarlem, trending toward Italian models and Mannerism, also distinguished themselves. During the second half of the century, Flanders and the northern provinces (which would later become the nation of Holland) were rent by bloody wars, rebellions, and attempts to break free of Spanish rule. There were terrible scenes of destruction, but they were set against a background of surging economic growth. Indeed, because of the excellent organization of the ports and their advanced nautical and commercial technology, the harbor cities along the North Sea proved to be quickest and most effective at grasping the extraordinary potential of the overseas trade routes. While in what is now Belgium the revolt was crushed

by the Spanish, the drive for independence of the northern provinces was not hindered even by the assassination at Delft of William of Orange, known as William the Silent, lieutenant general of Holland and the commander of the independence movement. The national identity of an emerging European power also involved the Dutch language and the Calvinist creed.

The prominent inscription commemorates the death of William the Silent in 1584: "He was killed this year in Delft, which grieved many."

Dressed soberly, yet with stern elegance, Cornelis Schellinger, a well-to-do citizen of Amsterdam, is a prototype for 17th-century Dutch portraits.

In Dutch paintings, symbolic references often appear. The top is a symbol of the brevity of life, which will end sooner or later as surely as the toy will stop spinning.

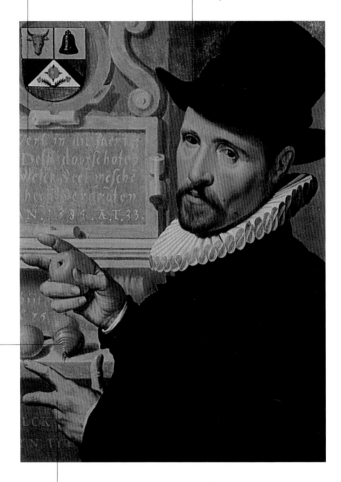

The strange position of the subject's fingers indicates his age at the time of the portrait: thirty-three.

◄ Antonis Mor, *Portrait of William of Orange, the Silent,* 1555. Kassel (Germany), Gemäldegalerie.

▲ Pieter Pietersz., *Portrait of Cornelis Schellinger,* 1584. The Hague, Mauritshuis.

The cow is the traditional symbol of Holland's agricultural wealth and its renowned abundance.

William of Orange is holding the symbolic cow firmly by the horns.

The haughty Philip II is seated on the back of a cow as if it were a spirited steed, driving his spur into its flank.

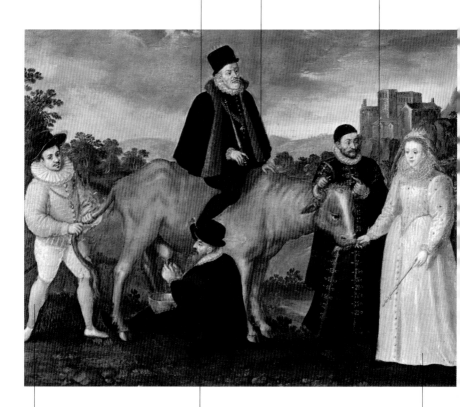

The figure holding the cow's tail is the duke of Anjou, a suitor hoping to wed Elizabeth of England. Here he is depicted sarcastically as a second-rate social climber, ready to exploit any opportunity.

The duke of Alba, ruthless governor of the Netherlands, is milking the cow.

The queen of England, Elizabeth I, ally of the United Provinces, is affectionately feeding the tame animal.

▲ Flemish artist, *Allegory of the Netherlands Oppressed by Philip II*, 1590. Private collection.

The saying "Either France or Spain, as long as we eat" nicely expressed the crisis of the former duchy. Milan, a jewel of the Spanish Empire, embraced the Counter-Reformation.

Milan

Despite the abrupt interruption in commissions and the exodus of artists caused by the fall of the Sforza duchy in the early 16th century, the production of art in Milan and areas with cultural ties to it continued apace. Leonardo returned in 1507 and stayed until 1513. With the exception of Bartolommeo Suardi, known as Bramantino, who executed monumental, austere compositions based on a geometric simplification of forms, the prevailing taste followed Leonardo. The Leonardesque manner found its highest expression in the work of Boltraffio, Solario, Cesare da Sesto, and Bernardino Luini, but in them it also found its extreme limit as a crystallized style. A new cultural phase began in the 1530s with the arrival in Milan of Savoldo and Gaudenzio Ferrari and the delivery there of masterpieces by Titian. During the second half of the century, the Milanese artistic scene was dominated by the initiatives of Carlo Borromeo. Appointed archbishop of Milan in May 1564, the man who would become Saint Charles dictated "instructions" for architecture and sacred art and found

1500: Definitive fall of Ludovico il Moro. Milan under French rule.
1507–13: Leonardo returns to Milan.
1515: Battle of Marignano; French supremacy.
1521–35: Provisional restoration of Sforza rule, with Francesco II, under Spanish tutelage. Collapse of the "Filarete tower," emblem of the Sforza castle.
1525: Battle of Pavia: final Spanish victory.
1535: Death of Francesco II Sforza. Milan passes under Spanish rule.
1542: Titian sends to Milan the altarpiece of *Christ Crowned with Thorns*, now in the Louvre.
1570: Giovanni Paolo Lomazzo publishes his *Treatise on Painting*.
1584: Death of Saint Charles Borromeo, archbishop of Milan.

Pellegrino Tibaldi to be his most reliable interpreter. The critical conscience of the late Renaissance in Milan was Giovanni Paolo Lomazzo, first a painter but, after he went blind, a writer of treatises. His works in praise of the local tradition almost constitute a Lombard response to the ideas of Vasari, and they direct attention toward unorthodox subjects and forms of expression.

◄ Giovanni Paolo Lomazzo, *Self-Portrait*, ca. 1570. Milan, Pinacoteca di Brera.

189

This series, a very rare example of the genre entirely conceived and executed by Italian artists and craftsmen, is composed of twelve tapestries, corresponding to the months of the year.

Dominating the center of this tapestry is the coat of arms of Gian Giacomo Trivulzio, marshal of the French army and governor of Milan after the fall of the Sforza duchy.

At the top of each scene is the zodiac symbol corresponding to the month, here Aries the Ram.

As in the medieval tradition, certain agricultural tasks were associated with each month, in this case felling trees and planting gardens.

The central figure of each scene is the allegorical personification of the month: the youthful March, a spring month when the fields are reborn, is characterized by the tiny heads of newborns poking out of his chest.

Bramantino, one of the leading painters in Lombardy, created the cartoons. He took care to insert details in every scene that would emphasize the perspectival rendering of objects, figures, and backgrounds.

▲ Tapestry weavers of Vigevano, to cartoons by Bramantino, *The Month of March*, ca. 1508. Milan, Castello Sforzesco, Civiche Raccolte d'Arti Applicate.

The espalier of roses harks back to and updates one of the most renowned mystical and symbolic contexts of the Virgin, common in late-Gothic art.

Luini applies the unmistakable Leonardesque model with great refinement to the face of the Virgin.

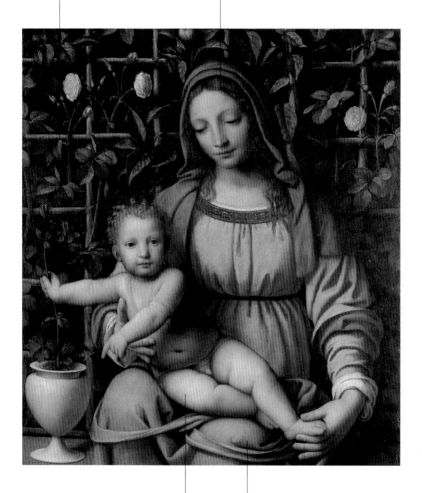

The Christ child is also based on earlier works by Leonardo, but with a certain degree of liberty. Luini does more than merely copy the work of his master, and here he offers a delicately original composition.

Bernardino Luini is perhaps the most talented and certainly the most prolific of all the Lombard artists who worked in direct contact with Leonardo.

Bernardino Luini, *Virgin and Child of the Rose Garden*, ca. 1510. Milan, Pinacoteca di Brera.

Milan

The painting was conceived for the altar in a chapel frescoed by Gaudenzio Ferrari, in the church of the monastery where Leonardo painted his Last Supper. We thus clearly see its importance for the development of art in Milan.

There are further references to classicism: the bust of Tiberius atop the architrave and the torturer dressed in full armor refer to ancient models.

The scene is sometimes referred to as a "Flagellation," but it is actually the Crowning with Thorns. The altarpiece was made for the Holy Crown chapel in the church of Santa Maria delle Grazie in Milan.

The violence of the torturers painted by Titian was destined to make a great impression on the imagination of the very young Caravaggio.

The colossal, burnished forms of the figures show a distant yet persistent rivalry with Michelangelo.

▲ Titian, *Christ Crowned with Thorns*, 1540–42. Paris, Louvre.

The painting is a masterpiece from the period of Titian's most intense interaction with the Mannerists. The figure of Christ can be compared with the copy of The Laocoön (page 32) that Titian kept in his studio.

The painter was active in Cremona, a provincial city that at the time had a flourishing artistic community that was capable of finding a middle ground between the refinement of Mannerism and the solid, concrete qualities of the Lombard "provincial" tradition.

Although the artist clearly felt the need for a human presence to justify the title, the painting is for the most part a particularly successful "still life," with fruit and vegetables displayed in a wide array of receptacles.

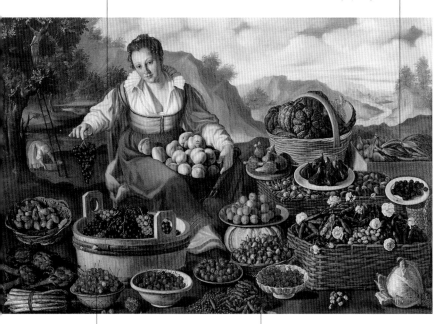

Vincenzo Campi composed spectacular images of fruit, game, and birds and repeated them on numerous occasions.

Campi's scenes are always governed by a distributive rigor that is almost restrictive. The direct dialogue between the image and its public is the cultural background that gave rise to the "natural" painting of Caravaggio and the Carraccis.

▲ Vincenzo Campi, *The Fruit Seller*, ca. 1588. Milan, Pinacoteca di Brera.

The Great Kingdoms:
France, Britain, and Portugal

The trend toward the formation of large centralized nation-states—new in the 16th century and diametrically opposed to the preceding age of duchies and local seigniories—manifested itself not solely in the gigantic global dimensions of the Habsburg Empire or the expansionism of the tsars of "All the Russias" and the Ottoman sultans but also in European nations endowed with strong monarchs. Now, areas that were split up politically into small territories (such as Germany and Italy) were at a relative disadvantage. The age of geographic discoveries was unquestionably a golden one for Portugal, which—despite its size and its location at the margins of Europe—experienced in the early 16th century a period of successful cultural and artistic independence, under the leadership of King Manuel. 16th-century England was characterized by the strong figures of the Tudor monarchs Henry VIII and Elizabeth I, extremely active both on the international scene and in the attempt to resolve the difficult relationship with Scotland and unite Britain. While England could not yet boast of a highly original artistic school, there were many interesting cultural initiatives on the path from the Perpendicular Gothic to the age of Shakespeare. Even richer and more interesting was the situation in France, during a century that witnessed, on the one hand, the frustration of Francis I's expansionist ambitions (and yet fully redeemed by a phase of magnificent architectural and artistic commissions) and, on the other hand, the brutal succession of sanguinary religious wars. We find this flourishing cultural and artistic chapter embodied in the school of Fontainebleau, one of the most alluring periods of the late Renaissance and Mannerism in Europe.

From Francis I to Henry IV, the kings of France developed court art, primarily inspired by Italian models, but with the growing involvement of local masters.

Paris

In the first decades of the 16th century, the kings of France, Louis XII and Francis I, made repeated attempts to conquer northern Italy, especially the former duchy of Milan. A quarter century of wars culminated in a Spanish victory at the Battle of Pavia (1525). The military campaigns in Italy coincided with the obsolescence of the Gothic models of art and architecture. After the Sack of Rome (1527) and the siege of Florence (1530), Francis I was able to summon to France small armies of Italian painters, stucco artists, sculptors, and architects and gave them prestigious commissions. The royal tombs in the abbey of Saint-Denis confirmed the direction of court style toward the Italian Renaissance and the adoption of the "Modern Manner." In Paris, however, the Italian style mixed with more traditional models: the last late-Gothic churches (Saint-Eustache, Saint-Étienne-du-Mont, Saint-Germain l'Auxerrois) were going up just as work was being done on the Renaissance structures designed by Pierre Lescot for the Cour Carré of the Louvre (1546) and the town fountains by Jean Goujon and Germain Pilon. Alongside the court portraits and *crayons* by Jean and François Clouet, we find major treatises of classic inspiration on art and architecture. In the second half of the century, the Wars of Religion changed the course of French history: a taste for the bizarre insinuated itself in painting, along with an abstruse intellectualism. This dramatic phase was symbolized by the anguished sculptures of Ligier Richier and sealed by Henry IV with the renowned phrase, "Paris is well worth a mass."

1515: Francis I occupies Milan following the Battle of Marignano but is then defeated at Pavia (1525). 1529: The "Peace of the Ladies" between the Holy Roman empire, France, and England. 1544: The Peace of Crépy between the empire and France. 1547: Francis I dies; Henry II succeeds him as king. 1557: The French are defeated by the Spanish at San Quintín. 1559: Peace of Cateau-Cambrésis between France and Spain. Henry II dies during a tournament. 1560: Charles IX takes the throne, with Catherine de' Medici as his regent. 1562: The first war of religion. 1572: Saint Bartholomew's Day Massacre. 1574: Charles IX dies. Henry III is the new king. 1589: Henry III is assassinated. Henry of Navarre (Henry IV) lays siege to Paris. 1594: After announcing that he has become a Catholic again, Henry IV enters Paris. 1598: Edict of Nantes: end of the Wars of Religion. 1600: Henry IV marries Marie de' Medici.

◀ Jean Goujon, Panel with nymph, from *The Fountain of the Innocents*, 1547. Paris, Place des Innocents.

The face, its features rendered cunning and pungent by a faint smile, clearly shows the influence of Leonardo.

The general composition, with a frontal bust set against a background of exquisite fabrics, harks back to the standard composition of French royal portraits established in the mid-15th century by Jean Fouquet.

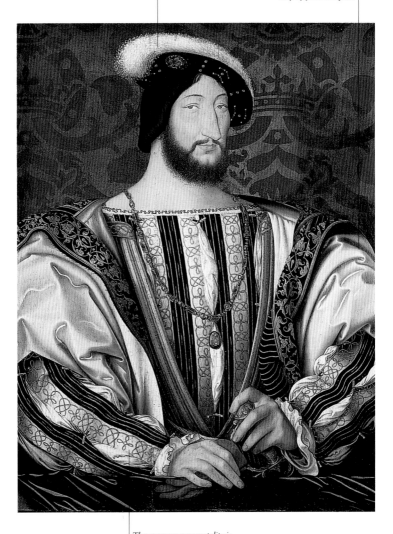

The serene monumentality is completely Renaissance, but Clouet does not hesitate to measure himself against Flemish masters in the minute depiction of the precious embroidery on the fabric.

▲ Jean Clouet, *Portrait of Francis I,* ca. 1525. Paris, Louvre.

Trained on the building site of Fontainebleau as an assistant to Primaticcio, Caron took part in the popular antique-style (or *antichizzante*) fashion, but with a precise characteristic touch in his treatment of views and buildings: not an archaeological revival, but a free inspiration that in some ways prefigures the Baroque.

The scene is set in a surreal space, a vast square lined with whimsical pieces of architecture, where small figures wander alone or in groups.

The range of enameled colors and the extreme, almost mincing grace of the gestures belong to the affected style of international Mannerism.

The subject of the painting was fairly common in the erudite 16th century: the Tiburtine sibyl tells the emperor Augustus of the imminent coming of Christ.

▲ Antoine Caron, *Augustus and the Sibyl*, ca. 1571. Paris, Louvre.

Henry IV's typical and slightly mocking expression is easily recognizable, even beneath his masquerade in the guise of the god Mars.

Dubois was a member of the "second school of Fontainebleau." Originally from Antwerp, he moved to Paris in 1599 and became Henry IV's official painter and portraitist after the death of Toussaint Dubreuil.

▲ Ambroise Dubois, *Portrait of Henry IV Dressed as Mars*, ca. 1600. Pau, Musée du Château.

The classic contrapposto, which involved a slight twisting of the chest, is the favorite pose of Mannerist painters.

This painting was probably part of the decoration of the Parisian Palais del Tuileries.

In 1530 Francis I commissioned the Italian painter Rosso Fiorentino to oversee the decoration of his country home; Rosso's arrival triggered a vast program of renewal.

Fontainebleau

One direct result of the Sack of Rome in 1527 and the subsequent siege of Florence was the exodus of artists from Italy, to a generous welcome from King Francis I in the construction yard of his home in Fontainebleau, almost as a "rebate" for the military defeats he had suffered on Italian soil. Rosso Fiorentino worked at Fontainebleau from 1530 until his death in 1540, Primaticcio came to live there in 1532, and Niccolò dell'Abate arrived in 1552. Thanks to them, a thriving school of French masters formed. Notable among them were the portraitist François Clouet and the refined sculptors Germain Pilon and Jean Goujon. France became the leader of international Mannerism, which can be summarized in the two successive phases of the school of Fontainebleau, made up of the artists that revolved around the court in the second half of the 16th century. It was an unusual period in art. On the one hand, there was a complacent return to classical models in the poses of the figures, in the Latin verses that were sometimes used as commentary on the images, and in the settings that surrounded the figures. On the other hand, there was an almost obsessive quest for visual seduction, through nude female figures, flowers, or other meticulously depicted objects, and a proliferation of descriptive details. Themes, styles, and characteristics of the paintings of Fontainebleau are so closely entwined that it is sometimes difficult to tell the individual masters apart. The school of Fontainebleau, which accepted the themes of mythology and classical culture, refused to subject itself to realism, preferring to cultivate the enchantments of the fantastic.

1525: Defeat of Francis I at Pavia.
1530: Rosso Fiorentino works at Fontainebleau.
1534–37: Rosso Fiorentino and Primaticcio create the Gallery of Francis I.
1540: The edict against heresy is issued at Fontainebleau.
1547: Death of Francis I.
1552: Niccolò dell'Abate begins the "second school of Fontainebleau."

▼ Francesco Primaticcio, Frescoes and stuccoes, 1541–44. Fontainebleau, château.

Gaia represents the
earth and its pepper.

Neptune symbolizes
the sea and its salt.

Is the saltcellar a masterpiece of the gold-
smith's craft, or is it a small sculpture?
Although it is made of solid gold and
enamel, with exquisite attention to detail, it
is a major masterwork in the history of art.

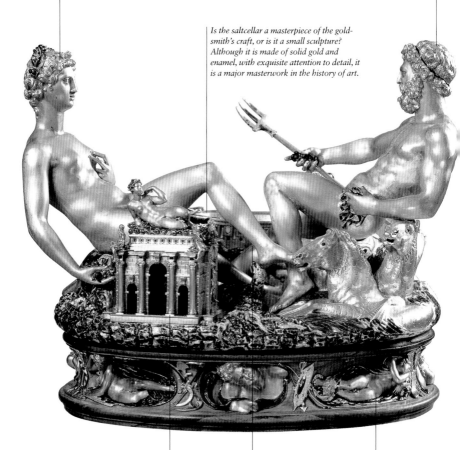

The allegorical figures of Earth and
Sea are flanked, respectively, by a
small temple and a seashell, which
were made to hold pepper and salt.

As Cellini wrote in his
autobiography, the
two figures' legs are
intimately inter-
twined, like the inlets
and promontories of a
coastline, where the
sea alternates with the
land: "Thus I accord-
ingly gave them this
graceful pose."

This renowned cen-
terpiece is a symbol
of the international
nature of European
courts in the High
Renaissance. It was
made by a Florentine
in Francis I's
Fontainebleau and
donated to the
Habsburg court in
Austria.

▲ Benvenuto Cellini, *Saltcellar of
Francis I*, 1540–43. Vienna, Kunst-
historisches Museum.

The domestic realism of the room with a servant sewing beside the fireplace contrasts sharply with the idealized scene in the foreground.

The setting, with the nude women in a bathtub and heavy curtains, takes its inspiration from the intimate setting of François Clouet's painting A Lady in Her Bath, now in Washington (page 278).

The painting appears calligraphic, intellectual, symbolic, and yet at the same time sensual.

This painting is problematic, the work of a nameless master from the second school of Fontainebleau, and it is traditionally known as Double Portrait of Gabrielle d'Estrées and Her Sister the Duchesse de Villars in Their Bath. The duchess is pinching the nipple of Gabrielle d'Estrées, who was Henry IV's mistress.

▲ Painter of the school of Fontainebleau, *Gabrielle d'Estrées and Her Sister*, ca. 1590–99. Paris, Louvre.

The châteaus of the Loire Valley were among the most important international laboratories of the "Modern Manner" in a number of areas: architecture, decoration, and garden design.

Châteaus of the Loire

Francis I, who hosted the elderly Leonardo da Vinci at Amboise, was the first ruler of a major European state to encourage artistic development in the "modern" direction. A remarkable opportunity for formal exploration and development was offered by the royal châteaus along the Loire River valley. Here, Renaissance innovations coexisted with more traditional materials and approaches. Along with the château of Blois, the most renowned was that of Chambord, built for Francis I between 1519 and 1534 as a royal hunting lodge. Chambord is an exemplary mixture of the French tradition and Italian influence. Its impressive cylindrical towers derive from the architectural idiom of ancient manor houses, reinvented by elegant Renaissance decoration and a pleasing rhythm of walls and apertures. One distinctive element is the hip roofs, while the alternation of building materials, especially slate and tufa stone, gives the entire structure a delicate interplay of color. Last, the spectacular roof terrace, surrounded by turrets, chimneys, pediments, and crowns: a Renaissance reinterpretation of the Gothic motif of the spire. The Mannerist love for monumental painting and sculpture led to the decline of the fine goldwork, tapestries, and other decorative genres that had characterized the age of the courtly Gothic.

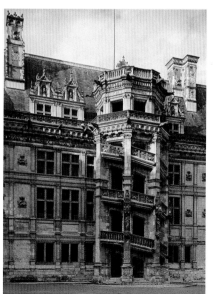

▶ Château of Blois, Exterior of the octagonal staircase, in the wing of Francis I.

The stylistic model remains The Nymph of Fontainebleau, *by Benvenuto Cellini, now in the Louvre.*

The slender figure of Diana reveals the interest for the sculptor (who studied in Rome) of classical models, without the contrivances of Mannerism.

The figure of Diana, goddess of the hunt, not only was appropriate to a country castle surrounded by woods but also referred to Diane de Poitiers, mistress of King Henry II and owner of the château of Anet.

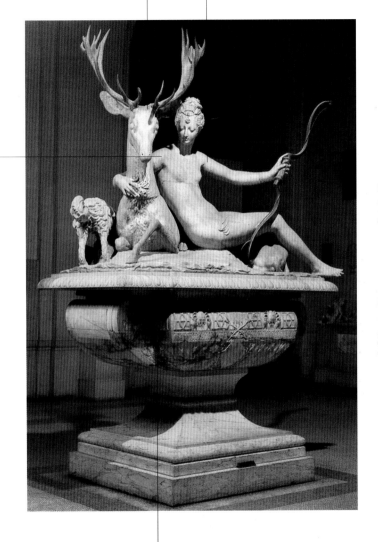

▲ Jacquio Ponce (attributed), *Diana*, formerly part of a fountain at the château of Anet, 1550–60. Paris, Louvre.

On the elegant pedestal we see the initials of Diana and Henry.

Amid the general European tendency toward the consolidation of major nation-states, England under the Tudors stood out as a new economic and naval power.

London

The imposing figure of Henry VIII strongly influenced the first half of the 16th century in Britain, as England emerged as a great maritime power, both in North America and in India. The English 16th century, which attained its cultural apogee during the age of Shakespeare, can be viewed as a succession of lacerating divisions and internecine wars. To list them briefly: the Anglican schism brought about by the king, using as pretext the pope's refusal to authorize his divorce; the early phase of persecution that culminated in the execution of Sir Thomas More; the suppression of the monasteries between 1535 and 1540; the emblematic loss at Portsmouth of the *Mary Rose,* flagship of the war fleet (1545); the contest for the throne between the two half-sisters Mary and Elizabeth; the continuous wars along the Scottish borders; the beheading of the deposed Scottish queen, Mary Stuart. . . . One could go on. Yet, even in the midst of these challenging historical troubles, the Tudor Age began with the last fleeting triumph of the most extravagant Gothic and went on to develop as one of the most original versions of the Renaissance, with the construction of

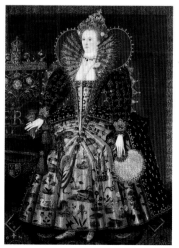

great mansions (Hampton Court, followed by Burghley House, begun in 1555, perhaps the grandest country house of the Tudor era) and the development, in the figurative arts, of a school of painting that was especially devoted to portraits: Hans Holbein's for the court of Henry VIII, the work of Flemish painter Hans Ewouts (Eworth), and finally the success of Nicholas Hilliard, portraitist to Elizabeth I.

The walls are perforated and lightened by large windows.

Unquestionably the most enchanting detail is the spectacular solution for the fan vaults, which extend outward like palm trees.

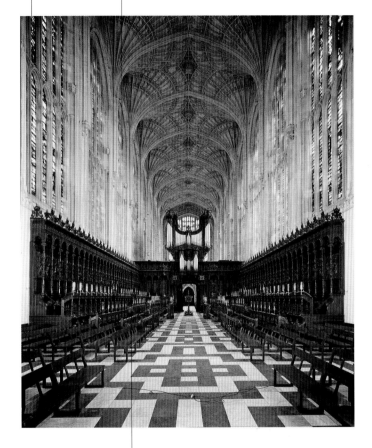

The chapel documents the persistence of the Gothic style right up to the beginning of the 16th century. During those same years, similar architectural approaches can be seen in Henry VII's chapel at Westminster Abbey in London, designed by William Vertue.

◄ Workshop of Nicholas Hilliard, *Portrait of Queen Elizabeth I*, ca. 1599. Hardwick Hall (Derbyshire).

▲ John Wastell, Vaults and choirstalls of King's College Chapel, Cambridge, 1508–15.

The king is portrayed in a completely frontal pose, so large and broad that he fills the entire available surface. In fact, he almost seems to be raising his right elbow to try to make room for himself.

The face exudes the tireless sensuous vitality and the will to power that were such distinctive features of Henry VIII's personality.

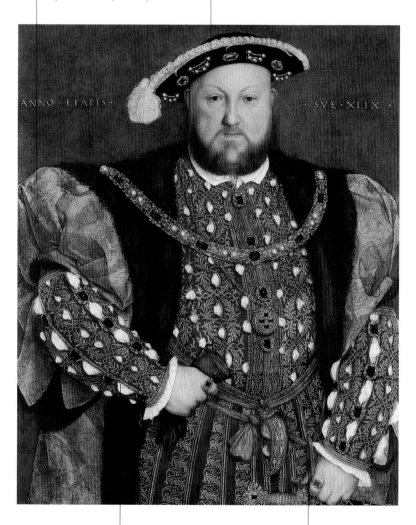

▲ Hans Holbein the Younger, *Portrait of Henry VIII*, 1539–40. Rome, Palazzo Barberini, Galleria Nazionale di Arte Antica.

The king is wearing the magnificent costume that was made for his fourth wedding, to Anne of Cleves, whom he married on January 6, 1540, after his plan to marry the princess of Denmark (page 138) proved unworkable.

This is probably the last portrait of Henry VIII by Holbein, and many copies of it were made.

Celestial intervention comes here, not
through the traditional figure of a saint
or the Virgin Mary, but through the
personification of Peace (with her olive
branch), surrounded by the gods of
Olympus.

Born in the Netherlands, Ewouts was
considered one of the most important
portraitists of the 16th century in Great
Britain, a link between Holbein and
Hilliard.

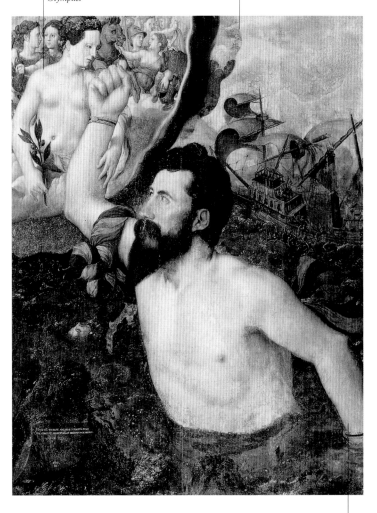

▲ Hans Ewouts (Eworth), *Allegorical
Portrait of Sir John Luttrell*, 1550.
Dunster Castle, Luttrell Collection.

*Sir John Luttrell saves himself from shipwreck both by his
Herculean physical strength and by sheer determination,
assisted by a divine apparition. According to a recent
interpretation, this painting might symbolize not so much
the rescue of an individual person as the hope of peace
and conciliation among all European powers.*

A chilling portrayal of the neurotic hardening induced by power, this portrait of the queen seems to have been chiseled into a tough, austere form, reminiscent of Bronzino's portraits of the Medici.

The portrait dates from the time of the short, unhappy marriage with the Spanish prince and future emperor, Philip II.

The graphic clarity of Antonis Mor's portrait makes the queen appear stern and relentless, truly deserving of her nickname, Bloody Mary, with which she has gone down in history.

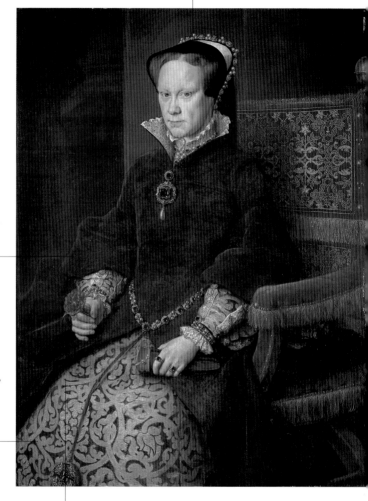

▲ Antonis Mor, *Portrait of Mary Tudor*, 1554. Madrid, Prado.

Her unsuccessful marriage with Philip II and her defeat in the subsequent war against France turned the queen's early moderation to harshness and radicalism. The restoration of Catholicism, orchestrated in concert with Reginald Cardinal Pole, soon degraded into a campaign of violence.

The 16th century endowed Scotland with major monuments but also started it down the path toward union with England after the death of Elizabeth I (1603).

Edinburgh

In 1503, the wedding of the Scottish king James IV to Margaret, daughter of the English king Henry VII, served to contrast the Tudors with the Stuarts, the Scottish royal house, whose emblem was the thistle. The claim to the English throne became the main theme in Scottish politics and history, culminating in the strife between Mary Queen of Scots (daughter of James V Stuart) and Elizabeth I of England. In the background lurked just one of the many religious struggles in 16th-century Europe that pitched Catholics against Protestants. In 1529, the palace of Holyroodhouse was built in Edinburgh as the royal residence of James V and his French wife, Mary of Guise, introducing new models of style and comfort to the homes of the Scottish nobility. After 1560, when the Protestant pastor John Knox moved to the capital, religious debate raged. The Protestants turned to the Presbyterian Church, and the Catholic Mary, daughter of James V, found herself caught in an increasing tumult which included the murder of her Italian secretary and Lord Darnley. The defeat of her supporters at Langside marked the end of Mary's power; she was held prisoner by Elizabeth I for almost twenty years and finally beheaded in London.

1513: The English defeat the Scots at Flodden Field.
1538: James V marries Mary of Guise.
1542: Death of James V. The newborn Mary Stuart becomes the new queen as English troops repeatedly attack Scotland.
1548: Mary Stuart, betrothed to the dauphin of France, is sent to Paris.
1560: John Knox founds the Presbyterian Church.
1561: The widowed Mary Stuart returns to Scotland.
1567: Abdication of Mary Stuart.
1568: Protestant revolt. Mary flees to England, where she is imprisoned. The kingdom of Scotland is entrusted to James VI.
1582: James VI is kidnapped by William Ruthven.
1587: Mary Stuart is found guilty of treason and beheaded.
1603: James VI of Scotland, son of Mary Stuart, becomes king of England, with the name of James I.

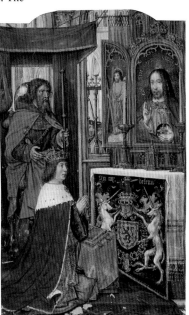

◄ Gerard Horenbout (Master of James IV of Scotland), *James IV of Scotland at Prayer*, 1502–3. Vienna, Österreichische Nationalbibliothek.

Before the unification of the Iberian crowns (1580), Portugal experienced a golden age, marked by overseas conquests and the lengthy career of an extreme, fanciful Gothic style.

Lisbon

1500: Pedro Álvares Cabral lands in Brazil and establishes a Portuguese colony there.
1501: King Manuel founds the monastery of the Jerónimos in Belém.
1502: Vasco da Gama founds a Portuguese colony in India.
1510: The Portuguese take over Goa.
1515: King Manuel orders the construction of the Tower of Belém, in the middle of the Tagus River.
1520: Ferdinand Magellan (Magalhães) sails around Cape Horn, while the Portuguese establish trading centers in China.
1542: Portuguese merchants reach Japan and New Guinea.
1572: Queen Catherine, wife of John III, orders the choir of the monastery of Belém built as a royal pantheon.
1578: King Sebastian I is killed in Morocco: this lays the ground for Spanish annexation of Portugal, which takes place in 1580.
1589: Lisbon is attacked by the English.

The voyage around the Cape of Good Hope by Vasco da Gama (1497) and the exploration of Brazil by Pedro Álvares Cabral marked the culmination of the age of discovery and the greatest expansion of the Portuguese commercial empire. Aided by solid political treaties and the wisdom of her trading fleet commanders, Portugal became in the course of a few decades the leading importer from the Far East, throwing Venice's traditional monopoly in the spice trade into crisis. This policy of oceanic exploration and trade was encouraged by King Manuel I (r. 1495–1521), for whom the "Manueline" style, a brilliant period of the late Gothic, was named. In 1511, the construction of a new royal palace on the banks of the Tagus River radically modified the urban design of the capital. The center of the Manueline style is the quarter of Belém, along the Tagus. Manuel built two symbolic monuments of the Portuguese late-Gothic style here, slender and fanciful, and reminiscent of the Moorish style: the monastery of the Jerónimos (Hieronymites), an elaborate building designed by Diogo Boitac and João de Castilho, and the votive Tower of Belém, which stands in the middle of the river. The walls bear a proliferation of distinctive decorations with maritime motifs: hawsers, sextants, armillary spheres, anchors, sails, caravels, nautical instruments, and exotic animals. The Manueline style continued to develop even after the king's death in 1521, but eventually made way for the introduction of Italian Renaissance models.

The decoration of the windows and stringcourses alludes to maritime motifs, such as hawsers and armillary spheres.

The top of the tower contains a votive chapel dedicated to the Virgin Mary, whose name was so often invoked by sailors. In contrast, the dungeon, located below the water level of the river, was long used as a prison.

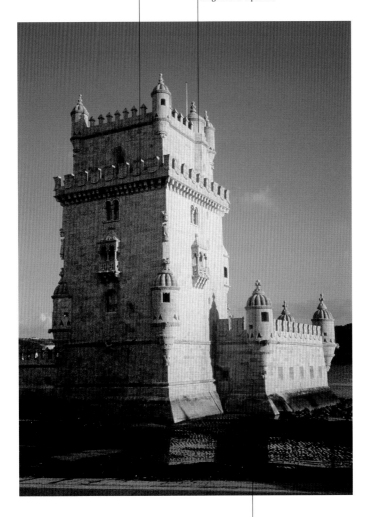

◄ Portrait of Vasco da Gama (detail), from the *Livro de Lizarte de Abreu*, 1558–64. New York, Pierpont Morgan Library.

▲ Tower of Belém, Lisbon, 1515–21.

A distinctive example of the brilliant late-Gothic style that was called "Manueline," the tower stands in the middle of the Tagus River. It was a symbolic point of departure for the Portuguese trading fleet.

211

Italy

The complex and fragmentary geopolitical structure that had nurtured the extraordinary flourishing of Italian humanism was unable to withstand the shocks of history. Milan and Naples fell into foreign hands and, after many bitter contests, were drawn into the sphere of Spanish power. Rome and Florence suffered looting and siege. Venice, even though it managed to enjoy a century of spectacular art and architecture, suffered greatly from the attacks of the Holy League, first, and the Turks later. Small capitals of age-old duchies, such as Ferrara, Mantua, and Urbino, appeared to be nothing more than exquisite relics of a past that was doomed to vanish. On the other hand, thanks to the Counter-Reformation and the Council of Trent, Rome managed to survive the crisis of the Protestant schism and relaunch itself as the center—and not only in symbolic terms—of the Catholic world and as a magnet for artists of every land. Amid the overall economic and political decline of Italy, the only bright spot, besides papal Rome, was in the brilliant financial dealings of the Genoese. In art, however, the tastes of all Europe testified to the supremacy of Italian style, thanks to the unique and almost uncanny convergence of the great masters who interacted there over the course of the entire century. Raphael, Michelangelo, Leonardo, and Titian (to mention only the most resonant names) became paragons for the international artistic schools of the High Renaissance and Mannerism, and traveling to Italy for study became a mandatory step for aspiring painters, sculptors, and architects. The authority of Italian critics and art historians was unassailable. And of course, the monarchs of Europe did their best to stock their courts with Italian artists and continued to buy artworks from the "Bel Paese."

The early 16th century brought not only the culmination of artistic splendor in the Eternal City but also the Lutheran Reformation and the sacking by mercenaries in 1527.

Rome 1500–1534

In 1503, Giuliano della Rovere was elected pope and chose the name Julius II. His papacy (1503–13) was disastrous politically and financially, but he took from Florence and bestowed upon Rome the title of artistic capital. Bramante began the reconstruction of Saint Peter's, Michelangelo painted the ceiling of the Sistine Chapel, and Raphael frescoed the papal apartments. In 1513, Julius II died. Leo X, the new pope, was Giovanni de' Medici, the son of Lorenzo the Magnificent. Raphael established a close rapport with him over shared ideals. Michelangelo returned to work on the tomb of Julius II. Raphael's premature death (1520) coincided with the excommunication of Martin Luther (1521), which opened a lacerating schism. Following the death of Leo X (1521), the ascetic Dutch pope Adrian VI stopped work on major construction projects, considered demolishing Michelangelo's frescoes in the Sistine Chapel, and appointed his fellow Dutchman Jan van Scorel as the curator of Vatican antiquities. Clement VII de' Medici was elected pope in 1523, and he immediately resumed work on the artistic projects. Giulio Romano completed the fourth Vatican Stanza, taking up where Raphael had left off, but in 1524 moved to Mantua. His departure was balanced by the arrival of artists such as Parmigianino, Rosso Fiorentino, and Jacopo Sansovino. This new period was brutally interrupted by the Sack of Rome.

1503: Following the death of Alexander VI Borgia, Julius II becomes pope.
1506: Bramante begins work on the new Saint Peter's Basilica.
1508: Michelangelo and Raphael work in the Vatican.
1513: Giovanni de' Medici (son of Lorenzo the Magnificent) becomes pope with the name of Leo X. 1521: Leo X excommunicates Martin Luther. 1522: The Dutch pope, Adrian VI, from Utrecht, is elected.
1523: Giulio de' Medici is elected pope as Clement VII.
1524: Foundation of the order of the Theatines and, the following year, the order of the Capuchins.
1527: Sack of Rome.
1529: The pope makes peace with Charles V.
1534: The Anglican schism begins. Paul III Farnese is the new pope.

◄ Raphael, *Galatea*, 1512. Rome, Villa Farnesina.

213

Michelangelo depicts the "great fish" that swallowed Jonah and then expelled him alive after three days. This symbolic resurrection makes Jonah one of the chief forerunners of Christ in the Old Testament.

A small panel intentionally left in full view documents the state of the colors in Michelangelo's frescoes prior to the cleaning that was completed in 1994.

Michelangelo developed an absolutely unprecedented and daring pose for Jonah, which emphasized the powerful musculature of the young prophet. It placed him at a crucial juncture between the Bible scenes of the vault and the sections of the altar below.

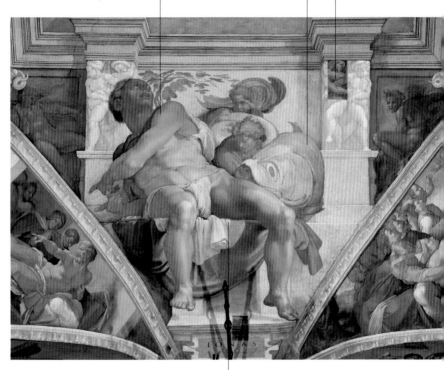

Jonah is one of the colossal prophets painted along the outer edge of the vault. He is located above the altar wall of the chapel, where Michelangelo later painted The Last Judgment.

▲ Michelangelo, *Jonah*, 1508–12. Vatican City, ceiling of the Sistine Chapel.

In a sort of prophetic dynastic alternation, alongside Leo X we see his nephew Giulio de' Medici, who would later become pope under the name Clement VII (page 217).

The pope is seated comfortably in an elegant armchair. His peaceful, untroubled temperament led him to move too slowly, without the needed urgency and energy, to deal with the crisis triggered by Martin Luther, which he rather shortsightedly dismissed as a "quarrel among monks."

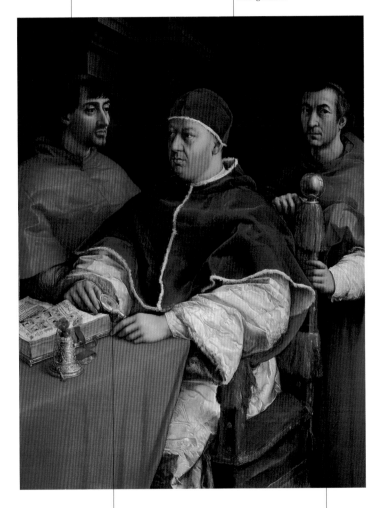

▲ Raphael, *Portrait of Leo X with Two Cardinals*, ca. 1514. Florence, Uffizi.

The son of Lorenzo the Magnificent, an art lover, a patron of the arts, and a collector, Leo X is portrayed by Raphael as he peruses a magnificent illuminated Bible, holding a magnifying glass in one hand to examine the decorations carefully.

Behind the pope, Raphael depicted one of the most influential cardinals in the Roman Curia, Luigi de' Rossi.

The apsidal exedra, a genuine jewel of Renaissance architecture, clearly shows the original purpose of the gallery: to house Giulio Cardinal de' Medici's collection of antiquities.

The frescoes, executed by Raphael's workshop, are a renowned example of "grotesque" ornamentation, which took its name and inspiration from the classical decorations uncovered in the ruins (or "grottoes") of Nero's Domus Aurea.

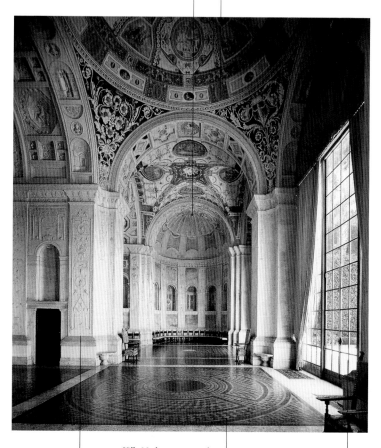

For the execution of the very fine stuccowork, Raphael could rely on a great specialist, Giovanni da Udine.

Villa Madama, now used as a residence for guests of state and for official receptions of the Italian Republic, was Raphael's creation. He designed both the architecture and the interior decor.

Large windows allow light to enter from the enchanting gardens. This beautiful building is only a small part of Raphael's larger plan, which was mostly left unfinished.

▲ Raphael and workshop, Interior decoration of Villa Madama in Rome, ca. 1520.

With many major commissions (it was for him that Raphael decorated Villa Madama), Giulio de' Medici, elected pope with the name of Clement VII, affirmed his special passion for collecting and patronizing the arts.

The portrait shows the pope without a beard, energetic and relatively young. After the Sack of Rome (1527), Clement VII would appear disturbed and prematurely aged, and, in fulfillment of a vow, he would never shave again.

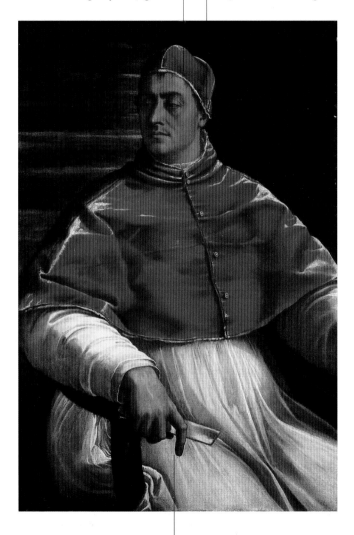

▲ Sebastiano del Piombo, *Portrait of Clement VII*, 1525. Naples, Museo di Capodimonte.

The broad, expanded, and extended forms are typical of Sebastiano del Piombo, who became the pope's favorite painter.

The religious renewal of the church manifested itself in Rome with the construction of the dome of Saint Peter's, the "timeless art" of late Mannerism, and the initiatives of Pope Sixtus V.

Rome 1534–1600

The papacy of Paul III Farnese (1534–49) came at a time when the church was struggling to solve delicate religious and political problems, but it also marked a return to monumental construction projects. The most prominent figures were Antonio da Sangallo the Younger and Michelangelo. The latter worked as an architect on the restoration of the Campidoglio and the construction of Saint Peter's and the Palazzo Farnese. Michelangelo's late architectural work became an obligatory point of reference for all artists working in Rome in the second half of the century. With the church of the Gesù, Vignola established the prototype of the collective place of worship in the spirit of the Counter-Reformation. New spiritual requirements were met with an unprecedented devotional orientation of religious painting, which was challenged around 1600 by the sophisticated style of late Mannerism. The election of Sixtus V as pope (r. 1585–90) initiated a magnificent phase of urban renewal in Rome. With the collaboration of the Ticinese architect Domenico Fontana, the pope laid out new

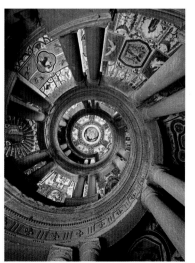

streets and boulevards, marked by obelisks, to link the basilicas with the city center, indicating as well the new directions in which Rome was to develop. Meanwhile, painters rebelled against the contrivances of Mannerism. The rediscovery of the "natural" lay behind the rethinking of art by two very different artists who came to Rome after 1590: Annibale Carracci and Caravaggio.

The immense nude figures hovering freely on the wall transmit a sensation of instability and uncertainty, reflective of the religious disquiet of those years.

The scene, devoid of all architectural context and projected onto a dense turquoise sky, features in the two upper lunettes bands of angels bearing the symbols of the Passion.

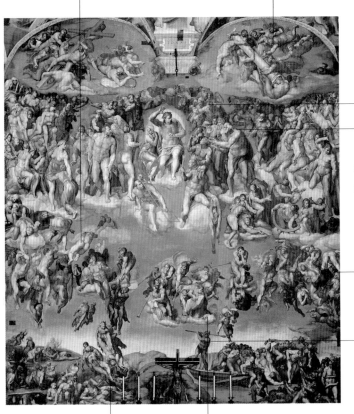

The assembly of saints, patriarchs, apostles, and martyrs clusters around the terrible Christ the Judge, before whom even the Virgin Mary seems to shrink in fear.

Among the saints we can recognize the majestic Peter and Paul. In front of Christ, on the right, Saint Bartholomew holds his empty skin, which conceals an anguished self-portrait of Michelangelo himself.

A battle rages between angels and demons, fighting over souls.

Just above the altar, we see Charon's boat and the boatman himself. He swings his oar at the damned souls debarking into the Inferno.

◄ Jacopo da Vignola, Spiral staircase of the Villa Farnese at Caprarola (Viterbo), built beginning in 1559.

The dramatic visual impact of the Last Judgment *mirrors Michelangelo's personal crisis and that of many of his contemporaries.*

The angels sound their trumpets to recall the dead to life. The archangel Michael, on the left, holds a register with the names of the chosen ones.

▲ Michelangelo, *Last Judgment*, 1536–44. Vatican City, altar wall of the Sistine Chapel.

Behind the pope stands his powerful nephew, the ever-vigilant Alessandro Cardinal Farnese.

The elderly pontiff, bony and bent with age, turns a sharp-witted gaze toward Ottavio.

The pose of the pope's lay nephew appears almost as a parody of one of the most renowned marble sculptures of antiquity, Myron's Diskobolos, or Discus Thrower.

The rapid, sketchy technique, with a few unfinished details, gives an impression of intrigue, a suffocating atmosphere.

Borrowing an idea from the portrait of Leo X painted by Raphael (page 215), Titian depicts the pope with his nephews Alessandro and Ottavio.

This was the most important painting done by Titian in the course of his only stay in Rome, during which he was able to meet Michelangelo and explore the developments of Mannerism.

▲ Titian, *Portrait of Paul III with His Two Nephews*, 1545. Naples, Museo di Capodimonte.

The telamons painted in grisaille simulate stuccowork, merging seamlessly with the actual three-dimensional decoration of the walls.

The main scene is the Triumph of Bacchus and Ariadne. Thus Annibale Carracci completed the path that took him from his Bologna years, during which he painted "from life," to formulating the learned and eclectic code of classical academicism.

In the luminous quality of the landscapes and in his use of color, Carracci imitated the light tones of Correggio's painting.

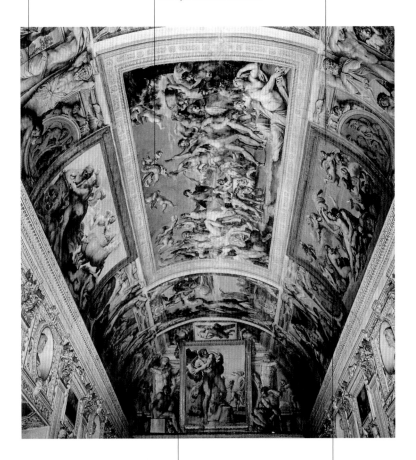

▲ Annibale Carracci, Vault of the gallery of the Palazzo Farnese, Rome, 1597–1602.

This room, today the main reception room of the French Embassy in Rome, was transformed into a veritable collection of ancient paintings with mythological subjects, overlying the architectural structure of the room.

Illusionistic gilded cornices, richly matched with false stuccowork and antique-style motifs, frame a series of episodes, simulating a gallery of paintings hanging from the ceiling.

Capital of humanism and the early Renaissance, Florence lost its standing as the beacon of the arts to Rome. Still, its creative fervor remained astonishing.

Florence

At the turn of the 16th century, Gonfalonier Pier Soderini headed an oligarchic government in Florence. Thanks in part to commissions of powerful symbolic significance, such as Michelangelo's *David,* art underwent a radical renewal, with rivalry between Leonardo and Michelangelo and the arrival of Raphael. In just a few years, however, Leonardo went back to Milan, and Michelangelo and Raphael left for Rome. At the school of Andrea del Sarto, a new generation of artists was trained, including Pontormo and Rosso Fiorentino. The consequences of the imperial siege of Florence (1529–30) were damaging: Michelangelo left for Rome, Rosso went to France, and Pontormo descended into solitary brooding, while Andrea del Sarto died in 1531. Charles V restored Medici power over the city. The duchy of Cosimo I de' Medici (r. 1537–1574) marked a new direction in Tuscan art. Bronzino, the official court painter, set a model for international Mannerism. Cellini, Vasari, Buontalenti, Ammanati, and Giambologna adopted theatrical solutions for Florentine architecture and urban furnishings, and the city became a stage setting for power. The Palazzo Vecchio, the court residence, was linked to the new Palazzo degli Uffizi. The Vasari Corridor was built to connect the Uffizi to the Palazzo Pitti and the new Boboli Gardens over the Ponte Vecchio. The 1568 edition of Vasari's *Lives* and the construction of a majestic tomb for Michelangelo in the church of Santa Croce (1570) both projected a potent grand-ducal image.

The measured, composed perspectival views employed by Tuscan painters almost to the end of the 15th century were replaced in this extravagant structure of an altar-qua-temple by an eclectic assemblage of classical architectural motifs, whimsically overlapping.

The frescoes in the Strozzi Chapel mark in an explicit and even dramatic manner the transition from Florentine humanism—based on equilibrium and harmony—to a new period.

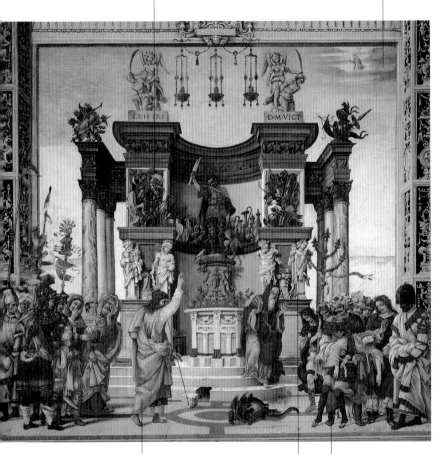

Saint Philip is exorcising a dragon that has nested beneath the steps of a church and has been poisoning the faithful with its pestilential breath.

The dizzying continuum between sculptures, reliefs, votive offerings, panoplies, polychromed statues, and realistic details conveys a sense of instability that resonates through the groups of figures.

The rhetorical gestures, the caricatured expressions, the surreal colors, the ambiguity of architecture and figures, all combine to make Filippino Lippi a precursor of a stylistic renewal.

◄ Enameled plaque with a view of the Piazza della Signoria at the end of the 16th century. Florence, Museo degli Argenti.

▲ Filippino Lippi, *Saint Philip Expelling the Dragon from the Temple of Hieropolis*, 1502. Florence, Santa Maria Novella, Strozzi Chapel.

The construction of the New Sacristy adjoining the basilica of San Lorenzo, with the tombs of the Medici, was unquestionably the most important artistic project undertaken in Florence during the 1520s.

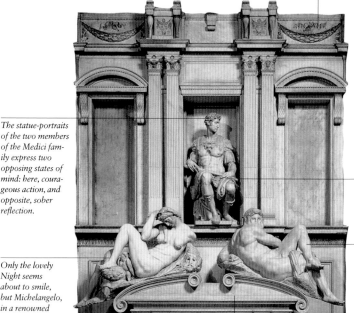

The statue-portraits of the two members of the Medici family express two opposing states of mind: here, courageous action, and opposite, sober reflection.

Giuliano de' Medici, duke of Nemours, who seems about to leap to his feet, depicts the mind of action.

Only the lovely Night seems about to smile, but Michelangelo, in a renowned quatrain, underscores that the apparent serenity of the figure is merely due to her surrender to sleep and forgetting.

The allegorical figure of Day allows a frightening face to emerge from the screen of massive muscles, almost the visage of a phantom.

Each of the allegorical statues communicates a different, specific sense of unease. Only a careless viewer would think they were similar, even though they are taken from the classical model of river gods.

▲ ► Michelangelo, *Sepulchral Monuments to Lorenzo and Giuliano de' Medici*, ca. 1525. Florence, New Sacristy.

On the side walls are located the tombs of two young members of the house of Medici, both of whom died prematurely.

The luminous indoor space, with exactly the same volume as the symmetrical Old Sacristy built by Brunelleschi almost a hundred years previously, contains the vibrant tension between the white walls, the profiles in gray stone, and the sculptures.

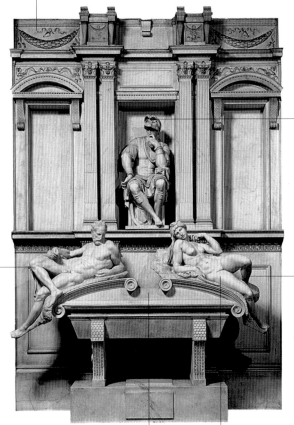

Lorenzo, duke of Urbino, is in a thoughtful pose, following the Renaissance typology of the "melancholic."

Evening sprawls out, with a weary expression that is hard to read.

The allegorical figures, perched in pairs over the sarcophagi, represent the four parts of the day: Dawn and Evening, Day and Night.

Beneath the statue-portraits of the two "dukes," the tombs fit into the rhythm of the architecture.

Dawn stretches out her limbs with a pained grimace.

225

Florence

The drapery in the background is reminiscent of the images of French kings, while the armor has significant parallels in Spanish imperial portraiture. The tradition of the state portrait was being established.

The ruler of Florence performs a double torsion of chest and neck, in keeping with the "serpentine" line of the Mannerists. All the same, the image remains substantially bulky.

Cosimo I, having gained the title of Grand Duke of Tuscany, moved the family residence from the 15th-century Medici palazzo in the Via Larga to the Palazzo Vecchio; adjoining it he built a grand administrative building, the Palazzo degli Uffizi.

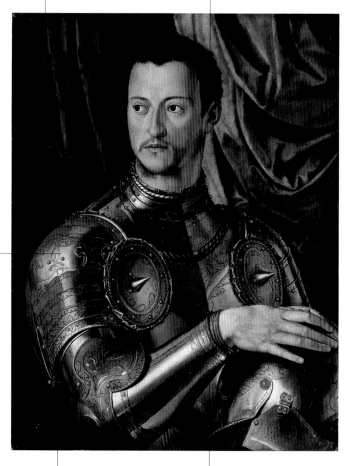

Cosimo considered this portrait to be his official image, and he ordered numerous copies made.

▲ Agnolo Bronzino, *Portrait of Cosimo I*, 1545. Florence, Uffizi.

Bronzino establishes with extraordinary efficacy the chilly gleam of the armor, conferring upon the entire image a sense of impenetrable, solid hardness.

Many of the panels in the Studiolo refer to a sophisticated syncretism among mythology, science, hermeticism, and research, accurately reflecting the tastes of Francesco I, a refined collector and a passionate scholar of alchemy and the natural sciences.

The private study, or Studiolo, of the grand duke Francesco I, a small private room next to the immense Salone dei Cinquecento, was designed and decorated as an exquisite jewel box.

A collective masterpiece of Florentine art during the second phase of Mannerism, the Studiolo alternates niches containing refined statuettes by sculptors like Ammanati, Giambologna, Bandini, and Vincenzo de' Rossi (there are four such at the back, in the second tier) with thirty-four panels painted by Stradanus, Alessandro Allori, Maso da San Friano, Santi di Tito, Girolamo Macchietti, Mirabello Cavalori, and Jacopo Zucchi.

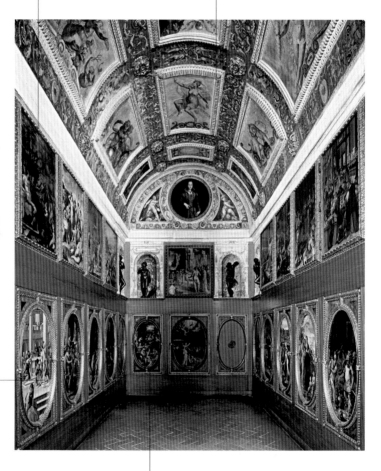

▲ Studiolo of Francesco I, 1570.
Florence, Palazzo Vecchio.

The Palazzo Vecchio was the principal laboratory of Florentine art in the second half of the 16th century. The work done by Bronzino and Salviati during the 1540s for Cosimo I was followed by the radical renovations carried out under Vasari during the 1560s: the grand staircase, the painted coffered ceiling in the Salone dei Cinquecento, and the stuccoed decoration of the courtyard.

In the first half of the century, Siena's proud independence was expressed through commissions and artists of great evocative power, in a constant dialogue with the city's venerable cultural tradition.

Siena

Domenico Beccafumi
Montaperti (Siena)
ca. 1484–Siena 1551

School
Tuscan

Principal place of residence
Siena

Travels
Long visits in Rome
(1509–10), Genoa
(1532–33), and Pisa
(1537–39)

Principal works
Various altarpieces now in
the Pinacoteca Nazionale
of Siena; designs for the
floor of the Duomo; fres-
coes in the Palazzo
Pubblico

Links with other artists
Contacts with Pinturicchio
and Sodoma in Siena,
Raphael and Michelangelo
in Rome; dialectical rela-
tionship with the
Florentine school of the
first phase of Mannerism

Protected from and independent of Florence, Siena thrived under the rule of Pandolfo Petrucci. The Duomo, or cathedral, was the main artistic project under way in the city. Michelangelo made marble statues for the Piccolomini altar, and in 1502 Pinturicchio frescoed the elegant Libreria Piccolomini, in part using drawings by Raphael. In the same period, the Piedmontese artist Giovanni Antonio Bazzi, known as Sodoma, arrived in Siena, bringing with him an expressive Leonardesque style that he had acquired in Milan. The leading figure in 16th-century Sienese art was Domenico Beccafumi. A painter and a sculptor in bronze, he worked almost without interruption for forty years in his native city, transforming the untroubled decline of a venerable capital into an experimental workshop for effects of light, color, and expression. Beccafumi died in 1551, while Cosimo I de' Medici was casting his covetous gaze on Siena. In 1553, the city was sur-rounded by a formidable army made up of Spanish, German, and Florentine troops. Siena put up a heroic resistance: after two years of extremely harsh siege, 24,000 troops broke into the city, finding only 8,000 survivors. Siena's artistic history effectively ended there.

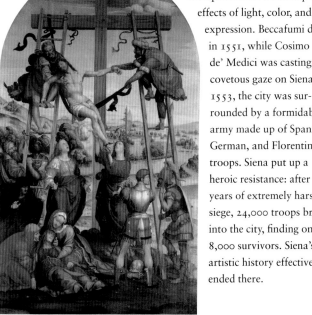

► Sodoma (Giovanni Antonio Bazzi), *The Deposition from the Cross*, 1519. Siena, Pinacoteca Nazionale.

Particularly effective is the background, combining architectural ruins with glimpses of savage nature.

The otherworldly scene, with the risen Christ freeing the patriarchs from Limbo, allowed Beccafumi to make an extremely evocative use of oblique, reflected light.

Beccafumi offers a highly personal interpretation, anxious and intense, of the forms and poses typical of Mannerism.

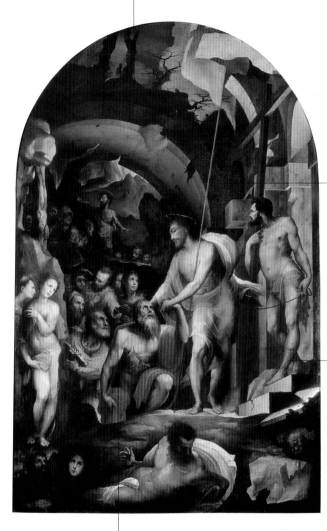

▲ Domenico Beccafumi, *Christ's Descent into Limbo*, 1536. Siena, Pinacoteca Nazionale.

The figure of Christ, like many other figures in this scene, reveals a careful study of Michelangelo's models, without a great deal of exaggeration.

*The world looked to the "most triumphant city in the universe"
with an admiration that concealed envy for its commercial empire,
its diplomacy, and the wonders of its art and architecture.*

Venice

The independence and pomp of Venice were mirrored in an urban
setting and an artistic school without rivals. Giovanni Bellini was
the master of a generation never to be repeated (Giorgione, Titian,
Lotto, and Sebastiano del Piombo), characterized by a remarkable
exploration of light and color. The ambitious Andrea Gritti,
elected doge in 1523, gave the city a new, more dynamic image, in
keeping with a well-thought-out program of construction and dec-
oration. With Sansovino's arrival in the city, the canons of classi-
cism became the stylistic code of an architecture of power. For
decades, the art scene was dominated by Titian, but toward mid-
century there was an influx of figurative models linked to Tuscan
and Roman Mannerism. Among the emerging artists were Paolo
Veronese and Jacopo Tintoretto. In the 1560s, Venice's popula-
tion topped 170,000. (Today's population is less than
half that.) Palladio began work on the church
and monastery complex of San Giorgio
Maggiore, opposite the basilica of San
Marco, while Sansovino's buildings sprang
up at significant points in the city's
topography. In 1570, the Ottoman
Empire attacked Venice's posses-
sions in the eastern
Mediterranean, while the
Venetian naval victory of Lepanto
(1571) had only symbolic value.
The separate peace signed by the
Venetian senate endorsed the loss
of Cyprus. In 1577, fire devas-
tated the Doge's Palace, symboli-
cally marking the end of an era.

▶ Venetian wood carver,
*Allegory of Venice as an
Image of Justice*, statue
for the official gondola
(Bucintoro) of the doge
Andrea Gritti, 1525. Venice,
Museo Navale.

The enormous altarpiece, more than seven
meters high, was installed in 1518 on the main
altar of the Gothic Franciscan basilica. It doc-
uments Titian's complete supremacy over all
Venetian art.

The treatise author
Ludovico Dolce
wrote (1557):
"Unskilled painters
and the foolish pop-
ulace, who had not
seen till that time
anything other than
the cold, dead cre-
ations of Bellini and
Vivarini, devoid of
relief and move-
ment, had only bad
things to say about
that altarpiece."

The ascending
movement of the
Virgin Mary is
accentuated by the
torsion of the figure,
the surrounding ring
of angels, and the
figure of God the
Father above, not
axial but inclined to
one side.

Thanks especially to
the dazzling power
of his colors, Titian
succeeded in merg-
ing together the
three distinct planes
in which the scene
takes place.

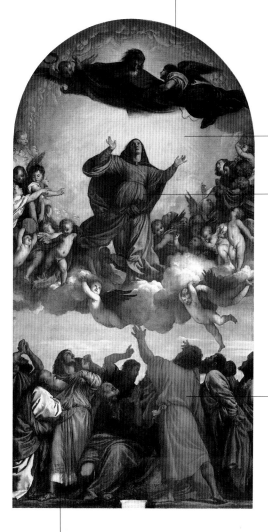

▲ Titian, *The Assumption of the
Virgin*, 1516–18. Venice, basilica of
Santa Maria Gloriosa dei Frari.

For the monumental figures of the
apostles, it seems that Titian used as
models, not the proportions of clas-
sical statuary, but fishermen from
the lagoon.

Andrea Gritti, who was elected doge in
1523 and died in 1538, was responsible
for the classicist imprint that distin-
guished Venetian architecture of the
High Renaissance.

The sense that the
painting is a "monu-
ment" to the mem-
ory of a man of
action explains the
dynamic rotating
motion, completely
different from the
typical official pose
and especially the
painting's remark-
able "unfinished"
quality. Titian's work
with color can be
compared with
Michelangelo's treat-
ment of marble.

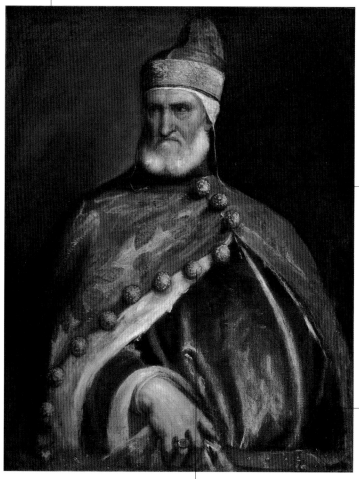

As was the case with
other major figures
of the international
political scene, Titian
tended to identify
with the personality,
determination, and
iron will of the doge.

▲ Titian, *Posthumous Portrait of Doge
Andrea Gritti*, ca. 1546–48. Washington,
D.C., National Gallery of Art.

The portrait, which preserves the
painting's intentionally rough and
grainy surface, was executed a few
years after Gritti's death.

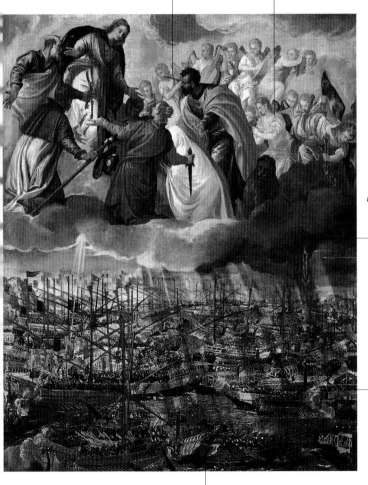

Executed for the church of San Pietro Martire, on Murano, this is one of many artworks commemorating the naval victory of the Christians over the Ottoman fleet, in 1571.

Here, the outcome of the battle remains uncertain, and a group of Venetian saints asks the Virgin Mary to intercede.

The celestial army fights side by side with the Christians: the angels hurl darts that become thunderbolts.

The actual battle takes place below, with the chaotic clash between Turkish and Christian galleys, roughly half of them Venetian.

▲ Paolo Veronese, *Commemorative Allegory of the Battle of Lepanto*, 1571. Venice, Galleria dell'Accademia.

Despite the naval victory, the war ended with a Venetian loss, forcing the republic to cede the island of Cyprus to the Turks.

*A golden divine light pours through
the intricate beamed ceiling,
allowing Tintoretto to portray an
unusual perspectival grid.*

The Adoration of the Shepherds *is one
of the most renowned of the Gospel
scenes that line the walls of the great
Renaissance hall.*

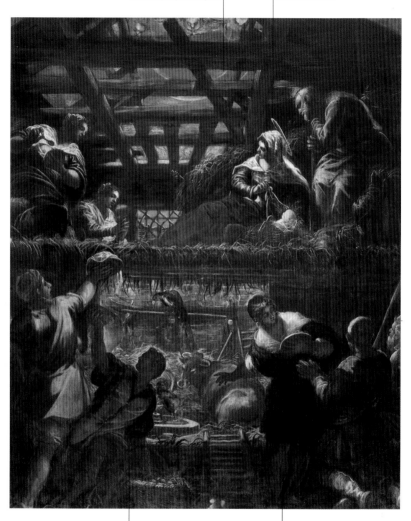

▲ Jacopo Tintoretto, *The Adoration of
the Shepherds*, 1577–78. Venice, Scuola
Grande di San Rocco.

*The series of paintings for the Salone
Superiore of the Scuola Grande di
San Rocco, thirty canvases in all,
was done by Tintoretto between
1576 and 1581, in parallel with the
beginning of his work on the redeco-
ration of the Doge's Palace.*

*Making good use of his creative talent
for the interpretation of perspective
and points of view, Tintoretto painted
a hut in Bethlehem on two levels, with
the shepherds arriving downstairs and
the Holy Family upstairs.*

In the Po Valley, between Lombardy and Emilia, a "third way" developed for art, independent both of central Italian Mannerism and Titian's exaltation of color.

Lombard Region

In many northern Italian towns, a clear artistic evolution was going on. Lorenzo Lotto in Bergamo, Gaudenzio Ferrari in Varallo, Correggio in Parma, Giovanni Antonio da Pordenone in Cremona and Piacenza—the Brescian and Bolognese masters did not so much form a unitary school as offer a series of solutions. Brescia and Bergamo, both close to Milan but longtime possessions of the Republic of Venice, developed a distinctive local figurative culture, marked by a fervent quest for reality, a love of everyday objects, the capacity to delve into melancholy and disquiet, and an early grasp of the Counter-Reformation ideas for sacred art. Ferrari was the mastermind behind the Sacro Monte of Varallo, a remarkable combination of folk religiosity and very modern formal treatments, with the unification of sculpture and painting. In Parma, a dialogue developed between Correggio's soft allure and Parmigianino's intellectual approach. In Bologna, finally, the enduring influence of Perugino and Raphael was interrupted on the occasion of the solemn coronation of Charles V (1530), when artists from various regions, including Michelangelo and Titian, converged upon the city, prompting a thoroughgoing rethinking of the developments of the High Renaissance. Bologna, "the Learned," thus became a major center for collectors and artistic debate.

1513: Lorenzo Lotto moves to Bergamo; Gaudenzio Ferrari frescoes the great wall of Santa Maria delle Grazie in Varallo.
1522: Titian's Averoldi polyptych arrives in Bergamo, becoming a point of reference for the local school.
1527: The Papal States cede Parma and Piacenza to the Holy Roman Empire; Alfonso d'Este seizes Modena and Reggio.
1530: Solemn coronation of Charles V.
1534: Death of Correggio.
1545: Parma and Piacenza are bestowed as a Farnese fief.
1547: The Council of Trent is temporarily moved to Bologna.
1582: The Carracci family founds the Accademia degli Desiderosi in Bologna.

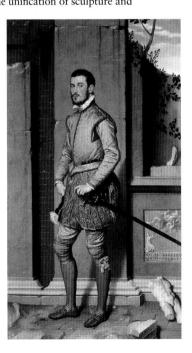

◀ Giovanni Battista Moroni, *Portrait of Gian Gerolamo Grumelli (Cavaliere in Rosa)*, 1560. Bergamo, Palazzo Moroni.

On the vast wall of the Romanesque cathedral, Pordenone laid out his dramatic and absorbing theatrical style, creating a whirling composition of great popular impact.

The scene covers the huge interior wall of the cathedral's facade. It is the most impressive of the scenes of the Passion painted by the Friuli-born artist, part of the major painting cycle by a variety of artists that decorates the interior of Cremona's cathedral.

A stormy, overcast atmosphere suggests fluctuating light effects; the three crosses are arranged asymmetrically and at an angle.

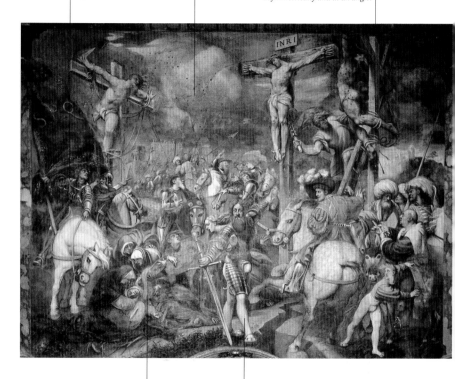

The great expressiveness and the folk pathos link this fresco by Pordenone to the spirit of the northern Italian "Sacri Monti."

The crowd surges this way and that; the harshly foreshortened horses have an almost demonic appearance; and the entire composition rotates around the giant mercenary soldier at the center.

▲ Pordenone, *The Crucifixion*, 1520–22. Cremona, cathedral.

The luminous natural atmosphere is highly reminiscent of Giorgione's pastoral elegies.

Savoldo is unfailingly attentive to the psychological and human relationships among his characters.

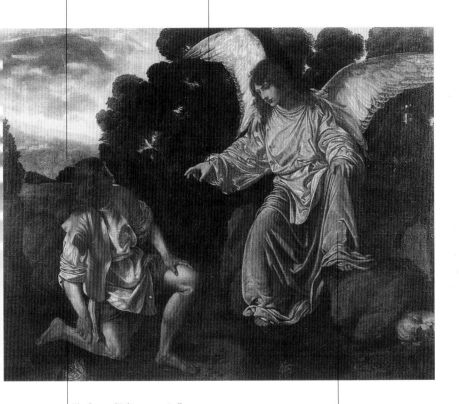

The figure of Tobias energetically embodies the requirement, typical of 16th-century Brescian painters, that realism be straightforward and immediate, but never vulgar.

Exquisite reflections, as if from silk, gleam on the angel's lavish drapery, reminiscent of the detail of Gabriel in Titian's polyptych for Brescia a few years previously.

▲ Giovanni Girolamo Savoldo, *Tobias and the Angel*, ca. 1527. Rome, Galleria Borghese.

Three small capitals struggled to maintain their roles as brilliant centers of architectural and decorative projects. This was the golden sunset of Italy's Renaissance courts.

Mantua, Ferrara, and Urbino

In Mantua, the chief force in the cultural scene was Isabella d'Este, whose correspondence with various painters provides an extraordinary documentation of the relationship between clients and artists. Her Studiolo contained paintings (now at the Louvre) by Mantegna, Perugino, Lorenzo Costa, and Correggio. Like her brother, Alfonso d'Este, Duke of Ferrara, Isabella also commissioned work from Titian. Alongside her initiatives came those of her son Federico, who shifted the art of the court in a "modern" direction. In 1524, Giulio Romano arrived in Mantua: his Palazzo Te (1527–34) was an exemplary workshop of architectural and decorative innovations. The chief artist in Ferrara was Dosso Dossi. The presence of a great literary figure, Ludovico Ariosto, encouraged a cultural climate in Ferrara that tended toward the fanciful and evocative. Dosso was one of the artists involved in the decoration of the Studiolo of Alfonso d'Este (destroyed in 1598), for which Titian had painted the magnificent Bacchanales. In Urbino, the Della Rovere family commissioned art from Titian as well as Federico Barocci, an interpreter of the tradition of Raphael in a Counter-Reformation context.

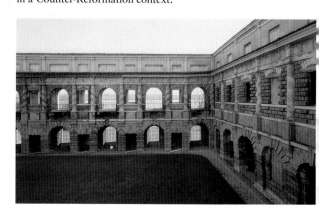

▶ Giulio Romano, Cortile della Cavallerizza, ca. 1530. Mantua, Palazzo Ducale.

238

A remarkable Renaissance figure, a refined patroness of many artists, and the true mastermind of the Gonzaga collections, Isabella was the sister of Duke Alfonso d'Este of Ferrara and of Duchess Beatrice d'Este of Milan, the wife of Ludovico il Moro.

With the characteristic graciousness that marked her actions, her taste, and her letters, Isabella d'Este wrote: "Our portrait by the hand of Titian pleases us so that we doubt whether we ever were, at the age when we were portrayed, as beautiful as in that painting."

▲ Titian, *Ideal Portrait of Isabella d'Este*, 1536. Vienna, Kunsthistorisches Museum.

At the time, the marchioness was actually over fifty. She sent Titian a portrait painted three decades earlier and asked him to reinvent that image.

Alfonso d'Este drew up an iconographic program with a high literary tone for his Camerino in the Castello Estense, but unlike his sister (who preferred paintings inspired by the arts and love), he chose an exuberant protagonist for his mythological series: the god Bacchus.

In this painting, the third and last work in Titian's series, a festival of wine and love is held to celebrate the arrival of Bacchus on the island of Andros.

Titian's work on Alfonso's Camerino dei Baccanali was finished around 1529, when he modified the landscape of The Feast of the Gods, *painted by Giovanni Bellini fifteen years before.*

The Bacchanales series, a triumph of Titian's mythological painting, constituted the core of the decoration of Alfonso's Camerino. It competed with the comparable room created in Mantua by his sister Isabella d'Este.

▲ Titian, *Bacchanalia of the Andrians*, 1519–20. Madrid, Prado.

The scintillating colors, the festive but not vulgar sensuality, and the warm light make this one of the finest secular paintings of all time.

The prevailing reference to the colors and luminous atmospheres of Venetian art is here combined with the tireless quest for esoteric and literary seductions that characterized the Ferrarese school.

The traditional identification of this figure as the terrible sorceress from the Odyssey has now shifted; she is now believed to be the beneficent enchantress Melissa, described by Ariosto in Orlando Furioso.

Dosso Dossi offers a persuasive essay in stylistic versatility and evocative brilliance, contrasting the glittering armor with the lavish brocade of the woman's gown.

The landscape once again harks back to the unforgettable vision of Giorgione, with whom Dosso Dossi spent a formative period of his education.

Dosso Dossi, *Melissa (or Circe the Enchantress)*, 1522–24. Rome, Galleria Borghese.

In contrast with the Sleeping Venus *of Dresden, left unfinished by Giorgione and completed by Titian (pages 300–31), this young woman is not sleeping but staring at the viewer with warm intensity.*

The handmaidens rummaging through a clothing chest give a touch of domestic authenticity to the background.

It is perhaps best to leave it to the taste and sensibilities of the reader to judge the meaning of the gesture of the goddess's left hand: that is, whether this is simply a pose of mannerly modesty or, on the contrary, an openly erotic contact.

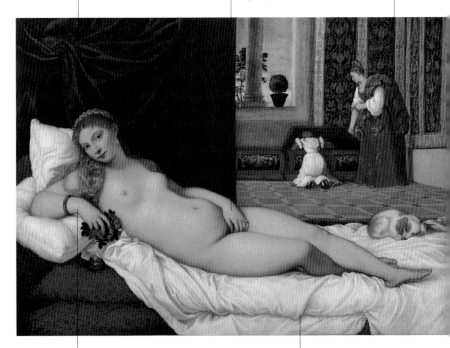

"A youthful Venus, lying down, with flowers and certain very fine cloths around her, very lovely and well made." Vasari cited this master-piece as if he were the lapdog curled up at the foot of the bed, showing more appreciation of the soft, cozy cushions than the enchanting figure lying upon them.

The canvas was commissioned in 1536 by Guidobaldo della Rovere, the duke of Urbino; it has been extraordinarily popular and was copied countless times.

▲ Titian, *Venus of Urbino*, 1538.
Florence, Uffizi.

The fine complexion, done in almost pastel tones, is a typical characteristic of Barocci's art.

The pose is openly inspired by Titian's portrait of Philip II in armor. Francesco Maria attempted to emulate in every way possible the monarch for whom he had fought valorously at the Battle of Lepanto, and for his pro-Iberian loyalty he was dubbed "Anima de España."

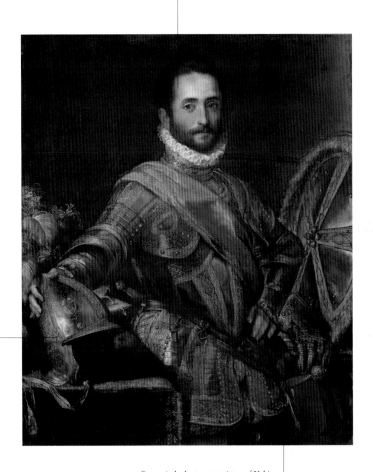

Barocci, the last great painter of Urbino, certainly had in mind the portraits of the Della Rovere family by Titian, but he confers upon this portrait a touch of ineffable melancholy. This is in effect a work from the dwindling twilight of the last of the small Italian principalities.

▲ Federico Barocci, *Portrait of Francesco Maria della Rovere, Duke of Urbino*, 1572. Florence, Uffizi.

La Superba, or the Proud, as Genoa was known, was unique: an independent state almost devoid of territory and not particularly powerful militarily that nevertheless enjoyed immense wealth.

Genoa

In the first quarter of the 16th century Genoa stood by, from a pro-French position, as the wars raged for control over northern Italy. Throughout the western section of the Ligurian Riviera, or Ponente, as well as in the city of Genoa itself, the Provençal influence of the Brea brothers remained strong, with occasional new Lombard or Leonardesque ideas brought to Savona by Giuliano della Rovere, who later became Pope Julius II. The historic ties between Flanders and Genoa continued with the arrival of such masters as Gerard David (1506) and Joos van Cleve. The taste in altarpieces began to change with the arrival in the Genoese church of Santo Stefano of the monumental work by Giulio Romano, *The Stoning of Saint Stephen* (1520), in step with the latest Raphaelesque style. In 1528, Andrea Doria took power, reforming the constitution of the republic and redefining its diplomatic and financial terms with Spain under Charles V, for whom

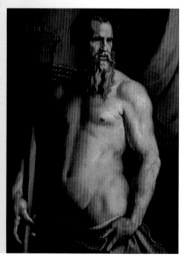

the Genoese bankers were now the chief financiers. Andrea Doria associated a "modern" artistic and architectural image with his new regime and administration. The center of the artistic initiatives was the so-called Palazzo del Principe, his splendid residence on the outskirts of the city, where Perino del Vaga painted celebratory frescoes in an openly classical style, comparable to the solutions of Giulio Romano in the Palazzo Te in Mantua. Beginning in the middle of the 16th century, Genoa's extraordinary prosperity was mirrored in the grand residences that lined the spectacular "Strada Nuova," designed by Galeazzo Alessi. The favorite setting for Genoa's aristocracy, the palazzi of the Strada Nuova were the venue for a florescence of great secular decoration, while Luca Cambiaso helped to found an independent and fully modern school of painting.

The composition can usefully be compared with a similar scene painted by Giulio Romano in Mantua (pages 52–53). Perino and Giulio were two of Raphael's most talented pupils in their early years.

The commissions of Andrea Doria contributed in a timely manner to the diffusion of Mannerism in Europe, in the wake of the exodus of artists from Rome after the sack of 1527.

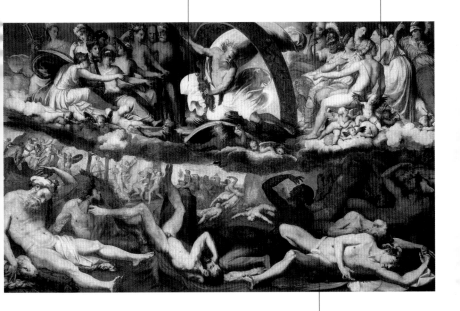

Jupiter is driving the giants from Mount Olympus, as the other gods and goddesses look on. The bodies of the fallen giants offer a powerful anthology of Mannerist anatomy.

◄ Angolo Bronzino, *Portrait of Andrea Doria Dressed as Neptune*, ca. 1540. Milan, Pinacoteca di Brera.

▲ Perino del Vaga, *Fall of the Giants*, 1530. Genoa, Palazzo Doria "del Principe."

LEADING ARTISTS

Pieter Aertsen

Albrecht Altdorfer

Andrea del Sarto

Giuseppe Arcimboldi

Hans Baldung Grien

Federico Barocci

Jacopo Bassano

Alonso Berruguete

Hieronymus Bosch

Agnolo Bronzino

Pieter Bruegel the Elder

Hans Burgkmair

Antoine Caron

Annibale Carracci

Benvenuto Cellini

Jean and François Clouet

Correggio

Jean Cousin the Elder

Lucas Cranach the Elder

Luis de Morales

Adriaen de Vries

Dosso Dossi

Albrecht Dürer

Gaudenzio Ferrari

Frans Floris

Fra Bartolommeo

Giambologna

Giorgione

Giulio Romano

El Greco

Matthias Grünewald

Joseph Heintz

Nicholas Hilliard

Hans Holbein the Younger

Lorenzo Lotto

Lucas van Leyden

Mabuse (Jan Gossaert)

Quinten Metsys

Michelangelo

Antonis Mor

Parmigianino

Joachim Patinir

Germain Pilon

Jacopo Pontormo

Francesco Primaticcio

Raphael

Ligier Richier

Tilman Riemenschneider

Rosso Fiorentino

Jacopo Sansovino

Giovanni Girolamo Savoldo

Sebastiano del Piombo

Bartholomaeus Spranger

Jacopo Tintoretto

Titian

Joos van Cleve

Maerten van Heemskerck

Jan van Scorel

Paolo Veronese

Peter and Hermann Vischer

◄ Albrecht Dürer, *Self-Portrait*, 1500.
Munich, Alte Pinakothek.

Aertsen interpreted the shift in tastes in the second half of the 16th century with intelligent originality. His canvases were sought after by international collectors.

Pieter Aertsen

Amsterdam
ca. 1507–1575

School
Flemish

Principal place of residence
Antwerp

Principal works
Various versions of *Christ in the House of Martha and Mary*; kitchen and market scenes

Links with other artists
Other Antwerp masters of the second half of the 16th century, including Pieter Bruegel. His paintings circulated in Italy and especially influenced the Genoese school

Though he was born and died in Amsterdam, Aertsen spent much of his career in Antwerp, where he is documented from 1535 to 1560. There he assembled an interesting school, out of which emerged his nephew by marriage and artistic heir, Joachim Beuckelaer. In the artistic hotbed of late-Renaissance Antwerp, Aertsen did not conform to the widespread tastes of the "Romanists" but instead introduced everyday themes and a substantial, heartfelt realism. Indeed, he may be considered an immediate precursor of Pieter Bruegel and a pioneer of the nascent genre of the still life. He made an innovative decision to deemphasize on the nominal scene and to focus more attention upon opu-

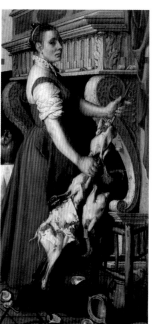

lent marketplaces and well-stocked kitchens. His references to characters and scenes from the Gospels became simply a narrative pretext for sketching scenes of everyday life, as would happen later with the *bodegones* of the young Velázquez, or even in Vermeer's early works. Marketplaces and kitchens had almost become self-sufficient subjects, thus laying the foundations—between the end of the Renaissance and the dawn of the Baroque era—for the birth of genre painting, which was immediately popular among princely collectors all over Europe.

▶ Pieter Aertsen, *The Cook*, 1550. Genoa, Galleria di Palazzo Bianco.

Altdorfer established himself as the leading painter of the Danube school, the artistic current in southern Germany that was characterized by an impassioned, romantic rendering of nature.

Albrecht Altdorfer

After training under his father, Ulrich, and following a possible trip to northern Italy, in 1505 Altdorfer moved to Regensburg. His style shifted from the meticulous miniaturistic approach of his youth to a grandiose sense of the monumental. One distinctive characteristic was his focus on nature, which resulted in the production of the first landscape paintings unfettered by any iconographic pretext. In 1513 he was summoned by Emperor Maximilian of Habsburg to Innsbruck, where he began working on various commissions for the court. In the 1520s, as matters became increasingly worrisome in the wake of the Reformation, Altdorfer worked primarily on the architecture of public buildings, and his production of paintings slowed. In his paintings in this period we note a careful attention to the perspectival and architectural context. Altdorfer got involved in politics during the third decade of the century, becoming first a member of the city council and later "city architect," in charge of the fortifications of Regensburg. In 1528, he was offered the position of burgomaster, but Altdorfer declined because of the demands of *The Battle of Alexander at Issos*, which he was painting for Duke William of Bavaria. In the years that followed, he would paint only a few works, a reflection of the tension between the Catholic tradition and the Lutheran Reformation.

Regensburg or Altdorf
ca. 1480–Regensburg 1538

School
German

Principal place of residence
Regensburg

Travels
Various trips and long stays in southern Germany and the Tirol; he may also have traveled to Lombardy

Principal works
Panels with *The Passion of Christ* (1509–16, Abbey of St. Florian, near Linz); *Saint George and the Dragon* (1510, Munich, Alte Pinakothek); *Battle of Alexander at Issos* (1529, Munich, Alte Pinakothek)

Links with other artists
In the court of Innsbruck, direct contacts with Dürer and Burgkmair. Possible relationships with Italian masters, including Leonardo

◄ Albrecht Altdorfer,
Landscape of the Danube Valley, ca. 1520. Munich, Alte Pinakothek.

During his career, Altdorfer received and carried out various commissions as an architect, and his eclectic creativity is confirmed here by the complicated, original structure of the church, an unusual setting for the event in question.

A ring of angels emphasizes the composition's spatial and perspectival depth.

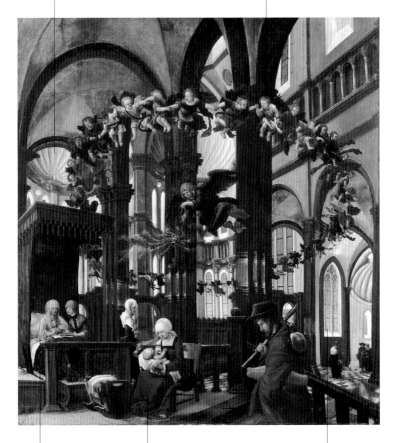

The main subject, with Saint Anne in bed following the birth, is in the background.

In this symbolic sacred building, which is meant to emphasize the typically Catholic analogy between the Virgin Mary and the Church, we find a convergence of Romanesque (ambulatory, galleries with small columns), Gothic (ogival windows), and Renaissance (barrel-vault ceilings, seashell-shaped niches) architectural elements.

▲ Albrecht Altdorfer, *The Birth of the Virgin*, ca. 1520. Munich, Alte Pinakothek.

The newborn Mary is in the midwife's arms, while in the foreground, Joachim, Saint Anne's husband, is approaching.

Altdorfer was commissioned to paint the final battle in the war between Alexander of Macedon and the Persians under King Darius (333 B.C.).

In the desire to confer a "classical" appearance upon his residence, Duke William IV of Bavaria summoned various painters to work upon two series of panels that depicted historic episodes involving illustrious heroes and heroines of antiquity.

The landscape, one of the most captivating in the entire history of art, may have been inspired by the Salzburg area. In an exceptionally evocative atmosphere, the sun is setting behind endless mountain chains, while the sickle moon gleams in the sky above.

Despite the painting's small size, the two armies, the movements of the troops, and the encampments can clearly be made out. Alexander, dressed in a golden suit of armor near the center of the painting, is galloping in pursuit of the chariot in which Darius is attempting to flee.

This work was painted during a time of bloody battles upon European soil, and the victory of the "Greek" Alexander over the "Eastern" Darius might be taken as a metaphor for the recurring wars against the Turks.

▲ Albrecht Altdorfer, *The Battle of Alexander at Issos*, 1529. Munich, Alte Pinakothek.

He proposed an elegant updating of the Florentine tradition with ample scope, "modern" without any of the daring polemics of the early Mannerists, who were all pupils of his.

Andrea del Sarto

Andrea d'Agnolo
Florence 1486–1531

School
Florentine

Principal place of residence
Florence

Travels
In his youth, two trips to Rome and one to Venice. One-year stay (1518–19) at the court of the king of France, Francis I

Principal works
Frescoes in Florence (Scalzo cloister, 1515; various frescoes in the church of the Santissima Annunziata; *Last Supper of San Salvi*, 1529)

Links with other artists
Key figure for generations of Florentine artists: a pupil of Piero di Cosimo, influenced by the works of Leonardo and Fra Bartolommeo, he was the master of Pontormo and Rosso Fiorentino

The appellation "painter without errors," coined by Vasari as a term of praise, strikes us instead as reductive when applied to the variety of themes and the excellence of formal development of this Florentine master. The son of a tailor (Italian *sarto*), he trained as a painter with Piero di Cosimo. Andrea soon stood out for his skill as a copyist, and he soon conquered the techniques of the great masters. In 1508, he opened his own workshop. Just as he began his career, Michelangelo, Leonardo, and Raphael left Florence, and the young Andrea found himself called upon to fill the "void" that had suddenly opened in the local school. His first major public commission was the series of frescoes for the Chiostrino dei Voti in the church of Santissima Annunziata. After a trip to Rome, during which he met Raphael and saw the works of Michelangelo and Sansovino, Andrea began his innovative grisaille decoration of the cloister of the Florentine confraternity of the Scalzo, a fundamental work for the development of Florentine design in the early

16th century. His noble, painstaking, measured style influenced a generation of emerging artists, including Pontormo and Rosso Fiorentino. He completed *The Madonna of the Harpies* (Florence, Uffizi) just before a trip to France in 1517, in the wake of Leonardo and prior to the arrival of Rosso Fiorentino.

▶ Andrea del Sarto, *The Sacrifice of Isaac*, ca. 1529. Madrid, Prado.

The structure of the group freely improvises on the traditional triangular scheme of the Sacra Conversazione of the 15th century.

The energetic pose and evident musculature of Saint John the Evangelist echoes comparable figures by Michelangelo.

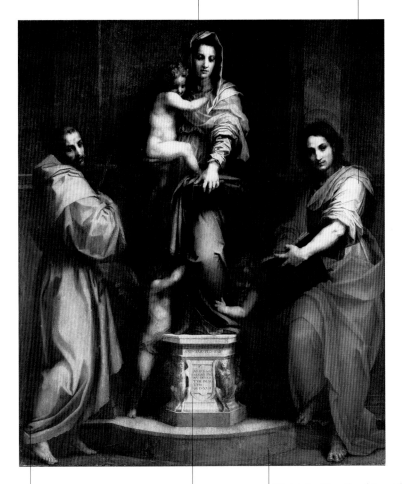

The figures strike eloquent poses, without the slightest physical strain, while the modeling, with its soft sfumato transitions, is reminiscent of Leonardo.

This painting falls midway between the declining confidence of humanism and the tensions of Mannerism.

The painting takes its name from the figures decorating the Virgin's pedestal. Vasari called them "harpies," but they are actually sphinxes, a symbol of the ancient wisdom that serves as a foundation for Christian faith.

▲ Andrea del Sarto, *The Madonna of the Harpies*, 1517. Florence, Uffizi.

Arcimboldi's "composite heads," a virtuoso expression of Mannerism and a demonstration of his exceptional talent, are one of the 16th-century's most unmistakable creations.

Giuseppe Arcimboldi

Also called Arcimboldo; Milan 1527–1593

School
Northern Italian–international Mannerism

Principal place of residence
Milan, then Prague (from 1562 to 1587), and then Milan again

Travels
As a consultant to Rudolf II, he traveled to purchase artworks and natural curiosities

Principal works
Series of the Four Seasons (1563) and the Four Elements; *Rudolf II as Vertumnus* (ca. 1509, Stockholm, Skoklosters Slott)

Links with other artists
In Milan, he received the late Leonardesque heritage from artists in the circle of Lomazzo and Figino; in Prague he participated in the school assembled by Rudolf II

▶ Giuseppe Arcimboldi, *Allegory of Summer*, 1563. Vienna, Kunsthistorisches Museum.

Arcimboldi's youthful production, reflecting the tranquil, almost sleepy Lombard school of the mid-16th century, does little to hint at this artist's highly original later developments. Summoned to Prague in 1562, Arcimboldi unleashed a series of unprecedented and bizarre fantasies, composing portraits and allegories through the juxtaposition of various objects, animals, fruits, flowers, or other natural elements. His style, occasionally interpreted as a forerunner of Surrealism or dismissed as an amusing and isolated extravagance, should rather be considered in the context of the decline of the Renaissance, when collectors of curios and university scholars were turning new attention to nature. Arcimboldi, moreover, based his work on the precepts and drawings of Leonardo, which were well known in Milan. For the court of Prague, the painter designed costumes, stage sets, and decorations. He also acted as the agent of Emperor Rudolf II in locating and buying artworks and naturalistic curiosities for his *Wunderkam-*

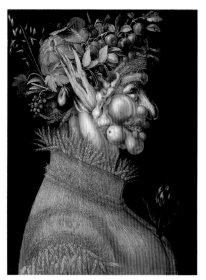

mer, as well as executing many paintings, often organized into thematic series, with complex allegories brilliantly resolved into strikingly dramatic images. In 1587 Arcimboldi returned to Milan. He stayed in touch with the emperor, however, and sent him the renowned portrait of Rudolf II as the god Vertumnus (page 58). In return, Rudolf II made him Count Palatine in 1592.

For a brief time, Baldung Grien struck a balance between the German Gothic heritage—full of legends, chivalry, and disquiet—and a monumental sensibility linked to Italian humanism.

Hans Baldung Grien

Baldung Grien moved to Strasbourg as a child, and the Rhenish city remained his preferred home. In 1503, he traveled to Nuremberg. There he met Dürer and became his most reliable assistant and one of his closest friends; when Dürer left for Venice, he entrusted his workshop to Baldung Grien. It was his love for green clothing that earned him the sobriquet of Grien, which of course means "green." After he returned to Strasbourg, he did devotional illustration for treatises on the Virgin Mary and painted nude maidens gazing at themselves in the mirror, stalked by Death, fairytale knights galloping through the woods, and Christs on the sepulcher. In 1510, he began to dedicate himself to themes linked to the image of the female body, ranging from monstrous and seductive figures of witches to allegorical figures. For four years, starting in 1512, he worked on the polyptych of the Freiburg cathedral: a large winged altarpiece, whose main panel features, at the center, the Coronation of the Virgin. The year after he finished this masterpiece, Baldung Grien returned to Strasbourg. The climate had changed by then, and strident voices heralded the Reformation; the painter was one of the first to respond to Luther's call. From that time on, his sacred works were few and small, and he focused instead on allegories and moralistic subjects, illustrations for books, and excursions into his favorite theme: witches.

Schwabisch Gmünd
1484/85–Strasbourg 1545

School
German, Rhenish

Principal place of residence
Strasbourg

Travels
Long visits in Nuremberg
(1503–9) and Freiburg
(1512–16)

Principal works
Polyptych of *The
Coronation of the Virgin*
(1512–16, Freiburg,
cathedral)

Links with other artists
He worked with Dürer in
Nuremberg; contacts with
Grünewald

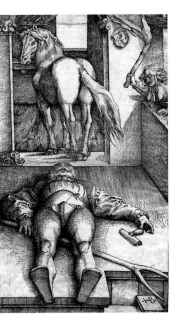

◄ Hans Baldung Grien,
The Bewitched Stable Boy,
ca. 1540.

255

Hans Baldung Grien

Thanks to a magical light that glows in the dark, Baldung Grien creates a delicate depiction of the silent night of Christmas, announced as well to the shepherd who can be glimpsed in the background.

The painting was done shortly before Baldung Grien converted to Lutheranism and stopped treating religious subjects.

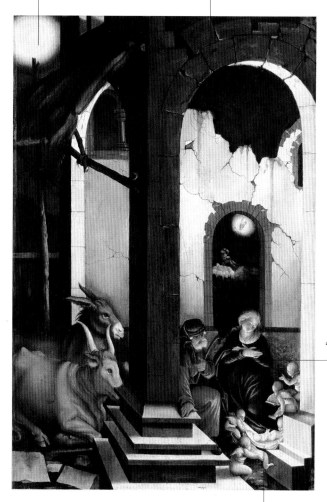

Mary, in compliance with her role as a devout Virgin, must pray, but she cannot restrain a smile, and her praying hands are impatient: soon she will cradle the luminous, defenseless, almost phosphorescent Christ child.

▲ Hans Baldung Grien, *The Nativity*, 1520. Munich, Alte Pinakothek.

Baby Jesus radiates the sweet light of any newborn, while even the ass and the ox seem to smile along with the little angels who are helping Mary. All is silence, shadow, sweetness, secrecy, suspended enchantment, and affectionate intimacy.

This painter, born in the Marches, served as a link between the great masters of the 15th century and the new art of the dawning 16th century, from the Carraccis to Rubens.

Federico Barocci

Educated amid the remarkable artistic heritage of Urbino and especially in the tradition of Raphael, Barocci adopted in his earliest works the smiling grace of Correggio, enriching it with a taste for warm Venetian colors. An important visit to Rome, where he painted in the Vatican and encountered the latest generation of Mannerists, culminated in his eventual return to Urbino (1565). This somewhat isolated location did not prevent Barocci from exercising a decisive influence on late-Renaissance painting, thanks in part to his early and complete adherence to the recommendations for sacred art issued by the Council of Trent. Barocci's compositions were, in fact, simple and straightforward, with details of touching everyday veracity (children, objects, furnishings, domestic animals), and constituted a direct precedent for the work of the Carraccis. In his most ambitious works, painted between the 1560s and 1580s, we can detect a quest for increasingly expansive allusions to space, while in the altarpieces and devotional paintings of his later years, such as *The Communion of the Apostles* in the cathedral of Urbino (1599), the accent on the spiritual heralds the coming Baroque era. One extremely interesting, though perhaps secondary, aspect of Barocci's production lies in his remarkable pastel portraits and drawings. The painter enjoyed an international reputation. He was in contact with the Prague court of Rudolf II, and he sent works to aristocratic collectors in various nations.

Urbino 1535–1612

School
Central Italian

Principal place of residence
Urbino

Travels
In all likelihood, travel for study in his youth in Emilia (Bologna, Parma) and Venice. Long stays for study in Rome; various trips to the Marches, Umbria, and Emilia

Principal works
The Deposition from the Cross (1567–69, Perugia, cathedral); *Madonna del Popolo* (1569–79, Florence, Uffizi); *The Martyrdom of Saint Vitalis* (1583, Milan, Pinacoteca di Brera)

Links with other artists
Although he mostly lived in isolated areas, Barocci had direct or indirect contacts with all the leading Italian artistic schools of the second half of the 16th century

◀ Federico Barocci, *The Annunciation*, 1592–96. Perugia, Santa Maria degli Angeli.

Federico Barocci

The figure of Christ would be copied by Rubens for a similar work some forty years later for the cathedral of Antwerp.

The scene borrows motifs from an altarpiece painted nearly fifty years before by Rosso Fiorentino in Volterra (page 347) but with an effusion of sentiment that differed sharply from the angular, chilly composition by the Florentine artist

A gust of wind ruffles the outlines of the figures and tosses the drapery.

With an expressive emphasis that includes a hint of sensuality, the lovely Holy Women hasten to assist Mary, who has fainted.

Barocci enjoyed special favor among the religious orders and confraternities engaged in a radical renewal of the Catholic Church. The narrative clarity and the sentimental atmosphere of his works aligned perfectly with the precepts on religious images issued by the Council of Trent.

▲ Federico Barocci, *The Deposition from the Cross*, 1567–69. Perugia, cathedral.

Jacopo kept himself up to date with the most advanced developments in art and showed impressive skill at developing "provincial" compositional solutions that had great expressive power.

Jacopo Bassano

The central figure in a family that produced numerous artists, he served his apprenticeship in his native town, alongside his father, Francesco Bassano the Elder. He broke free of his father's tradition around 1535, following a visit to Venice. Although he never abandoned a solid, provincial-style narrative sense, Bassano collected in the following years a vast array of cultural reference material: he studied prints and drawings by northern artists, and he overlapped with several figures from the Roman Renaissance who were familiar with Salviati, Parmigianino, and Mannerism in general. Thus, although he continued to work in the provinces, the master possessed a figurative culture comparable to that of Veronese and Tintoretto, and his style was constantly evolving. Bassano alternated rustic scenes and characters with studies of color and light, accented with electric highlights. In the 1560s, the Mannerist experiment seems to have concluded. Jacopo returned to a style close to that of Titian, as is evident from his solemn, dramatic altarpieces, where the intensity of his long, ragged brushstrokes was gradually accentuated, foreshadowing the work of El Greco. In his final year, evidently aware of a change in international collecting, he worked on genre paintings, such as series of the seasons, often in collaboration with his four sons.

Jacopo da Ponte; Bassano del Grappa ca. 1510–1592

School
Venetian

Principal place of residence
Bassano del Grappa

Travels
Long visits in Venice and elsewhere in the Veneto region

Principal works
Crucifixion with Saints (1562–63, Treviso, Museo Civico); *Saint Valentine Baptizing Saint Lucilla* (1575, Bassano, Museo Civico)

Links with other artists
Direct relationships with the main painters of 16th-century Venice and with El Greco

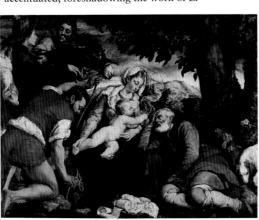

◀ Jacopo Bassano, *The Rest on the Flight into Egypt*, 1547. Milan, Pinacoteca Ambrosiana.

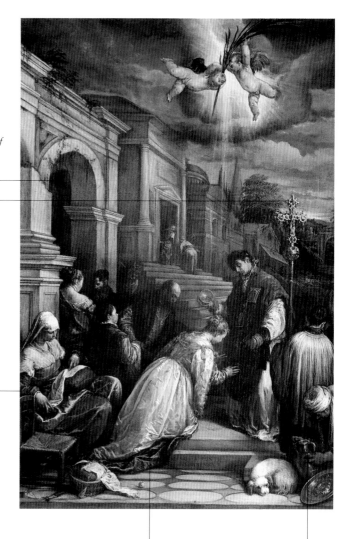

The diagonal arrangement of the buildings in perspective is reminiscent of models from treatises on set design.

The descriptive details, acutely singled out, increase this work's realism.

A distinctive feature of all of Bassano's painting is the presence of figures taken from simple working-class humanity.

The main figures, resplendent with light and color, reflect the sumptuous style of 16th-century Venice.

Despite its location in the provincial town of Bassano, the altarpiece has been admired for centuries as a "miracle" of color. Giovanni Battista Tiepolo would write that he had seen in it a white cloth that appeared black.

▲ Jacopo Bassano, *Saint Valentine Baptizing Saint Lucilla*, 1575. Bassano del Grappa (Vicenza), Museo Civico.

Also active as a painter, Berruguete was above all a great sculptor who worked in wood and alabaster and translated Spanish spirituality into the sinuous and restless forms of Mannerism.

Alonso Berruguete

After receiving an elementary education from his humanist father, Alonso moved to Italy as early as 1505, before he turned twenty. He spent a few years in Rome, and then beginning in 1508 he lived in Florence. He was an alert participant in the epochal developments in the art world around 1510, acquiring a taste for elongated forms, expressively distorted to the point where they looked unnatural. Some of the proto-Mannerist paintings from this period are exemplary, such as *Salome with the Head of John the Baptist,* from the Uffizi. In 1517–18, he returned to Spain. In Saragossa he was appointed court painter by Charles I (the future emperor Charles V). For four years he worked with the sculptor Felipe Vigarny, gradually shifting from painting (which he never abandoned completely) to sculpture. After designing a series of frescoes (which were never painted) for the Cappila Real of Granada, he moved to Valladolid. Here he undertook the complex project of executing a retable in carved wood, painted and gilded, for the church of San Benito el Real. This was a lengthy project (1527–32), striking in its dramatic effect, but perhaps a trifle overbusy in its proliferation of details and figures. Then he moved to Toledo, where he gathered many pupils, including a number of sculptors from Flanders and Holland. In the cathedral he executed first the stalls and ornamental statuettes of the choir, then the group of *The Transfiguration* above the bishop's throne, with a remarkably emotional, expressive effect and dramatic impact.

Paredes de Nava ca. 1486–Toledo 1561

School
Spanish

Principal place of residence
Valladolid (1523–39) and Toledo (from 1539 on)

Travels
Long stay in Rome and Florence (1505–17); various trips to Spain (Saragossa, Granada, Oviedo, Ubeda)

Principal works
Adoration of the Magi (1527–32, Valladolid, Museo Nacional de Escultura); *The Transfiguration* (1543–48, Toledo, cathedral)

Links with other artists
The son of the painter Pedro Berruguete, he was in direct contact with Italian artists in Florence (Leonardo, Raphael, Michelangelo, and the early figures of Mannerism); in Spain he worked with Felipe Vigarny

◀ Alonso Berruguete, *The Transfiguration,* 1543–48. Toledo, cathedral.

Acclaimed and widely imitated, Bosch created images that are apparently fantastic and surreal but that are actually deeply rooted in an awareness of man's sins, follies, and instincts.

Hieronymus Bosch

Jeroen van Aken;
's Hertogenbosch
ca. 1450–1516

School
Flemish-Dutch

Principal place of residence
's Hertogenbosch

Travels
Venice and northern Italy
(1500–1503)

Principal works
Triptychs *The Garden of Earthly Delights* and *The Haywain* (Madrid, Prado); *The Temptation of Saint Anthony* triptych (Lisbon, Museo Nacional)

Links with other artists
Although he substantially lived in isolation, he was still well informed about developments in Flemish and German painting (partly through engravings). His travels in Italy allowed him to study the works of such masters as Leonardo and Giovanni Bellini

Bosch lived and worked in his birthplace, a major cultural center of the northern Netherlands, where his father and grandfather had both been painters. In 1480, by now a free master and the owner of a workshop with numerous workers, he came into contact with the Brotherhood of Our Lady, belonging to the cathedral of 's Hertogenbosch; he joined this confraternity in 1486–87. At the turn of the 16th century, he executed the great triptychs *The Haywain* and *The Garden of Earthly Delights*. He painted major works during a stay in Venice that took place sometime between 1500 and 1503. His contact with Italian painting and with Dürer enriched Bosch's style with a new awareness of com-

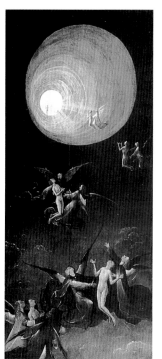

position, vast landscapes, and new color effects. An extraordinary example of this development is found in the triptych *The Temptation of Saint Anthony* in Lisbon. Following that work he painted the triptych *The Epiphany,* now at the Prado in Madrid. In 1503–4, he returned to his hometown. By then he had become renowned throughout Europe, and he alternated small commissions for the Brotherhood of Our Lady with work for foreign collectors. In his later work, probably influenced by Italian examples, he abandoned his earlier compositional approach to paintings on sacred subjects for a simple, monumental composition and half-figures.

▶ Hieronymus Bosch, *The Ascent of the Blessed into the Celestial Paradise*, 1500–3. Venice, Doge's Palace.

This painting is the central panel of a triptych. The side panels depict the Creation of Eve and Hell.

The clumps of multicolored rocks in the background, as well as the winged creatures flying through the sky, suggest a chaotic, confused situation, in continual and astonishing transformation.

The subject, then, is situated at a point in human history (understood both as man's collective destiny and as the course of an individual life) midway between the purity of creation and the eternal punishment of sin.

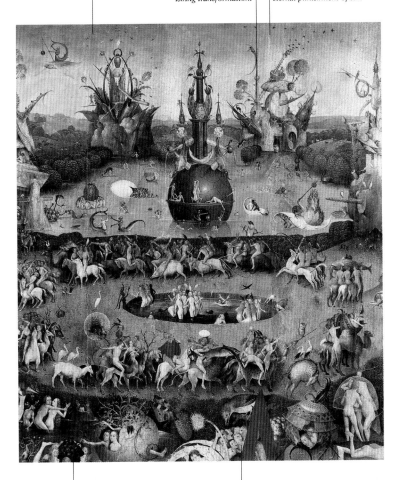

Many details, such as the berries and the birds wading into the pond in the middle distance, are clearly out of proportion, as if to emphasize an unnatural, contrived, sinful condition.

▲ Hieronymus Bosch, *The Garden of Earthly Delights*, central panel of the *Triptych of the Garden of Earthly Delights*, 1503–4. Madrid, Prado.

Within a vast luminous landscape, Bosch organizes the scene into a succession of four different planes with circular structures, teeming with hundreds of naked human beings, animals, monstrous creatures, references to earthly delights (note the strawberries and red berries) and to alchemy.

Bosch's satirical/moralizing allegory is based on an old Flemish proverb: "The world is a pile of hay: let each grab as much as he can hold."

Good and evil are ever linked. Beneath the figure of God the Creator, the rebellious angels plummet downward, soon to form the demonic progeny of hell.

A motley crowd presses forward, willing to brawl and even throw itself under the wheels of the wagon in its eagerness to draw close. Even the pope and the emperor, though they ride on horseback and are richly garbed, pursue the haywagon, sharing the common fate of humanity.

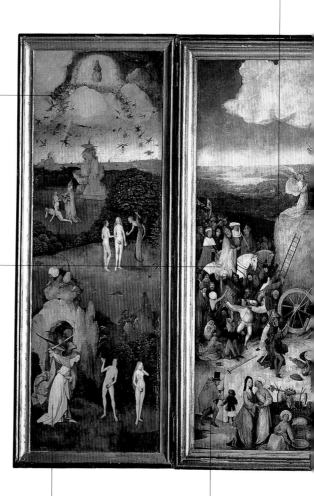

▲ Hieronymus Bosch, *Triptych of the Haywain*, 1500–1502. Madrid, Prado.

Expelled from Eden by the angel, Adam and Eve are stripped of their paradisiacal condition and begin the long, hard road of mankind.

Bosch's culture mingles folk wisdom with humanistic elements, references to other painters, religious beliefs, alchemy, and science.

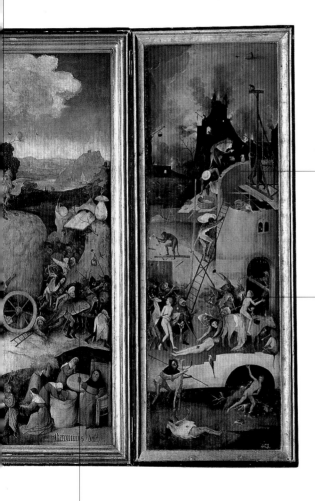

Atop the hay, isolated as in a dream, a group of lovers sing and dance. But the music is provided by a fife-playing demon, while an angel sends a resigned prayer heavenward.

Devilish bricklayers are building a new edifice to house the damned souls about to arrive.

Humanity, corrupted by the pleasures of the world, enmeshed by folly, and inexorably marching toward eternal damnation, is Bosch's favorite theme.

With bitter wit, Bosch pillories the common descent toward ruin of mankind, blinded by the desire for money, possessions, and power. Indeed, no one (not even the viewer, at first) notices that the haywagon is being pulled by cackling demons, and that its final destination is the flames of hell.

Bronzino's career epitomizes the history of Mannerism, from the initial rebellion against traditional formulas to its final establishment as an enigmatic style for an elite cultural aristocracy.

Agnolo Bronzino

Agnolo di Cosimo di Mariano Tori; Florence 1503–1572

School
Florentine

Principal place of residence
Florence

Travels
Long stays in Pesaro and Urbino at the court of the Della Rovere family; short trip to Rome in 1548

Principal works
Frescoes in the chapel of Eleonora of Toledo (1543, Florence, Palazzo Vecchio); numerous portraits of the grand-ducal court of the Medici, now mostly in Florence, at the Galleria degli Uffizi

Links with other artists
A student of Pontormo, he had close contacts with all the Florentine artists of the first half of the 16th century, from Andrea del Sarto to Vasari; in Pesaro, he worked alongside Dosso Dossi

Bronzino worked with his master Pontormo on major Florentine projects throughout the 1520s, from the frescoes in the Certosa del Galluzzo to the splendid decorations of the Capponi Chapel in Santa Felicita. Summoned in 1530 to the Della Rovere court in the Marches, Bronzino painted frescoes in the Villa dell'Imperiale, near Pesaro, and also began to paint portraits, developing his own style, set apart from Pontormo's by his compact, almost enameled rendering of color. He returned to Florence, where he worked on the decorations for the wedding of Cosimo I and Eleonora of Toledo (1539). He became the favorite painter of the Medici court and Florentine aristocracy in general, in part because of his talent as a man of letters. An ineffable limner of the rigorous etiquette of the grand-ducal court of Florence, Bronzino was a key figure in the development of European Mannerism. A large Bronzino *Deposition* was sent by Cosimo I to the cardinal of Granvelle, one of Charles V's powerful ministers, and can still be seen in Besançon. He alternated portraiture with interior decoration, such as frescoes for the Medici villas, the renovation of the private apartments in the Palazzo Vecchio (where he painted magnificent frescoes for the chapel of Eleonora of Toledo, 1543), and the production of cartoons for tapestry works.

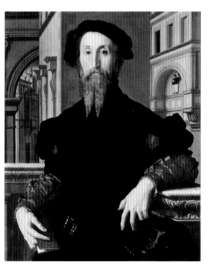

▶ Agnolo Bronzino, *Portrait of Bartolomeo Panciatichi*, ca. 1540. Florence, Uffizi.

An example of the refined intellectual culture of international Mannerism, characterized by an unabashed vein of sensuality, this allegory uses the embrace of Venus and Cupid to present a strong ethical message.

Behind the "positive" characters, we find their "opposites:" the agonized Jealousy behind Love (Cupid), the monstrous Fraud behind Play, while an enigmatic empty head (left), possibly Truth or Oblivion, contests with Time (right) over a veil to cover Venus's beauty.

The three main characters are Venus, Amor (Cupid), and the smiling putto who represents play or folly.

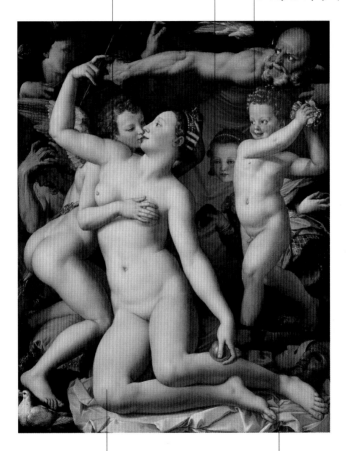

▲ Agnolo Bronzino, *An Allegory with Venus and Cupid*, ca. 1544–45. London, National Gallery.

The intricate subject is worked out in a formally impeccable manner, with a brilliant, enameled, incorruptible composition.

The empty masks indicate the symbolic code behind this painting: the need to uncover what lurks behind appearances.

Young Giovanni, the son of Eleonora of Toledo and Cosimo I, was not destined to survive childhood; here he appears somewhat stiff, with a stupefied, unnatural expression, his large eyes staring.

Against a dense, smooth background, hard and glistening like lapis lazuli, the silhouette of the motionless grand duchess is as perfect as a Chinese idol.

Nobility, self-control, composure, severity, detachment: all emotions are restrained or filtered by the unmoving mask of aristocracy.

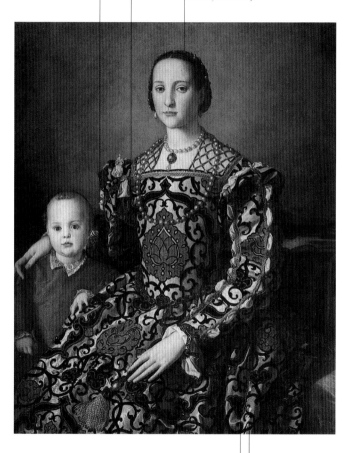

▲ Agnolo Bronzino, *Portrait of Eleonora of Toledo and Her Son Giovanni*, 1545–46. Florence, Uffizi.

Eleonora bore Cosimo a total of eleven children. She died of malaria along with two of her sons, including Giovanni, in 1562.

It was on the occasion of the wedding of Cosimo I and Eleonora of Toledo, in 1539, that Bronzino became the Medici's court painter.

Bruegel sets the eternal realm of the emotions and the temporal cycles of the seasons and nature as the background of every scene, intersecting with everyday life, human urges, and rustic poetry.

Pieter Bruegel the Elder

The life and art of Pieter Bruegel unfolded in major cultural centers and in a busy historic period; and yet we have only a few reliable facts about his life. One surviving document is his enrollment in the guild of painters of Antwerp, with the title of master (1551). Substantially uninvolved with the classically influenced school of Antwerp painters and mostly indifferent to the Italian Renaissance, despite a trip to Italy between 1552 and 1556, Bruegel followed three main tracks: draftsman, engraver, and painter. Recurring themes are the folk culture of proverbs, the love of nature, a disenchanted irony regarding man and the world, and a determination to portray every event, including those of sacred history, as part of the simple yet poetic banality of existence. After his marriage, Bruegel moved to Brussels, where his first-born son, Pieter, was born in 1564. Pieter would paint copies and derivations of his father's work, while his second son, Jan, born in 1568, would become one of the greatest still-life artists. Pieter the Elder's most complex and ambitious series of paintings dates from 1565, the so-called Seasons or Months (only five of which survive). By this point, the artist had become an established personality, and his works take on a new monumental solidity. Exemplary in this sense are the scenes of peasant life, now in Vienna.

Breda (?) 1525/30–Brussels 1569

School
Flemish

Principal place of residence
Antwerp and later Brussels

Travels
Long journey in Italy, from the Alps to Naples, between 1552 and 1556

Principal works
The Months series (ca. 1565, now scattered among Vienna, New York, and a private collection in Bohemia); *Peasant Wedding* (ca. 1568, Vienna, Kunsthistorisches Museum)

Links with other artists
Even though he belonged to the congregation of painters in Antwerp, he rejected the prevailing Italian influence and harked back to the tradition of Bosch. His two sons, Pieter and Jan, would also become respected painters

◀ Pieter Bruegel the Elder, *The Misanthrope*, ca. 1568. Naples, Museo di Capodimonte.

269

Few other works of art manage to communicate this sense of chilly air, with an impending snowfall lowering over the highest craggy peaks. The skeletal treetops of the bare trees form a black screen, projected against the dense backdrop of the sky.

The memory of the snowy peaks and rocky crags of the Alps, which Bruegel crossed to go to Italy, takes shape in an image in which reality and fantasy combine in an evocative manner.

Far below, the buildings of the little village lie scattered along the bleak valley.

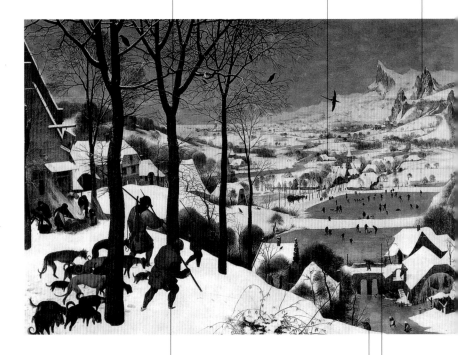

Bruegel lays out the composition from a vantage point that is elevated with respect to the foreground, and he focuses on the essential contrast between the white of the snow and the black silhouettes of the characters, the trees, and the buildings.

This is the best-known painting in the series known as The Months, large scenes depicting different periods of the year, and painted for Emperor Rudolf II.

▲ Pieter Bruegel the Elder, *Hunters in the Snow*, 1565. Vienna, Kunsthistorisches Museum.

The children playing on the ice-covered pond give a delightful note of cheerfulness to the scene, in sharp contrast to the butchering of the pig on the left.

A work from late in Bruegel's career, it depicts a peasant wedding celebration.

The bride, smiling, chubby, and blushing, sits at the middle of the banqueting table, with a green cloth hanging on the wall behind her. On either side of her are her mother and her new mother-in-law, while her frowning father has been given the best chair, with a high backrest.

The groom may be the young fellow whose eyes are bugging out as he stuffs himself, sitting on the right hand of the bride while his new father-in-law sits to her left.

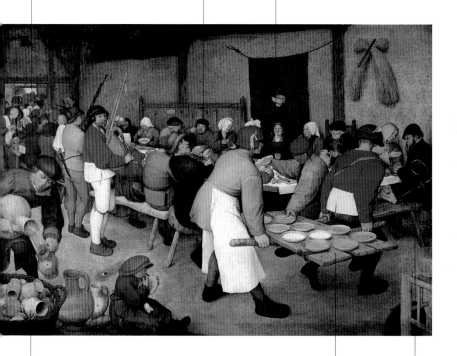

The drinks being poured into carafes are reminiscent of the iconographic treatment of the Wedding at Cana, to which Bruegel's painting can be considered a realistic, "secular" response.

The banquet is a homely version of The Land of Cockaigne, with dishes carried by waiters and rapidly scooped up by the guests, who seem to be casting greedy glances at the dishes that are being offered in a continual round of generosity.

▲ Pieter Bruegel the Elder, *Peasant Wedding*, ca. 1568. Vienna, Kunsthistorisches Museum.

At the far right, on an improvised seat (an overturned tub), a well-dressed man is taking part in the feast; this may be the painter himself.

Burgkmair was the leading artist in the school of Augsburg, at the height of the flourishing economy powered by the house of Fugger.

Hans Burgkmair

Augsburg 1473–1531

School
German

Principal place of residence
Augsburg

Travels
In the Rhineland, the Netherlands, and twice to Italy (Venice and Lombardy); from 1512 to 1519 he was often in Innsbruck, working on commissions for the emperor Maximilian

Principal works
Triptych with *Saint John on Patmos* (1518, Munich, Alte Pinakothek); *Battle at Cannae* (1529, Munich, Alte Pinakothek)

Links with other artists
A student of Martin Schongauer; he worked with Altdorfer and Dürer for Maximilian of Habsburg and, later, for Duke William of Bavaria. At Augsburg, he shared artistic supremacy with the Holbeins

The son of an Augsburg artist, Burgkmair nevertheless trained at Colmar under Martin Schongauer, then went back to enroll in the painters' guild of Augsburg in 1498, taking over his father's workshop. At first Burgkmair specialized in portraiture (among other work, he painted a posthumous portrait of Schongauer), but in time he expanded his range of subjects, techniques, and formats, keeping up with new developments. His pursuits led him to divide his time between commissions executed in his hometown and major trips to the south. As is shown by the Roman Basilicas series begun in 1500 for the Saint Katharina convent in Augsburg, he had a special interest in architecture depicted in perspective, somewhat different from the landscape backgrounds so typical of the Danube school from the same period. Engaged in the artistic projects for Emperor Maximilian of Habsburg, he worked along-

▶ Hans Burgkmair, *Saint John on Patmos*, 1518. Munich, Alte Pinakothek.

side Altdorfer and Dürer on a series of engravings celebrating the glory of the empire. He traveled to Italy frequently. Burgkmair's style, enriched by references to Venetian painting, appears particularly stern in comparison with that of his Danube school colleagues ; it is steeped in an imposing, dramatic monumentality. After returning to Augsburg to stay, he painted the important *Saint John Triptych* (1518, now in Munich) and later moved toward a closer contact with the Protestant Reformation.

Caron is one of the most appealing artists of international Mannerism, thanks to the elegant, spirited clarity with which he cuts through the intellectual complexities of his subjects.

Antoine Caron

After his initial training in stained-glass windows, Caron began in 1540 as an assistant to Primaticcio at Fontainebleau, where he was working on the first phase of construction on the royal palace, under Francis I. The earliest work known to be his, however, dates from around 1559–60, at the beginning of the "second school" of Fontainebleau, linked to the fanciful compositions of Niccolò dell'Abate. A major figure in the French Mannerist school as court painter to the queen mother Catherine de' Medici and to Kings Charles IX and Henry III, Caron alternated painting projects with the drafting of cartoons for tapestries, drawings for furniture and sculpture, illustrations for manuscripts, and ephemeral decorations for court ceremonies and celebrations. Much of his creative energy must have been devoted to these highly perishable displays, which explains the relatively scant body of surviving paintings. Caron's career mirrors the development of the school of Fontainebleau. With a refined and fanciful visual idiom, he set events of various kinds (ranging from ancient history to allegory) in an unreal world in which, against a backdrop of classical architecture, diverse crowds move restlessly, communicating a thirst for the new, a nostalgia for the bygone past, and that feeling of disquiet and anxiety so typical of the last years of the century.

Beauvais 1521–Paris 1599

School
French

Principal place of residence
Fontainebleau and Paris

Travels
He traveled with the French court on their regular moves between the country residences and Paris

Principal works
Massacres of the Triumvirate (1566, Paris, Louvre); *Tiburtine Sibyl (Augustus and the Sibyl)* (ca. 1571, Paris, Louvre)

Links with other artists
Primaticcio, Niccolò dell'Abate, Jean Cousin, and the artists of the school of Fontainebleau

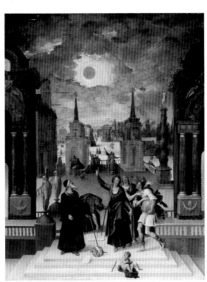

◄ Antoine Caron, *Dionysius the Areopagite Converting the Pagan Philosophers*, ca. 1570. Los Angeles, J. Paul Getty Museum.

Blending a variety of influences, Annibale Carracci created a style that was at once measured and expressive, an intersection of the Renaissance and the Baroque.

Annibale Carracci

Bologna 1560–Rome 1609

School
Italian

Principal place of residence
Bologna, and later Rome

Travels
Aside from minor trips, his stay in Venice around 1587 was important

Principal works
The Crucifixion (1583, Bologna, Santa Maria della Carità); the Galleria of the Palazzo Farnese in Rome (1595–98)

Links with other artists
Contacts with Venetian painters, and especially with Veronese; ties with Barocci; in Rome, interaction with emerging young painters of the next generation: Caravaggio, Rubens, and Guido Reni

It is thought that Annibale trained with his brother Agostino in the workshop of their cousin Ludovico in Bologna. From the very beginning Annibale abandoned the cold intellectual formulas of Mannerism, returning to a more straightforward style of painting, with such unusual subjects as butcher shops and common folk eating. Travel for purposes of study around 1585 led Annibale to master the styles of Titian, Veronese, and Correggio, triggering a new and updated revival of their work. The Carraccis' founding of the Academy of the Incamminati in Bologna marked the establishment of an artistic approach that was at once classical and innovative. The move to Rome, around 1590, propelled the academy, and Annibale's work, into the heart of the artistic debate. At the dawn of the Baroque era, Rome saw a confrontation between the last years of Mannerism, the clients in the religious orders of the Counter-Reformation, and more innovative impulses, which sprang from the quest for a more "natural" and human imagery: Caravaggio's realism and Annibale Carracci's eclectic academicism. In Rome, Annibale devoted passionate study to classical art, paying it homage in the remarkable ceiling of the gallery of the Palazzo Farnese, to which he devoted his last years. On that project, and in the lunettes of the Doria Pamphilj Gallery, Annibale worked with many young assistants, nearly all of them from Emilia; they would soon found the successful school of classicism.

▶ Annibale Carracci, *The Bean Eater*, 1584. Rome, Colonna Gallery.

This composition was very popular among princely collectors, and Annibale Carracci made more than one version of the painting.

The gesture of Adonis is a fine example of contrapposto, but rendered fluidly, without the contrivance typical of Mannerism.

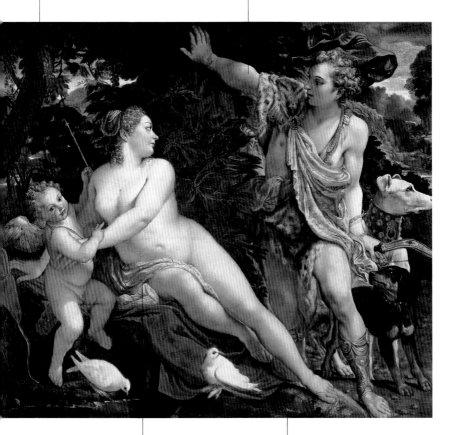

The luminous female nude harks back to the tradition of the Venetian cinquecento.

▲ Annibale Carracci, *Adonis Discovers Venus*, ca. 1595. Vienna, Kunsthistorisches Museum.

This canvas was painted just as work was beginning on the Farnese Gallery, Annibale Carracci's great Roman masterpiece, and it marks his stylistic shift toward classicism.

One of the greatest goldsmiths of all time, Cellini was also a master sculptor and a talented writer: his autobiography is a gripping account of the life of a late-Renaissance artist.

Benvenuto Cellini

Florence 1500–1571

School
Tuscan–international
Mannerism

Principal place of residence
Rome, Fontainebleau, and
Florence

Travels
Cellini preferred to live
permanently in the cities
where over the years he
amassed a fortune

Principal works
Saltcellar of Francis I
(1543, formerly in Vienna,
Kunsthistorisches
Museum); *Perseus with the
Head of Medusa* (completed in 1554, Florence,
Loggia dei Lanzi)

Links with other artists
Living in Florence and
Fontainebleau, Cellini was
in contact with all the leading masters, ranging from
the French school to the
generation of Florentine
grand-ducal Mannerists

▶ Benvenuto Cellini,
*Perseus with the Head
of Medusa*, completed
in 1554. Florence,
Piazza della Signoria,
Loggia dei Lanzi.

In his autobiography, Benvenuto Cellini sketches his life and artistic career in novelistic tones that probably include a dose of melodramatic coloration (particularly notorious is the section concerning the Sack of Rome). Still, trimming away the excesses, it is possible to discern the arc of 16th-century Italian art in his story, ranging from the glories of the High Renaissance to the fruition of international Mannerism, culminating, after mid-century, in the measured dignity of grand-ducal Florence. After a first period of work in Florence, entirely devoted to goldwork, Cellini undertook a successful new career by moving to the court of Francis I at Fontainebleau (1540–45); here he executed his famous gold-and-enamel saltcellar (page 200), making a dramatic entrance onto the stage of court Mannerism. Again for the palace of Francis I, he tried his hand at monumental sculpture, casting the great bronze of Diana, goddess of the hunt, now at the Louvre. After returning to Florence, he began the lengthy and complex process of casting the *Perseus* for the Loggia dei Lanzi. This remarkable piece of technical virtuosity won Cellini special regard in the intellectual milieu under Grand Duke Cosimo I. For the grand-ducal court he executed notable sculptures in both bronze and marble, including a colossal bust of Cosimo I. In part due to his role as an author of treatises and blistering polemics (he wrote two treatises, on sculpture and goldsmithing, in addition to his autobiography), Cellini established himself as a model for the international style and technique of the mid-16th century.

Jean and François Clouet were for decades artistic models in the French court; their work characterized its transition from the brief Renaissance phase to the Mannerism of Fontainebleau.

Jean and François Clouet

The two Clouets were truly a "dynasty" of court painters, with the position handed down directly from father to son. A painter and miniaturist of Flemish origin, Jean established himself at the court of Francis I with his portraits. In 1533 he was given the title of *peintre et valet de chamber* to the king. Among the fairly limited number of paintings that can be attributed to him with certainty, the portraits of Francis I and Guillaume Budé are masterpieces of the genre of court portraiture. More sizable is the series of small-format portraits, the *crayons*, executed with charcoal and hints of color, depicting various figures from the court of Francis I. Aside from the northern influences, one can detect a direct link with the art of Leonardo (a guest of Francis I from 1516 to 1519), especially in the soft outlines and the use of chiaroscuro. François took his father's place as *peintre et valet de chamber* to Francis I in 1541. A portraitist who had also done mythological paintings in the Mannerist style of the school of Fontainebleau and genre paintings with chivalrous inspiration, François abandoned his father's chilly hues, of northern deriva-

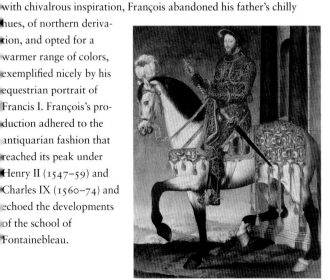

tion, and opted for a warmer range of colors, exemplified nicely by his equestrian portrait of Francis I. François's production adhered to the antiquarian fashion that reached its peak under Henry II (1547–59) and Charles IX (1560–74) and echoed the developments of the school of Fontainebleau.

Jean: Brussels ca. 1485–Paris 1540
François: Tours ca. 1510–Paris 1572

School
French

Principal place of residence
Paris

Travels
Numerous trips in France, following the travels of the court and executing portraits

Principal works
For both, series of *crayons* (pencil portraits); for Jean, *Portrait of Francis I* (1525, Paris, Louvre); for François, *A Lady in Her Bath* (ca. 1570, Washington, National Gallery)

Links with other artists
All the artists of the school of Fontainebleau, beginning with the reign of Francis I

◄ François Clouet, *Equestrian Portrait of Francis I*, ca. 1540. Florence, Uffizi.

Jean and François Clouet

Behind a curtain we see a handmaiden, who has an illustrious forebear in Titian's Venus of Urbino, as well as a set of windows that direct the viewer's gaze into a garden.

The young protagonist's contemplative idealization is underscored by the contrast with the realistic vigor of the other elements in the scene, clearly an instance of Flemish influence, ranging from the "still life" in the foreground to the interior in the background.

An emblematic work of late-Renaissance France, the painting presents a complex articulation of spatial depth, scanning three different, almost theatrical scenes. The aggregate significance of the painting, however, remains somewhat obscure.

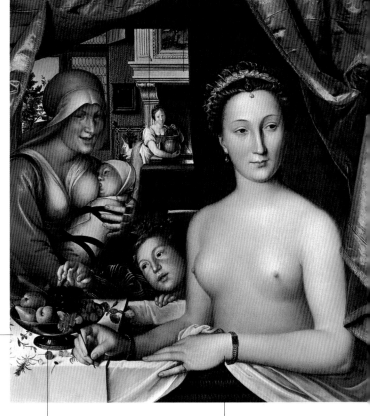

The rather static nude woman is counterbalanced by the rustic but not unpleasing wet nurse who is suckling a newborn while, at the center, a child reaches his hand toward the bowl of fruit.

▲ François Clouet, *A Lady in Her Bath*, ca. 1570. Washington, D.C., National Gallery of Art.

The heavy draperies open to allow a female nude to appear in the foreground, languidly relaxing in a bathtub.

In the unhurried backwater of Parma, liberated from the obligation of competing directly with other great masters, Correggio developed a "third way" for the Renaissance.

Correggio

Correggio trained in Mantua, between Mantegna's last years and the first diffusion of a gentler Raphaelesque style. Upon this foundation, the painter intelligently overlaid Leonardesque and Venetian ideas, especially in the use of atmospheric sfumato and tonal color. These influences can be glimpsed in Correggio's early years, up to his first great creation in Parma, the Camera della Badessa in the convent of San Paolo (1519). The originality of his iconographic solutions, always tempered by a refined taste for expression and color, foreshadows his dazzling series in the church of San Giovanni Evangelista in Parma, begun with the dome (1520–21) and continuing in other parts of the church, with the help of his assistants. In the 1520s, he produced a series of brilliantly conceived altarpieces, with interlinked gestures, smiling countenances, and soothing colors. The masterpiece that brought it all together was *The Assumption of the Virgin* in the dome of the Parma cathedral, an astounding piece of perspective. In the last years of his life, Correggio went back to working for the Gonzagas, with two canvases for the Studiolo of Isabella (now in the Louvre) and the Loves of Jupiter series, now divided among several museums.

Correggio responded to the explosive color of Venetian painters and Tuscan-Roman Mannerism with a fluid, luminous style. That style was immensely engaging, due to the sweetness of the expressions and great audacity in the use of perspective.

Antonio Allegri Correggio (Reggio Emilia) ca. 1489–1534

School
Northern Italian

Principal place of residence
Parma

Travels
Training in Mantua; various trips to northern Italy; there is no documentation of stays in Rome, though scholars think it likely he visited

Principal works
Frescoes in Parma: Camera della Badessa (1519), dome of San Giovanni Evangelista (1521), dome of the cathedral (1528)

Links with other artists
A pupil of Mantegna, he was in contact with the most important painters working in northern Italy, from Leonardo and Lotto to Titian and Gaudenzio Ferrari. Among his pupils, Parmigianino stands out

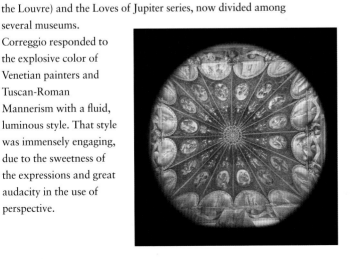

◄ Correggio, Dome of the Camera della Badessa, 1519. Parma, Convent of San Paolo.

Correggio

The adolescent figure of Cupid, seated in Danaë's boudoir, adds a further note of eroticism.

The light that softly models the nude Danaë is an eloquent example of Correggio's typical sensuality.

Danaë's features and the delicate use of the sfumato are clear evidence of careful study of Leonardo's work.

The painting illustrates, without any particular inhibitions, the mythological episode of Jupiter's metamorphosis: he transformed himself into a shower of golden rain, descending into the lap of the lovely Danaë, who was imprisoned in a tower.

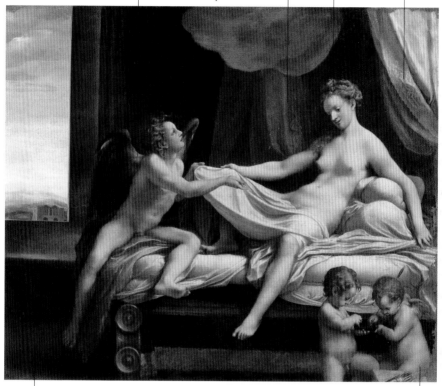

The painting forms part of the Loves of Jupiter series, painted by Correggio for Federico Gonzaga.

The two little cupids are an image of adorable freshness. Correggio succeeded in transforming the erudite literary theme—how love can assume different forms—into something immediate and lovable.

▲ Correggio, *Danaë*, 1531–32. Rome, Galleria Borghese.

Cousin carried on the tradition of the multifaceted court artist: he was a painter, an engraver, an author of treatises; he did drawings for sculptures, stained-glass windows, and many other media.

Jean Cousin the Elder

His career began in his native Burgundy, where he supplied cartoons for the stained-glass windows of the cathedral of Sens and other churches. In 1532, he designed the stained-glass windows of the chapel of the château of Fleurigny, which were made by the Parisian master Jean Chastellain. From then on, Cousin became a major figure in the development of French court style, which was trending toward Mannerism. In Paris beginning in 1539, he began a prolific production of cartoons and graphic designs for temporary installations and stained-glass windows. Dating from 1549 is his series of six canvases, *Stories of Saint Germain of Auxerre,* in collaboration with Louis Dubreuil. His most renowned painting, *Eva Prima Pandora,* an innovative mixture of classical mythology and Christian themes, was also done in this period. We have relatively few artworks by Cousin's hand, though we can detect his models in embroideries, ecclesiastical vestments, goldwork, and miniatures. The loss of a number of major works mentioned in the documentary sources and his frequent collaborations with his son, also named Jean, make it difficult to retrace the development of his style and the story of his life.

Soucy (Burgundy) ca. 1490–Paris 1560/61

School
French

Principal place of residence
Paris

Travels
Training in and various later trips to Burgundy

Principal works
Stained-glass windows with *Augustus and the Sibyl* (1532, Fleurigny, chapel of the château); *Eva Prima Pandora* (ca. 1549, Paris, Louvre)

Links with other artists
He was in regular contact with French Renaissance masters (we have documentation of his relationship with the sculptor Jean Goujon); in his later work, he was joined by his son Jean the Younger, and it is in some cases impossible to distinguish between the work of father and son

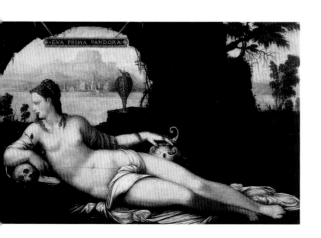

◄ Jean Cousin the Elder, *Eva Prima Pandora,* ca. 1549. Paris, Louvre.

Cranach set classical myths and sacred scenes in Reformation Germany. His spirited draftsmanship attenuated into an elegance that verged on abstraction, a response to Italian Mannerism.

Lucas Cranach the Elder

Kronach (Upper Franconia)
1472–Weimar 1553

School
German

Principal place of residence
Wittenberg

Travels
Lengthy trip in his youth
through southern Germany
and the Tirol

Principal works
*Portrait of Dr. Cuspinian
and His Wife* (1502–3,
Winterthur, Reinhart
Foundation); various ver-
sions of *Judith with the
Head of Holofernes* and
portraits of Martin Luther
and Katharina von Bora

Links with other artists
Intense, ongoing dialogue
with Altdorfer and Dürer,
especially in his youth and
early maturity

Himself the son of a painter, Cranach served his apprenticeship and began his career in Bavaria. In 1498, he decided to travel in southern Germany and Austria. He became one of the artists of the Donauschule (Danube school), distinguishing himself with the magical vitality of his fairytale depictions of nature and for the incisive power of his characters. In 1505 he was invited to Wittenberg by Prince Elector Frederick of Saxony, known as "the Wise," who was also a client of Dürer's and a proponent of a refined humanism. Until his death, nearly fifty years later, Cranach worked for the court of Saxony, becoming one of the longest-lived and most prolific artists of the German Renaissance, with a stylistic arc that gradually evolved from the legendary expressionism of his earliest work to the decorative, almost abstract, intellectual draftsmanship of his latest works. His pro-duction ranged through a variety of fields, including engraving:

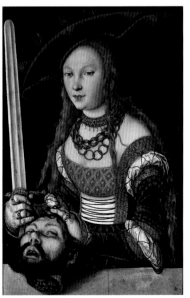

▶ Lucas Cranach the Elder,
*Judith with the Head of
Holofernes*, ca. 1530.
Vienna, Kunsthistorisches
Museum.

from altarpieces and classical nudes to portraits and moral allegories, hunting scenes and Lutheran propaganda. Cranach was, in fact, one of the first artists to embrace the Reformation, and he did numerous portraits of Luther, his wife, Katharina von Bora, and Philip Melanchthon, as well as illustrations of the themes of Reformation theol-ogy. Cranach also did prints illustrating Luther's German translation of the Bible.

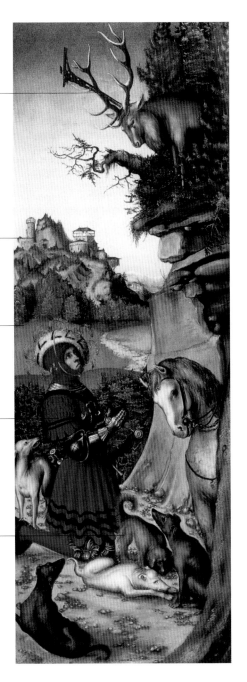

The miraculous stag peers down from the wooded crag, with a crucifix between its antlers. With an effective contrivance, Cranach painted the stag with its muzzle projecting out against the sky, in a lively visual contrast with the twisted branch.

As is typical of the work of painters from the Danube region, the landscape is of great importance, with evocative and charming views.

The painting belongs to the period in Cranach's career prior to the Reformation; the painter would later become one of the earliest and most devoted followers of Lutheranism.

The saint is dressed as a young aristocrat from Cranach's time, a wealthy horseman wearing the latest fashions. Cranach always tended to treat the subjects of his paintings, whether religious or mythological, in a contemporary manner.

The hunting dogs and the horse still belong to the late-Gothic tradition of chivalry.

▶ Lucas Cranach the Elder, *Saint Eustace*, ca. 1515. Vienna, Collection of the Princes of Liechtenstein.

Cranach lavishes equal attention on evoking the personalities of his characters (the man: brash, aggressive, almost picaresque; the woman: apparently docile but with a hint of cunning in her eyes) and the enameled spectacular quality of the heraldry in gold, blue, and red.

It is interesting to note how the full-length portrait was becoming rapidly common in German art, while in Italy it was only beginning to spread cautiously. After Titian, it became the norm.

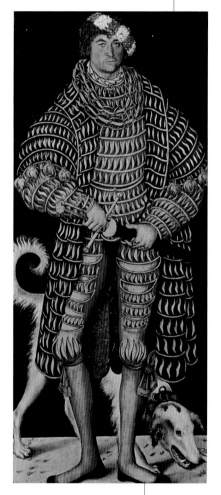

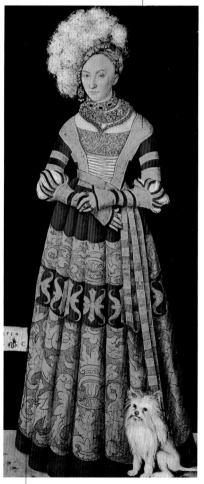

▲ Lucas Cranach the Elder, *Henry the Pious, Duke of Saxony* and *Catherine of Mecklenburg, Duchess of Saxony,* 1514. Dresden, Gemäldegalerie.

In a singular commemorative invention, the Saxon princely couple is at once a portrait and a coat of arms.

The panel bears the date and Cranach's initials, along with the silhouette of a small dragon, an emblem that the painter often used.

This most influential Spanish painter stood alongside the great mystics of his nation in his devotionally intense works, composed with deep shadows, in a cadence of wonder and grief.

Luis de Morales

The paintings of Luis de Morales show such variety and such a wealth of potential stylistic influences that one is led to assume that he must have traveled to Italy to study. The grace of Raphael, the sfumato and chiaroscuro of Leonardo, the anatomical contortions of the Mannerists may, however, have filtered in through the circulation of models (paintings or prints) or the mediation of other Spanish artists, such as Alonso Berruguete. It also appears that Flemish painting was a decisive influence, leading him to accentuate the pathetic expressions of his paintings of Ecce Homo and the Virgin with Child. Luis de Morales probably trained in Seville with Pedro de Campaña. He was summoned by Philip II to work on El Escorial but spent little time there. He enjoyed greater success with the polyptychs that he executed for Salamanca, Palencia, Évora, and other towns between 1560 and 1580; those works were already in tune with Counter-Reformation mysticism. Most renowned for his production of religious paintings, he was also a solid, austere portraitist.

Though he was highly respected in his time, and dubbed "El Divino" because of the idealistic mysticism of his works, Luis de Morales died almost penniless, a fact that practically turned him into a figure of folk legend. The enormous fame of his work served to spread iconographic models that would have lasting repercussions in the religious painting of 16th-century Spain.

Badajoz ca. 1510–1586

School
Spanish

Principal place of residence
Badajoz and Extremadura

Travels
Aside from various trips within the Iberian peninsula (especially to Castile and Andalusia), certain stylistic references suggest a stay in Italy, though there is no documentation to that effect

Principal works
A number of variants on his favorite themes: Ecce Homo, Virgin Mary with Christ child, and Pietà

Links with other artists
Pupil of Pedro de Campaña; interesting stylistic links with Beccafumi, Sebastiano del Piombo, and Florentine Mannerism

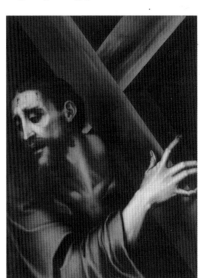

◄ Luis de Morales, *The Nazarene*, 1566. Valencia, Real Collegio del Patriarca.

A sculptor of great virtuosity and erudition, working in Prague during the reign of Rudolf II, de Vries raised the art of the monumental bronze to new levels of refinement and elegance.

Adriaen de Vries

The Hague ca.
1560–Prague 1626

School
International Mannerism

Principal place of residence
Augsburg and Prague

Travels
Training and early career in
Italy (Florence, Milan, and
Turin); travel and work in
Germany and Denmark

Principal works
Fountains in Augsburg;
sculptures formerly in the
Wallenstein gardens in
Prague, now in Stockholm

Links with other artists
Pupil of Giambologna; at
the court of Rudolf II in
Prague, he was in contact
with Hans von Aachen,
Arcimboldi, Spranger, and
Heintz; in Augsburg, with
the architect Andreas Höll

► Adriaen de Vries,
Mercury and Psyche,
1593. Paris, Louvre.

A pupil of Giambologna in Florence, de Vries had a brilliant career that climbed steadily, with prestigious commissions from ambitious city governments and refined princely courts, in locations ranging from Turin and Scandinavia to Bavaria and Prague. After leaving Florence in 1586, de Vries spent time in Milan and worked with Pompeo Leoni on the execution of bronze statues commissioned by Philip II of Spain and intended for El Escorial. In 1588 he began an independent career. After a short stay at the Savoy court in Turin, he went to Prague for five years (1589–94). His "civic" series of three great fountains—depicting Augustus, Hercules, and Mercury—along the main street of Augsburg (ca. 1590) is magnificent and resolved in a masterful fashion. One of his most spectacular creations was *The Neptune Fountain* (1615), commissioned by King Christian IV of Denmark for the Frederiksborg Palace; it was dismantled by Swedish troops in 1659 and many fragments of it are now in the Nationalmuseum of Stockholm. Especially lengthy and important was de Vries's tenure at the court of Rudolf II in Prague, beginning in 1601. He became the emperor's portraitist and developed a sophisticated sculptural style with elongated, sensual forms, which won great favor at the court. After the emperor's death (1612), de Vries executed monumental bronze statues for the palace of Graf Albrecht von Wallenstein in Prague, and for churches in Bückeburg and Stadthagen.

In the alluring city of Ferrara, which had already begun its decline, Dosso was full of imagination, and driven by the desire to use images to tell stories.

Dosso Dossi

We do not know exactly when or where the painter was born, but he was destined to become the leading figure of the Ferrarese school of the early 16th century. The first stylistic influence in Dosso's training was Venetian art, but it was immediately tempered with the expressive tradition of the Ferrarese school and an independent narrative style. His youthful works with mythological subjects showed links with Giorgione, but soon references to classical culture and to Raphael emerged. Around 1510, Dosso was working in Mantua, and from 1514 on he worked as a court painter in Ferrara, in tandem chronologically and conceptually with Ludovico Ariosto, then the Este court poet. His paintings (now in the Galleria Estense of Modena) decorated the vault of Alfonso d'Este's Camerino d'Alabastro (Alabaster Chamber), alongside masterpieces by Giovanni Bellini and Titian. Thanks to frequent travel (to Venice especially, but also to Florence and Rome) he managed to stay current with the latest developments in art. He carried on an intense artistic conversation with Titian. In his lengthy collaboration with the Este court, he alternated work on altarpieces (at times, in collaboration with Garofalo) with decorative cycles that featured literary or mythological themes. Around 1530 he was working on the frescoes of the Villa dell'Imperiale in Pesaro and the Castello del Buonconsiglio in Trent, where he met Romanino. In his last years, his chiaroscuro contrasts and symbolic references came to dominate.

Giovanni Luteri; Ferrara (?) ca. 1486–Ferrara 1542

School
Northern Italian

Principal place of residence
Ferrara

Travels
Stays in Mantua, Rome, and Venice; work in Pesaro and Trent

Principal works
The *Costabili Polyptych* (beginning in 1514, Ferrara, Pinacoteca Nazionale); *Melissa* (1516, Rome, Galleria Borghese); frescoes in the Castello del Buonconsiglio, Trent (1531–32)

Links with other artists
In Venice, he met Giorgione; in Ferrara he interacted with Titian; in Pesaro he worked alongside Girolamo Genga, and in Trent with Romanino. His brother Battista worked with him

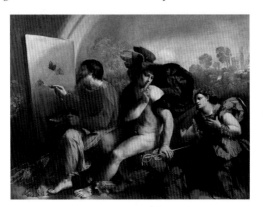

◄ Dosso Dossi, *Jupiter Painting Butterflies, Mercury and Virtue,* 1522–24. Vienna, Kunsthistorisches Museum.

Dosso Dossi

The cupids shooting arrows of love are quite reminiscent of Raphael. Dosso tended to combine various artistic references, but his results show complete liberty.

Decoding the subject is further complicated by the fact that Dosso painted over the woman dressed in red and green, covering her up with more landscape. She was revealed during restorations in the 19th century.

The lush citrus trees are reminiscent of the marvelous natural effects found in the Bacchanales series that Titian painted for Ferrara.

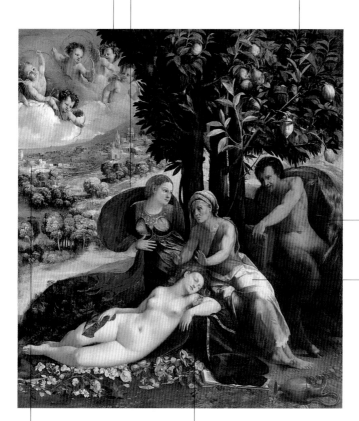

The subject here is complex and coded, and the only clearly identifiable figure is the god Pan.

The elderly woman guarding the sleeping maiden has been interpreted as Gaia, personification of the earth.

The landscape that shades into light-blue tones veined with gold is homage to Giorgione, of whom Dosso Dossi had been an attentive follower in his youth.

The magnificent sleeping nude girl could be the nymph Echo, beloved of Pan. The literary significance of the theme, in any case, is of secondary importance compared with the beauty of this rich and original composition, with gleaming colors and an irresistible vitality.

▲ Dosso Dossi, *Mythological Scene (Pan with a Nymph)*, ca. 1524. Los Angeles, J. Paul Getty Museum.

Germany's greatest artist was a "universal" master, interested in exploring a wide variety of themes, formats, and techniques and constantly striving to further artistic progress.

Albrecht Dürer

Dürer trained first with his father, a goldsmith, and later in the workshop of Michael Wolgemut. At the age of nineteen, Dürer set out on a long trip for purposes of study (1491–94); in effect, his artistic culture expanded to become European in scope. He stayed a while in Basel, then moved to Colmar, in Alsace, where he lived with the sons of Martin Schongauer. In the nearby city of Strasbourg he met Hans Baldung Grien, and the two artists established a lasting friendship. After taking a first trip to Venice, he began a thriving career as a painter and engraver in Nuremberg, working for Maximilian of Habsburg, among others. He returned to Italy from 1505 to 1507, immersing himself in the culture of the Italian Renaissance at its highest levels, just as it attained its greatest splendor. Dürer lingered in Venice, precisely when the local school was evolving from the stylistic tradition of the Bellinis and Carpaccio to the new generation of Giorgione, Lorenzo Lotto, and Titian. The result of that shift was one of the exciting moments in the history of European painting. Following this contact, Dürer's compositions, always characterized by a painstaking attention to draftsmanship, now also evinced an ample monumental and perspectival scope. A later trip, in 1521, took him to Antwerp and the Netherlands, where he met Metsys and Lucas van Leyden. In his later years, he sought in art—in part through the composition of technical treatises—an equilibrium among the tensions that were coursing through Germany.

Nuremberg
1471–1528

School
German

Principal place of residence
Nuremberg

Travels
Southern Germany
(1491–94); two trips to
Venice; travels through
Flanders and the
Netherlands (1521)

Principal works
*Adoration of the Most
Holy Trinity by the
Communion of Saints*
(1511, Vienna,
Kunsthistorisches
Museum); *The Four
Apostles* (1526, Munich,
Alte Pinakothek)

Links with other artists
In contact with all the masters of German art
(Grünewald, Cranach,
Altdorfer, and Baldung
Grien). In Italy he met
Giovanni Bellini and perhaps Leonardo; in the
Netherlands, Quinten
Metsys, Joachim Patinir,
Lucas van Leyden, and
Mabuse (Jan Gossaert)

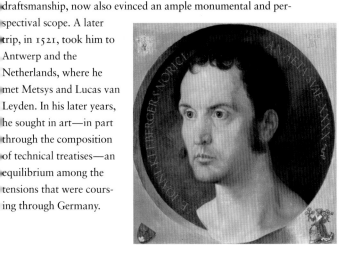

◄ Albrecht Dürer, *Portrait of Johann Kleberger*, 1526. Vienna, Kunsthistorisches Museum.

Albrecht Dürer

As the Last Judgment draws nigh, the saints assemble around the Holy Trinity, depicted in keeping with the northern tradition of the "Throne of Grace," with God the Father supporting Christ on the cross.

A great many of the figures, both saints and characters from the Old Testament, are recognizable from their iconographic attributes. Here are David with his harp and behind him Moses with the stone tablets.

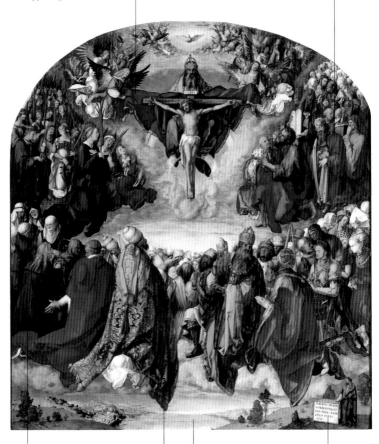

This altarpiece was done for the chapel of All Saints, on a commission from the benefactor, Matthias Landauer, depicted at the left.

The landscape, with a broad, calm, luminous lake, may be a memory of Lake Garda, which Dürer admired during his travels in Italy.

The artist appears next to the inscription, at the bottom right.

Dürer courageously harmonizes his noble composition, based on four concentric circles of figures, and perhaps influenced by Raphael's frescoes in the Vatican, with the proliferation of descriptive details.

▲ Albrecht Dürer, *The Adoration of the Most Holy Trinity by the Communion of Saints*, 1511. Vienna, Kunsthistorisches Museum.

The two panels, donated by Dürer himself to the city of Nuremberg, are the painter's spiritual testament.

In an earlier tradition, these might have been the side panels of a triptych, but Dürer conceived them, in an entirely innovative manner, as independent works standing alone.

The pairs of apostles (John and Peter, Mark and Paul) are personifications of the "temperaments of the human soul."

John and Peter represent, respectively, the sanguine and the phlegmatic temperaments.

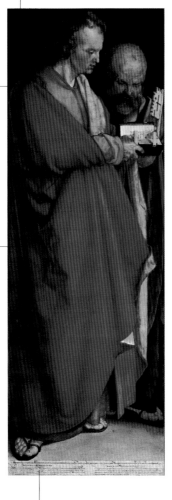

▲ Albrecht Dürer, *The Four Apostles*, 1526. Munich, Alte Pinakothek.

The long inscription at the bottom urges moderation, conciliation, and listening to the others' points of view. In 1525, the city of Nuremberg had officially joined the Reformation.

Mark and Paul are images, respectively, of the choleric and melancholic temperaments; Paul, Luther's favorite apostle, dominates the composition with a stern monumentality.

Gaudenzio Ferrari managed to shatter the Venice-Florence duality through the passionate intensity of his work, fully aware that he was trying to blaze a "third way" for Renaissance painting.

Gaudenzio Ferrari

Valduggia (Vercelli)
1475/80–Milan 1546

School
Northern Italian

Principal place of residence
Varallo Sesia, then Vercelli
(1527–37), and finally Milan

Travels
Probable youthful trip to
Rome

Principal works
Frescoes and statues of *The
Adoration of the Shepherds*
and *The Crucifixion* in the
Sacro Monte of Varallo
(1517–24); frescoes and
altarpiece for the church of
San Cristoforo in Vercelli

Links with other artists
Numerous contacts, not
always documented:
Bramantino, Leonardo,
Perugino, and perhaps
Raphael in his youth; then,
Lotto, Correggio, Savoldo,
Titian, and perhaps Holbein

▶ Gaudenzio Ferrari, Statue
of a shepherd, chapel of *The
Adoration of the Shepherds*,
1520. Varallo Sesia (Vercelli),
Sacro Monte.

Driven by a deeply moving sense of everyday life, but at the same time a careful follower of the most recent figurative developments, Gaudenzio was the inventor of a very specific artistic genre, the Sacro Monte. This hybrid of landscape design, architecture, painting, and sculpture made the complex that he established on the hillside over Varallo a "total artwork," one of the most innovative solutions of the 16th century in the Alpine region. Born into the artistic culture of Lombardy and Piedmont, Gaudenzio attained artistic maturity through a likely (but not documented) journey to Rome. Its effects are evident in the frescoes on the great partition wall in Santa Maria delle Grazie in Varallo (1513), done prior to the creation of the two chapels of the Sacro Monte (*The Adoration of the Shepherds* and *The Crucifixion*), where he did both the sculptures and the surrounding frescoes. Gaudenzio's style is composite and rich, not only because of his close ties with all of the main artists then working in northern Italy (especially Lotto at the turn of the 1520s), but also in his attention to ideas from the north

beginning with Dürer's prints. After completing his work in Varallo, Gaudenzio devoted himself exclusively to painting. The collective emotion of a great collaborative project is evident in such works as the frescoes and altarpiece (1529–34) in San Cristoforo in Vercelli, *Angel Musicians* (1534–36) in the dome of the sanctuary at Saronno, and the paintings he did in his late years in Milan.

The attention to the servants and the descriptive details accentuate the sense of realism in this scene.

Only Christ's frontal position is reminiscent of the model of Leonardo's Last Supper, *which for almost half a century had been the obligatory example for all renditions of the Gospel episode painted in Lombardy.*

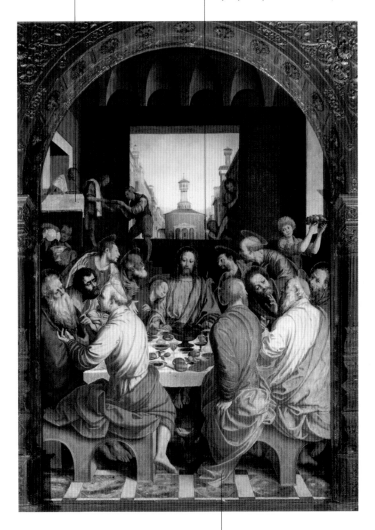

▲ Gaudenzio Ferrari, *The Last Supper*, 1542–43. Milan, Santa Maria della Passione.

The apostles are arrayed around a small square table. Gaudenzio took his inspiration from the engravings of Dürer but worked with a strong and independent personality.

Floris proposed a refined, current, and intellectual version of Italian models and motifs, laced with a growing sense of sadness at the passing of a "golden age."

Frans Floris

Frans de Vriendt; Antwerp 1519/20–1570

School
Antwerp–international Mannerism

Principal place of residence
Antwerp

Travels
Long stay in Italy (1542–46), with trips to Rome, Genoa, Mantua, and Venice

Principal works
The Fall of the Rebel Angels (1554, Antwerp, Musées Royaux des Beaux-Arts); *The Banquet of the Gods* (1561, Stockholm, Nationalmuseum)

Links with other artists
A pupil of Lambert Lombard in Liège. Close friendships with the Italian Mannerists (Giulio Romano, Perino del Vaga, Francesco Salviati), as well as (naturally) with the school of Antwerp

▶ Frans Floris, *The Fall of the Rebel Angels*, 1554. Antwerp, Musées Royaux des Beaux-Arts.

In the school of Antwerp, Frans Floris constituted a link, with a strong Mannerist accent, between the generation of the earliest "Italianists" (Mabuse, Metsys, Van Cleve, and Coecke van Aelst) and the later explosion of Rubens's genius. After apprenticing with Lambert Lombard in Liège, where he received a first dose of Italian influence, Floris returned to Antwerp, joined the painters' guild, and immediately set off for Italy. He made stops in Genoa (almost obligatory for the Antwerp school), Mantua, and Rome, with keen observations of works by contemporary artists (Raphael, Michelangelo, Giulio Romano, Perino del Vaga) and classical monuments. Direct traces of this trip remain in Floris's notebook of sketches. He returned to Antwerp around 1546 and established a thriving workshop, with dozens of collaborators. His monumental style, openly influenced by Italian art, placed him at the center of a vast market of clients. Although his style remained firmly in line with European Mannerism, we can detect in Floris's later works aspects of the Antwerp school's growing quest to portray everyday realism. Several major religious works, including *The Assumption of the Virgin* for the cathedral, were destroyed in the Iconoclastic Fury that swept through Antwerp just a few years before his death in 1570.

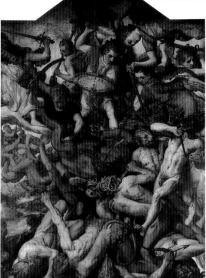

Fra Bartolommeo was one of the leading figures of the early 16th century in Florence. His stylistic contribution, however, would be shunted aside with the advent of the early Mannerists.

Fra Bartolommeo

A fellow student of Piero di Cosimo under Cosimo Rosselli, this painter began his career working alongside Mariotto Albertinelli. The sermons of Savonarola, however, led him into a mystical crisis and, in the year 1500, he abandoned painting and took vows in the Dominican order. He took up art again in 1504, opening a workshop within the monastery of San Marco and reviving his partnership with Albertinelli. Beginning with his *Vision of Saint Bernard* (1504, now at the Uffizi), he displayed a perfect familiarity with the latest artistic trends, incorporating Leonardo's delicate rendering of atmosphere. In 1508, he went to Venice; after this trip, his colors shifted toward warmer, more substantial tones. In 1510 he was involved in the art commissioned at the behest of Gonfalonier Pier Soderini (unfinished altarpiece of *The Immaculate Conception of Mary*, now in the Accademia in Florence), which documents his constant involvement in politics. In his later work, the mystical monumentality of his divine figures grew (his magnificent *Saint Peter* and *Saint Paul*, painted in Rome in 1513, are now in the Pinacoteca Vaticana), in a rendering that was increasingly sensitive to nature and landscape. Fra Bartolommeo's stylistic influence endured for years, through the work of such artists as Fra Paolino of Pistoia and Suor Plautilla Nelli (one of the earliest women painters), who, like him, belonged to the Dominican order. In their work for various Tuscan monasteries and convents, they reutilized his designs and compositions.

Bartolomeo di Paolo del Fattorino, also known as Bartolommeo della Porta; Savignano (Prato) 1472–Florence 1517

School
Florentine

Principal place of residence
Florence

Travels
Stays in Venice (1508) and Rome (1513)

Principal works
The Vision of Saint Bernard (1504, Florence, Uffizi); *God the Father with Saints Mary Magdalen and Catherine of Siena* (1509, Lucca, Museum of Villa Guinigi)

Links with other artists
With many Florentine masters, especially Cosimo Rosselli and Raphael. Much of his work was done in the monastery of San Marco in Florence, where Fra Angelico had worked

◀ Fra Bartolommeo, *The Rest on the Flight into Egypt with Saint John the Baptist*, 1509. Los Angeles, J. Paul Getty Museum.

The imposing figure of God the Father is a peremptory and magnificent apparition; the simplicity of the colors emphasizes its effect.

The little angels mark the artist's abandonment of the recent but already outmoded tradition of Perugino.

Fra Bartolommeo was one of the first Florentine artists to adopt the new Leonardesque sfumato technique.

In Fra Bartolommeo's painting, there are ardent mystical references.

▲ Fra Bartolommeo, *God the Father with Saints Mary Magdalen and Catherine of Siena*, 1509. Lucca, Museum of Villa Guinigi.

The presence of objects in the foreground—here, a single lily stem—breaks the plane of the image with an effect that verges on trompe-l'oeil.

Giambologna is a central figure in extreme Mannerist style, especially for garden design and grandiose urban design projects.

Giambologna

Giambologna's early training in Mons, under the sculptor Jacques Du Broeucq, allowed him to acquire complete mastery of a broad array of techniques. In 1550, he traveled to Rome for study, as had become almost obligatory. This was a decisive experience, and afterward he tried to find a middle way between Michelangelo's sheer power and the sinuous elegance of Hellenism. On his way home, he was invited to Florence; he ended up spending the rest of his life in the city and at the Medici court. Involved in the grand-ducal art projects of Cosimo I de' Medici, Giambologna played a decisive role in the Florentine art scene for the entire second half of the 16th century. Beginning in 1561, he drew a regular salary from the grand-ducal administration and became the leading mastermind behind the seigneury's self-celebration in imagery, both in public spaces (such as the city squares, where he erected equestrian monuments and sculptural groups, beginning with the Piazza della Signoria in Florence) and in the most private settings (*The Fountain of Venus* in the Grotto of Buontalenti in the Boboli Gardens). His works range widely: refined bronze statuettes of mythological subjects, some reprised in numerous copies; the witty, realistic animals now in the Loggia del Bargello; and colossal allegorical sculptures, such as the gigantic statue of *The Apennines* in the garden at Pratolino. Giambologna also made spectacular creations in other cities, such as *The Fountain of Neptune* in Bologna.

Jean de Boulogne
Douai 1529–Florence 1608

School
Florentine–international
Mannerism

Principal place of residence
Florence

Travels
To Rome in 1550

Principal works
Mercury (1564–65, Florence,
Museo del Bargello); *The
Fountain of Neptune* in
Bologna (1563–66)

Links with other artists
A central figure of
international Mannerism,
Giambologna was in contact
with all the Florentine artists
and international sculptors,
such as Adriaen de Vries

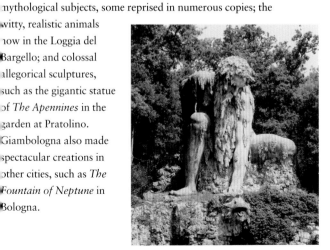

◀ Giambologna, Colossal
statue of *The Apennines*,
1569–81. Pratolino
(Florence), Villa Medici.

297

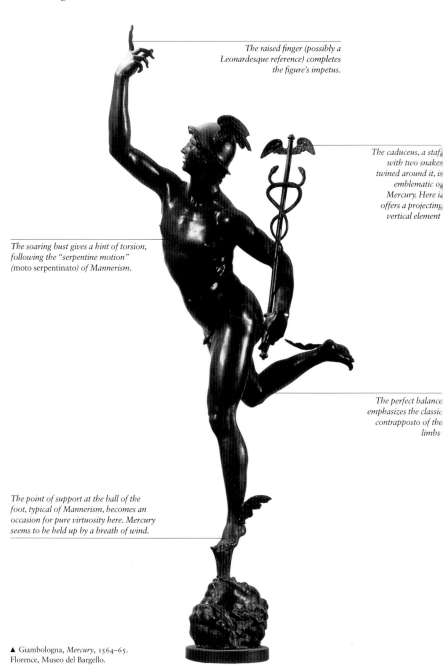

The raised finger (possibly a Leonardesque reference) completes the figure's impetus.

The caduceus, a staff with two snakes twined around it, is emblematic of Mercury. Here it offers a projecting vertical element

The soaring bust gives a hint of torsion, following the "serpentine motion" (moto serpentinato) of Mannerism.

The perfect balance emphasizes the classic contrapposto of the limbs

The point of support at the ball of the foot, typical of Mannerism, becomes an occasion for pure virtuosity here. Mercury seems to be held up by a breath of wind.

▲ Giambologna, *Mercury*, 1564–65. Florence, Museo del Bargello.

Giorgione can be considered a brilliant exponent of an intellectual milieu that was especially given to coded languages, esoteric symbols, and the exaltation of nature.

Giorgione

In all likelihood, Giorgione was a student of Giovanni Bellini, but rapidly incorporated the ideas brought by the "outsiders" who passed through Venice, such as Leonardo and Dürer. His entire production took place within the first decade of the 16th century: his death during an epidemic of plague cut short a promising career. All the same, it is possible to trace his stylistic development, from his earliest, most intensely Belliniesque works to the turning point marked by his altarpiece for the cathedral of Castelfranco Veneto (1504). There the traditional composition of a Sacra Conversazione was resolved into a broad view of landscape and a full immersion in natural light. Giorgione ran a lively workshop, where paintings were also produced collaboratively by several artists. In 1508, together with his pupil Titian, he frescoed the exterior of the Fondaco dei Tedeschi, on the Grand Canal, but only a few fragments of these paintings survive today. What do survive are his medium-sized and smaller paintings, executed for aristocratic collectors. The most popular types of paintings were portraits and religious subjects set against vast landscapes, but he also treated profane subjects, along with moralistic compositions, allegories of the "three ages of man," concert scenes, and abstruse mythological and literary themes. After his death, a number of unfinished works were completed by his two most talented pupils, Titian and Sebastiano del Piombo.

Giorgio da Castelfranco;
Castelfranco Veneto (Treviso)
1478–Venice 1510

School
Venetian

Principal place of residence
Venice

Travels
None are documented, with
the exception of a few brief
trips into the Veneto mainland

Principal works
The Madonna Enthroned (ca.
1504, Castelfranco Veneto,
cathedral); *The Three
Philosophers* (ca. 1504,
Vienna, Kunsthistorisches
Museum); *The Tempest* (ca.
1505, Venice, Galleria
dell'Accademia)

Links with other artists
A pupil of Giovanni Bellini,
in contact with Leonardo
and Dürer in Venice,
Giorgione was also the master of Titian and Sebastiano
del Piombo

◄ Giorgione, *Double
Portrait*, ca. 1508. Rome,
Museo di Palazzo Venezia.

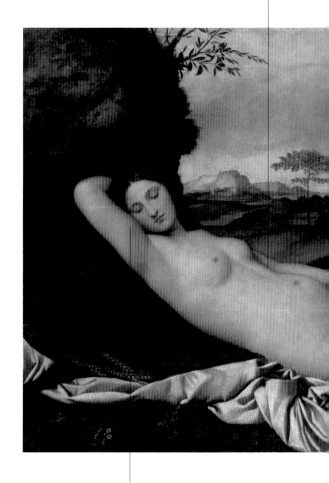

The soft, slender body of Giorgione's Venus is the prototype of the extremely popular genre of the reclining female nude, especially common during the Renaissance in the Venetia region.

▲ Giorgione (completed by Titian), *Sleeping Venus*, 1510. Dresden, Gemäldegalerie.

This Venus is serenely asleep, in contrast to Titian's nudes, which are always wide awake and seductive.

The cluster of rustic buildings on the hilltop at the right contrasts in a picturesque manner with the idealized beauty of the goddess.

The glaring white and red of the drapery, with its luminous highlights, were added by Titian, who completed the canvas that Giorgione left unfinished at his premature and sudden death.

X-ray analysis has revealed the presence of a small cupid in this spot, probably sketched out by Giorgione and then covered up by Titian.

Giorgione

A true masterpiece of tonalism, this painting captures in a magnificent way the transparency of the air, the enchantment of the sky, and the dense fabric of nature.

One of the most alluring and in some ways mysterious paintings of the Renaissance, it can be described as three figures, different in age, dress, and physiognomy, at the edge of a forest.

The sense of suspense and learned inquiry and a number of iconographic details have led some critics to suggest that the figures might be astronomers, or even the Magi witnessing the first appearance of the star.

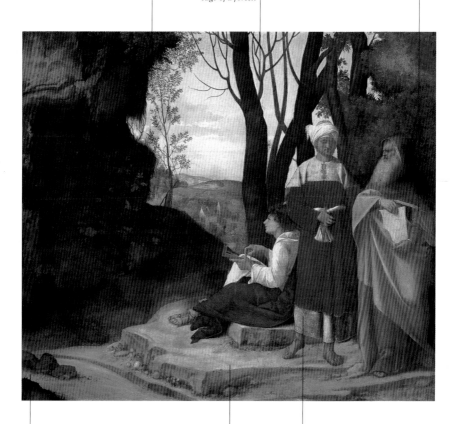

The great geographic discoveries of the era coincided with the first symptoms of the disquiet that would lead to the Protestant schism. The "philosophers" understood in this context become symbols of three different states of mind, moments of the "inner journey" undertaken by all men in the various ages of life.

The figures have been interpreted as an allegory of human races, philosophies, or even the "three ages of man," a common theme in Venetian art of the early 16th century.

The youngest of the three is looking attentively at the landscape, as if expecting a revelation or taking a measurement, while the other two talk, perhaps comparing their observations.

▲ Giorgione, *The Three Philosophers*, ca. 1504. Vienna, Kunsthistorisches Museum.

Giulio Romano orchestrated astonishing buildings, interpreting themes and spaces with solutions that incorporated audacious uses of perspective and combinations of stucco and fresco.

Giulio Romano

A respected architect and decorator, Giulio Romano began his career in the workshop of Raphael. He became Raphael's most trusted collaborator in the execution of such important cycles as the Vatican Stanzas and Loggias, Villa Farnesina, and Villa Madama. After Raphael's death in 1520, Giulio Romano took over as director of the workshop, completing a number of demanding projects (the Sala di Costantino in the Vatican). An especially plastic style and the use of metallic hues distinguish his signed works, in which we also see an emerging tendency toward emphatic gestures and expressions, in line with the new Mannerist school. In 1524, at the invitation of Baldassare Castiglione, he moved to Mantua, where he directed the last phase of Renaissance court art in Italy. He began a career as architect and painter that Vasari described as "varied, rich, and copious." For over twenty years, Giulio Romano built or modified the most important aristocratic and religious buildings in Mantua and its surrounding territory. His best-preserved and most renowned creation is the Palazzo Te (1527–34), the "villa of delights" of Federico Gonzaga, on the outskirts of Mantua, one of the great models for European Mannerism. Palazzo Te presents many innovative features, both architecturally and in its decoration. Giulio Romano later oversaw the decoration of the Appartamento di Troia in the ducal palace (1536–38).

Giulio Pippi;
Rome 1492/99 Mantua 1546

School
First Roman, later moving toward international Mannerism

Principal place of residence
Rome, and later Mantua

Travels
The two different phases of his career were in Rome and then at the court of the Gonzagas

Principal works
The Stoning of Saint Stephen (1523, Genoa, San Stefano); projects in Mantua, especially in the ducal palace and the Palazzo Te (1524–35)

Links with other artists
A pupil of Raphael, in Rome he was in contact with all the great artists working in the Vatican; in Mantua he was acquainted with Titian, and among his closest collaborators was Primaticcio

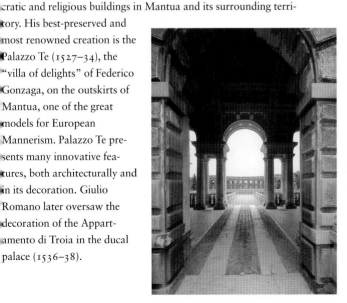

◀ Giulio Romano, Entrance to the court of honor of Palazzo Te in Mantua, 1527–34.

303

Giulio Romano

A large and efficient team of collaborators helped translate Giulio Romano's preliminary sketches into frescoes. All the same, the quality of the Sala di Amore e Psiche suggests that Giulio himself worked on the frescoes in this room.

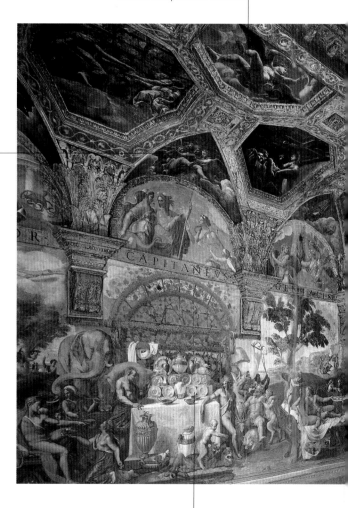

While a luminous array of decorations runs in a flowing continuum along the walls, the ceiling is divided up into panels, rich in perspectival effects and an unexpected play of light.

▲ Giulio Romano, *The Wedding Feast of Cupid and Psyche*, ca. 1530. Mantua, Palazzo Te, Sala di Amore e Psiche.

The descriptive details are finished painstakingly, in order to give a lively and believable image of the lush Gonzaga court. Aside from the individual subjects of the various halls, the celebration of a dynasty remains the basic theme of the frescoes throughout the palazzo.

The two protagonists, the newlyweds Cupid and Psyche, are shown on their wedding bed, but the viewer does not immediately pick them out from the vast and crowded scene.

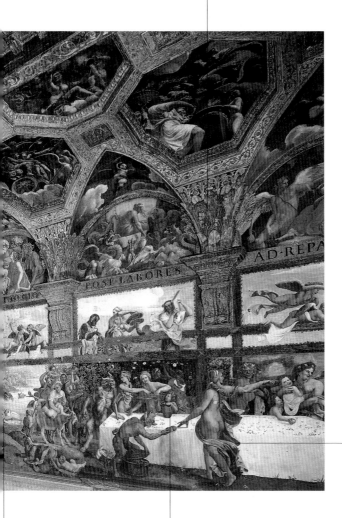

Each room in the Palazzo Te is different in terms of size, structure, and decoration, constantly conveying a sense of surprise and illusion.

Everywhere one sees sensual nudes and serpentine poses, so much a part of the Mannerist style.

The sudden, deep views of landscape give a sense of light and space to the compositions.

The paintings in this room depict different moments during the wedding feast of Cupid and Psyche, with various banqueting scenes and the participation of humans, gods, and animals of every sort, as well as sylvan creatures.

Incomparable lights, phosphorescent colors, mystical pathos, startlingly innovative compositions: El Greco cut an absolutely unique path through the landscape of European art.

El Greco

Domenikos
Theotokopoulos;
Crete 1541–Toledo 1614

School
Spanish

Principal place of residence
Toledo

Travels
During his training, he
stayed a considerable time
in Italy, in Venice and
Rome

Principal works
*The Burial of the Count of
Orgaz* (1586–88, Toledo,
San Tomé); *The Disrobing
of Christ* (Toledo
Cathedral, sacristy)

Links with other artists
After his training in Crete,
close relationships with
Italian artists, especially
Venetians (Titian,
Tintoretto, Bassano), as
well as the miniaturist
Giulio Clovio

He probably trained with the Cretan icon painter Michael Damaskenos, and as early as 1560 he is mentioned in his homeland as a "master painter." Shortly thereafter, he moved to Venice and entered into contact with the great artists of the High Renaissance. Titian, Tintoretto, and Jacopo Bassano were crucial influences in the development of his style. El Greco acquired a rich sense of bright color, and in the works of his youth we see evidence that he had studied with special care the elaborate perspectival structures of Tintoretto. Around 1572, the still-young painter was in Rome, where he studied the work of Michelangelo and enrolled at the Accademia di San Luca. He left Italy and in 1577 we know he was in Toledo, a city that became his adopted home. From this time on, he used his nickname of El Greco; it harked back to a birthplace from which he was increasingly distant but which he never forgot.

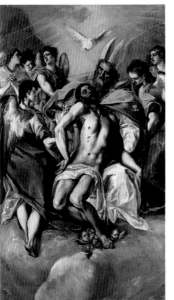

▶ El Greco, *The Trinity*, 1577–79. Madrid, Prado.

The first paintings he did in Spain (such as the Michelangelesque *Trinity,* Prado, 1579) were still inspired by Italian culture of the mid-16th century, and they feature solid human bodies that are well developed in anatomic terms. Then, progressively, his painting took on a fanciful, visionary tone, with figures elongated beyond the limits of verisimilitude. In the last years of the 16th century and especially with the work he did in the 17th, El Greco moved increasingly toward a magical, hallucinatory style, charged with suggestive tension.

We can identify references to the mysticism of Byzantine icons, the colors of Titian, the works of Raphael and Michelangelo, the magical light effects of Tintoretto and Jacopo Bassano, the gestural deformations of Mannerism, perhaps even the compositions of Dürer. And yet what emerges is a new work of art, not a mere juxtaposition of models.

The attendees at this funeral are said to have seen the skies open and the refulgent glory of Christ appear, surrounded by saints and angels.

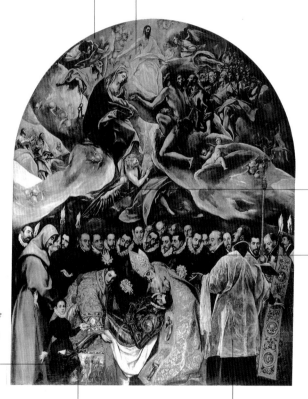

An angel bears the soul of the knight up into heaven, thus linking the two parts of this painting, the earthly precinct and the celestial apparition.

The child in the foreground is probably Jorge Manuel, the painter's son.

El Greco confers upon the entire scene a throbbing disquiet, rendering the expressions feverish, the hands restless, the eyes moist, especially in the exceptional gallery of gentlemen sternly dressed in black.

Still hanging in the modest church for which it was painted, the large canvas depicts a miracle that occurred at the beginning of the 14th century.
Following the death of the pious knight Don Gonzalo Ruiz, count of the small town of Orgaz, it was said, Saints Stephen and Augustine appeared and personally supervised the burial of the nobleman.

▲ El Greco, *The Burial of the Count of Orgaz*, 1586–88. Toledo, San Tomé.

Within a magnificent and well-governed composition, El Greco dominates his painterly material, turning it to surprising effects. The cleric's translucent stole is closely reminiscent of the Venetian precedent by Jacopo Bassano (page 260).

El Greco

In the flight of angels, with their virtuosic and elaborate poses, we can once again detect the influence of a declining Mannerism.

The unusual format (the height is more than twice the width) is perfectly functional for the painter's style, which tended to elongate figures to an unnatural degree.

In keeping with the dictates of the Counter-Reformation, El Greco shows an array of reactions in the face of the sacred: surprise, prayer, tenderness, debate.

The detail of the lamb with its legs tied is not a pastoral observation, but an allusion to the sacrifice of Christ, the "mystical lamb," which would become increasingly common in devotional painting of the 17th century, even as a subject in its own right.

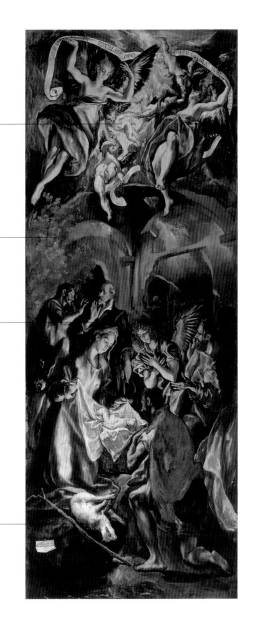

▲ El Greco, *The Adoration of the Shepherds*, 1598–99. Bucharest, National Museum of Art.

Grünewald's work offers an elevated testimonial to a dramatic era, as experienced by a mind closely involved in the crisis of renovation within religion and society.

Matthias Grünewald

Prior to 1505, when he was commissioned to paint an epitaph at Aschaffenburg, we have no documentary sources for this master. Beginning in 1510, Grünewald worked in Mainz and Frankfurt, alternately painting and working as a hydraulic engineer. This versatility earned him a position in 1511 as the court artist to the archbishop of Mainz, Uriel von Gemmingen. The following year he began work on the great altarpiece of Isenheim (now at Colmar), completed in 1516, when Grünewald entered the service of Cardinal Albrecht of Brandenburg, archbishop of Mainz and Halle, who also commissioned work from Dürer, Cranach, and Holbein. He mingled increasingly with other great masters of the German Renaissance. In 1520, he attended, with Dürer, the coronation of Charles V at Aachen. Implicated in the repressions that followed the defeat of Thomas Müntzer's Peasants' War, he was forced to leave Mainz for Frankfurt, where he effectively gave up painting and became a paint merchant; he also manufactured a medicinal soap. In 1527, he worked in Halle, as a hydraulic engineer. He died in 1528. Among the possessions in his estate were spectacular outfits made of valuable fabrics and also, sealed in a locked drawer, numerous Lutheran tracts. "Mathis der Mahler" became a metaphor for a man of genius faced with tragedy.

Matthis Gothardt-Neithardt; Würzburg ca. 1480–Halle 1528

School
German

Principal place of residence
Mainz

Travels
Various stays in numerous German cities: Aschaffenburg, Isenheim, Frankfurt, and Halle. A trip to Aachen for the coronation of Charles V

Principal works
Altarpiece of Isenheim (1516, Colmar, Musée d'Unterlinden); *Virgin and Child* (1517–19, Stuppach, parish church)

Links with other artists
There is documentation of a meeting with Dürer at Aachen

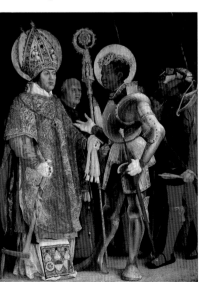

◀ Matthias Grünewald, *The Meeting of Saints Erasmus and Maurice*, 1525. Munich, Alte Pinakothek.

From the time the critics rediscovered it, just after the First World War, the altarpiece of Isenheim has been considered one of the greatest masterpieces of German art and, at the same time, a bone of contention. It was a model for 20th-century Expressionism and yet it was rejected as degenerate art by the Nazis.

Mary's white dress, along with the vivid red of John the Evangelist, stands out starkly against the dark background of the sky.

At the foot of the cross, Mary Magdalen kneels with a moving impetus of grief.

▶ Matthias Grünewald, The Crucifixion, central panel of the polyptych of Isenheim, 1516. Colmar (France), Musée d'Unterlinden.

Depicted in the predella is the Deposition into the Sepulcher, with Christ still bleeding from his many wounds.

The enormous, outsized Christ is riddled with wounds, bruised, beaten, his head tortured with a horrifying crown of thorns, hands and feet massacred by the nails pounded into the unfinished, knotty wood of the cross.

Grünewald's panels originally served as the doors of the large shrine cabinet that had been carved by Nikolaus Hagenauer some ten years previously for Jean d'Orlier, the "preceptor" (prior) of the hospital monastery of the Antonites of Isenheim. His successor, the Sicilian Guido Guersi, was Grünewald's client.

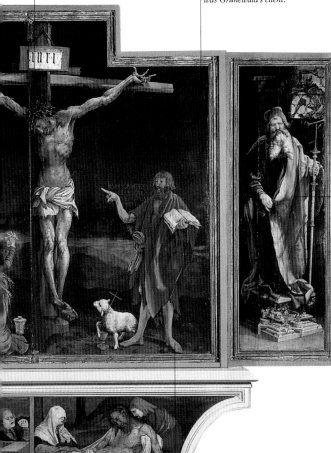

In the side panels, we see Saint Anthony the Abbot and Saint Sebastian, both invoked for the healing of maladies and sores.

An unusual figure is the monumental John the Baptist, accompanied by the mystical lamb; John is pointing to Christ while pronouncing the words, "He must increase but I must decrease" (John 3:30).

A melodious voice in the chorus of artists working in Prague, Heintz brought to the late season of Mannerism an uninhibited sensuality and a refined, seamless, glossy technique.

Joseph Heintz

Basel 1564–Prague 1609

School
German–international Mannerism

Principal place of residence
Prague

Travels
Long stay in Rome for purposes of study

Principal works
The Fall of Phaeton (1596, Leipzig, Museum der Bildenden Künste); *Satyrs and Nymphs* (1599, Munich, Alte Pinakothek)

Links with other artists
In Rome, contacts with the late Mannerist tradition; in Prague he was a member of the group of masters working for Rudolf II (Hans von Aachen, Spranger, Arcimboldi, the Miseroni brothers, and Adriaen de Vries)

After training in Basel, Heintz entered as a young man into the tradition established by Hans Holbein the Younger. In particular, Heintz studied the monumental murals that Holbein executed on the facades of houses, with classical scenes and large figures. Stimulated by Italian references that were common in the figurative culture of southern Germany, Heintz decided at the age of twenty to move to Rome, where he absorbed the latest heritage of Mannerism. In 1591 he moved to Prague and soon became one of the leading figures, along with Bartholomaeus Spranger and Hans von Aachen, in the eclectic court of Rudolf II of Habsburg. He stayed in Prague for the rest of his life. Characteristic of the emperor's sensual and intellectual tastes were mythological paintings on copper, abounding with female nudes. The specialized technique of painting on copper demanded painstaking execution and bright, enameled colors. Heintz's paintings shared the fate of all the collections of Prague, which were looted and largely scattered during the Swedish conquest of the city during the Thirty Years' War. Aside from painting, Heintz also worked as an architect and an interior designer, collaborating with Elias Holl, the leading builder in the late Renaissance in southern Germany, and especially in the wealthy town of Augsburg.

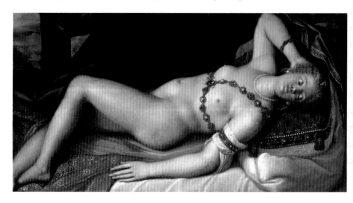

▶ Joseph Heintz, *Sleeping Venus*, ca. 1600. Vienna, Kunsthistorisches Museum.

312

Hilliard's aristocratic, sophisticated, and at the same time passionate portraits are linked to the image of Elizabethan England, as if they were a visual transposition of the works of Shakespeare.

Nicholas Hilliard

The evident lack of an English national school of "history painting" (religious, mythological, or narrative, and not only in the Tudor period, but afterward as well) was in part made up for by the brilliant tradition of portraiture, which derived from the long stay of Hans Holbein at the court of Henry VIII. Hilliard, the most important portraitist of the Elizabethan age, trained as a goldsmith, a skill that was to prove invaluable, not only in his refined prowess as a draftsman, but also for the creation of frames that held the miniature portraits on parchment that were his finest creations. Aside from the model of Holbein, Hilliard also looked to Hans Ewouts (Eworth), the Flemish portraitist who was active in London in the years after 1550. Moreover, even though he preferred to work in the medium of miniatures, which was already in decline, Hilliard showed a keen awareness of the developments of court art over the course of the century, beginning with the Clouets' *crayons*, drawings that depicted distinguished French aristocrats. In the rigorous immobility of the poses, the acute details of fashion and accessories, and the expressions veined with aristocratic melancholy and literary references, the figures of the court of Elizabeth I portrayed by Nicholas Hilliard, beginning with the queen herself, provide us with a vivid inner portrait of an era. It is quite likely that Hilliard, a refined intellectual, was the author of a brief treatise on miniatures that remained anonymous and unpublished until the turn of the 20th century.

Exeter ca. 1547–London
1619

School
English

Principal place of residence
London

Principal works
Miniature portraits (*Sir Francis Drake*, 1585, Greenwich, National Maritime Museum; *Young Man Leaning against a Tree among Roses*, 1587, London, Victoria and Albert Museum)

Links with other artists
Stylistic references to François Clouet

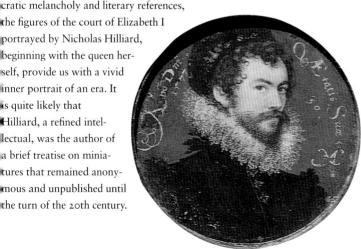

◀ Nicholas Hilliard, *Self-Portrait*, 1577. London, Victoria and Albert Museum.

313

Nicholas Hilliard

Nicholas Hilliard's refined
miniature portraits are a
distinctive expression of English
culture during the Tudor period.

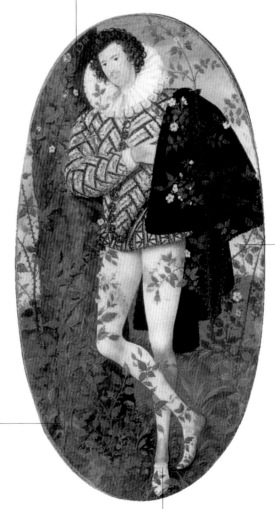

Despite their tiny
size, portraits like
these evoke the
atmosphere of
Elizabethan
England, from court
etiquette to casually
"sporting" young
gentlemen.

A love of gardening
would eventually
become proverbial
in the country
houses of the British
aristocracy.

▲ Nicholas Hilliard, *Young Man
Leaning against a Tree among
Roses*, 1587. London, Victoria
and Albert Museum.

Crossed legs and a thoughtful expression
make this young English gentleman quite
different from his Continental counterparts,
who would be posed according to the canons
of Mannerist portraiture.

Holbein, with his masterful command of three-dimensional mass, his psychological empathy, and his realistic precision, was one of the greatest portraitists of the European Renaissance.

Hans Holbein the Younger

The son and pupil of Hans Holbein the Elder trained as an artist in his hometown of Augsburg. In 1516, he began his own career, along with his brother Ambrosius, working first in Basel and later in Lucerne (1517–19). It is possible to discern the effects of travel to Lombardy in the Leonardesque style of the female half-figures and the early portraits, which are already exemplary for their psychological penetration and their acute rendering of the characters' physical presence, as in the memorable silhouette of Erasmus of Rotterdam. Over the course of the 1520s, Holbein focused on painting religious subjects and also did cartoons for stained-glass windows and engravings. His sacred works reveal both a classical sense of the monumental, in step with the latest developments in Italian art, and a notably intense realism, an analytical—even obsessive—quest for descriptive detail. There are also references to Grünewald's crudeness. During his first stay in England (1526–28), he was favored by the support of Sir Thomas More. Then came new outdoor frescoes done in Basel and a trip to Italy,

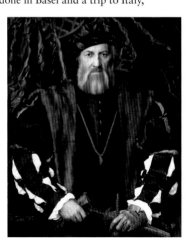

during which Holbein encountered Lotto's portraits. The spread of the Reformation and the substantial drying-up of commissions for sacred art in Germany persuaded Holbein to move permanently to London in 1531. From 1536 (the year Henry VIII married Jane Seymour) on, he was the portraitist to the royal court and to the intellectual aristocracy of England. He died in 1543 of bubonic plague.

Augsburg 1497/98–
London 1543

School
Rhineland–German

Principal place of residence
London (1526–28, and
from 1531 until his death)

Travels
Youthful stays in Basel and
Lucerne; two probable trips
to Lombardy (Milan and
Bergamo)

Principal works
Dead Christ (1526, Basel,
Kunsthalle); *Erasmus of
Rotterdam* (1523, Paris,
Louvre); *The Ambassadors*
(1533, London, National
Gallery)

Links with other artists
The son and brother of
painters, Holbein had
opportunities to mingle with
the masters of southern
Germany (Dürer) and in the
Alsatian-Rhenish milieu. In
Lombardy, he encountered
the Leonardesque school
and Lotto

◀ Hans Holbein the
Younger, *Portrait of Charles
de Solier, Lord of Morette*,
1534–35. Dresden,
Gemäldegalerie.

Hans Holbein the Younger

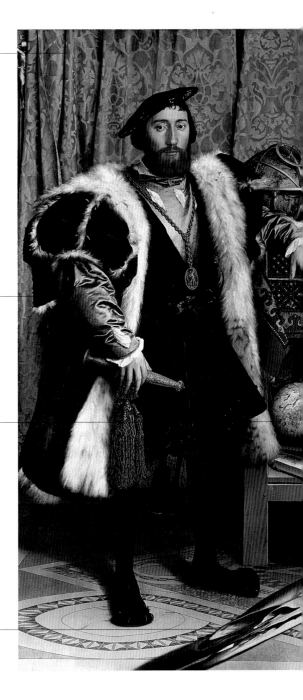

This painting was executed on the occasion of a visit from Bishop Georges de Selve to his friend Jean de Dinteville in London, during the Easter season of 1533. The two young men, respectively twenty-five and twenty-nine years old, were both enjoying rapidly advancing and brilliant diplomatic careers.

Jean de Dinteville, the French ambassador to London and Lord of Polisy, was one of Francis I's most trusted advisors in the field of international affairs.

In the culminating phase of his career, Holbein developed a great capacity for psychological penetration and minute rendering of optical detail.

The apparently mystifying object in the foreground is an anamorphic representation of a human skull, painted with an optical deformation that was also employed by Leonardo.

▶ Hans Holbein the Younger, *The Ambassadors*, 1533. London, National Gallery.

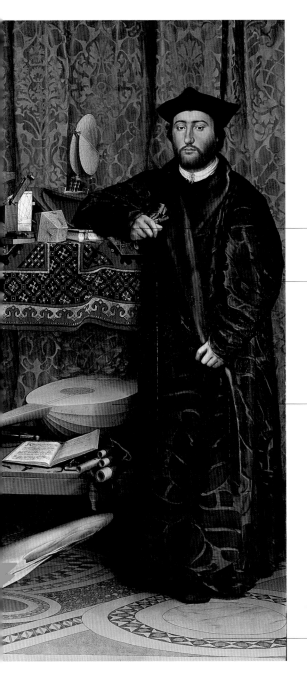

On and in the piece of furniture, which the two diplomats are leaning on with nonchalant elegance, are arranged books and musical and scientific instruments, in a pattern of symbolic references; the piece of furniture is covered with an Anatolian carpet with a geometric motif.

Georges de Selve, dressed in chaste yet refined ecclesiastical garb, was elevated to the rank of bishop while still a young man. He had been posted to the Holy See and later sent as ambassador to Venice, working to reconcile the divisions between Catholics and Protestants.

The motif here is the transient nature of beauty, art, and harmony.

The reference to London is shown by the exact reproduction of the mosaic floor of Westminster Abbey.

The bitter experiences of Lotto's life stand in perfect contrast to Titian's overwhelming personal success. Lotto portrayed a more interior, moody, and suffering image of humanity.

Lorenzo Lotto

Venice ca. 1480–Loreto 1556/57

School
Venetian–northern Italian

Principal place of residence
Chiefly Venice, but with extended stays in Bergamo and in the Marches

Travels
These correspond to the various stages of an unsettled life: stays in Treviso, Rome (1508–10), and Bergamo (1513–26), and several periods in the Marches

Principal works
Virgin and Child with Saints (1513, Bergamo, San Bartolomeo); frescoes in the Suardi oratory (1524, Trescore Balneario, Bergamo); *The Annunciation* (ca. 1527, Recanati, Pinacoteca Comunale)

Links with other artists
Lotto was involved in various milieux: the Venice of Giorgione and Titian, the Rome of Raphael, and Lombardy after Leonardo

After completing his apprenticeship under Giovanni Bellini, Lorenzo Lotto showed an early predisposition for portraiture and sought fresh ideas for altarpieces, experimenting with a new clarity of light and a northern-influenced design. After two stays in the Marches, separated by a difficult time in Rome, where he worked alongside Raphael (1508–10), he moved to Bergamo, where he lived from 1513 to 1526. He was exposed to the work of Gaudenzio Ferrari, and perhaps that of Correggio; he renewed his relationship with northern European art, took up the challenge of working with various techniques, and furthered his study of portraiture. During the 1520s, Lotto painted works that suggest he was pondering Protestant ideas, though his religious beliefs remained contradictory. In 1526, the artist returned to Venice. The Venetian milieu, dominated by Titian, did not welcome a painter with two decades of experience in other parts of Italy, and consequently Lotto maintained his relations with the Marches. After his return to Venice, he sent to Jesi (near Ancona) *The Saint Lucy*

Altarpiece, and to Recanati his *Annunciation,* an example of the psychological dynamism that drove his work. Among the paintings he did for Venetian churches, the most significant is *The Charity of Saint Anthony,* painted in 1542 for the basilica of the Santi Giovanni e Paolo. In 1549, living on the edge of poverty, Lotto left Venice, ending his life as an oblate of the Santa Casa of Loreto.

The objects arranged in an orderly fashion in the room are depicted carefully, almost as if to comment upon the contrast between the quiet flow of life and the upheaval caused by the apparition of the angel.

God the Father, in the background, emerges from the clouds, leaning down from the portico outside Mary's room.

The energetic figure of Gabriel, the angel of the Annunciation, casts a shadow across the floor.

Lotto's absolute creative and psychological liberty is expressed particularly through Mary's gesture of fright, as she stops reading, falls to her knees, and appears to be turning toward the viewer.

A shiver of fear runs through the scene, from the vulnerable, fragile Virgin to the diabolical cat that scampers off, its back arched.

◄ Lorenzo Lotto, *Portrait of a Young Man with a Book,* ca. 1526. Milan, Castello Sforzesco, Pinacoteca.

▲ Lorenzo Lotto, *The Annunciation,* ca. 1527. Recanati (Ancona), Pinacoteca Comunale.

An exceptional engraver and a great painter, Lucas helped to push northward the boundaries of Renaissance art, making Leyden a "mini-capital," open to an international dialogue.

Lucas van Leyden

Lucas Huyghenszoon van Leyden; Leyden ca. 1489–1533

School
Dutch–northern European

Principal place of residence
Leyden

Travels
Antwerp (1521–22); river trip with Mabuse through Zeeland, Flanders, and Brabant (1527)

Principal works
The Temptation of Saint Anthony (1509, Brussels, Musées Royaux des Beaux-Arts); *Virgin and Child with Saint Mary Magdalen and a Donor* (1522, Munich, Alte Pinakothek); *The Last Judgment* triptych (1527, Leyden, Museum Lakenhal)

Links with other artists
In Antwerp he became acquainted with the local school (Mabuse, Metsys, Patinir) and met Dürer

Endowed with an extraordinary talent for design, Lucas trained in the Dutch city of Leyden, in the workshop of the finest local artist of the time, Cornelis Engebrechtsz. He began his career as an engraver, immediately evincing a level of technical skill, creative power, and sureness of hand comparable only to Dürer's. Alongside prints of Bible stories, he produced early genre subjects, figures, and scenes drawn from peasant life. After a stay in Antwerp (1521–22), his style showed the influence of the local Italianist school, but at the same time Lucas established an even closer bond with Dürer's lucid, rich humanism, becoming close friends as well with the artist himself. The next development was a quest for a free form of composition, in which the figures were no longer restricted by the traditional, centralized composition. Eloquent results of this effort were the great triptychs of his later years, such as *The Golden Fleece* of Amsterdam and the *The Last Judgment* of Leyden. In 1527, Lucas embarked on a specially equipped boat, in the company of Mabuse, for a trip through Flanders, Zeeland, and Brabant. He returned to Leyden seriously ill with tuberculosis and was bedridden for the last six years of his life.

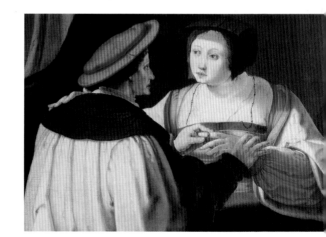

► Lucas van Leyden, *The Lovers*, ca. 1520. Strasbourg, Musée des Beaux-Arts.

Because of the wide array of subjects that he treated and the wealth of his compositional solutions, Mabuse became one of the most influential artists of early 16th-century northern Europe.

Mabuse (Jan Gossaert)

His sobriquet derives from the old version of the name of his birthplace, Maubege. He was a member of the painters' guild of Antwerp as early as 1503. In 1508 he traveled to Rome with Duke Philip of Burgundy. This led to the very early development of a distinctive style, in which the tradition of the Flemish 15th century had not yet been entirely cast off but, at the same time, the Italian "Modern Manner" had already been consciously adopted, not only in the rendering of perspective, but also in the monumental scope of the figures, in the sense of light, and in the relationship among figures and setting. His earliest works, such as *The Malvagna Triptych* (1510, Palermo, Galleria Regionale) and the various versions of *Saint Luke Drawing the Madonna*, reveal an overabundance of decorative elements, an ornamental richness in which an extreme Gothic style seems to merge with a nascent modernism. More "modern," but still marked by a taste for descriptive invention, were the paintings with classical or mythological subjects, such as the *Neptune and Amphitrite* of Berlin, or the late *Danaë* of Munich (1527). Of note was the boat trip that Mabuse took with Lucas van Leyden in 1527, touring the main cities of Flanders, Brabant, and Zeeland and sailing along canals and navigable rivers. His work was sought after by the courts of Burgundy, Denmark, and the Flemish branch of the house of Habsburg.

Jan Gossaert; Maubege ca. 1478–Middelburg 1532

School
Flemish

Principal place of residence
Antwerp

Travels
To Rome in 1508; periodic trips to Malines and other Flemish-Dutch towns (Middelburg, Utrecht); river trip with Lucas van Leyden through Zeeland, Flanders, and Brabant (1527)

Principal works
Saint Luke Drawing the Virgin (1515, Vienna, Kunsthistorisches Museum); *Danaë* (1527, Munich, Alte Pinakothek)

Links with other artists
Close relationships with the main artists of northern humanism, including Dürer and Lucas van Leyden

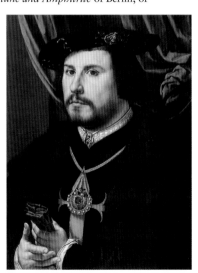

◀ Mabuse (Jan Gossaert), *Portrait of Francisco de los Cobos y Molina,* 1530–32. Los Angeles, J. Paul Getty Museum.

This versatile painter never entirely abandoned the style of the Flemish "primitives," while staying in tune with new artistic developments and exploring realism and the grotesque.

Quinten Metsys

Quentin Massys; Leuven 1466–Antwerp 1530

School
Flemish

Principal place of residence
Antwerp

Travels
Trip through Italy, Milan and Venice

Principal works
Saint Anne Triptych (1509, Brussels, Musées Royaux des Beaux-Arts); *The Money-Changer and His Wife* (1514, Paris, Louvre)

Links with other artists
Within the school of Antwerp, he had contacts with Holbein, Lucas van Leyden, Bosch, and Dürer, as well as a close friendship with Patinir. During his trip to Italy he studied works by Leonardo

After training in his hometown, at first with his father, Josse, a noted blacksmith and clockmaker, and later in the workshop of Dirck Bouts, Metsys began his career as a painter fairly late but spent his youth in the atmosphere of the last period of the Flemish "primitives." His youthful work as a forger of artistic wrought iron explains the little mallet that Metsys sometimes painted as the insignia of his works. Metsys joined the guild of painters of Antwerp in 1491 and soon became the leading figure of the local school, facilitating a decisive opening of early 16th-century Flemish art to the "Italian style." Nevertheless, he would never entirely forget the great tradition of Van der Weyden and Memling. He received many commissions from the crafts guilds of Antwerp and Leuven. In the first decade of the 16th century, he took a trip to Italy, focusing especially on the art of Leonardo, after which his style became richer. His interest in the humanist

culture also led him toward an increasingly broad intellectual involvement. In 1517, through his friendship with Pieter Gillis, he became acquainted with the humanists Erasmus of Rotterdam and Sir Thomas More. In 1521, clearly a prosperous businessman, he purchased and decorated a luxurious residence in the center of Antwerp. His relatively early death interrupted a career that was still on the rise.

▶ Quinten Metsys, *Grotesque Old Woman (Ugly Duchess)*, ca. 1513. London, National Gallery.

The critical conscience of the Renaissance at its height, and later a witness to its crisis, Michelangelo dominated and characterized the 16th century as a sculptor, architect, painter, and poet.

Michelangelo

A pupil of Ghirlandaio, Michelangelo began his career amid the revival of antiquity promoted by Lorenzo the Magnificent. With his *Pietà* for Saint Peter's Basilica in Rome, he began a pattern of alternating stays in Florence and Rome, responding variously to the requests or demands of popes and grand dukes, Roman Curia or Florentine Signoria. After completing the *David* in 1504, Michelangelo vied with Leonardo in the decoration (since lost) of the Palazzo Vecchio and also painted the *Doni Tondo*. He was then summoned back to Rome by Pope Julius II, where he began the colossal and exhausting tasks of the pontiff's tomb and the frescoes on the Sistine Chapel ceiling, a dramatic synthesis of the history of man and, at the same time, an absolute celebration of the beauty of creation. After completing this project, upon which he worked incessantly from 1508 to 1512, Michelangelo returned to sculpture, working on the revised project of the tomb of Julius II (statue of *Moses* and *The Captives*). In Florence, he designed the facade of San Lorenzo and the New Sacristy with the Medici Tombs for the new pope, Leo X. In 1534, he took up his paintbrushes again, for the lengthy gestation of *The Last Judgment* in the Sistine Chapel. This "terrible" masterpiece was followed, in his old age, by such magnificent architectural masterpieces as the dome of Saint Peter's and the Piazza del Campidoglio in Rome.

Caprese or Arezzo
1475–Rome 1564

School
Tuscan–Roman

Principal place of residence
Florence and Rome (where he lived beginning in 1534)

Travels
Brief stays in various cities
(Venice, Bologna, Siena)

Principal works
David (1501–4, Florence, Galleria dell'Accademia); frescoes in the Sistine Chapel in Rome (1508–12 and 1537–41); Medici tombs (from 1519, Florence, New Sacristy of San Lorenzo)

Links with other artists
Fundamental artist of the Italian Renaissance; practically all the artists interacted with him. He was a rival at different times of Leonardo, Raphael, and Titian. Some of his drawings were made into paintings by Sebastiano del Piombo and Pontormo

◄ Michelangelo, *Doni Tondo*, 1504. Florence, Uffizi.

Michelangelo

Adam slowly lifts his powerful, agile body from a sloping ridge. His still-uncertain finger extends toward the absolutely firm finger of God, in a silent exchange of gazes, will, and power.

It almost seems as if we can detect a cosmic spark in the space—at once tiny and unfathomable—that separates the index finger of God from that of man.

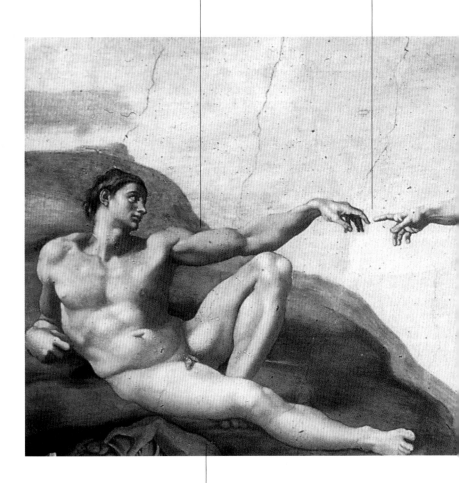

▲ Michelangelo, *The Creation of Adam*, 1508–12. Vatican City, ceiling of the Sistine Chapel.

This renowned scene is the deeply moving focal point of the entire ceiling. In an eternal instant, suspended in the void, life is infused into a being created in the image and semblance of the divine. The subsequent scenes, leading up to the Salvation of Noah, all seem to follow from this fateful act.

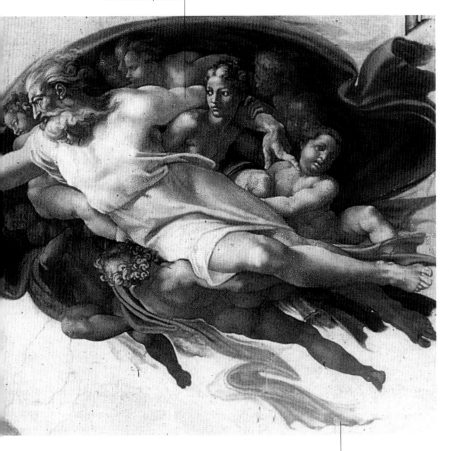

Michelangelo insistently strives to convey "terribilità." The irresistible will and power of God the Father dominate the ceiling. The Creator sails by, flying through the spaces of the ceiling. Every gesture is a command, every instant is an explosion of power, which reaches its crescendo in the scene of the Creation of Adam.

Set between pairs of "ignudi" (nude men), the Bible scenes occupy the highest and central section of the ceiling of the Sistine Chapel.

The figure of Nicodemus, the summit and support of the entire pyramidal group, is a suffering self-portrait of Michelangelo around the age of seventy-five.

The contrast between the almost-roughed-in face of Mary and the well-polished arm of Christ is an instance of the "non finito" (unfinished) effect, the technique that Michelangelo used increasingly in the sculptures of his maturity and later years.

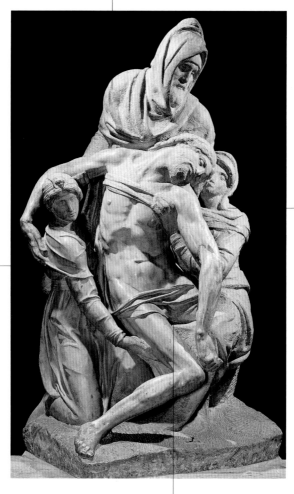

Mary Magdalen, lamentably disproportionate in her dimensions, was finished by Tiberio Calcagni.

Precisely because of his powerful autobiographical identification with this piece, Michelangelo was unsatisfied with the result. He destroyed the left leg of Christ and failed to resolve the supporting figure on the left.

▲ Michelangelo, *The Pietà*, ca. 1550. Florence, Museo dell'Opera del Duomo.

Intensely moving is the close proximity—indeed, practically melding into a single block—of the heads of Christ and Mary.

The sculpture is unfinished. Michelangelo continued to work on it until three days before his death.

The arm on the left is all that remains from a previous composition for the group, which Michelangelo abandoned.

The composition with two vertically oriented figures is intensely experimental, entirely different from the traditional formulation of the Pietà, including those composed by Michelangelo himself.

Christ's lifeless legs are the most "finito" (finished) and polished part of the block of marble.

A somewhat disconcerting detail is Mary's naked leg, with which she tries to support the body of Christ.

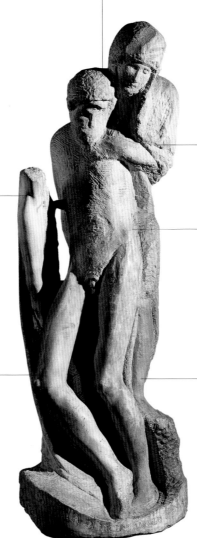

▲ Michelangelo, *The Rondanini Pietà*, ca. 1564. Milan, Castello Sforzesco, Sala degli Scarlioni.

Also known by his Latinized name of Antonio Moro, he was one of the most respected northern European portraitists of the late 16th century.

Antonis Mor

Utrecht ca. 1520–Antwerp 1576

School
Flemish–Dutch

Principal place of residence
Utrecht and Antwerp

Travels
In 1548 he was in Augsburg; in 1550–51 he was in Italy; then in Portugal, Spain (where he would return in 1559), and finally London in 1554

Principal works
Cardinal Granvelle (1549, Vienna, Kunsthistorisches Museum); *Hendrick Goltzius* (1576, Brussels, Musées Royaux des Beaux-Arts)

Links with other artists
He was a pupil of Van Scorel. In Augsburg he met Titian; in Italy he came into contact with Bronzino and Moroni, while in London he followed in the footsteps of Holbein

▶ Antonis Mor, *Portrait of Sir Thomas Gresham, Founder of the Royal Exchange of London,* ca. 1570. Amsterdam, Rijksmuseum.

A pupil of Van Scorel, oriented toward the Italian style from his apprenticeship, Mor enrolled in the Antwerp guild of painters in 1547. The next year, he went to Augsburg to attend the diet convened by Charles V. There he met Titian and decided to specialize in aristocratic portraiture. The dignitaries present in Augsburg, including the powerful Cardinal Granvelle, were his first clients. Antonis Mor sensitively captured the spirit of a tense and conflicted time, and the chilly composure and suspicious haughtiness of the international aristocracy that took the Spain of Philip II as its model. In 1550–51, he traveled to Rome; his journeys through Venetia and Lombardy allowed him to complete a wideranging education, at a particularly fertile moment in the history of portraiture. Mor was a wanderer who moved frequently among the courts of Madrid, Lisbon, and London (1554). In brief, he inherited much from the great portraitists of the first half of the century, from Holbein to Titian. His verisimilitude merges with an

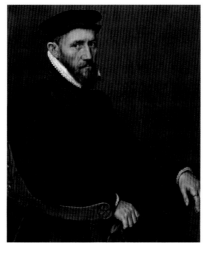

exaltation of the subject's rank to express the solitude of the powerful, touched at times with a sense of anguish. After returning home to a somewhat more stable life, he alternated stays in Utrecht and Antwerp and continued to work in portraiture, with a distinctively cool, impersonal manner, marked by a sense of extreme nobility, and with mostly neutral, dark backgrounds.

Parmigianino offered a stylistic counterpoint to the work of Correggio, and together they made Parma one of the most advanced artistic laboratories in the 1520s and 1530s.

Parmigianino

Born into a family of mediocre painters but endowed with a precocious talent, Parmigianino immediately came into contact with Correggio, for whom he worked as a creative and independent assistant on the side-chapels frescoes of San Giovanni Evangelista in Parma. At the age of twenty he painted *The Bath of Diana* in the Rocca (castle) at Fontanellato, beginning a long client–artist relationship with Galeazzo Sanvitale. In 1524, after providing evidence of his innovative virtuosity with his *Self-Portrait in a Convex Mirror*, he went to Rome and plunged into the artistic milieu of the court of Pope Clement VII. In that arena, he produced portraits with a clear-eyed, refined composure and sacred paintings in which his admiration for antiquity, steeped in nostalgia, combined with Raphaelesque elements and an increasing elongation of bodies in turning, flexing poses. Following the Sack of Rome in 1527, he spent a few years in Bologna, where he painted dramatic altarpieces. He returned to Parma in 1531. Here he began the demanding project of the frescoes for the church of Madonna della Steccata, aspiring to a refined, stylized classicism. In his painstaking draftsmanship, his esoteric intellectualism, and his serpentine poses, we clearly see his polemic rejection of Correggio's flowing softness. In the last years of his short life, Parmigianino turned inward, focusing with passionate interest on alchemy, whose influence can be detected in works dense with symbolic references, such as *The Madonna of the Long Neck*.

Francesco Mazzola; Parma
1503–Casalmaggiore 1540

School
Northern Italian–
international Mannerism

Principal place of residence
Parma

Travels
Long stay in Rome, interrupted by the Sack of Rome in 1527; he then spent a period in Bologna

Principal works
Frescoes in the Rocca di Fontanellato (ca. 1523); *The Madonna of the Long Neck* (ca. 1533, Florence, Uffizi)

Links with other artists
Constant interaction and conflict with Correggio; in Rome, he was in contact with the school of Raphael, which continued when Giulio Romano moved to Mantua

◄ Parmigianino, *Self-Portrait in a Convex Mirror*, 1524. Vienna, Kunsthistorisches Museum.

Parmigianino

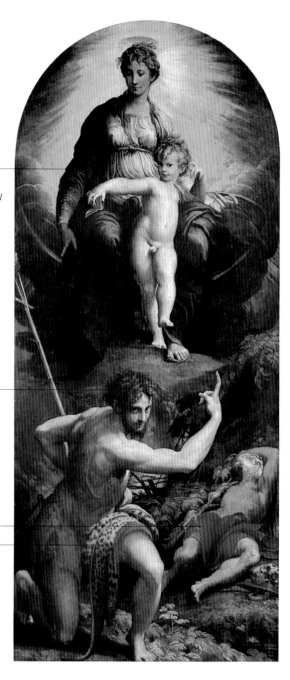

Executed during the painter's time in Rome, the altarpiece shows the influence of Michelangelo and Raphael but also attempts to further intensify the passionate effects.

Through the interplay of gazes and gestures, Parmigianino attempts to spark an acute and ambiguous dialogue with the viewer.

This painting depicts the vision of Saint Jerome, but Parmigianino reverses the usual format: the sleeping saint is in the background, while the true protagonist is the vision itself, with the Baptist pointing to the Madonna with Christ child, summoning the spectator to participate.

The powerful rotation of the body of the Baptist in the foreground is an instance of Parmigianino's intense and original interpretation of Mannerism.

▶ Parmigianino, *The Vision of Saint Jerome*, 1526–27. London, National Gallery.

Panoramas open out before the viewer: far horizons, fantastic combinations of twisted rocks, and immense bodies of water form the moving style of one of the first specialists in landscape.

Joachim Patinir

Born in the Walloon section of Belgium and perhaps trained in Bruges, under Gérard David, Patinir moved to Antwerp and in 1515 enrolled in the local confraternity for painters. Attempts to reconstruct Patinir's life and work are hindered by the almost complete lack of documents or contemporary sources, as well as the confusion engendered in the past by the small number of signed works and the poor quality of imitations by many follow-ers or copyists. During his youthful artistic training, he no doubt observed and admired the works of Bosch, from whom he bor-rowed a visionary style and a penchant for creating fantastic set-tings while making use of realistic details. An early specialist in landscape, long before it became an independent genre, Patinir established relationships with the leading Antwerp masters, and especially with Quinten Metsys, whom he occasionally asked to paint the figures in his works. The paintings of Patinir, so advanced and daring in terms of their landscapes, are in fact mediocre in their characters. The figures for the most part appear as mere pretexts to justify vast panoramic settings, created with robust blues and greens and dramatic contrasts between areas that are peopled and serene and those of a tortured, deserted, bizarre nature.

Also mentioned as Patinier; Bouvignes or Dinant ca. 1485–Antwerp 1524

School
Flemish

Principal place of residence
Antwerp

Travels
Not documented; it is quite likely that he encountered Bosch, perhaps at 's Hertogenbosch

Principal works
The Baptism of Christ (1515–19, Vienna, Kunsthistorisches Museum); *The Temptation of Saint Anthony* (1520–24, Madrid, Prado)

Links with other artists
He collaborated with Gérard David, Quinten Metsys, and Joos van Cleve. His admiration for Dürer is documented

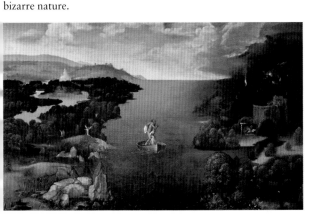

◄ Joachim Patinir, *Charon Crossing the River Styx*, ca. 1520. Madrid, Prado.

Pilon developed a new form for official court sculpture, with images in which Catholic devotion blend with Mannerist intellectualism without losing allure or refinement.

Germain Pilon

Paris 1528–1590

School
French

Principal place of residence
Paris

Travels
Very likely that he spent time studying in northern Italy

Principal works
Monument to the Heart of Henry II (1560, Paris, Louvre); *Funerary Monument for Henry II and Catherine de' Medici* (1565–73, Saint-Denis, basilica)

Links with other artists
Probable contacts with Leone Leoni; in France, links with Primaticcio and the second school of Fontainebleau

Germain trained in the workshop of his father, André, a Paris sculptor, and like all of the leading masters during the reign of Francis I, Pilon also spent time at the building site of Fontainebleau. There he worked alongside Primaticcio and would in time become one of his most skillful assistants. Ambitious, talented, focused on important alliances, Pilon sought and found a prestigious role in court circles. Appointed royal sculptor in 1558, he debuted with a series of marble sculptures intended for the tomb of Francis I, though they were never installed. The turning point in Pilon's career came with some commissions from Catherine de' Medici, beginning with the elegant urn to hold the heart of Henry II, now in the Louvre. Under the supervision of Primaticcio, Pilon established his reputation as the chief sculptor for the "Chapelle des Valois" in the basilica of Saint-Denis. Pilon worked as easily in bronze as in marble, with exacting attention to the surface finish and the rendering of features and costume details. In 1565 he became director of the project, which revolved around the monumental tomb of Henry II and Catherine de' Medici. The monarchs are depicted lying dead beneath and kneeling in prayer above amid magnificent allegorical figures of the Virtues. This work was followed by other sculptural groups for Saint-Denis, in tune with the ideas of the Counter-Reformation, and notable groups of sacred subjects (*Lamentation over the Dead Christ*, now at the Louvre), medals, and portrait-busts, at times astonishing and macabre in their realism.

▶ Germain Pilon,
Monument to the Heart of Henry II, 1560.
Paris, Louvre.

A tormented, erratic, dissatisfied artist, brilliant and courageous but also given to bursts of anguished crisis, Pontormo was the protagonist of a watershed in Florentine painting.

Jacopo Pontormo

After training in the lively milieu of early 16th-century Florence, amid the still-resounding echo of Savonarola's sermons and the early works of Michelangelo, Pontormo began his career as a pupil of Andrea del Sarto, with frescoes in the church of the Santissima Annunziata and the cloisters of Santa Maria Novella. Driven by a determination to exaggerate the expressivity of his figures, Pontormo made use of innovative references, such as Dürer's prints. Around 1520, along with Rosso Fiorentino, he was one of the leading figures in the birth of Mannerism. The Medici hired him for the decoration of the villa of Poggio a Caiano (1519–21); later he frescoed the lunettes of the cloister of the Certosa del Galluzzo. Around 1525 he was working on the Capponi Chapel in Santa Felicita, in Florence. Pontormo executed the altarpiece with *The Deposition of Christ*, the fresco of *The Annunciation* on the side wall, and three of the four ceiling tondi with evangelists; the fourth tondo was assigned to his promising pupil Bronzino. This phase was interrupted in 1529, when the siege of Florence by imperial troops drove Pontormo into profound despair. An early prototype of a *peintre maudit*, Pontormo turned his energy to a colossal undertaking, the decoration of the apse of the basilica of San Lorenzo. He hoped to compete directly with Michelangelo, at whose side he appears to have worked diligently, but with apparently disappointing results.

Jacopo Carucci; Pontorme (Empoli) 1494–Florence 1557

School
Florentine

Principal place of residence
Florence

Travels
Short trips in Tuscany

Principal works
Lunette with *Vertumnus and Pomona* (1521, Poggio a Caiano, Medici Villa); decoration of the Capponi Chapel (1525, Florence, Santa Trìnita)

Links with other artists
Possibly a pupil of Leonardo, later with Rosso Fiorentino under Andrea del Sarto, and spent his life in rivalry with Michelangelo

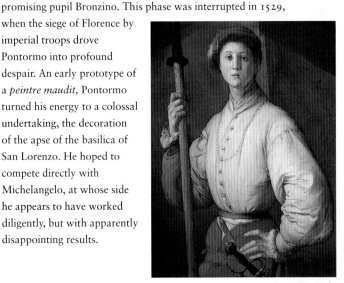

◀ Jacopo Pontormo, *Portrait of a Halberdier (Francesco Guardi?)*, 1528–30. Los Angeles, J. Paul Getty Museum.

*This mythological and pastoral fresco
constitutes a rare and invaluable
"secular" interval in a body of work that
was almost invariably tense, neurotic, and
focused on portraits or religious scenes.*

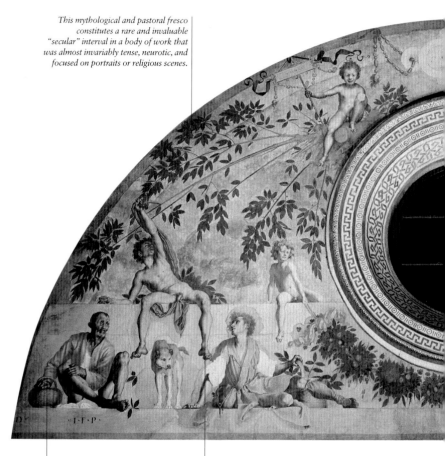

*Unexpectedly, here Pontormo shows
that he is capable of a humane and
empathetic realism. The mythological
subject—the wooing of Pomona by
Vertumnus, both Italian deities of gar-
den and fruit—goes virtually unnoticed.*

*The references to Michelangelo, and
specifically to the Sistine Chapel, are
not as fraught as those found in other
followers.*

▲ Jacopo Pontormo, Lunette with
Vertumnus and Pomona, 1521.
Poggio a Caiano, Medici Villa.

This prestigious commission for one of the loveliest homes of the Medici family was executed quite successfully by Pontormo, who freely interpreted the space of the large lunette, which is interrupted at the middle by a circular window.

Thanks to his customary, painstaking preparatory drawings (careful sketches survive for nearly all the figures), Pontormo endowed each figure with a charming freshness. Here Pomona grasps the tree that represents her husband and lover, Vertumnus, the radiant youth on the left.

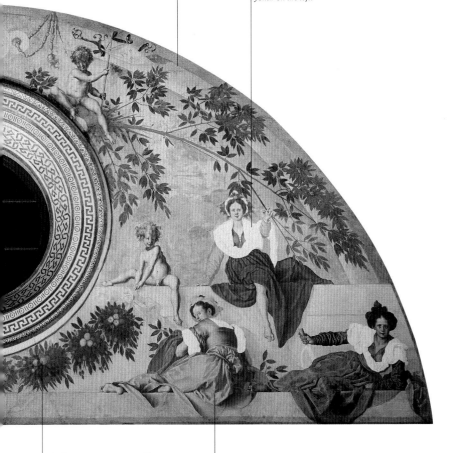

The fresco conveys a sense of luminous spaciousness, evoking an afternoon in the countryside, set in the midst of nature, which is suggested by nothing more than a few leafy branches.

The gazes of some of the figures, and especially that of the woman on the right, capture and draw in the viewer.

The unusual embrace between the two women, shown both frontally and in silhouette, with the colors of their outfits symmetrically reversed, is a disturbing device, involving the viewer in an intellectual exercise on one's relationship with an artwork.

Pontormo abandons all iconographic precedents and composes a monumental urban setting that is silent, gloomy, and almost spectral.

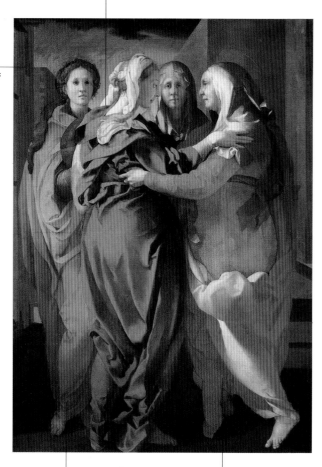

▲ Jacopo Pontormo, *The Visitation*, 1528–29. Carmignano (Florence), San Michele.

Abandoning the 15th-century conceit of the painting as a "window" looking out onto reality, Pontormo prompts the viewer to engage in a new understanding of the "Modern Manner," in which the artist is understood to be creating an "artificial nature."

In the foreground Mary and Elizabeth tower, voluminous and solemn, shown in silhouette; behind them emerge, as if they were metaphysical "doubles," the same figures but viewed frontally, gazing toward the viewer.

Possessed of eclectic talents as a painter, sculptor, and architect, Primaticcio was considered a genuine master in terms of style and taste by the workshops of international Mannerism.

Francesco Primaticcio

Primaticcio worked under Giulio Romano in Mantua, where he excelled in the decorations of the ducal palace and the Palazzo Te. There he showed his originality in the stucco friezes, which worked as narrative elements—fully complementary to the frescoes—as well as decoration. In 1532, he moved to Fontainebleau, where he worked for Francis I. Together with Rosso Fiorentino, he designed and decorated the gallery of the château, in a spirit of up-to-date intellectualism. Unfortunately, nearly all the work documented as having been carried out in the royal apartments—a brilliant fusion of frescoes, stuccoes, and gilding—has been lost. Primaticcio elaborated on the supple elegance of Parmigianino's style, combining it with the robust expressivity of Giulio Romano and the sheer power of Michelangelo. After Rosso died (1540), Primaticcio took over as the general supervisor and also became head purchaser for archaeological finds and casts. This last responsibility took him frequently back to Italy, where he caught up with the latest artistic developments and encouraged other artists to come to France. The spectacular product of his labors is

the Galerie d'Ulysse, done with the assistance of Niccolò dell'Abate, whom Primaticcio had lured to Fontainebleau. After a period of partial obscurity during the reign of Henry II (1547–1559), Primaticcio was appointed royal architect, replacing Philibert de L'Orme.

Bologna 1504–Paris 1570

School
International Mannerism

Principal place of residence
Fontainebleau

Travels
He spent some time in Mantua (1526–32), with extended stays in Venice and Bologna; he frequently returned to Italy (Bologna, Rome, Milan, Ferrara, and Mantua)

Principal works
Stuccoes in the Palazzo Te in Mantua; frescoes in Fontainebleau; *Ulysses and Penelope* (ca. 1545, Toledo Museum of Art, OH)

Links with other artists
In Mantua he worked with Giulio Romano; in France, aside from the various French masters (from Clouet and Goujon to Cousin and Pilon), he was in contact with the Italian artists Rosso Fiorentino, Sebastiano Serlio, and Niccolò dell'Abate

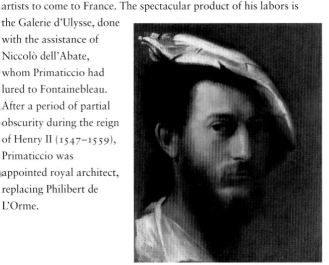

◀ Francesco Primaticcio, *Self-Portrait*, 1540. Florence, Uffizi.

Francesco Primaticcio

The French king Francis I liked to identify himself with Ulysses. It was not uncommon in the 16th century for rulers to "select" a character for themselves from classical antiquity.

Penelope's intricate hairstyle and the eroticism implicit in the situation portrayed are both distinctive features of the artistic school of Fontainebleau.

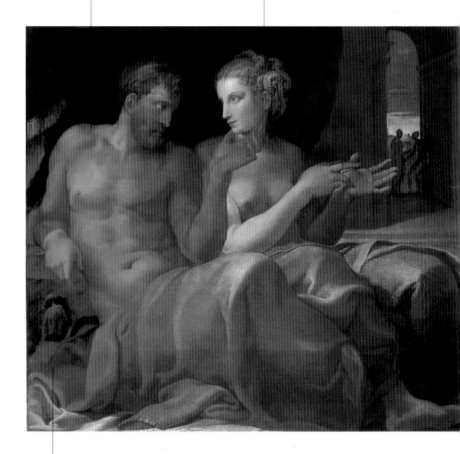

This painting is one of Primaticcio's few canvases to have escaped dispersal or repainting.

▲ Francesco Primaticcio, *Ulysses and Penelope*, ca. 1545. Toledo (Ohio) Museum of Art.

In his brief life, Raphael attained a delicate and exquisite equilibrium of serene perfection, a style that was at once natural and ideal, with a spontaneous and enchanting beauty.

Raphael

The son of a painter and author of treatises named Giovanni Santi, Raphael took over his father's Urbino workshop while still a boy. At sixteen he was already a master in his own right. Around 1500, Raphael became an attentive and critical collaborator of Perugino. His gift for absorbing and elaborating the ideas of other artists marked his time in Florence (1504–8). In a dialogue with Leonardo and Michelangelo, the still-young artist managed to balance the proper use of the rules governing Renaissance art with the imitation of nature and sweetness of expression. In 1508, Pope Julius II summoned him to Rome to fresco the rooms (*stanze*) of his private Vatican apartment. The series began with the Stanza della Segnatura (1508–11) and continued with the Stanza di Eliodoro (1511–13), with an evolution from harmoniously composed scenes with symmetrical backgrounds to scenes of greater turmoil and an evocative play of light. At the same time, Raphael was producing altarpieces, portraits, and frescoes, including the decoration of the Villa Farnesina. During the papacy of Leo X, Raphael became curator of Vatican works and took special pains to safeguard the archaeological patrimony.

Urbino 1483–Rome 1520

School
Central Italy

Principal place of residence
Rome (from 1508 on)

Travels
Various stays in the Marches, Umbria, and Tuscany (with a crucial stay in Florence), until he moved permanently to Rome

Principal works
Sposalizio (The Marriage of the Virgin) (1504, Milan, Pinacoteca di Brera); frescoes in the Vatican Stanze (from 1508 on); *The Transfiguration* (1520, Vatican City, Pinacoteca Vaticana)

Links with other artists
Close contacts throughout his life, the most important of which were with Perugino in his youth, Leonardo in Florence, Michelangelo, Bramante, and Sebastiano del Piombo in Rome

◀ Raphael, *Self-Portrait*, 1509. Florence, Uffizi.

The misunderstanding that this painting is supposed to represent a "folk" setting is based on Mary's unusual costume, with a sort of turban on her head and a colorful, patterned shawl around her shoulders.

The tondo format suggests a strongly centripetal composition. The eyes of the figures, turned toward the viewer, almost create a vortex of emotions.

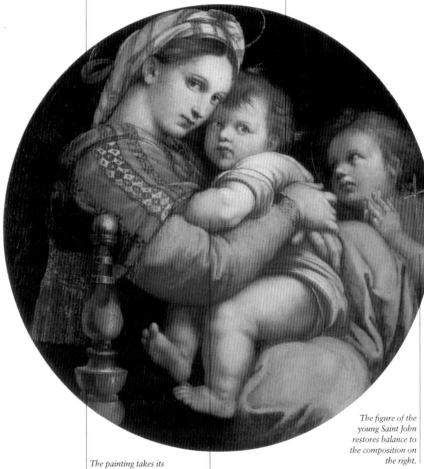

The figure of the young Saint John restores balance to the composition on the right.

The painting takes its name from the elegant carved chair (sedia), not a simple seat but an especially refined piece of furniture.

▲ Raphael, *The Madonna della Sedia*, ca. 1513. Florence, Palazzo Pitti, Galleria Palatina.

The fulcrum of the entire group is the elbow of baby Jesus, which coincides in practical terms with the geometric center of the tondo and extends toward the viewer, capturing a distinctive shaft of light.

The group of the Madonna and Child establishes an unrivaled equilibrium between realism and idealization, between classical models and sense of nature.

The face of the Virgin resembles that of Raphael's lover, Margherita Luti, daughter of a baker from Siena who had a shop in the Contrada Santa Dorotea in Rome. She was made famous by Raphael with the sobriquet of "La Fornarina," or "Baker's Girl."

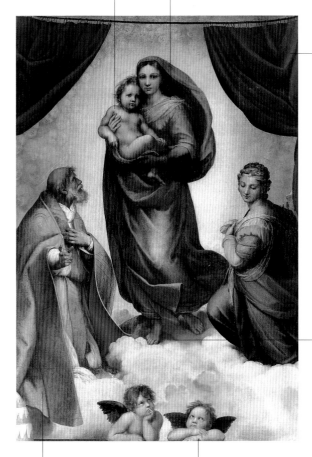

The altarpiece was installed to correspond with the large window in the church's apse. Raphael creates the illusion of a real window, with the drapes pulled back and, at the bottom, a cornice as the sill. If one looks closely, one sees that the "sky" is formed of the faces of countless cherubs.

Standing upon a bank of clouds, the enchanting Virgin Mary seems to be stepping toward us, moving forward and down.

The name of the painting is a reference to its original location, the church of San Sisto in Piacenza. The saint in question— Saint Sixtus—is the bishop on the left.

▲ Raphael, *The Sistine Madonna*, 1515–16. Dresden, Gemäldegalerie.

The renowned little angels, often depicted separately, underscore the illusory presence of a windowsill, upon which they seem to be leaning.

Raphael

▲ Raphael, The Transfiguration, 1520. Vatican City, Pinacoteca Vaticana.

This artist, who created dramatic, lofty masterpieces, is concealed behind his own bold choices, which made him a "maudit" artist ahead of his time, a bitter witness to the end of the Renaissance.

Ligier Richier

This great and tortured Lorraine-born sculptor trained from 1515 to 1520 in Rome, where he was influenced by Michelangelo. After returning home, he worked for increasingly prominent clients. In 1531 and 1540, he sculpted two dramatic monumental groups of *The Deposition* for churches in Saint-Mihiel. In these groups, a virtuosity with roots still deep in Gothic art blended with a total mastery over his material, and especially with an energetic sense of an anguished present. Around 1544, Richier executed the tomb of René de Châlons, Prince of Orange, with a macabre skeleton ripping its heart from its chest (page 84), a creation that linked the medieval Danse Macabre with the Baroque-style Triumph of Death. Later he carved a sarcophagus in marble for Philippa de Gueldres, second wife of René II, duc de Lorraine, now in the Church of the Cordeliers in Nancy. After executing a large altar at Bar-le-Duc, Richier embraced Protestantism. He largely stopped work as a sculptor and, in 1564, immigrated to Lausanne, where he soon died. Thus ended the erratic, complex career of a master who lived in the High Renaissance but, rejecting classicist conformism, was both a Gothic and a Baroque artist—at once ahead of his time and yearning for the world of the past.

Saint-Mihiel ca. 1500–Lausanne 1567

School
French

Principal place of residence
Lorraine region

Travels
Long educational stay in Rome

Principal works
Group of *The Entombment* (1531, Saint-Mihiel, abbey church); tomb of René de Châlons, Prince of Orange (1544, Bar-le-Duc, church of Saint Pierre)

Links with other artists
It has been conjectured that he studied under Michelangelo

◄ Ligier Richier, *The Entombment*, 1531. Saint-Mihiel (France), abbey church.

343

Riemenschneider was a sensitive interpreter of passions, emotions, and sentiments. His unforgettable masterpieces brought the genre of the carved wooden altar to its full maturity.

Tilman Riemenschneider

Osterode ca.
1460–Würzburg 1531

School
German

Principal place of residence
Würzburg

Travels
Numerous trips in southern
Germany, especially to
Swabia, Rhineland, and
Franconia

Principal works
Holy Blood altarpiece (1504,
Rothenburg, Jakobskirche);
altar of the Assumption
(1510, Creglingen, parish
church); tomb of Emperor
Henry II (1513, Bamberg,
cathedral)

Links with other artists
He trained in the workshop
of Jörg Syrlin in Ulm and
was in direct contact with
Veit Stoss

The greatest wood sculptor in the German Renaissance, Riemenschneider was a versatile, dynamic artist. Thanks to his training in Saxony and Bavaria (Erfurt, Ulm), he became equally skilled working in stone, marble, and wood. An unmistakable feature of his style is the exaltation of the tactile and chromatic values of materials, which he left in their natural hues rather than covering them with gilding and paint as was customary. This approach was evident from his first monumental work, the altar of Münnerstadt (partially dispersed), done in collaboration with Veit Stoss. Although he excelled in wood sculpture, Riemenschneider worked with a variety of materials. Alongside the great wooden altars of Rothenburg and Creglingen—considered one of the greatest sculptural masterpieces of the waning era of Gothic and the dawning period of northern humanism—we find the alabaster monument to Emperor Henry II in the Bamberg cathedral and limestone tombs and reliefs for the Würzburg cathedral. Regardless of medium, we find a consistent emotional tension in the characters, expressed through faces and gestures of yearning and yet noble, controlled intensity. Riemenschneider had a rather adventurous life, in which periods of renown (with his well-staffed workshop in Würzburg and his broad array of official commissions) alternated with times of obscurity. Caught up in the unrest that followed the advent of the Reformation, he was arrested at an advanced age. He ran the risk of having his right hand cut off and was forced to stop working.

▶ Tilman Riemenschneider,
Saint Barbara, ca. 1510.
Munich, Bayerisches
Museum.

A number of details, such as the Gothic twin-light windows and the excessively emphatic beards, belong to the 15th century tradition, but the composition overall has a distinctly Renaissance air to it.

In contrast with his predecessors, Riemenschneider opted not to paint the figures with lively colors, preferring the warm simple hues of the wood, and thus emphasizing the quality of the carving.

For the first time, Riemenschneider "opens" the back of an altar compartment, with a sequence of two- and three-light glazed Gothic windows.

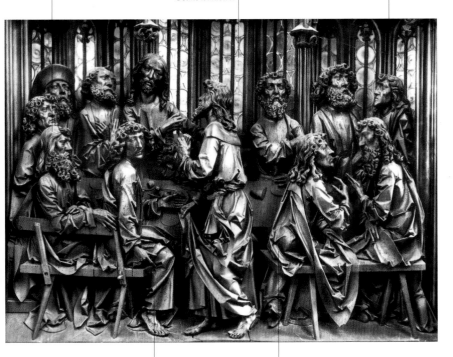

The noble and melancholy figure of John introduces the main scene, depicting the establishment of the sacrament of the Eucharist.

The groups of apostles are carved out of a number of blocks of limewood. With exceptional skill, Riemenschneider succeeded in concealing the joints, giving the scene an effective sense of unity.

▲ Tilman Riemenschneider, *The Last Supper*, central shrine of the *Holy Blood* altarpiece (1504, Rothenburg ob der Tauber, Jakobskirche).

Open to radical experimentation, to the point of questioning the Renaissance concept of "grace," Rosso was a key artist in the transfer of the "Modern Manner" from Italy to the rest of Europe.

Rosso Fiorentino

Giovanni Battista di
Jacopo; Florence ca.
1495–Fontainebleau 1540

School
Tuscan

Principal place of residence
Florence, then
Fontainebleau

Travels
Apart from a few trips in
Tuscany (Volterra), he lived
in Florence until early
adulthood. He was in
Rome in 1523 but fled the
Sack of Rome (1527). He
moved permanently to
Fontainebleau in 1530

Principal works
The Deposition (1521,
Volterra, Pinacoteca
Comunale); gallery of
Francis I in the château of
Fontainebleau in 1530

Links with other artists
Intense. In Florence, he and
Pontormo were pupils of
Andrea del Sarto. In Rome,
he was in contact with
Parmigianino and Giulio
Romano; in Fontainebleau
he worked with Primaticcio

A leading figure in the first, crucial period of Florentine Mannerism, Rosso trained along with Pontormo in the workshop of Andrea del Sarto and began his career working with them on the frescoes of the Chiostrino dei Voti (Santissima Annunziata). His figures often had bizarre features that aroused the concern of his clients. *The Deposition* of Volterra (1521) is emblematic in its violent contortion of figures and colors, and in its disconcerting aggressivity. Over just a few years, Rosso shifted from Florentine influence to the Roman influence of Michelangelo, eventually interacting with Parmigianino directly. After the Sack of Rome (1527), his already vivid style began to feature harsh outbursts, intensely dramatic compositions, and leaden hues. In 1530, King Francis I of France appointed him official court painter and assigned him to enlarge and decorate the palace of Fontainebleau. At the head of a team that included Primaticcio, which soon became a full-fledged school, Rosso oversaw the creation of the magnificent gallery of Fontainebleau (1531–37), a work that was fundamental to the spread of the Mannerist aesthetic throughout Europe.

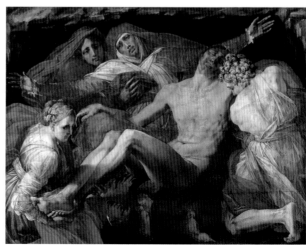

This large altarpiece is one of the emblematic works of early Tuscan Mannerism because of the violent contortion of the figures and the metallic jolt of the enameled colors, disconcerting in their aggressivity.

A contrived, surreal scaffolding of ladders and smoothed beams encloses figures that are petrified into theatrical postures.

The sky is astonishingly dull colored, compact and dense like an impenetrable, unnatural mantle of painted lead.

The monumental, dramatic figure of the weeping Saint John dominates the right side of the altarpiece, creating a powerful asymmetry with the group of women on the left.

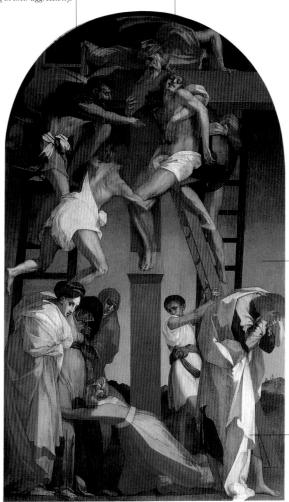

◄ Rosso Fiorentino, *The Pietà*, 1535–38. Paris, Louvre.

Mary, supported by two women, has fallen senseless, while Mary Magdalen throws herself at the Virgin's feet.

▲ Rosso Fiorentino, *The Deposition*, 1521. Volterra, Pinacoteca Comunale.

The canons of classicism became the symbolic insignia of political power, expressed also through explicit references to the monumental structures of antiquity.

Jacopo Sansovino

Jacopo Tatti; Florence
1486–Venice 1570

School
Italian

Principal place of residence
Venice

Travels
Two long stays in Rome
(1506–11 and 1516–27)

Principal works
Libreria Marciana in
Venice (begun in 1537);
Scala d'Oro (Golden
Staircase) in the Doge's
Palace in Venice (1544)

Links with other artists
A central element of
Sansovino's biography is
his lengthy, close friendship
with Titian. Moreover, in
the various stages of his
life, he was in contact with
all the most significant
artists, such as Raphael,
Michelangelo, and Andrea
del Sarto between Rome
and Florence, Tintoretto,
Veronese, and Alessandro
Vittoria in Venice

Sansovino was one of the greatest artists of the ample, serene, confident classicism of the High Renaissance. His Florentine beginnings focused on marble sculpture, linked to the example of the master Andrea Sansovino, whose nickname he adopted. We have an elegant example of this work in the *Bacchus* in the Museo del Bargello in Florence (1512). During a long stay in Rome (1516–27), he moved into architecture. He fled Rome after the sack of 1527 and almost by chance fetched up in Venice, which became his adoptive home. Within a few years he became a *protomastro* in charge of the city's public buildings, an office that he held for more than forty years. His close ties with Doge Gritti and with Titian and Pietro Aretino allowed him to mold the appearance of the "new" Venice, creating monumental architecture of enormous symbolic value at key points throughout the city. He designed numerous buildings surrounding Saint Mark's Square: the Procuratie Nuove, the Loggetta del Campanile, the Libreria Marciana, the interior of the Doge's Palace, the Zecca (or Mint). Sansovino also continued to work as a sculptor. He achieved effects of Mannerist calligraphy in bronze that were ahead of their time, in the reliefs that he did for the Loggetta del Campanile and the choirs of Saint Mark's.

▶ Jacopo Sansovino,
Facade of the Libreria
Marciana in Venice,
begun in 1537.

A refined painter of the Brescian school and a painstaking experimenter with light and reflections, Savoldo foreshadowed Caravaggio in his balance between Venetian color and Lombard realism.

G. Girolamo Savoldo

Though Savoldo spent almost his entire career in Venice, it is correct to place him in the Brescian school, both because of his frequent commissions from his hometown and because of his clear ties with the current of realism and subtle psychological interpretation of the Brescian (Romanino, Moretto) and Bergamasque (Lotto and later Moroni) Renaissance. Savoldo's work in the Veneto began on an adventuresome note around 1520, when he was called to complete the large altarpiece of the church of San Nicolò in Treviso. The altarpiece that he painted shortly thereafter, *Hermit Saints Anthony and Paul* (Venice, Galleria dell'Accademia), and, even more clearly, the magnificent *Virgin and Child with Four Saints* for the Dominicans of Pesaro (1524, now in the Pinacoteca di Brera in Milan) mark the rapid phases of a successful career. In his production, alongside the altarpieces, we find a growing number of portraits and paintings of sacred subjects for private clients, in some cases copied in more than one version, such as the *Saint Mary Magdalen* or *The Rest on the Flight into Egypt*. In this phase, Savoldo's paintings are illuminated with gleams of light, vivid colors, and touches of silver. In the 1530s he worked in Milan for Francesco Maria Sforza, and this luminosity began to diminish, in a quest for more delicate, muted hues. Savoldo's paintings, such as *Flute Player in a Room* and the finest version of *The Adoration of the Shepherds*—both in Brescia—are among the most important "Lombard precedents" for the work of Caravaggio.

Brescia 1480/85–ca. 1548

School
Northern Italian–Venetian

Principal place of residence
Venice

Travels
Numerous contacts with his hometown of Brescia; in Milan in 1534

Principal works
Virgin and Child with Four Saints (1524, Milan, Pinacoteca di Brera); *Saint Matthew and the Angel* (1534, New York, Metropolitan Museum)

Links with other artists
In constant dialogue with the other Brescian masters (Romanino, Moretto), Savoldo was also well connected in the Venetian milieu (Titian, Lotto, Sansovino)

◀ Giovanni Girolamo Savoldo, *Mary Magdalen* (detail), ca. 1530. London, National Gallery.

349

Giovanni Girolamo Savoldo

The shepherd leaning on the balustrade is meant to increase the "common" atmosphere of the scene, but the refinement of the figure's execution demonstrates the great nobility of Savoldo's brushwork.

An effective invention, which brings in unexpected light and space, is the little window at the far end of the stable, through which a bearded shepherd peers in, while a second shepherd, at his elbow, clamors to get his turn.

In the background, far in the distance, a glow in the sky marks the appearance of the angel to the shepherds. This is the only supernatural reference in a painting that is solidly rooted in reality.

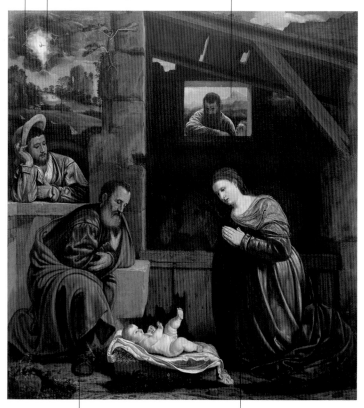

The figures of Joseph and Mary have simple, almost rustic features. The detail of Joseph's humble footwear is a further note of human verisimilitude.

Savoldo, a Brescian by birth but working permanently in Venice, sprinkles the customary highlights of Venetian painting over the Virgin's clothing.

▲ Giovanni Girolamo Savoldo, *The Adoration of the Shepherds*, ca. 1540. Brescia, Pinacoteca Tosio-Martinengo.

A leading art figure in two capital cities, Sebastiano interacted with all the most important artists of the first half of the 16th century, carving out a robust and effective personal style.

Sebastiano del Piombo

After training in the school of Giorgione, Sebastiano debuted in Venice with major works as early as 1510, in a period of transition from the warm harmony of Giorgione to the aggressive style of Titian. The success of the latter led Sebastiano to accept the invitation of the banker Agostino Chigi to move to Rome in 1511, where he worked at Raphael's side on the frescoes of the Villa Farnesina (episodes from Ovid's *Metamorphoses*). This marked the beginning of his role as an intermediary between Venetian color and the expressive experimentation of the Romans, especially of Michelangelo. Sebastiano became a trusted friend of Michelangelo, even using drawings by Buonarroti for his large altarpiece, *The Raising of Lazarus* (1519, London, National Gallery), painted to compete with Raphael's *The Transfiguration*. An avowed imitation of Michelangelo's style, not only in the treatment of male nudes but also in its dramatic, austere religiosity, is found in the gripping *Pietà* of Viterbo and the frescoes in San Pietro in Montorio (*The Flagellation* and other scenes in the Borgherini Chapel, 1517–24). Meanwhile, his portraits, numerous and vivid, bespeak his Venetian origin. Sebastiano remained in Rome even after the sack of 1527, and in 1531 Pope Clement VII conferred upon him the "Officio del Piombo," a wealthy church living, from which his nickname was taken.

Sebastiano Luciani; Venice ca. 1485–Rome 1547

School
At first Venetian, later Roman

Principal place of residence
Rome

Travels
Venetian by birth, he lived permanently in Rome from 1511 on, except for short trips

Principal works
Organ panels in the church of San Bartolomeo (1510, Venice, Galleria dell'Accademia); *The Raising of Lazarus* (1519, London, National Gallery)

Links with other artists
In Venice, with Giorgione and Titian; in Rome with Raphael, Sodoma, and Michelangelo

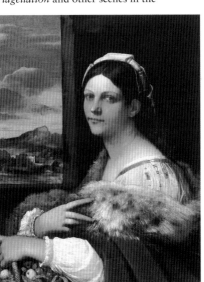

◄ Sebastiano del Piombo, *Portrait of a Young Woman (Dorotea)*, 1512–13. Berlin, Gemäldegalerie.

Sebastiano del Piombo

The background, with a cloudy landscape illuminated by a sudden beam of light, is an original creation of Sebastiano, who was clearly influenced by his Venetian training.

This large altarpiece, painted in competition with Raphael's Transfiguration, was the culminating—and, sadly, conclusive—episode in the dialectic exchange between the style of Raphael and that of the Michelangelo-Sebastiano duo. Both of the paintings were commissioned by Cardinal Giulio de' Medici (the future Pope Clement VII) for his bishopric in Narbonne.

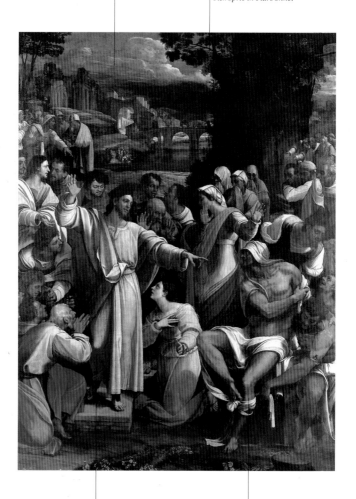

▲ Sebastiano del Piombo, *The Raising of Lazarus*, 1517–19. London, National Gallery.

The team of Michelangelo and Sebastiano could not conceal a degree of rhetorical contrivance in their composition, which is a trifle overcrowded.

The commission was theoretically assigned to Sebastiano but, in fact, "under supervision and design in some areas by Michelangelo," as can certainly be noted in the monumental figure of Lazarus.

*A master who epitomized the latest style of European Mannerism,
Spranger characterized the school of court art surrounding Rudolf II
of Habsburg, with the insertion of a note of indulgent eroticism.*

Bartholomaeus Spranger

After his training in an Antwerp that was already steeped in the
Italian style of the High Renaissance, in 1565 Spranger set out for
Italy. After studying the Mannerist school of Fontainebleau, he
reached Milan, Parma, and finally Rome. He absorbed the latest
ideas of Lombard artistic culture, exploring the art of Correggio
and Parmigianino. Then he found important commissions with
the Farnese family in Rome and at the villa of Caprarola, a
microcosm of aristocratic Mannerism, immersing himself in the
Roman taste for classicism and the calligraphic. In 1570, he was
named painter to the pope. He did few works with sacred sub-
jects, however, because he greatly preferred to tackle mythologi-
cal and literary themes. Spranger originated an intelligent, refined
style, in which intellectuals could pride themselves on recognizing
an array of cultural and artistic allusions, and yet one that man-
aged to convey a chilly sensuality, all the more provocative for its
apparent detachment. In the service of Emperor Rudolf II, he
worked first in Vienna and then, after 1581, in Prague. Here he
interacted with Arcimboldi, Joseph Heintz, and Hans von
Aachen, as well as the sculp-
tor Adriaen de Vries and the
Milanese masters of intaglio
and goldsmithing. The works
that the emperor loved best
were those in which Spranger,
on the pretext of illustrating
classical myths, filled the can-
vas with ample, luminous
female nudes. Popularized
through Goltzius's engrav-
ings, these paintings became
very famous.

Antwerp 1546–Prague 1611

School
International Mannerism

Principal place of residence
Rome, and later Prague

Travels
A youthful stay in France
(Fontainebleau) and Italy (Milan,
Parma, and Rome); he then
moved to Vienna (1575–80)
before taking up permanent resi-
dence in Prague; a short trip to
the Netherlands (1602)

Principal works
*Hercules and Omphale; Salmacis
and Hermaphroditus* (1582,
Vienna, Kunsthistorisches
Museum)

Links with other artists
In Italy he studied with
Parmigianino and Correggio and
worked in the context of late
Roman Mannerism. At the court
of Rudolf II he was a central
figure in the school of Prague

◀ Bartholomaeus Spranger,
Self-Portrait, 1580–85.
Vienna, Kunsthistorisches
Museum.

The painting belongs to a series of mythological canvases intended for Rudolf II and inspired by the loves of the gods described in Ovid's Metamorphoses.

The contrast between the sea monster and the plump, seductive nymph is a typical feature of the late-Mannerist style of the court of Rudolf II in Prague.

The use of color and the preference for iridescent hues are also typical of Italian late Mannerism.

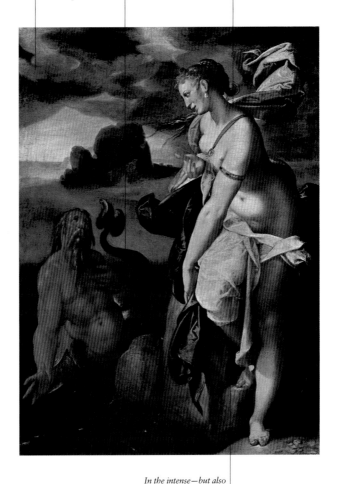

In the intense—but also calculated—sensuality of this work, we sense clear echoes of the painting of Correggio and Parmigianino. It was from the latter that Spranger derived the sinuous softness of his elongated forms.

▲ Bartholomaeus Spranger, *Glaucus and Scylla*, 1580–85. Vienna, Kunsthistorisches Museum.

▶ Jacopo Tintoretto, *Susanna and the Elders*, ca. 1555. Vienna, Kunsthistorisches Museum.

Tintoretto introduced grandiose gestures, muscular bodies, and daring perspectival points of view into the core of Venetian painting, in keeping with Michelangelo and the "Modern Manner."

Jacopo Tintoretto

Extremely short in stature, born to a clothes dyer of Lucchese origin, Tintoretto was first recognized as a protagonist of the Venetian school in 1548, when he delivered *Saint Mark Rescuing the Slave* to the Scuola Grande di San Marco. By a suspicious coincidence, Titian was not in Venice at the time, but with Emperor Charles V in Augsburg. In the absence of the unquestioned leader of the Venetian school, Tintoretto's work was recognized as the creation of a spectacular new talent in the Venetian cultural landscape. During the 1550s, Tintoretto painted mythological and religious scenes with great ease and nimble brushstrokes, alternating solutions reminiscent of Veronese (*Susanna and the Elders*, below) with harshly contorted poses. He was not intimidated by colossal projects, and in 1564 he began work on the decoration of the Scuola Grande di San Rocco with a series of dozens of canvases that would typify his development in several phases. From the earliest scenes, magniloquent and overcrowded, he progressed to compositions of intense expressivity, and on to the late visionary images found in the hall on the ground floor. He painted dozens of altarpieces for churches in Venice and, along with his efficient workshop, supervised the redecoration of the Doge's Palace (from 1577), culminating in the immense *Paradise* in the Sala del Maggior Consiglio.

Jacopo Robusti; Venice
1519–1594

School
Venetian

Principal place of residence
Venice

Travels
None to speak of

Principal works
Series of canvases in Venice:
Scuola Grande di San Rocco,
Madonna dell'Orto, Doge's
Palace

Links with other artists
In Venice, he worked at the center of the local school. Indirect relations with the artists of central Italy, such as Michelangelo

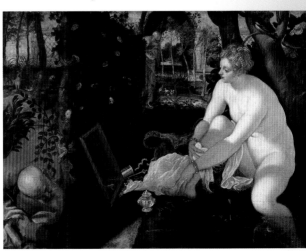

Jacopo Tintoretto

None of the numerous characters appears to notice the apparition of Saint Mark; instead they all stare in amazement at the miraculous shattering of the chains and the instruments of torture.

In a daring piece of foreshortening, Mark, the patron saint of Venice, descends from heaven to free from his chains a slave who is about to be tortured and killed.

In the background, we glimpse several pieces of very up-to-date architecture, close to the classical taste of Sansovino and the earlier works of Palladio.

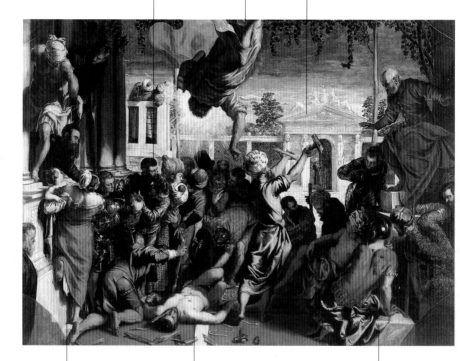

The slave's powerful body, supine on the ground, nearly constitutes a perspectival counterpart to the flying saint who frees him.

Although he accommodates the popular style of Mannerism, Tintoretto always remained solidly wedded to powerful, concrete forms.

▲ Jacopo Tintoretto, *Saint Mark Rescuing the Slave*, 1548. Venice, Galleria dell'Accademia.

The muscular appearance of several of the figures harks back to the motto that, according to tradition, Tintoretto had posted in his workshop: "Color by Titian, design by Michelangelo."

If we explore the art of Titian, we can see nearly a century of Renaissance painting, from the initial apogee of grace and harmony to the dramatic culmination of the last works.

Titian

Titian's long life, an unending parade of successes and honors, turns up several recurring motifs: tireless research, a bottomless ability to test himself, a willingness to take on new challenges, a drive to compete with nature and with the tools of art. A pupil of the Bellinis and a member of Giorgione's circle, Titian was quick to win a leading position in the Venetian school, thanks to the formidable richness of his colors and his dynamic compositions. Beginning in 1516, he was the official painter of the Venetian Republic, an office he held for the rest of his life. While his *Assumption of the Virgin* at the church of Santa Maria Gloriosa dei Frari in Venice revolutionized the composition of altarpieces, in 1518, with his Bacchanales series for Alfonso d'Este, duke of Ferrara, Titian began his career as a court painter. Soon he was doing work for the Gonzagas and, later, for the Della Rovere and Farnese families. In 1530, he met Charles V, who would become his most important client.

Titian's expressive dynamism became more muted for a brief period around 1540, when he took stock of the work of the Mannerists. A trip to Rome (1545–46) culminated in a somewhat divisive meeting with Michelangelo. After two trips to Germany in the entourage of Charles V, Titian began work in 1555 on his last awesome Venetian altarpieces and mythological paintings, interpreted as a tragic mirror held up to the human condition.

◀ Titian, *Self-Portrait*, ca. 1570. Madrid, Prado.

Tiziano Vecellio; Pieve di Cadore (Belluno) 1488/90–Venice 1576

School
Venetian

Principal place of residence
Venice

Travels
Sojourns in Padua, Ferrara, and Mantua; trip to Rome in 1545–46; he was present with Charles V in Augsburg in 1548 and 1551

Principal works
The Assumption of the Virgin (1516–18, Venice, church of the Frari); *Equestrian Portrait of Charles V* (1548, Madrid, Prado); *The Pietà* (1576, Venice, Galleria dell'Accademia)

Links with other artists
A central figure of Renaissance painting, Titian was a point of reference in Venetian art for at least three generations. Direct contact with Michelangelo in Rome (1545)

Titian

In this work, with its complex allegorical meaning, we see an expression of a vital and glorious classicism by the young Titian.

The painting is a magnificent and auspicious wedding gift from the influential Venetian aristocrat Nicolò Aurelio to his bride, Laura Bagarotto.

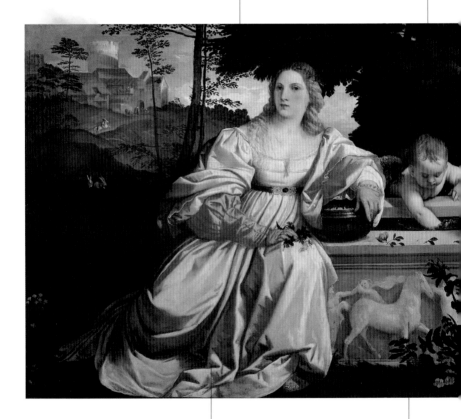

The two lovely girls, so similar that they seem to be identical twins, are dressed in completely opposite ways: one is magnificently appareled, in a gown that seems to allude to a wedding, while the other is practically nude.

Christian and pagan elements merge in a composition in which Titian, influenced by Neoplatonic philosophy, celebrated in earthly beauty a reflection of divine perfection.

In contrast to the bucolic serenity of Giorgione's landscapes, Titian here creates a background charged with action: clouds, winds, figures, animals, leafy branches, and flowing water all participate in the inexhaustible vital rhythm of the universe.

The clothed woman alludes to love in the context of marriage, while the nude woman elevates this same love toward a celestial, eternal plane, symbolized by the lamp in her hand.

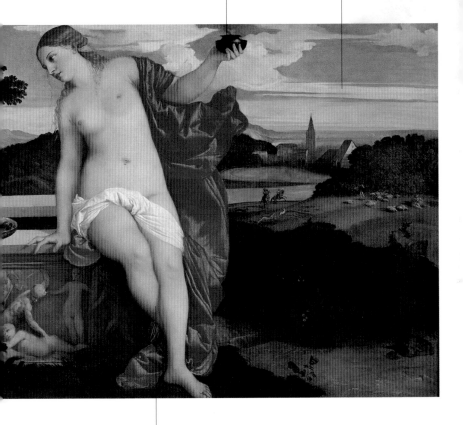

▲ Titian, *Sacred and Profane Love*, 1514. Rome, Galleria Borghese.

According to classical and medieval iconographic tradition, the simultaneous appearance of two figures, one nude and one clothed, indicates, not opposition (as the title that has erroneously been applied to this work might suggest), but rather complementary qualities.

Painted for Bishop Jacopo Pesaro, the
altarpiece has remained in its original
location, the altar of the Conception in
the basilica of the Frari.

The sense of novelty in this altarpiece
is emphasized by the unprecedented
articulation of the architectural ele-
ments, with two massive columns
that loom beyond the boundary of
the cornice.

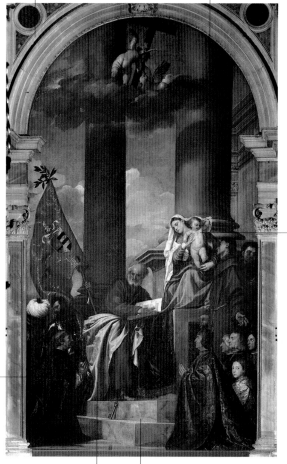

The Pesaro family,
along with the
patron saints of the
dynasty and various
characters that
allude to the military
victories of the
founding father,
turns toward the
Virgin in a motion
that revolutionizes
the canonical
triangular scheme
of the Sacra
Conversazione.

In consideration of
the placement of
the altar, off to the
side, along the left
aisle of the
Franciscan church,
Titian sharply shifts
the Madonna's
throne off to the
right, thereby alter-
ing the customary
symmetrical
arrangement of the
various figures.

The colors are luminous, with a distinct
preference for pure hues and a general
rejection of half tones and sfumato.

▲ Titian, *The Pesaro Madonna (Virgin
and Child Enthroned with Saints and
Members of the Pesaro Family)*, 1519–24.
Venice, church of the Frari.

The most innovative aspect of the
painting is its compositional structure,
with the definitive abandonment of the
geometrical organization of late-
fifteenth-century altarpieces.

The sleeping cupid is a symbol of Adonis's determination to pursue the chase rather than love; he does not yield to Venus's embrace and instead leaves for the fatal hunt.

The painting is part of the cycle of canvases with mythological subjects that Titian sent to the court of Spain, which the painter himself called "poems."

The impatient hunting dogs have already scented the prey and seem to be dragging Adonis toward the woods.

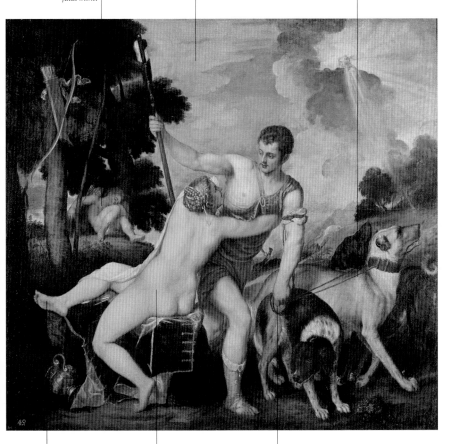

Venus, in an awkward pose, tries in vain to keep Adonis from going; he will die in a hunting accident.

According to the accompanying letter written to Philip II by Titian, Venus's pose was selected as complementary to the frontal nude of Danaë, in order to create a pleasing contrast in the king's collection.

If we look carefully, we can see that Adonis is posing in the classical contrapposto, but still Titian is far from the refinement and references of Mannerism.

▲ Titian, *The Farewell of Venus and Adonis*, 1553. Madrid, Prado.

Titian

On either side are statues, ghostly in their evanescence, of Moses and the Hellespontine sibyl.

The tragic scene is framed by a massive rusticated arch with a small apse lined with gilded mosaic tile.

When Titian died, the canvas was not entirely finished. The few unfinished parts, such as the angel with the torch, were completed by Palma the Younger.

Titian, well over eighty years old, depicted himself as the elderly Nicodemus. He meant for the painting to decorate his tomb, but it never did.

In the corner at bottom right, Titian has painted a votive offering, with which he asks the Virgin to spare him and his son Orazio from the plague. But they were both to die during the epidemic of 1576, Orazio of plague, at the Lazzaretto (a quarantine island near the Lido), and Titian of an unknown ailment.

The body of Christ, tortured and ravaged, is an extreme example of the "non finito" style.

▲ Titian, *The Pietà*, ca. 1576. Venice, Galleria dell'Accademia.

▶ Joos van Cleve, *Portrait of Queen Eleonora of France, Sister of Emperor Charles V*, 1530. Vienna, Kunsthistorisches Museum.

A crucial artist in the Antwerp school, he had the sensitivity to interpret the new ideas gathered on his travels and to synthesize into an eclectic style many of the figurative models of European art.

Joos van Cleve

Joos van Cleve's life and artistic career span a period that ranges from the tradition of the Flemish Primitives to the heart of international Mannerism. The Antwerp painter, therefore, played a crucial role in gathering and diffusing artistic culture on an international scale. One crucial factor contributing to this role was his love of travel, which took him to many nations. But he always returned to Antwerp and the local guild of painters, in which Joos had enrolled as early as 1511, and to which he brought new Italian stylistic and iconographic motifs. The most important work of his early career in Antwerp was a triptych, *The Death of the Virgin* (1515), now in Cologne. Around 1520 (though documentation is lacking), the Flemish painter set out on a trip through Europe. One of his chief destinations was Italy, and especially Genoa, where he painted the altarpiece of the church of Santa Maria della Pace, now in the Louvre. Over the many trips that followed—to Germany, to the court of King Francis I of France, and even to England—he enriched his artistic culture with eclectic components. We find references to Leonardo, especially evident in the treatment of the faces of the Virgins, references to Patinir for the vast horizons of the rocky landscapes, and homages to Dürer in the refined portraits. Among those portraits, we should mention those of Francis I of France and his wife, Eleonora of Austria, done around 1530, during his stay in Fontainebleau.

Joos van der Beke; Kleve or Antwerp ca. 1485–Antwerp 1540

School
Flemish

Principal place of residence
Antwerp

Travels
Numerous trips, not all of them documented. In his youth, he spent time in Kalkar and Bruges, and later in his life he probably stayed in Genoa and, most important, Fontainebleau

Principal works
Triptych of *The Death of the Virgin* (1515, Cologne, Wallraf-Richartz Museum); *The Lamentation* altarpiece (1525–27, Paris, Louvre)

Links with other artists
A pupil of Jan Joest, he met Gerard David in Bruges. In his many travels, he was in contact with various schools of art (Leonardesque, Fontainebleau), as well as with the Antwerp milieu (Mabuse, Patinir, Metsys)

A pupil and later a rival of Jan van Scorel, he was one of the most interesting but most elusive Dutch painters of the century. His body of work, varied and lively, offers a wide array of surprises.

Maerten van Heemskerck

Maerten van Veen;
Heemskerck (Utrecht)
1498–Haarlem 1574

School
Flemish–Dutch

Principal place of residence
Haarlem

Travels
Long stay in Rome
(1532–36); contacts with
Antwerp

Principal works
Family Portrait (ca. 1530;
Kassel, Staatliche
Kunstsammlungen); *Venus
and Cupid* (1545, Cologne,
Wallraf-Richartz Museum)

Links with other artists
In the years he spent in
Rome he established close
ties with Michelangelo. He
was in contact with Flemish
(Antwerp) and Dutch
(Utrecht) artistic circles

Bold changes in style and subject matter over the phases of a long career seem to be the most distinctive feature of this painter, who rendered his own times using especially dynamic models and flexible solutions. The one constant element is the quality of the design. Van Heemskerck was one of Europe's most skilled draftsmen. During his earliest activity, in Van Scorel's workshop in Haarlem, he devoted himself primarily to portraiture. Van Heemskerck's rapid success excited Van Scorel's jealousy and led to Maerten's early departure for Rome (1532). The four years that he spent there turned him into one of the best-versed and original masters in northern Europe, capable of outstripping the generic Raphaelism of the "Romanists" of Antwerp with the dramatic and plastic power of Michelangelo and classical sculpture. After returning home, Van Heemskerck established a unique form of Mannerism, distinguished—in both mythological paintings and dramatic religious scenes—by a spirited graphic exploration, which produced results reminiscent of Pontormo and Parmigianino. This "elevated" work, however, alternated with prosaic portraits, detailed still lifes, landscapes, and other compositions that hint at the future development of genre painting in the Netherlands.

▶ Maerten van Heemskerck,
Venus and Cupid, 1545.
Cologne, Wallraf-Richartz
Museum.

364

This is, in effect, a "double" self-portrait, with a hint of amused irony.

Covered with creepers, vines, and leafy vegetation, the Colosseum evokes meditations on the grandeur but also the decadence of classical antiquity.

The painter depicts himself in the foreground as a middle-aged man and, at the same time, harks back to his experience in Rome twenty years before, portraying himself in the person of the little draftsman intently sketching the immense skeletal structure of the Colosseum.

▲ Maerten van Heemskerck, *Self-Portrait in Front of the Colosseum*, 1553. Cambridge (England), Fitzwilliam Museum.

A successor to Raphael in the office of curator of the Vatican antiquities, Van Scorel was emblematic of the Italian-influenced taste that pervaded Flemish and Dutch painting.

Jan van Scorel

Schoorl (Alkmaar)
1495–Utrecht 1562

School
Flemish–Dutch

Principal place of residence
Haarlem

Travels
Youthful experience of
"Wanderjähre," years of
travel: after a few trips close
to home (Amsterdam,
Utrecht), a lengthy trip
through Germany
(Nuremberg) and Italy
(Venice and Rome)

Principal works
Mary Magdalen (ca. 1528,
Amsterdam, Rijksmuseum)

Links with other artists
In his youth, he met Dürer,
the Venetian masters of the
early 16th century, and
Raphael. Among his pupils,
Van Heemskerck in particu-
lar emerged as a major talent

The painter's byname is a reference to the Dutch city where he was born. He trained in the neighboring Alkmaar, a small art-producing town whose work was typified by an acute sense of realism, and Van Scorel went on to complete his early training with stays in Amsterdam and Utrecht (1517–19), where he studied the work of Mabuse. Before settling down to live in Haarlem, Van Scorel took a trip across Europe, and in four years of travel, he even went to Palestine. Among his most important stops were Nuremberg—where he met Dürer—Venice, and, especially, Rome. In the Eternal City, during the papacy of his fellow Dutchman Adrian VI of Utrecht, Van Scorel borrowed motifs from Raphael and Michelangelo and was awarded the high office of curator of Vatican antiquities. When he returned to Holland, he exploited his extensive cultural experience, proposing a new style of painting, almost entirely emancipated from all memories of the Flemish tradition and not decisively oriented toward the nascent school of Mannerism. In this context, it is interesting to note the presence of Venetian elements (influence of Giorgione and Titian) in place of the more fantastic settings of Bosch and Patinir. Among the finest pupils trained by Van Scorel in Haarlem, we should mention Maerten van Heemskerck, whose precocious talent actually aroused the master's antipathy.

▶ Jan van Scorel, *Mary Magdalen* (detail), 1528. Amsterdam, Rijksmuseum.

Venice entrusted to the luminous, iridescent palette of Veronese the most felicitous image of the city's glory. He knew how to transform any subject into a sunny and festive celebration.

Paolo Veronese

After his apprenticing in the workshop of the Veronese painter Antonio Badile, in 1551, with the Giustiniani altarpiece for the church of San Francesco della Vigna, Paolo Veronese entered into the heart of Venetian painting and soon became one of its most admired practitioners. Thanks to his exceptional skill at rendering vividly the most abstruse allegories, his paintings acquired great power of expression and charm. Veronese's success can be measured by the steady increase in commissions: altarpieces, artworks for collections, large official allegories, and frescoes for villas on the "mainland," as the Venetians called their hinterland, such as the unforgettable series for the great Palladian Villa Barbaro in Maser. His secular compositions, teeming with coy figures in sumptuous costumes, often endowed with a touch of seductive sensuality, found a steady market, and as a result the artist produced numerous replicas of certain subjects. Among Veronese's most beloved subjects were the "banquet" paintings, huge canvases in which the sacred subject (such as the Last Supper or the Marriage at Cana) was transformed into a lavish aristocratic feast. The doubts expressed by the Inquisition about the *Feast in the House of Levi* (1573, Venice, Galleria dell'Accademia), however, brought a halt to his giddy exuberance.

Paolo Caliari; Verona
1528–Venice 1588

School
Venetian

Principal place of residence
Venice

Travels
Various trips in the Veneto
region

Principal works
Frescoes in the Villa
Barbaro in Maser (ca.
1560); series of paintings in
the Doge's Palace in Venice;
Feast in the House of Levi
(1573, Venice, Galleria
dell'Accademia)

Links with other artists
Close relations with all the
Venetian artists of the 16th
century, and especially
Zelotti, Titian, Tintoretto,
Palladio, and the sculptor
Alessandro Vittoria

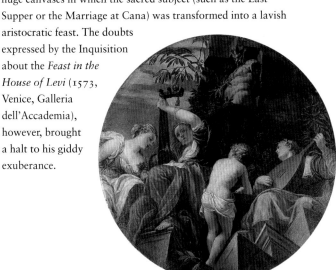

◀ Paolo Veronese, *Music*,
1556–57. Venice, Libreria
Marciana.

The great fluted columns and the diagonal composition are an open homage to Titian's Pesaro Madonna, *painted about fifty years earlier (page 360), which Veronese admired greatly.*

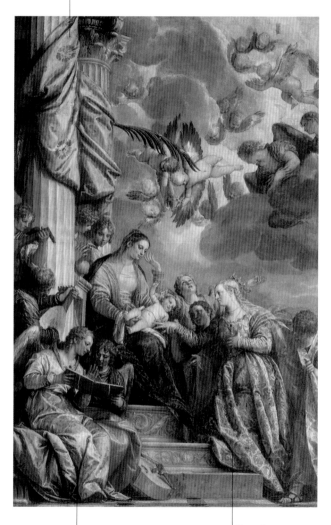

▲ Paolo Veronese, *The Mystic Marriage of Saint Catherine*, 1573. Venice, Galleria dell'Accademia.

Veronese's customary love of exceptionally rich colors, highlighted by dazzling light effects, here attains a level of pageant, already acclaimed by the authors of the time.

The 17th-century art critic Marco Boschini imagined that Veronese "mixed together gold, pearls, and rubies / and emeralds, and sapphires of passing worth / and exceedingly pure and perfect diamonds."

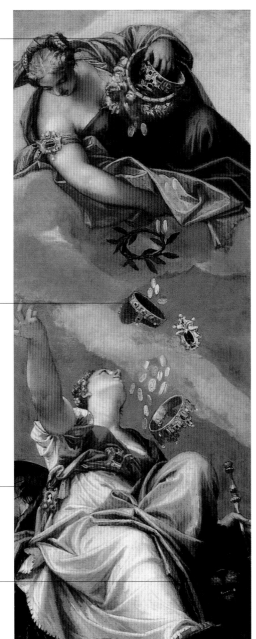

Juno, the queen of classical Olympus, showers precious gifts from the sky: glory, peace, regal splendor, and wealth.

The canvas has a strong political content. Among the "gifts" of Juno one cannot help but notice the brocade cap customarily worn by the doge, a symbol of ducal power.

At the age of just twenty-five, with this painting, Veronese began his decades-long work in the Doge's Palace. He soon became the most powerful figure in the supervision of the official decorative displays of the Venetian Republic.

The allegory of Venice, seated on a lion, the traditional symbol of Saint Mark, is a young blonde woman, prosperous and flourishing in her beauty.

▶ Paolo Veronese, *Juno Showering Gifts upon Venice*, 1553–54. Venice, Doge's Palace, Sala del Consiglio dei Dieci.

Paolo Veronese

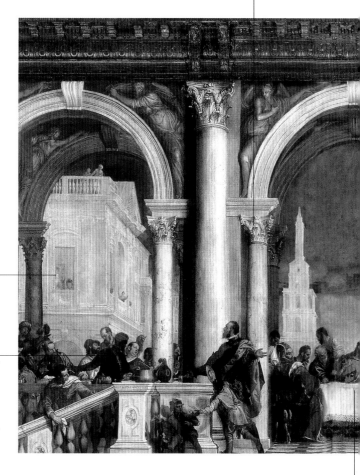

Veronese composes this scene within three large arches reminiscent of Palladio's architectural style, which form a scaenae frons and convey the impression of a stage production that is further enhanced by perspectival backdrops.

This magnificent composition was intended for the refectory hall of the monastery of San Zanipolo. The painting was commissioned to replace a Last Supper by Titian, which had been destroyed by fire in 1571, during the war with the Turks, when the building was requisitioned for military use.

Especially spectacular are the staircases crowded with servants, jesters, and guests, suggesting the scene of a lavish and quite secular banquet.

▲ Paolo Veronese, *Feast in the House of Levi*, 1573. Venice, Galleria dell'Accademia.

Aside from Christ and the apostles, there is a crowd of characters moving about in the immense hall, dressed in contemporary garb and depicted in quite casual poses. A fair number of these figures seem completely indifferent to the Gospel episode that is taking place.

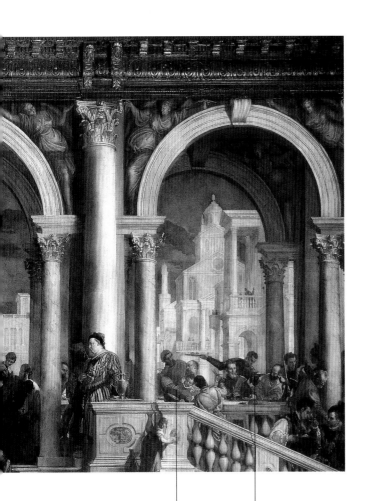

The tribunal of the Inquisition, held at the request of the Dominican fathers, decided that this composition was unacceptable and actually indicted the painter, charging him with failure to respect the dictates of Catholic iconography. In the face of the judges' questions concerning his seriousness and whether his subject was recognizable to viewers, Veronese defended with apparent candor but great determination his freedom as an artist.

At the end of his trial, Veronese agreed to make only a few changes to the painting. He also changed the title, however, from Last Supper to Feast in the House of Levi, and therefore showed that the Inquisitors had good reason to criticize how difficult it was to identify the exact nature of the subject.

Father and son, illustrious members of a renowned family of sculptors working in bronze, they formed a bridge from the late-Gothic style to a type of self-aware northern European humanism.

Peter and Hermann Vischer

Peter the Elder: Nuremberg
ca. 1460–1529
Hermann: Nuremberg ca.
1486–1517

School
German

Principal place of residence
Nuremberg

Travels
Various trips in German
and the Tirol; for
Hermann, also to Meissen
and Krakow

Principal works
Monumental statues for
the tomb of Maximilian I
of Habsburg (1513,
Innsbruck, Hofkirche)

Links with other artists
In contact with the arts
milieu of Nuremberg
(Dürer, Veit Stoss) and with
the court of Maximilian
(Altdorfer)

Peter Vischer and his descendants helped to shape the development of bronze sculpture in the German Renaissance. Setting out from a Gothic crafts tradition (the tomb of an archbishop in the cathedral of Magdeburg, 1488), through his contacts with Italian artistic culture via the humanists of Nuremberg, Peter gradually acquired an "intellectual" awareness of his work. His development ran parallel with the arc of Nuremberg itself, during the years of its artistic apogee, when it was open to Renaissance culture and at the same time the guardian of a tradition of fine craftsmanship. He shared with his compatriot Dürer certain stylistic trends and even career elements, such as the work he did for Maximilian I of Habsburg in 1513. For the emperor, Vischer designed some of the spectacular bronze statues that surround the monumental tomb in the Hofkirche of Innsbruck, as well as the masterpiece that epitomized his career, the reliquary-tomb of Saint Sebaldus in Nuremberg, completed in 1519. During the complicated work involved in casting this project, which went on for many years, with considerable alterations to the original design, the work done by Hermann, the eldest and most talented of Peter's artist sons, grew in importance. Hermann's exceedingly promising career, with work done in Meissen and in the cathedral of Krakow, was cut short by an early death. The Vischer family tradition was carried on by two other sons, Peter the Younger and Hans, who went on to become Mannerist artists in their own right.

▶ Peter Vischer the
Elder, *Self-Portrait*,
detail of the reliquary-
tomb of Saint Sebaldus,
ca. 1519. Nuremberg,
St. Sebaldus Kirche.

More than a sculpture, we can call this a
masterpiece of goldsmithing enlarged to a
monumental scale, in keeping with
Nuremberg's unique status as a center for
the fine working of precious metals.

The magnificent and highly original
reliquary-tomb in bronze is in effect a
fretwork baldachin, supported by slender
columns and topped by three cusps.

▲ Peter Vischer the Elder, Reliquary-
tomb of Saint Sebaldus, 1507–19.
Nuremberg, St. Sebaldus Kirche.

The structure created by Vischer
supports and surrounds the older
reliquary-coffin of the saint,
made of gilt silver, easily
glimpsed on the interior.

All of the decorative elements, ranging
from the columns to the many statuettes,
clearly hark back to a classical idiom,
but the work as a whole still reflects the
late-Gothic love of virtuosity.

APPENDIXES

Chronology
Index of Artists

◀ Pieter Bruegel the Elder, *Peasant*
Wedding (detail), ca. 1568. Vienna,
Kunsthistorisches Museum.

Chronology

1500

Charles of Habsburg, the future emperor Charles V, is born in Ghent.

Pedro Álvares Cabral lands at Brazil and claims it for Portugal.

In Rome, Michelangelo completes *The Pietà* for St. Peter's Basilica.

Dürer commemorates his own fur-clad social success with his *Self-Portrait,* now in Munich.

1501

Michelangelo begins work on the *David.*

The University of Vienna is founded.

1502

In Florence's Palazzo Vecchio, the decision is made to decorate the Salone dei Cinquecento with frescoes of two battles by, respectively, Leonardo and Michelangelo. Leonardo begins work on *Mona Lisa (La Gioconda).* Carpaccio in Venice begins work on the series of paintings for San Giorgio degli Schiavoni.

Dürer begins work on series of engravings of the Life of the Virgin.

1503

Following the death of Pope Alexander VI Borgia and the brief papacy of Pius III, Pope Julius II Della Rovere is elected.

Around this date Bosch paints the *Triptych of the Garden of Earthly Delights.*

1504

Isabella the Catholic dies. Her daughter, Joan the Mad, becomes queen of Castile.

In Rome, Bramante begins the Cortile del Belvedere in the Vatican.

1505

Around this year, Giorgione paints the *Castelfranco Altarpiece* and *The Tempest.*

1506

Dürer is in Italy for the second time. He paints the *Virgin of the Rose Garlands,* now in Prague.

In Mantua, Andrea Mantegna dies.

King Sigismund I Jagiellon takes the throne of Poland.

In Rome, the marble sculptural group of *The Laocöon* is unearthed, while Bramante is laying the foundations of the new Saint Peter's Basilica.

1507

The regent Margaret of Austria returns the capital of the Netherlands to Brussels.

1508

Maximilian I of Habsburg, having been proclaimed emperor, attacks Venetian territories and is largely victorious. In Rome, Michelangelo receives the commission to fresco the ceiling of the Sistine Chapel; Raphael begins work on the Stanza della Segnatura.

1509

Henry VIII Tudor is proclaimed king of England.

Erasmus of Rotterdam publishes *In Praise of Folly (Encomium Moriae).*

1510

Death of Giorgione, in Venice, and of Sandro Botticelli, in Florence.

1511

The transoceanic conquests continue. The Spanish find gold deposits in Cuba, while the Portuguese occupy Malacca.

In Rome, after completing the Stanza della Segnatura, Raphael begins work on the Stanza di Eliodoro.

In Nuremberg, Dürer paints the *Landauer Altarpiece,* now in Vienna.

1512

With the support of the French king, Louis XII, the Medici return to power in Florence.

In Rome, Michelangelo completes the vault of the Sistine Chapel and goes to work on the funerary monument of Pope Julius II.

1513

Following the death of Julius II, the Florentine pope Leo X (son of Lorenzo the Magnificent) is elected.

Two fundamental treatises are written, about court life and politics: *The Prince* by Niccolò Machiavelli, and *The Courtier* by Baldassare Castiglione.

1514

Giovanni Bellini paints *The Feast of the Gods* for Alfonso d'Este, duke of Ferrara; the painting is now in Washington.

In Rome, Bramante dies.

Quinten Metsys, a member of the emerging school of Antwerp, paints *The Money Changer and His Wife,* now in Paris.

Dürer engraves *Melencolia I.*

1515

Following the defeat of the Swiss mercenaries at Marignano, the French under Francis I occupy Milan.

The sculptor Anton Pilgram completes the pulpit of the Stephanskirche in Vienna.

At the outskirts of London, the palace of Hampton Court is completed, for the use of Cardinal Wolsey.

1516

Following the death of Ferdinand II the Catholic, Charles of Habsburg becomes king of Spain, with the name of Charles I.

Treaty of Noyon between the emperor Maximilian and Venice.

Matthias Grünewald paints the *Isenheim Polyptych*.

Death of Giovanni Bellini. Titian becomes the official painter of the Republic of Venice.

1517

Martin Luther posts his Ninety-five Theses in Wittenberg, beginning an irreversible schism in Western Christianity.

In Florence, Andrea del Sarto paints *The Madonna of the Harpies*.

Coffee is introduced into Europe; three years later, cocoa arrives.

1518

Treaty of London between England, France, Spain, the Holy Roman Empire, and the papacy.

Presentation of Titian's *Assumption of the Virgin* in Venice.

In Parma, Correggio frescoes the Camera di San Paolo.

1519

Maximilian I of Habsburg dies; Charles I of Spain is elected emperor with the name of Charles V.

In Cloux, near Amboise, Leonardo dies.

The Portuguese navigator Fernão de Magalhães (Magellan) begins the first circumnavigation of the globe.

In Switzerland, Ulrich Zwingli preaches in favor of the Reformation.

1520

Suleiman the Magnificent becomes sultan.

Rebellion in Sweden against the Danish king, Christian II.

In Rome, Raphael dies, leaving the *Transfiguration* unfinished.

1521

Pope Leo X excommunicates Martin Luther.

The Turks conquer Belgrade.

The king of Portugal, Manuel I a leading figure in the age of geographic discoveries, dies. He gave his name to the late-Gothic "Manueline" style.

Melanchthon publishes the *Loci communes rerum theologicarum*, the chief doctrinal text of the early years of the Reformation.

The Spanish captain Hernán Cortés conquers the Aztec empire in Mexico.

Rosso Fiorentino paints *The Deposition* for Volterra.

1522

The Dutch pope Adrian VI of Utrecht is elected.

François Rabelais publishes *Gargantua and Pantagruel*.

1523

Following the death of Adrian VI, Clement VII de' Medici is elected pope and resumes the artistic commissions undertaken by his uncle and predecessor, Leo X.

Gustav Vasa is crowned king of Sweden.

Andrea Gritti is elected doge of Venice and becomes the protagonist of an intense *renovatio urbis*.

Hans Holbein the Younger paints the *Portrait of Erasmus of Rotterdam* that is now in Paris.

1524

Giovanni da Verrazano explores the northern shores of America.

1525

The Peasants' War in Germany is violently suppressed.

Albert of Hohenzollern, last grand master of the Teutonic Knights, recognizes the supremacy of King Sigismund I Jagiellon.

Battle of Pavia: the Spaniards defeat the French decisively in the quest for dominance in Italy.

1526

Battle of Mohács: the Turks begin their conquest of nearly all of Hungary.

Luther publishes his *Catechism* in two volumes. The Reformation at this point is already widespread in much of Germany.

Lucas van Leyden paints in his native city the *Triptych of the Last Judgment*.

Dürer paints *The Four Apostles*, now in Munich.

1527

Sack of Rome by the mercenary lansquenets of the imperial army. The international exodus of artists that followed would lead to the remarkable sophistication of the construction of Fontainebleau.

In Florence, the republic is restored.

The future king Philip II is born in Valladolid.

1528

Death of Albrecht Dürer in Nuremberg.

1529

Peace of the Ladies between France, England, and the Holy Roman Empire.

Albrecht Altdorfer paints *The Battle of Alexander at Issos*, now in Munich.

1530

Coronation of Charles V in Bologna.

Siege and surrender of Florence; Medici restoration.

The Knights of Saint John, after the fall of Rhodes to the Ottoman Empire, move to Malta.

1531

The Protestant German princes form the Schmalkaldic League against the emperor.

1532

The Gallery of Francis I is begun at Fontainebleau.

Giulio Romano begins to decorate the Sala dei Giganti at Palazzo Te (Mantua).

1533

The future queen Elizabeth I, daughter of Henry VIII and Anne Boleyn, is born.

Francisco Pizarro conquers the Inca Empire in Peru.

Hans Holbein paints *The Ambassadors* in London.

Titian is proclaimed "*pintor primero*" by Charles V.

1534

Henry VIII proclaims himself head of the Church of England and begins the Anglican schism.

Ignatius of Loyola founds the Jesuit order.

Death of Clement VII. Pope Paul III Farnese is elected.

1535

Execution of Sir Thomas More in London.

Dutch painter Maerten van Heemskerck travels to Rome. The Italian style becomes stronger in the Antwerp school.

1536

Following the death of Catherine of Aragon and the beheading of Anne Boleyn, Henry VIII marries Jane Seymour.

Foundation of Buenos Aires.

Michelangelo begins work on *The Last Judgment* in the Sistine Chapel.

1537

Cosimo I de' Medici takes power. The grand-ducal age begins in Florence.

1538

Henry VIII is excommunicated.

John Calvin, expelled from Geneva, moves to Strasbourg.

Titian paints the *Urbino Venus* (now in Florence) for the Della Rovere family.

1539

Hans Holbein paints the portrait of King Henry VIII, now in Rome.

Cosimo the Elder is married to Eleonora of Toledo. Bronzino becomes the official painter to the Medici in Florence.

1540

Benvenuto Cellini created the saltcellar for Francis I of France.

1541

Michelangelo completes *The Last Judgment* in the Sistine Chapel.

The geographer Mercator makes his first globe.

1542

Mary Stuart becomes queen of Scotland.

Pope Paul III establishes the Inquisition and appoints Cardinal Carafa as its head.

Andrea Palladio builds his first villa in the area around Vicenza.

1543

Two scientific milestones: Andreas Vesalius publishes his treatise on anatomy, *De humani corporis fabrica*; and in Nuremberg Copernicus's *De revolutionibus orbium coelestium* is published.

1544

Peace of Crépy between France and the Holy Roman Empire.

1545

The Council of Trent begins, a fundamental debate within the body of Catholicism.

1546

Death of Martin Luther.

1547

Two great monarchs die: Henry VIII of England and Francis I of France; they are succeeded on their respective thrones by Edward VI and Henry II.

The Council of Trent is temporarily moved to Bologna.

Jean Goujon sculpts the *Fountain of the Innocents* in Paris.

1548

Charles V defeats the Protestant princes at Mühlberg. The victory is commemorated by an equestrian portrait by Titian, now in Madrid.

Titian establishes his reputation in Venice with *Saint Mark Rescuing the Slave*.

The Jesuit missionary Francesco Saverio reaches Japan.

1549

The architect and sculptor Philibert de L'Orme builds the château of Anet for Diane de Poitiers.

Pope Paul III dies; the ensuing conclave elects Pope Julius III del Monte.

1550

The great architect Sinan builds in Constantinople the Mosque of Süleymaniye, a refined development of Ottoman architecture.

In Florence, the first edition of Giorgio Vasari's *Lives* is published.

1552

With the conquest of Kazan and the wars against the Tatars, Tsar Ivan IV "the Terrible" begins his policy of expansionism.

1553

Following the death of Edward VI, Mary I takes the throne of England and reestablishes Catholicism.

Paolo Veronese moves to Venice and starts working in the Doge's Palace.

1554

Philip II weds Mary of England, his second wife.

The Bolognese naturalist Ulisse Aldrovandi begins to collect naturalistic objects and curios, creating the prototype of the *Wunderkammer*, the eclectic proto-museum collections of the late Renaissance.

1555

Peace of Augsburg between Charles V and the German Protestant princes. This puts an end to the most violent phase of Europe's Wars of Religion, but the Ottoman conquest of Tripoli is a vivid reminder of the Turkish threat to Europe.

Construction begins on the cathedral of St. Basil in Moscow.

Colonial expansion continues: the Portuguese reach Macao, and tobacco makes its first appearance in Europe.

Following the death of Julius III and the brief papacy of Marcellus II Cervini, the Cardinal Inquisitor Carafa becomes pope with the name of Paul IV.

1556

Charles V abdicates and divides the Habsburg Empire between his son Philip II (Spain and the overseas territories) and his brother Ferdinand (the "Austrian" territories).

The so-called price revolution attains dramatic levels, triggering a radical evolution of economic policies in Europe.

1557

Work begins in Rome on the church of the Gesù, the mother church of the Jesuit order and the prototype for the churches of the Counter-Reformation.

Battle of San Quintín. To commemorate this victory, Philip II orders the construction of the monastery of El Escorial.

The importance of the Savoy dynasty in Piedmont grows with Emmanuel Philibert.

1558

Solitary death of Charles V.

Following the death of Mary I, Elizabeth I takes the throne of England.

1559

France and Spain sign the Peace of Cateau-Cambrésis.

Pope Paul IV is succeeded by Pius IV de' Medici.

The Index of Forbidden Books is promulgated.

1560

Charles IX is the new king of France, under the regency of Catherine de Médicis.

Death of the king of Sweden, Gustav Vasa.

Melanchthon dies.

Vasari builds the Palazzo degli Uffizi in Florence.

1561

Madrid becomes the new capital of Spain.

1562—63

Paolo Veronese paints the *Marriage at Cana*, now in Paris.

In France, the religious war rages between Catholics and Huguenots.

1563

Conclusion of the Council of Trent.

Construction of El Escorial begins.

1564

Emperor Ferdinand I of Habsburg dies; he is succeeded by his son Maximilian II.

Michelangelo dies in Rome, leaving the *Rondanini Pietà* unfinished.

Tintoretto begins the series of canvases that decorate the Scuola Grande di San Rocco in Venice.

1565

Bruegel paints the series The Months.

1566

Suleiman the Magnificent dies.

The Dominican Pius V Ghislieri becomes pope.

The Netherlands revolt against Spanish rule; this will lead to the independence of the United Provinces (now Holland). Amsterdam loses many great artworks to the Iconoclastic Fury.

1567

The duke of Alba is entrusted with suppressing the insurrection in Belgium. This effort will culminate in the execution of Counts Egmont and Hornes, in the following year.

1568

Portuguese colonists found Rio de Janeiro.

Giorgio Vasari publishes the second edition of his *Lives of the Most Eminent Painters, Sculptors, and Architects.*

1569

Cosimo de' Medici becomes grand duke of Tuscany.

1570

In order to uphold the Catholic cause, Pope Pius V excommunicates Queen Elizabeth.

Palladio publishes *I quattro libri dell'architettura*, a treatise that will enjoy enormous and lasting international popularity.

1571

Battle of Lepanto: naval victory of the Christian coalition led by Don John of Austria against the Turks.

Antoine Caron paints *Augustus and the Sibyl*, one of the most significant paintings of French Mannerism.

1572

In the Saint Bartholomew's Day Massacre, French Huguenots are slaughtered; the anti-Spanish rebellion in the Netherlands grows.

With the death of Sigismund II Augustus, the dynasty of the Jagiellons comes to an end.

The successor to Pope Pius V is Gregory XIII Boncompagni.

The poet Camões commemorates the great Portuguese conquests in *The Lusiads.*

1573

Bernardo Buontalenti builds the Grotto in the Boboli Gardens in Florence. Henry of Anjou is elected king of Poland, but he will return to France the following year to take the throne as Henry III.

Despite the victory of Lepanto, Venice is obliged to cede Cyprus to the Turks; in the meantime, Tunis is also conquered by the Ottomans.

1574

The astronomer Tycho Brahe publishes his first findings.

1575

Torquato Tasso completes his *Jerusalem Liberated.*

1576

Rudolf II takes the imperial throne.

The first theater opens in London.

During the terrible outbreak of the plague raging through Venice, Titian dies, leaving his *Pietà* unfinished.

1577

In Venice, fire devastates the Doge's Palace; the decoration of the halls is entrusted to Tintoretto and Veronese.

El Greco paints *The Disrobing of Christ* in Toledo.

A new revolt breaks out in the Netherlands, under the leadership of William of Orange, against the governor Don John of Austria.

1578

The new governor of the Netherlands, Alessandro Farnese, suppresses the revolt in Belgium. A clear division begins to emerge between the northern and southern provinces.

1580

Death of Andrea Palladio.

Philip II of Spain becomes king of Portugal. The unification of the two Iberian crowns will last sixty years.

1581

The seven United Provinces of the northern Netherlands proclaim independence.

In Pisa, Galileo Galilei observes the isochronism of the pendulum.

1583

Emperor Rudolf II of Habsburg moves the imperial court from Vienna to Prague.

1584

William of Orange, the leader of the Dutch fight for independence, is assassinated.

Death of Tsar Ivan the Terrible: his son Fyodor is incapable of ruling, and his uncle Boris Godunov is appointed regent.

Henry of Navarre is the heir to the French throne.

Sir Walter Raleigh founds the first English colony in America, Virginia.

Giordano Bruno begins to question the scientific and historical veracity of the Bible.

1585

Pope Sixtus V Peretti is elected. He carries out significant reforms in the papal Curia and major urban renovations in the city of Rome; he also excommunicates Henry of Navarre.

1586

El Greco paints *The Burial of the Count of Orgaz* for the church of San Tomé in Toledo.

1587

Mary Stuart is beheaded.

The Jesuits are expelled from Japan, where an initial cautious openness to the West is replaced by the harsh period of autarchy under the shogunate.

1588

The naval defeat of the Invincible Armada marks the end of Spanish dominance and the beginning of English power.

Death of Paolo Veronese.

1589

Henry of Navarre proclaims himself king of France with the name Henry IV. The Bourbon dynasty is founded.

1590

The wars for the succession continue in France.

Death of Sixtus V. The three papacies that follow will be very brief.

1592

The young Caravaggio leaves Milan and moves to Rome.

Pope Clement VIII Aldobrandini is elected.

1593

Henry IV publicly returns to Catholicism; this declaration is soon rewarded with his entry into Paris and the end of the wars.

1594

Death of Jacopo Tintoretto.

Shakespeare writes *Romeo and Juliet*.

1595

Henry IV, after surviving an attempted assassination, is accepted back into the Catholic Church and acknowledged as king of France.

The Dutch begin colonizing the East Indies.

Final edition of Montaigne's *Essais*.

1596

The Spanish fleet attacks the English, once again unsuccessfully. Death of Sir Francis Drake.

Caravaggio paints *Basket of Fruit*, now in Milan, an important step in the development of the still life.

1597

Annibale Carracci frescoes the Galleria of the Palazzo Farnese in Rome.

1598

Philip II of Spain dies.

With the Edict of Nantes, King Henry IV of France gives French Protestants freedom of religion.

Shakespeare's theater, The Globe, is built in London.

1599

Caravaggio begins to paint the canvases in the church of San Luigi dei Francesi in Rome.

1600

Foundation of the East Indies Company.

Peter Paul Rubens moves to Italy.

Henry IV of France marries Marie de Medici.

Shakespeare writes *Hamlet*.

Giordano Bruno is executed for heresy.

Index of Artists